THE ART
OF
GILBERT & GEORGE

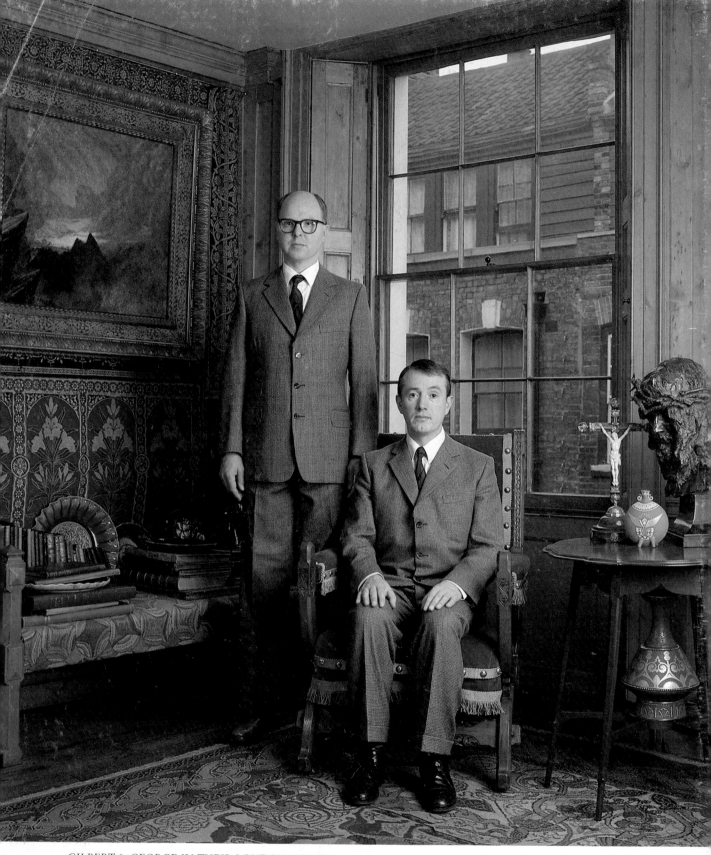

GILBERT & GEORGE IN THEIR LONDON HOUSE.

Photograph: David Montgomery. 1986.

THE ART
OF
GILBERT & GEORGE

OR
AN AESTHETIC
OF EXISTENCE

BY

WOLF JAHN

Translation by
David Britt

Thames and Hudson

First published in Great Britain in 1989 by
Thames and Hudson Ltd, London

Printed and bound in West Germany

CONTENTS

TOWARDS THE END

A Preface

Towards the end of the 1960s two students of sculpture, Gilbert and George, resolved to embark on a shared career as artists. They dreamt of art, of a better life and of greater creativity. But instead of creating anything, instead of carving or modelling sculptures, they turned the act of artistic creation into its opposite. They presented themselves as rigid and hollow men, devoid of personality and entirely bereft of imagination. This state found expression in the declaration that they themselves were LIVING SCULPTURE: not those who form but those who have taken form. Artists and artwork were now one and the same. Like a sculpture Gilbert & George held themselves stiff and rigid, in a state of total immobility.

What gave them form and transformed them into sculpture was the unchallenged hegemony of reason. Reason comprehends all things and reduces them to a state of ultimate sameness and equivalence; it has the same effect on man, and specifically on these artists, as they emphasized by exchanging names. GILBERT BY GEORGE AND GEORGE BY GILBERT was the title of one of their drawings, in which each gave a rigidly stereotyped rendering of the other. On occasion they emphasized their interchangeability further by adorning

their foreheads with comic-strip images of each other. Neither now possessed an individuality of his own which might serve to characterize him as a person and set him apart from the other. Instead both were linked by a state of absolutely empty identity. They announced this by discarding their surnames. They called themselves simply Gilbert & George. Their identical initial served to emphasize the element of shared and hollow identity, as did the stereotyped, uniform external appearance which both adopted.

Thus formed and prepared, Gilbert & George epitomized a constant twentieth-century phenomenon. Art and artists had been drained of all creative power, and reason held undisputed sway. What counted was not creativity but cognition: rational awareness.[1] The result was the hollow man, totally comprehended, without qualities of his own, without sexuality, without creativity.

Gilbert & George's self-presentation as "living sculptures", and as artists who had declared the loss of creative imagination to be the subject of their art, was not an entirely new phenomenon. The imitation of mechanical forms and processes, the renunciation of individual creativity, the loss of sexuality and other human qualities, are recurrent motifs throughout twentieth-century art and literature.[2] Even their promotion to the status of an artwork, the assumption of total identity between the artist and his creation, was nothing new. Similar ideas had been in circulation for years, and it was common for artists to declare their own bodies to be works of art as a logical response to the way in which individual life had been rationalized and mechanized out of existence. Even Gilbert & George's self-presentation as a pair, two artists who in a state of total loss of imaginative power declared themselves to be identical, can be regarded as a modification of degree rather than as something new in kind. Hardly one specific trait distinguished them from the artists and actions

that were central at that time to the continuing debate on the meaning of art.

In relation to the art world of the late 1960s, and in particular to its increasing tendency to call in question traditional concepts of the nature of a work of art, what Gilbert & George were doing was more of a logical development than a quantum leap. The prevalent argument ran like this: when the artist can no longer produce anything original or individual, because everything has already been said and discovered, the only recourse left open to him is to declare himself and his life to be an artwork. The individuality of the artist and the originality of the artwork then coincide exactly in a state of total vacuity and absence of content. The artist, the artwork and the normality of everyday life coalesce in a unity whose lifeless, mechanical rigidity serves to indicate what is absent: a life beyond the iron despotism of the rational awareness. Instead of offering an alternative, the artist mimics reality in all its profaneness in order to indicate, by default, the longed-for "other" life beyond. There is no image of that alternative reality, only intimations of its existence conveyed through the artist's pointed adherence to the lifeless rigour of the rational world. The contrast between life and lifelessness stands as a surrogate for the life whose imagery is non-existent.

To this extent it would be possible to place Gilbert & George within a general artistic context. Their self-presentation as "living sculptures" marks the helplessness and inanition characteristic of the plight of modern art as a whole. Increasingly, the resources available to artists to make a positive response to the increasing mechanization, rationalization and desacralization of society have melted away. Not creation but exhaustion is the artist's message. There is nothing left with which to challenge society, whether by offering negative criticism or positive Utopia. All is grasped, comprehended, taken apart.

Towards the End

There is, however, a limit to the ease with which Gilbert & George's "living sculpture" pieces, and their work in general, can be fitted into a general social context. Quite soon after their debut as "living sculptures", the artists began to produce pictures that became harder and harder to assign to any contemporary artistic trend. There were some pictures that dealt with Nature, others that were distorted and deliberately amateurish-looking, and others again that showed a marked atmosphere of gloom and menace. Somewhat later there appeared pictures in which blood was a Leitmotiv. All this made it more and more awkward to fit Gilbert & George into traditional artistic categories. This was all made even harder by Gilbert & George's refusal to work with other artists and their increasing self-isolation from the mainstream of artistic debate.

There is just one explanation for the artists' abrupt rejection of the dominant artistic ideology of their day. This rejection was manifested in one uncompromising statement of fact and one unconditional and all-absorbing demand. In contrast to other artists, who regarded the state of hollowness, meaninglessness and abstractness simply as the reflection of a historical development, Gilbert & George defined themselves as the incarnation of that state. When they claimed to be "living sculptures" this was no joke – no ironic self-distancing from a possibility that was not really believed in – but a deliberate assumption of that condition in full knowledge of the consequences. To be a "living sculpture" is to be hollow, without qualities, sexless, with no concept of another life to look forward to. "Living sculpture" implies the acceptance of abstractness and meaninglessness in the form of an incarnate revelation: a form of awareness that is manifest in flesh and blood. It was precisely through this deliberate espousal of a state which in itself was not human at all that Gilbert & George were able to formulate their demand for a total sub-

version of the status quo. They proclaimed: "To be with art is all we ask,"[3] and thereby called for a life that would be full not of abstraction but of organic growth. They countered a hollow, lifeless normality with a Utopia of their own:

> Receptiveness is vital to stay alive for the nor-
> mality of tomorrow when we can all live and let
> live again with no frustration of criticism.[4]

By thus espousing a state of lifeless rigidity, on the one hand, and at the same time formulating a clear demand for a "normality of tomorrow", on the other, the artists established the principles that were to govern their subsequent evolution. To do some justice to this, at least in general terms, it will be necessary to depart from traditional methods of interpretation. The pictures that Gilbert & George produced from this point onwards cannot be contained within an approach to art that relates it directly to contemporary social trends, whether in philosophy, ideology, social criticism or the continuing artistic debate. By declaring themselves to be "living sculptures" Gilbert & George were responding to a fact of social life which was particularly evident in art; their subsequent career, how-ever, has taken them into areas which do not provide a reflec-tion of society at all.

It would be easy to ignore Gilbert & George's work totally for this very reason. If it makes no response whatever to society at large, why should that society be interested? But this is just the point. To achieve the goal that these artists had set themselves, the "normality of tomorrow", it was first necessary to abandon the old normality once and for all. Only then did the goal become attainable. And only then, in conse-quence, did it become possible to bring Gilbert & George's pictures back into contact with society at large. When this happened they did not reflect society, however: they presented new, qualitative standards for a new life.

Towards the End

With hindsight it is possible to see that the career of Gilbert & George follows a pattern. Its structure is prefigured in mythology, in religion and elsewhere. Although the artists embarked on it without any foreknowledge of how it would go, they have since pursued it single-mindedly and unerringly. And so the first, introductory chapter of this book is not about the artists themselves but about the central sequence of mythic events that enshrines the creation of the world and the origin of awareness.

This account serves several purposes. First, it takes religion out of the context to which, especially since the eighteenth-century Enlightenment, it has tended to be relegated: that of a hierarchical power structure and an imposed moral framework designed to hold humanity in a state of subjection. There is some truth in this view of religion, but it misses the central point of religious myth, which is the act of sacrifice and the awareness that life reposes on a profound cosmic principle of sexual polarity. Far from oppressing the individual, this knowledge liberates him by presenting him with meaning.

This chapter will also help to make sense of the successive phases of the artists' evolution; and to elucidate a number of images within it, such as that of sexual polarity and that of kingship, that are shared with the mythic image of the world. Lastly, the question arises – and an answer can be essayed – whether religious myth can even today take concrete form. This entails considering the extent to which Gilbert & George's assumption of the condition of "living sculptures" corresponds to the final phase of the life-cycle of a form of religious awareness: the point at which it is reduced to a hollow shell, which in turn is perceived by man as his own incarnation.

Once this basic context has been established, it will be easier to follow the description of Gilbert & George's work and evolution in the chapters that follow.

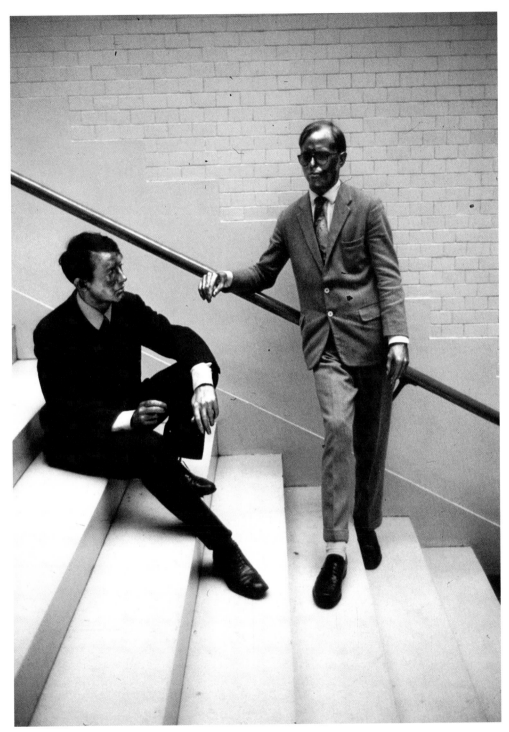

LIVING SCULPTURE. 1969. Stedelijk Museum, Amsterdam.
Person and artwork are identical and form a unity.

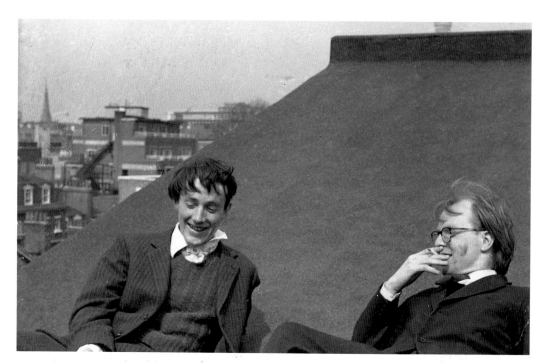

Gilbert & George, 'Relaxing'. St. Martin's School of Art. 1969.

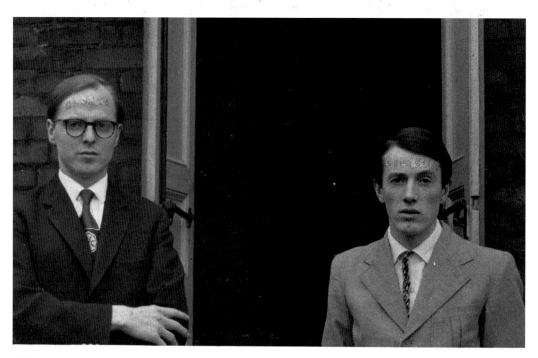

With glitter names on heads. London 1969.

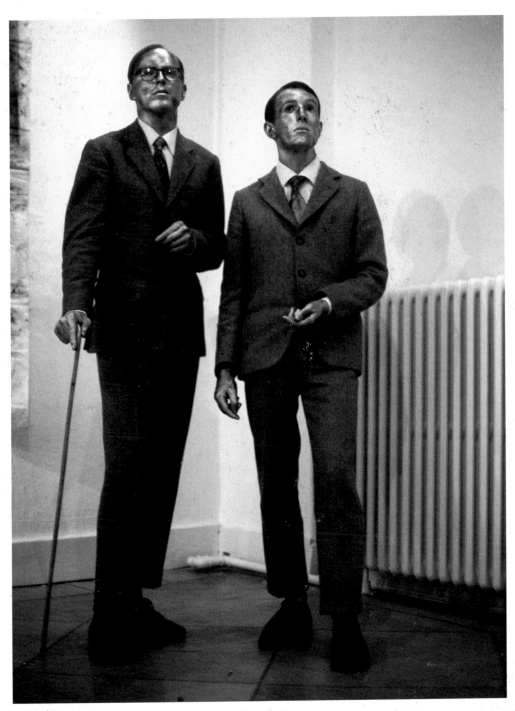

LIVING SCULPTURE. 1970. Folker Skulima Gallery, Berlin.

GEORGE BY GILBERT and GILBERT BY GEORGE. 1970. 30 x 42 cm. Art & Project Bulletin 20.

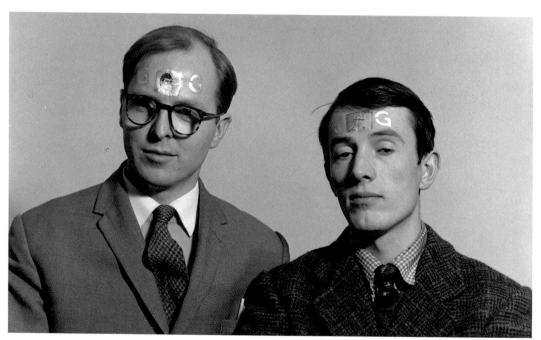

DESIGN FOR FOREHEADS. 1969.
Loss of individual creative power and interchangeability.

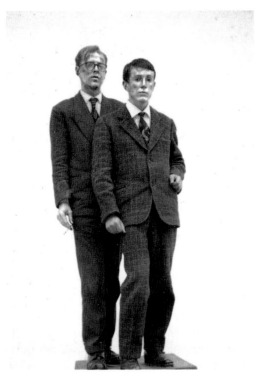

LIVING SCULPTURE. 1970.

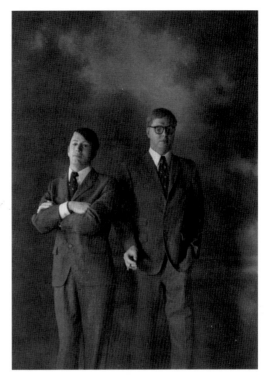

Wax figures by Patty Rogers. 1975.

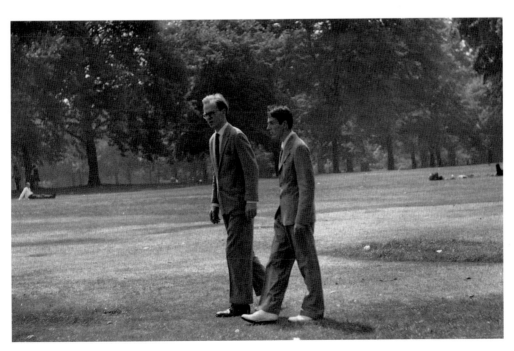

HYDE PARK WALK. 1969. A living piece.

'ART FOR ALL' LONDON, 1969

"*All my life I give you nothing*
and still you ask for more."

from the sculptors

George and *Gilbert*

POSTAL SCULPTURE. 1969.

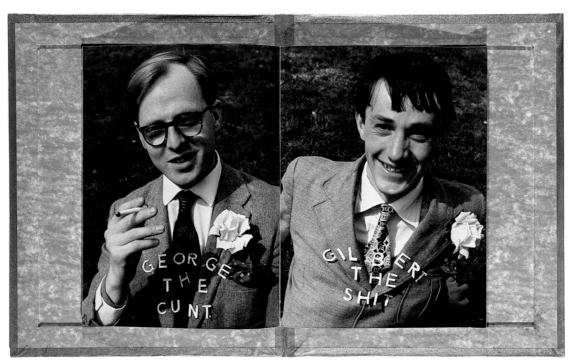

GEORGE THE CUNT AND GILBERT THE SHIT. 1970. A Magazine Sculpture.
All is invalidated and value-free: even rude words lose their force. Now they are nothing but names.

18

A SCULPTURE SAMPLE
ENTITLED
SCULPTORS' SAMPLES

1. *G &G's make-up.*

2. *G &G's tobacco and ash.*

3. *G &G's hair.*

4. *G &G's coat and shirt.*

5. *G &G's breakfast.*

Page from A MESSAGE FROM THE SCULPTORS. 1970. A Postal Sculpture.

PHOTO-PIECE. 1971. 133×150 cm.

STAGGERING. 1972. 77×101 cm.

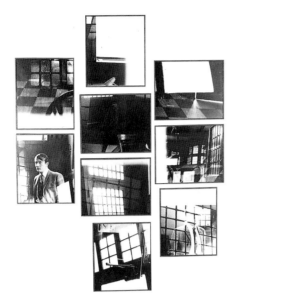

IMPRISONED. 1973. 119x92 cm.

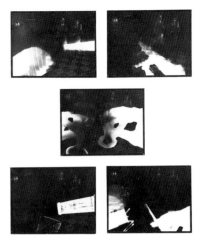

BOTTLE BAR. 1973. 53x46 cm.

Gilbert and George, the sculptors, say:—

'WE ARE ONLY HUMAN SCULPTORS'

We are only human sculptors in that
we get up every day, walking some-
times, reading rarely, eating often,
thinking always, smoking moderately,
enjoying enjoyment, looking, relax-
ing to see, loving nightly, finding
amusement, encouraging life, fighting
boredom, being natural, daydreaming,
travelling along, drawing occasionally,
talking lightly, tea drinking, feeling
tired, dancing sometimes, philoso-
phising a lot, criticising never, whist-
ling tunefully, dying very slowly,
laughing nervously, greeting politely
and waiting till the day breaks.

Text from A MAGAZINE SCULPTURE. 1970.

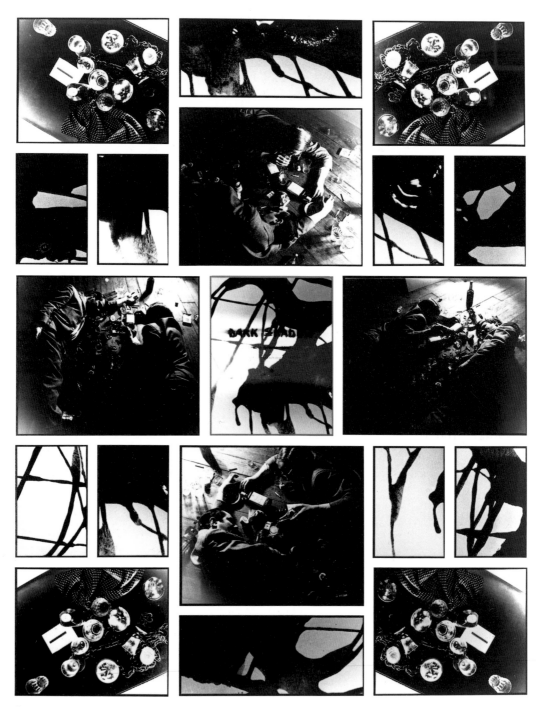

DARK SHADOW NO. 9. 1974. 212×166 cm. A later LEITMOTIV: blood.

MYTH
and
AWARENESS

An Introduction

Ever since State and Church became separate institutions, the identity that formerly existed between nation and congregation has been fading away. Religious institutions still exist, of course, often to conspicuous effect; but faith as a bond linking all men together has largely disappeared. Furthermore, faith itself has undergone a profound upheaval. It now occupies what in comparison with earlier times can only be called a marginal position.

This is the consequence of a potent and universal process, the so-called Enlightenment, which made use of critical reason to eliminate all structures of power and authority external to man. The Church and its doctrines were its first target. More and more people were chafing against the iron rule of the Church, its moral dictatorship and its largely authoritarian and oppressive educational mechanisms. This gave rise to a misconception that is still cherished to this day, by those who argue the Enlightenment point of view: that religion and the hierarchical institutions which represent it are one and the same. Religion has come to be regarded as a power structure par excellence which by claiming a divine sanction systematically crushes the freedom of the individual from the day of his birth.

To avoid falling into this trap of confusing religion with theocracy, it will be necessary in this Introduction to give an outline of the religious world-view as such, concentrating not on law and hierarchy but on the creation and meaning of the world.

There can be no question of making universally valid statements. Religions and mythologies are too complex to fit readily into a neat unitary picture. Nevertheless, the religious texts of many cultures do tend to agree in the way they deal with certain fundamental issues: the divine origin of the world and of man, and the nature of the historical process. Whether the tradition be Indian, Persian, Babylonian-Sumerian or Biblical, the account of Genesis has the same underlying structure and presupposes a common vision and experience. As these common features have nothing to do with individual forms of society, nor with the nature of the deities concerned, attention is directed to the basic pattern that underlies the traditional narratives. This pattern, which may be defined as "Absolute – Duality – Trinity", points to what is essential in the myths of transition from God to world.

THE ABSOLUTE: GOD

The question of the prime and absolute meaning of the Universe and Life is frequently answered in religious texts with the image of a non-image. They give no answer precisely where the desire for an answer is keenest: to the question of the origin of all being. The implicit admission that there is no answer is an acknowledgment of the limitations of the human senses and the human mind. The texts do, however, try to provide an answer of sorts by defining the origin of things through a negative, by asserting that it resides in God. Man's inability to see God has the consequence that God is described

as the "All" and the "Absolute", the Infinite and the Unknowable. Any more specific description would be in vain, because absolute Unity has no properties beyond its own absoluteness. So religious myth rests content with the image of an imageless God, who is All, Oneness, and yet also Nothingness. He is the undifferentiated entity who incorporates all possibilities without himself becoming a possibility, who possesses all qualities without manifesting any of them, who encompasses space, time and motion without embodying them. From him all comes, and to him all returns. This primordial God resides in himself alone and is sufficient unto himself in his own self-identical Being: he IS.[5]

Mythologies and religions mostly denote the state of absolute self-identity by using such terms as "primeval depths", "darkness" or "chaos", which indicate the unknowability of that primal state. The best-formulated description of the Absolute as God belongs to Indian tradition, where it or he is known as Brahma, "he who has no second or counterpart", "he who cannot be represented". The name itself thus points to the "in-difference" of the Absolute.

The existence of the visible cosmos, and with it of the world and man, is attributed by man to the divine Will which resides in the Absolute. When the Will begins to operate there begins a long process in the course of which the objects of the created world detach themselves from the mass of the Absolute; this is the origin, the quantum leap. Gods then appear in turn, as personifications of principles, of multiplicity and of individuation. Finally the world itself makes its appearance: the elements, the plants, the animals and man. All these are emanations, potential manifestations of one and the same God.

It is important to distinguish between God the Absolute and God the Creator. It is here that Biblical tradition itself has led to some unfortunate misunderstandings. The Book of Genesis does not begin with the nature of God but

with the Creation; and so the essential nature of God is passed over in silence, and the primordial God has come to be equated with God the Creator. But at the beginning of all those religious traditions that ascribe all being to a single origin, there stands God the Absolute, unqualified by any visible, manifest, just or moral quality. He might be likened to a zero, fertile in potential but manifesting none of its possible qualities.[6]

DUALITY AND SEXUALITY

The emergence of the Universe from the Absolute begins with separation; and this means duality. Duality manifests itself most fully in terms of sexual polarity. The male and female principles make their appearance. And so, in Indian tradition, Vishnu (the male principle) and his consort Lakshmi, who sits upon the serpent Sheiha (the female principle), are the first to emerge from the Absolute.[7] Their interaction, representing the power of manifestation, on one hand, and plenitude or fertility on the other, is the origin of the cosmos and its gods. In other traditions the male and female principles are represented by the Creator God and the Dragon, or – as in the Bible – by the "Spirit of God" and the "waters" that appear at the outset of creation: "And the earth was without form, and void; and darkness was upon the face of the deep. And the Spirit of God moved upon the face of the waters."[8]

Duality is thus the first qualitative development in the religious cosmogony. The appearance of sexuality in the form of two mutually dependent principles is the prime precondition for the further evolution and unfolding of the cosmos. Only this enables man, and with him all other entities, to appear.

By the nature of things, the images generated by the two principles are different, but within each of the sexes they

are consistent. Thus the female principle mostly shows itself as monstrous, formless, moist and menacing. Its images are serpents, the dragon, chaos (and its daemon), ocean, Hell, or simply fallow earth. None of this implies a moral judgment, rather the undifferentiated and un-ordered nature of the female principle, which corresponds in turn to a limitless and fruitful plenitude of wisdom. This principle holds within it all still-unformulated knowledge. Formless though the female principle may appear, it is rich, pregnant, heavy with wisdom and fruitfulness.

In contrast to the female principle, the male principle is manifest, whether in the guise of the Creator or of the Spirit of God. From the outset it has form, or the will to form. And through this will it is able to extract knowledge from the female principle and give it formal definition. The result is the visible, formulated cosmos of humanity. How this takes place will be explained in the following section.

TRINITY: SACRIFICE AND CONSCIOUSNESS

After the appearance of the fundamental duality, represented by the sexual principles of life and of the continuance of life, there occurs the central event of sacred myth: a sacrifice, which leads to a redemptive rebirth, which in itself is an image of the world. From this rebirth man, or the whole cosmos, is born. Traditions differ at this point. In some texts the two initial principles themselves appear in the context of sacrifice, in others the deity who is sacrificed does not make his appearance until later. This deity is, however, always the progeny of the two first principles.

In Greek myth the sacrifice takes place first of all within the divine process of Genesis itself. A number of successive sacrifices are necessary in order to establish the divine pattern, the pantheon, which provides the archetypal

underpinning for man's existence. Thus, Cronus slays and castrates his father Uranus, whose blood mingles with the earth to produce further deities. Zeus, Cronus' son, repeats the process in his turn. He does not actually kill his father, but he acts out the castration in the symbolic guise of dethronement (pages 56–57).[9] These sacrifices ultimately reveal themselves to be necessary in order to build the divine world, that of the gods whose vicissitudes serve as a sacred pattern and guide for human history.

The structuring of this exemplary divine world of imagery is a process which in many traditions involves further acts of sacrifice. The Hindu version tells of the god Purusha, who grows inside an egg. After a period of incubation he hatches out and splits the egg in two. The upper half becomes the celestial sphere; the lower half becomes the earthly sphere. The god voluntarily submits to sacrifice. His thousand-limbed body is slaughtered, dismembered and dispersed. At his rebirth he recognizes his own scattered members as the structure, essence and order of the universe. His body is the macrocosm, whose image is the microcosm of human life (page 58).[10]

The creation of the visible world in Germanic myth follows a similar course. Here the giant Ymir, the first being to be endowed with life, is slain by the sons of Bor. Here too, his death makes possible the creation of the world. His blood and the parts of his body constitute the universe as a living organism. The streams of blood become the sea, the bones become the mountains, and from his brain arise the clouds.[11] In Babylonian tradition there is the sacrifice of the primordial created being, Tiamat, from whose dismembered body the Creator God, Marduk, makes a work of art, which is the cosmos (page 60).[12] Biblical tradition, too, once enshrined a sacrifice in its central story, that of the creation of man. According to one entirely plausible interpretation, which can

admittedly not be traced directly to a specific Biblical text, the archangel Lucifer was sacrificed and subsequently became the personification of the underworld of Hell. His sacrificial remains formed the clay from which man was created. God thus formed Adam in his own image from the material of a "dissident" but formerly divine and radiant body.[13]

The meaning of divine sacrifice is twofold. On the one hand it introduces the idea of death as a necessary and salutary fact of life; on the other it exemplifies the act of sexual reproduction. In the regenerative process of life, dying must eternally coincide with begetting, pleasure with cruelty. The lifeless remains of a former deity give rise to new life. And thus the corpse of the victim undergoes rebirth, and death no longer carries the threat of total annihilation.

Viewed from another aspect, divine sacrifice constitutes a projection of sexuality on to the cosmic level. The father, the male principle, enters and occupies the mother, the female principle. Through the act of sacrifice he penetrates the maternal ground of being, the substrate of wisdom, and brings back the knowledge of a sacred order which endows the cosmos with a visible – and also divine – structure, thus making it truly a cosmos. And this cosmic rebirth constitutes the Son, the offspring of the original "cosmic parents", and makes it possible to speak of a Trinity. In cognitive terms this means: The Knower (father) possesses the Known (mother). The offspring of this union is Knowledge (the son), and this in turn forms the visible and audible cosmos which man perceives as a divine order. This Knowledge is the primordial imaginative awareness, the faculty which gives us the universe, and is thus the King of human life. A King, because through divine sacrifice it sets up the order which man perceives as divine.[14] Man's world, and man himself, thus find a place in the direct line of descent from a God who was initially absolute and invisible.

Myth and Awareness

Such are, in outline, the central mythic events which describe the transition from an absolute and self-identical substance to the differentiated and sexually polarized world of mankind. There are three factors that characterize the mythic imagination and the religious understanding of the world:

1. The initial and eternal ground of man's being, the innermost meaning of life, is concealed from him. It is totally divine, but for this very reason it is unknowable. It is absolute, i.e. qualitatively undifferentiated and autonomous in its identity. Within it all the values that man recognizes as ultimate are enshrined and at the same time concealed.

2. Sexual polarity constitutes the prime and essential precondition of life as an unfolding of the Absolute. Although it can be interpreted in terms of human sexuality projected on to the cosmic plane, it manifests itself first of all in a space devoid of humanity. It is a basic prior condition of any Genesis in which man is created, even though he is born only at the end of that process.

3. The sacrifice of a divine being is a necessary prior condition of the emergence of the universe, of living beings and of Man. It introduces death as a necessary aspect of life and is revealed through the mythic theme of rebirth as knowledge or awareness. This represents the origin of the basic imaginative faculty of the human mind, and manifests the imaginal nature of his world, which is also that of the unfolded, manifest God. Thus the sacrifice of a second, third or subsequent deity serves to

make tangible that which in the Absolute remains unknowable. In the Absolute, knowing or the birth of awareness as a sexual act remains an unacted potentiality.

The primal mythic event thus outlines what can adequately be described as the macrocosm-microcosm relationship. Man recognizes his own nature and his universe as the image of a superior, divinely ordered cosmos. However – and this is a point that has tended to be overlooked – none of the divine ordinances that are inscribed in the heavens is permanently valid. The world in which man lives must constantly be the object of a new awareness: it must be known and read anew. Here the word "religion" can be understood in its derivation from the Latin verb RELEGERE, with its underlying sense of "to re-read", to repeat.

This means also that the act of sacrifice, which kills old life to promote new life, must constantly be repeated. Again and again, in the history of religion, the old awareness must suffer a cruel death so that life may go on under the auspices of a new awareness. The relationship between the human microcosm and the divine macrocosm can be summed up in the single aspect of sexual polarity; but this too cannot be restricted to a single consistent form. It is manifested everywhere except in the Absolute, the beginning. But sex does not constitute an order or a structure; it represents the forces that keep life going. It is only the working of sexuality, through death, procreation and rebirth, that maps out an awareness of life as subject to change through time. Religion is defined, first and foremost, not by order, structure or law, but by a constant and evolutionary flow of sexual polarities which constantly creates a new form of awareness even as it ruthlessly annihilates the old.

How does the world of manifestation unfold, and what

is the concept of time that underlies its history? This process, and the sequence of events involved, underlie the whole argument of this book. They form the subject of the section that follows.

THE RECURRENCE OF AWARENESS

The initial events of sacrifice and the birth of awareness must be repeated. The Son (the King) cannot live for ever. His concrete and fully elaborated form of awareness – which encompasses not only imagery but a whole moral, social and political context – is limited in duration, just as life on earth is. The world order set up by the initial sacrifice gradually decays. The indwelling and guiding powers within the old awareness fade away in the process of keeping it renewed. It must be sacrificed, and a new one must take its place.

The realization that no pattern of awareness lasts for ever has led to the doctrine that the universe passes through a succession of epochs. It is immaterial for present purposes whether this is seen as a degenerative process, or as the progressive purification of mankind. In every version there appears at the conclusion of universal history a moment of redemption at which the drama of sexual polarity and the necessity of death and procreation come to an end. In the Bible this takes the form of the Last Judgment and its promise of an afterlife which recaptures the condition of the primordial world: Paradise.

How does an epoch unfold and how is it constituted? Its existence in time makes it subject to the natural processes of birth and death. It passes through the stages of germination, flowering and maturity, and finally falls into decay. Its beginning and its end are not, however, identical. Time is traversed; it never returns. This means in practical terms that no cosmic epoch, with its governing form of awareness, can ever come

twice. Every one is new and unique. Cyclic time and linear evolution are directly related. Every cycle is like a turn of a screw. It revolves around an axis which is common to all cycles, but always returns to a point above or adjoining its starting-point. Time is thus neither an infinite straight line nor a closed ring but a constant tightening of a screw.[15] The evolution of the world and mankind has continuity but not linearity. It embodies a spiral tendency.

The first epoch (or Great Year) of all begins with the Creation, the initial divine sacrifice. The ensuing epochs are ushered in by "God-Men", individuals prepared to sacrifice themselves for the sake of the new. The God-Man, an intermediary between the celestial and terrestrial spheres, sacrifices himself as a surrogate for the dying epoch, and his rebirth and the new form of awareness that he embodies are the guarantee of continuity with the age that is to come.[16] The sufferings of the epoch that is in decay – and this means, essentially, the forces that maintain a form of awareness that is still dominant but can now no longer be regenerated – are accepted as his own, and he eliminates them by offering up the sacrifice of his own body. By so doing he consigns them to oblivion. This radical act of self-sacrifice makes him a saviour, the herald of the new epoch and its gospel of salvation. The sacrifice that he offers up is in symbolic terms not that of his body but of the form of awareness proper to the old epoch, now embodied in his own flesh and blood. And so he allows himself to be dismembered or crucified in order to eradicate the old awareness in incarnate form.

This man, who exists in the spirit according to all the traditions, and who became flesh and blood in Jesus Christ, bears the epithet "divine" by virtue of his sacrifice, which is initially a divine sacrifice. He himself as a person is the constantly renewed incarnation of the "Eternal Man" whose image is the subliminal face of God. This means that, just as

God the Absolute contains all possibilities within himself, so the Eternal Man contains within himself all the possible forms of awareness to which man in general can lay claim. The God-Man takes on a new aspect of this Eternal Man to represent the new epoch. One of his many names is "King of the World" – another allusion to the dominance of the new form of awareness that he represents. He is the human prototype who presides over the new epoch, whether as a lawgiver or as the harbinger of a new gospel of salvation. The form of awareness that he establishes governs the entire evolution of political, social and religious life.[17] (The sacrifice of a form of awareness IN CARNE, in the flesh, and the status of the new form of awareness as a human image, are reflected in the use of the word "incarnation" to denote the process by which the divine becomes human and man acquires his divine image.)

In the Persian BOOK OF BUNDEHESH the name of the Eternal Man is Yima. When an epoch draws to an end – and this means that the old form of awareness is too enfeebled to regenerate it – Yima intervenes in history in a succession of new incarnations, as King Fretun, as Zarathustra, or as Saoshyant. He suffers death each time – being, inter alia, crucified and sawn to pieces – and thereby makes his contribution to the renewal of the world (page 62).[18]

THE LIFE-HISTORY OF THE GOD-MAN

There has so far been little scholarly work on the life-history of the God-Man. There is an abundance of source material and of expository literature, but the fact of the killing of an incarnation is dealt with only as a marginal aspect.[19] Most accounts concentrate on the mythological material concerned with the hero's sacred journey, which is common to almost all cultures: the path of sacrifice which begins with the swallow-

ing of the hero by a monster (Hell), continues with the trials which he undergoes in his journey through the Underworld and finds its heroic conclusion in his glorious rebirth. So no detailed account of the stages and phases of his sacrifice and resurrection can yet be given, beyond the fundamental themes of Crucifixion (martyrdom), Harrowing of Hell and Rebirth. But there are a number of sources that do give more information about his life and passion; these exist mostly in religious myth and in the tradition of alchemy.

In his study of tradition, ÜBERLIEFERUNG, Leopold Ziegler has attempted to summarize the life-history of the God-Man in some detail. The study of a number of Old Testament figures leads him to list a number of characteristic features, of which he writes that they "are seldom found all together in any individual case, and yet it is not difficult, as a rule, to infer the presence of those that are not mentioned".[20]

Ziegler lists seven points. Those that are relevant in a general context are the following:

1. The Son (God-Man) is fatherless.
2. He is exposed in a cradle, or a basket, and is persecuted by the rulers of an enemy kingdom.
3. He is tortured or "transfixed" on the wooden instrument of his martyrdom and sacrifices himself for others, before undergoing a post-mortem journey, a Harrowing of Hell, a new birth and resurrection.[21]

The first two points serve to confirm at the outset the state of total desolation and isolation in which the God-Man finds himself. His lack of a father has two main implications: first, that he has no earthly father, and thus no life-history in an earthly or individual sense; and second, that by virtue of this

fact he can claim a divine origin. His life is devoted to the salvation of all men, and not to his own.

Fatherlessness can also be interpreted – and this Ziegler does not mention – as the LOSS of a father. This means that the absence of a father-figure can be equated symbolically with the absence of a sense of meaning or ruling form of awareness. The fact of exposure in a crib or basket confirms this. The individual who is exposed in this way – deserted by his father – is menaced by the world around him, the power of the hostile kingdom. This external power, in its turn, represents the old form of awareness, which to him is already lost.

The third of Ziegler's points, finally, indicates the necessity of sacrifice in order to bring to birth (rebirth) a new form of awareness. The man who is left at the mercy of his enemies is set free by the old father only after he has sacrificed him in his own body. He is then resurrected, to become in his turn the father of a new awareness.

This model of cyclic destruction and renewal through conflagration is derived from a simple natural phenomenon: the Harrowing of Hell. A plant, for example, germinates from a seed, passes through the stages of flowering and ripeness and finally dies. However, before decay sets in, it leaves behind a seed which may be symbolically regarded as its own incarnation. Before this can live and bear fruit in its turn it must go underground, into Hell, there to burn away the old life. From the dross of this process new life emerges. Transposed into terms of the life-history of the God-Man, this means that he incarnates the germ of the old awareness. The old life cannot in itself be regenerated, and so he must descend into Hell in order to set the process of life in motion again. The life-history of the God Man thus essentially follows the simple, natural, everyday sequence of combustion, death and renewal.

The history that is written in this way is that of the salvation of man, the bonds of death and sacrifice which bind

man to God. For man it signifies that he is human only in so far as he participates in the divine, or in the Eternal Man. This history is that of a new form of awareness which is always achieved only through death and which constantly stands in need of renewal. Seen in this light, religious or mythic history contains within itself an extraordinary faith in progress: it must constantly destroy and kill its own forms of awareness, for their own sake. This form of progress is of course diametrically opposed to the modern, post-Enlightenment idea of progress as a linear evolutionary process dominated by rationalism.

ALCHEMY: PURIFICATION OF MATTER

The mythical context presented here suffices in itself to lay the foundations for an understanding of the work of Gilbert & George. They too pass through the God-Man's cycle of life, death and rebirth, offer up the sacrifice of an awareness of life that can no longer be regenerated, and replace it with a new one. However, it is important to realize that the motif of renewal through death is not unique to religion and mythology, but manifests itself in other, quite distinct contexts. This is why it is worth giving here a brief account of alchemy, which provides by far the richest existing repertoire of iconographic material on the theme of the God-Man or "King of the World".

The fact that the alchemists, in particular, devoted themselves to the theme of sacrifice and rebirth may at first seem puzzling. The explanation is to be found in the nature of their quest. This involved two major considerations. First was the refining of materials, especially metals, with the aim of extracting a purified matter in the shape of gold or the

Philosophers' Stone.[22] In symbolic terms, gold was the sun, the heavenly body which never ceases to shine and which symbolizes divine power.[23] Behind this process of, initially, material and literal purification there lay in many cases the wish of the Adept (i.e. the member of the fellowship of alchemists) to undergo an individual process of purification which would afford him a vision of the celestial spheres.[24] The transfigured matter was to be the means by which the Adept himself would be elevated to the heights of divine knowledge and wisdom.

It is important to notice here that the alchemists' initial and dominant motive, which was to achieve through material action an esoteric participation in the Godhead, ultimately disappeared. As the modern scientific awareness of materials and their relationships progressively took over – an awareness to which alchemy had made an important contribution – the impulse to pursue a divine awareness progressively receded. The once dominant philosophy of the alchemists is now the preserve of a dwindling band of devotees whose contribution to human knowledge and wisdom is negligible.

In order to find a visual equivalent for the alchemical purification of matter, the illustrators of alchemical works exploited the resources of Biblical and mythological literature on a gigantic scale. Not unexpectedly, the episodes they chose were always those in which a human being or a god is tortured and killed, only to undergo a subsequent divine resurrection.[25] The religious theme of "renewal through death" was thus transposed by the alchemists to their own sphere of interest. This explains why they regarded even Christ himself as their precursor. His death, his blood and his resurrection could be used as symbolic equivalents for the alchemical purification (page 65). At the same time, and in the most varied guises, Duality was represented as a mother and father, procreation as an act of death and putrefaction, and finally the

birth of purified matter as a son (a new awareness). In other sequences of images the central event is the murder of the father, or of the King (page 66), by his son. Both suffer death together and descend into the grave. After a period of putrefaction the Son is reborn as the regenerate ruler (page 69).

Seen from another angle, the King, or the alchemists' Matter, undergoes an upward or downward shift along the cosmic scale or hierarchy which runs from the mineral sphere by way of the vegetable, animal, human and angelic spheres to that of God himself. The King experiences Descent in terms of menace and destruction, or of fascination and desire – like a drug experience which distorts and upends the prevailing order of things – and Ascent in terms of purgation and renewal. These experiences correspond to specific phases of the process of death and regeneration: burning, decay and ossification on the one hand, and sublimation and repeated re-forming on the other. This exemplifies once more a characteristic of the primordial religious sacrifice: that the new arises from the dross of the old (page 67).

Alchemy provides us with a wealth of illustrative material to document this originally religious and mythological motif. Even though it always represents death in human terms – the death of a King, or of a King and Queen, or of an anthropomorphic deity – and describes the successive phases of this Passion in entirely consistent terms, the death it refers to is never human death. It is not a person who is dismembered and killed but the alchemical Matter in its various vessels and pieces of apparatus. Thus, on page 66, the King is marked with the word ORO. He symbolizes the gold that requires one more cleansing. In other pictorial sequences, the process of purification culminates in the attainment of material wealth. Thus, page 69 shows a lady distributing money as the product of the alchemical purification of matter.

Myth and Awareness

In spite of all the analogies between the religious imagery of sacrifice and that which is employed in alchemy, the distinction is a fundamental one. In religious texts the old life is done to death in order to procure a new life which will bring salvation for all. The sacrifice is for the benefit of society at large. In alchemical tradition, on the other hand, the Matter is killed in order to enhance its productive capacity. This too might of course be of use to society – as indeed our own unprecedented prosperity goes some way to show. However, this has nothing whatever to do with a qualitative improvement in human life brought about by a new and shared form of religious awareness.

Finally, it is worth giving some account of the nature of the religious historical consciousness and world-view, in order to be able to set out in advance the main lines of Gilbert & George's evolution to date. Gilbert & George, too, undergo a process marked at the outset by the loss of the father (the loss of creative power), and they go on to harrow Hell and entomb themselves in dusty stasis before achieving an ultimate and radical renewal. They too suffer on society's behalf; for social life itself has decayed beyond hope and stands in need of total renewal.

What is unique about their artistic career – and this explains, among other things, the fact that this chapter begins with a religious creation myth – is its starting-point. Cosmic beginnings spring from the undifferentiated Absolute; and that is where Gilbert & George began too. Not that Gilbert & George set out to represent the Absolute – that would be a disastrous misconception – but they took the one and only qualitative attribute of the Absolute and incarnated it. When they declared themselves interchangeable, regarded all value as equivalent or immaterial, and expressly declared that they existed in a state "where something and nothing are both qualities",[26] then it was precisely the undifferentiated self-identity

of the Absolute that characterized Gilbert & George themselves. When they made the subject/object relationship into one of absolute identity, in which the human being is himself an object and thereby becomes interchangeable, they were invoking the primal state that religious tradition calls "darkness", "primeval depths" or "chaos". All is One, but by the same token all is indistinguishable and unknowable. For God the Absolute this state of being may be entirely natural; for a human being it is a curse, denying as it does everything that defines him: life, sex, death and the desire for differentiated beauty.

The Absolute is most often spoken of as something in which all is made clear and may be contemplated. This finds an analogy in the idea of the total work of art, the GESAMT-KUNSTWERK, a creative synthesis which encompasses and represents the whole of life. But the truth is that the Absolute is homogeneous: it contains everything but manifests nothing. For this reason if for no other, Gilbert & George have passed through a phase of Descent into death and sacrifice, ultimately followed by an Ascent. As in the initial creation, this Ascent manifests first as Duality, then as Trinity or World. All this in order to achieve what is lacking, "the normality of tomorrow", and to make it available in terms of formulated imagery. What counts for them is not their personal salvation but service to others; or, in their own words:

> That all is lost is not a fact so accept the gift of movement on this our planet. Because if not for you then it will be FOR A FELLOW CREATURE.[27] [Emphasis added.]

THE OLD AWARENESS AND THE CORPSE
OF THE OLD KING

This discussion of the essential religious context has left open the question of Gilbert & George's point of departure as "living sculptures" and their self-proclaimed status as hollow, abstract and contentless bodies. What brought these two artists to this state, which not only characterizes them but has a latent existence elsewhere? For there can be no doubt that the condition they espoused, which is one of total equivalence, in-difference, value-freedom and abandonment of qualitative distinctions, has become a fact of life in general.

Another issue that remains open is the nature of the old form of awareness that Gilbert & George sacrificially destroy in the course of their work. What constitutes it, and how does the religious and mythic act of sacrificing it acquire validity and bring salvation? Embedded in this question lies a central issue, especially as in these days the simple immolation and dismemberment of a body does not automatically invoke the hope of regeneration. What can be the form of that ancient and yet still prevalent form of awareness which allows an apparently obsolete myth to retain all its force and effect?

To answer these questions it is necessary first to adopt a completely new approach to the state of total abstraction which Gilbert & George embodied at the beginning of their career. Whenever attempts have been made to account for the present hegemony of reason, with its negation of all values, qualities and power structures, the explanations offered have mostly been inconclusive. On the one hand, reason is recognized to be necessary, as a critical tool for the dismantling of existing hierarchies and patterns of dependence; on the other hand it represents the greatest obstacle to its own operation, in that it has nothing to set up in place of those demolished bastions but an ever more diffuse and generalized Utopia. In

practice, a seemingly tolerable degree of dependence on reason leads on to its absolute hegemony. Reason reveals itself as a conceptual system (the world is rationally conceived, grasped, exposed and dis-covered) which has totally lost contact with the imagery of life.

The historical explanation that will be offered here for the hegemony of reason, and for its displacement of all competing value-systems, is, once more, based on religion. It posits an essentially religious historical process in whose operation reason has evolved into a dominant organ of awareness, but one which remains firmly under the control of the religious process itself. In its application to Gilbert & George this can be formulated as follows: Does their initial self-presentation as "living sculptures" embody a degenerate and obsolete form of awareness which draws its meaning from a religious process and thus, ultimately, from a God-Man? If so, then within the discontinuity of history there is a continuity of awareness – i.e. thought and action – which in itself ultimately constitutes the God-Man's gospel of hope.

One God-Man whose gospel is still potent today is of course Jesus Christ. His Passion and Resurrection conform to the life-cycle of the God-Man; historically speaking he is the most recent incarnation of Eternal Man, and very probably the only one to have existed in flesh and blood. For this reason alone his sacrificial death has inevitably had a substantially more potent effect than those which have taken place "only" in the spirit. It was above all the fact of Christ's Resurrection and subsequent Ascension that created a community of human desires that lasted for centuries. To the faithful, Christ's Crucifixion, and his subsequent rise to the right hand of God, represented the ultimate proof that all men might be at one in the enjoyment of a just and everlasting afterlife in which Adam's original sin, and the division of humanity into two sexes, would be forgotten.

This ultimate future event, which the sacrificial death of Christ makes into a sacred promise, has radically affected the course of history and the nature of Western civilization. The image of the divine body in which humanity is to be subsumed has retained its power to evoke the union and identity of all men. Here lies the central insight of Christianity: the universal human longing for a life that conquers death, a life in which all men are equal.

In the history of this powerful religious idea there has been one momentous and decisive shift. The desire for justice and redemption after death has gradually been displaced into the life that comes before death. "Nature" as the concept which epitomizes the true home of mankind – formerly symbolized by the gold ground in painting, and thus firmly localized in the Beyond – has made the transition into the mundane sphere of this world. Western man has thus begun to discover and promote terrestrial Nature as his "true" nature and as his true home. The sacred, celestial and immortal divine body, which unites all men, must now be realized on earth.

This historical process is one of discovery and exposure; at the same time it is one of dissection and dismemberment. It reveals things to be true or untrue, real or unreal, in objective, rational terms, and thus progressively effaces what has hitherto been seen as truth or revelation in divine terms. The process ends with total exposure and total dismemberment. In the end man himself is rationally conceived, known and utterly hollow. Man is known, not through a positive anthropology, but through an anthropology of unmasking and exposure. He is empty, with nothing on which to model his life or its values.

Well known under the names of secularization and desacralization, this process has the effect of dismantling all existing forms of authority, religion and social organization.

First detectable in the later Middle Ages, it made decisive strides in the period of the Enlightenment. Less familiar is the thesis that the process of secularization received a decisive impulse from the medieval power struggle between the Empire and the Papacy. Dietmar Kamper clarifies this in an essay which he calls "Der Körper des Königs" – "The Body of the King" – and in which he sets out to interpret this same evolutionary process in terms of a self-perpetuating structure of human action and thought.[28] Kamper shows – and this is crucial – that the work of exposure and dismemberment is carried out with the aid of reason. Rational awareness becomes the vehicle of a religious message. The consequence is that human imaginative power is converted into an abstractive power, which has as its objective the attainment of a rationally comprehensible "ground of being"; and this in its turn is none other than Nature in the image of man: "Human Nature".

The central historical event which for Kamper epitomizes the shift from sacred to profane is the dispute between Frederick II of Hohenstaufen and the Papacy. The Emperor sought to define the people of his Empire as the divine body, the CORPUS MYSTICUM. The life beyond, the immanence of God as manifested in the union of all souls in peace and justice, was thus to be achieved on earth. This marks the appearance of a rivalry between sacred and profane authority in which the profane seeks to usurp the role of the sacred. The Emperor thus in a sense

> ...institutes a shift towards the secular by the very fact of insisting throughout his life on the sacredness of the operations of the State... The crucial point is his attempt, forced on him by his competition with Rome, to bring down to earth a form of celestial authority whose sanction lies entirely in the realm of sacred myth, to capture

it in national and imperial institutions and thus
to make the Empire which subsists by Grace of
God into the instrument of the desacralization of
the world.[29]

In the interests of this gigantic undertaking Frederick II
adopted a political slogan which set in train the whole process
of uncovering and dismembering traditional structures:
MANIFESTARE EA QUAE SUNT SICUT SUNT; "Show what is, as it
is."[30] So utterly modern a methodology, which sets out to
make visible an empirically based reality, and thus admits only
such knowledge as can be verified in rational and logical
terms, is a process of exposure and dismemberment. Power
structures, religious images and religious ideas, and with them
the social structures which hold people together, are inexor-
ably exposed and dismembered (or vice versa). The process
thus begun has continued to operate to this day, much rein-
forced by the impulse of the Enlightenment.

As traditional images and structures are demolished and
progressively lose their validity there nevertheless subsist, on
the one hand, the sovereign will and all-encompassing unity of
what was formerly the divine body, and on the other the still-
to-be-exposed, still-to-be-dismembered elements of authority
which derive from it. Or, to put it in another way: the con-
cept of a ground of being or existence, in which all men are
for ever united in justice and equality, persists in spite of the
effectiveness of the process of exposure and dismemberment.

Kamper shows the operation of this historical process
in the gradual decline of monarchy into popular sovereignty
and democracy. Through all the dismantling of external power
structures, a central will persists. Once that will crowned the
Divine Right of Kings; now it appears as the individual soul,
standing alone against the desacralized world.

The medieval Empire is still the image of a living body

politic, whose head is the Emperor. The human beings within
it see themselves as living members of a literal body which in
its turn is the image of the divine body. But with the transi-
tion to the post-medieval State the ruler declines into a figure-
head. His subjects are no longer living parts of a body but
parties to a social contract. The monarchic body as a living
unity is dismembered. By the time democracy in its turn is
finally abolished, the image of the King as incarnation of
authority has disappeared altogether. His role as the unifying
and binding power which holds everything together is taken
over by the forces of economics. Kamper quotes Norman
O. Brown:

> Corporate existence is dissolved into property
> relations... Instead of the magic of personality,
> the fetishism of commodities. "The scepter no
> more to be swayed by visible hand", is what
> Blake saw in the French Revolution. What we
> got instead was the invisible hand of economic
> forces.[31]

The death of the King as a personified head of the body
politic is also a divorce between body and spirit. What was
once a living unity, a society with a presiding spiritual iden-
tity, collapses into a lifeless mechanical apparatus. The spirit
increasingly manifests itself in the guise of the individual soul;
from being the religious and social bond which holds the body
of the nation together, it becomes the refuge of individual
longings and constitutional aspirations. Brown again:

> There is a revolution in the body at the begin-
> ning of modern times; a revolution reflected in
> the philosophy of Hobbes and Descartes. The

ruling principle departs from the body into a separate substance, the soul, which confronts the body as absolute sovereignty, or will.[32]

It is this, according to Kamper, which

> ...bridges the gap between the macrocosm of society and the microcosm of the soul... With the abolition of monarchy, with the rise of the bourgeoisie,... the "mystical reality of the body" is displaced from the public sphere into the privacy of the individual soul. From that moment onwards it may be defined, crudely, as the "inner life". This is not by any means a vague concept but a conspicuous, elaborately formulated, logical reality. The Body of the King (which is now his subsisting, putrefying corpse) is now a form, an "information" within the soul.[33]

Kamper goes on to show how this "information" takes root in the youthful human individual, before he or she attains maturity and coherent identity, and remains locked within as in a capsule.[34] Hence the use of the term "information", with its multiple layers of meaning, to signify on one level the internalization of a will which emanates from outside and above the individual, and on another the language of signs and symbols which as it were imprints the desire to recapture a lost "order" and a putative former version of human nature. Kamper accordingly speaks of "a 'prison', peculiar to bourgeois man, whose cell walls are covered with the logical graffiti of an ancient world-order".[35]

The "Body of the King" (the image of a will which had its origins in the sacred, and which sought to encompass all

things and all people) thus finds definition as "an effective structure of action, thought, feeling and perception".[36] Kamper's "logical graffiti" constitute a mythic script which underlies all verbal and non-verbal communication, and whose effect is to create the mirage of an order which exists apart from man:

> But whether it is ancient myth or bourgeois Enlightenment that is operative, the outcome is the same: man's dependence on uncomprehended forces.[37]

This dependence is manifested in two ways. Firstly, it appears as a profound self-identification with a "true" reality, as expressed in the idea of "Nature", as also in a form of love and sexuality whose object is the union of the sexes, and in the inner, subjective life – emblematic of reality – that arises spontaneously within the individual. Man thus becomes the bearer of an internalized truth which he regards as absolute. Secondly, the same dependence manifests itself through the compulsive exercise of the critical faculty – the age-old work of exposure and dismemberment – through which the individual lays bare what he takes to be the real pattern of forces within society. Even when he is no longer endeavouring to unmask the true holders of power but has become aware that the belief in hypothetical power-structures is a mere fantasy which in itself creates a dependence on power, the critical faculty is still fully active. Here the "information" of which Kamper speaks takes the form of an internalized potential for resistance, which seeks to reduce an external entity to powerlessness through the critical exercise of reason and thereby to achieve its own salvation.

This critical approach to social reality is matched by an equally obsessive compulsion to comprehend the world as a

whole and all its inherent laws. However, this comprehension and interpretation is always couched in terms of historical evolution, and the present state of affairs is perceived as the product of such an evolution. Justifiable – and indeed necessary – though such an approach may be, sooner or later it turns out to rely on a conception of nature and reality derived from the past. And even when certain contemporary philosophers assert that present-day life is a mere simulacrum of past times and values whose raison d'être has long since vanished, such an assertion in itself remains wedded to the same old pattern of comprehension and interpretation.[38]

The disastrous consequences of "dependence on uncomprehended forces" are exemplified by the history of art. The artist reacted against the increasing desacralization of society and the world by producing a continual succession of new images to forestall the imminent collapse of the old living unity. Two recourses were available to him. The first was a critical aesthetic, which might be called reflective realism; the second was the continuing exploitation of the resources of his own psychic microcosm – which meant in practice that he constantly invented images that violated prevailing taboos, in the hope that in this act of self-liberation some possibility might be glimpsed of dealing a death-blow to his enemy, the uncomprehended external power. But both these options became progressively less and less useful. Rational criticism, armed with all its logical apparatus, had no difficulty in dislodging the artist from his chosen ground by unmasking both "critical" and "subversive" images as manifestations of suppressed desires. The onset of a critical and rational form of awareness shattered the aura of art and destroyed its autonomy, thus removing its essential meaning and purpose. Inevitably, the artist defended himself against the rationalist onslaught with ever more diffuse and abstract images, endeavouring to maintain, however nebulously, the reality of

an alternative, unsecularized world. In a way, he succeeded, as can be shown by reference to the art movements of the present day; but for this he paid the price of producing pictures that have nothing, but nothing, whatever to say.

"Dependence on uncomprehended forces", at least in the context of art, is an internalized form of the faith in authority. The artist believes, firstly, that the world about him is full of enemies, whose power he acknowledges, and secondly, that this external power can be countered only by an appeal to that incarnation of Utopia, the social order that will unite all men in peace. This becomes harder and more complicated all the time, because the external enemy is none other than the real, visible world itself, in which meanings and relationships can be found only at the cost of accepting that they have no objectively verifiable reality. This, of course, is just what the rationalist awareness makes unthinkable. So the artist can but maintain his critical attitude to the world about him, while his own Utopia progressively recedes into the invisible, nebulous, abstract region of an art which is reduced to examining the relationships between signs and their significances, and which ultimately abdicates and rests content with the artwork that has no meaning.

A chronic state of "dependence on uncomprehended forces" is marked in extreme instances by a persistent effort to grasp and define the world as a single entity: whether this be as an internalized truth or as a formula of social criticism. Such a state of dependence is a deep-seated and indeed fatal predicament; so much so that it is appropriate to regard the ingrained "information" that Kamper also calls "the logical graffiti of an ancient world-order", or the "effective structure of action, thought, feeling and perception", as a form of incarnation in itself. For Western man this "information" is in the blood: it lies at the root of all his perception and all his awareness.

Myth and Awareness

This has been an attempt to follow through the workings of the particular mental set, or form of awareness, that derives its existence from the God-Man, Jesus Christ. These workings have nothing to do with his gospel of love. But in the last resort, because his entry into a just and eternal divine kingdom has so decisively influenced the course of Western history, all that has happened since that event has happened in his name. The eventual downfall of his whole form of awareness is due to the impulse to establish a State on earth which shall conform to the ideal of divine justice, and to the consequent rise of a new mode of perception which uses critical reason to demolish all existing social and religious values.

The end of a form of awareness which has degenerated in this way takes a catastrophic turn. Everything is now grasped and interpreted solely in rational terms. Total comprehension, absolute visibility, reveals a gaping void, because all the imagery of religion and of sexual polarity has been eliminated. All is abstract, empty and understood. The dominant form of awareness, with its chosen methods of investigation, discovery and exposure, has completely worked itself out. It has done so because its quest for a universally valid and binding idea of Nature culminates in a total identity between subject and object. The longed-for Nature of Man has thus become a reality, but an unknowable one.

This is a desperate predicament to be in, because it eliminates all sources of value, both human and social. The real problem is not the existence of an external enemy – there is always some kind of enemy – but the loss of normality. This is so, above all, because individuals have internalized the will which programmes them to desire an order of society which will unite them, make them equal, and give them all their just deserts. But that is precisely what can never now be re-created, least of all through a form of awareness dependent on the critical exercise of reason.

Myth and Awareness

This digression on the religious context, both in terms of mythic redemption and of its immediate relevance to Western history, has been necessary in order to establish what went to make the artists Gilbert & George what they were at the outset of their career, and the nature of the path on which they set out, so unerringly and yet without premeditation. Their precise point of departure is marked by the state of total abstraction. They are "living sculptures", hollow and understood. They regard this state as the incarnation, in themselves, of a form of awareness that has now to be transcended. And this transcendence takes place on the basis of desire for a "normality of tomorrow" (see above, page 11), as well as through the sacrificial death of the incarnate "information". Only when this "blood" has been shed can a new life be created.

What Gilbert & George invented and saw, after this sacrifice, may be called their "aesthetic of existence". The phrase is borrowed from Michel Foucault, who used it to signify the establishment of man as a moral, ethical and social entity in the absence of authority and of a universally valid and binding concept or image of Nature.[39] An existential aesthetic makes life into a work of art, which then constitutes the world of the artist.

This takes place in the work of Gilbert & George in a way analogous to that in which the primordial divine sacrifice acquired its image and its meaning. What they immolate, along with the internalized and now rejected "information", is a whole cultural pattern of imagery, a system of perception, that has outworn its usefulness and can no longer be regenerated. From the dross of this old world they shape one that is new. What is unique to this process is the paired relationship of Gilbert & George themselves. This stands for the nucleus of all social relationships: one to one. And so the work they do is individual not in personal but in cultural terms. They furn-

ish the model of an autonomous culture, a whole world that they offer as a gift.

How this process of constituting an image and a culture takes place, what contours and properties it displays: this is what the work of Gilbert & George stands for. The ensuing account of their evolution from 1968 to 1987 follows the curve of the life-history of the God-Man: Descent followed by Ascent.

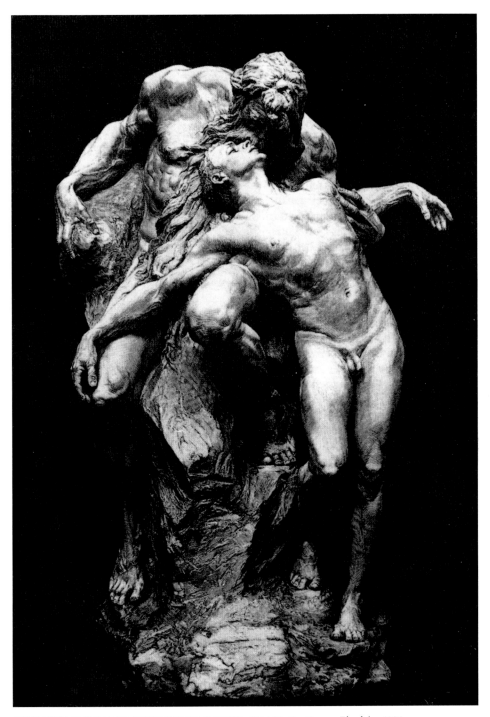

GOD THE FATHER BREATHING LIFE INTO ADAM. By Gustav Eberlein. 1904.

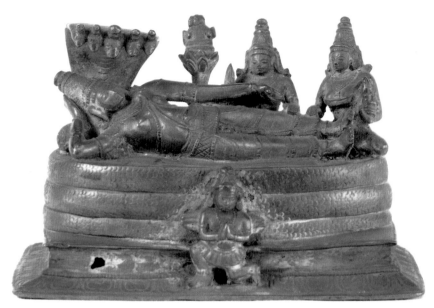

VISHNU RECLINING ON THE SERPENT SHEIHA. South India. Early 19th century.

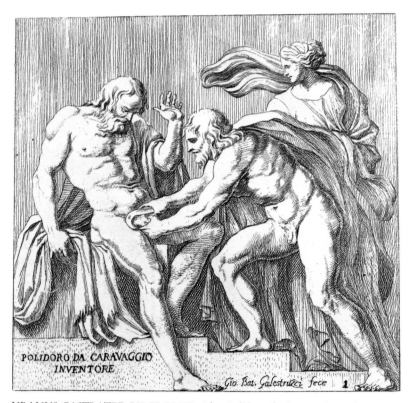

POLIDORO DA CARAVAGGIO
INVENTORE

Gio. Bat. Galestruzzi fece

URANUS CASTRATED BY CRONUS. After Polidoro da Caravaggio. 16th century.

CRONUS CASTRATING URANUS. 15th century. Vatican Library.
Emasculation, killing, burning and sacrifice form the prelude to the creation of the world and of humanity.

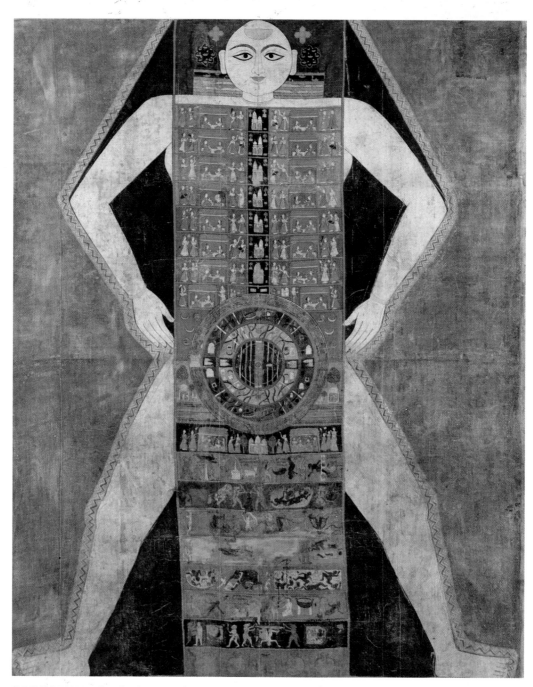

COSMIC MAN. Jain school. Late 17th century.
A sacrificed and reanimated deity represents the world as a living organism. This Cosmic Man embodies space, time and the manifold structure of the world.

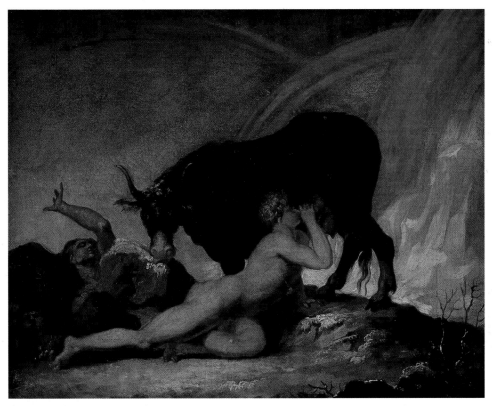

THE GIANT YMIR SUCKING THE COW AUDHUMBLA. By N. A. Abildgaard. 1777

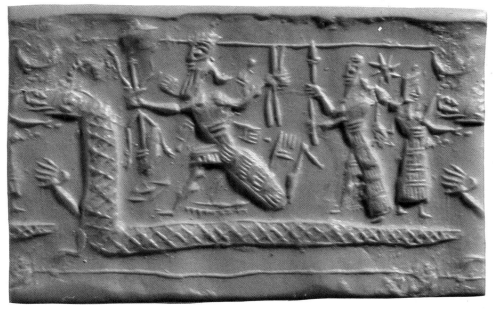

THE SLAYING OF THE SERPENT TIAMAT BY THE GOD MARDUK. Assyrian. 9th to 8th century BC.

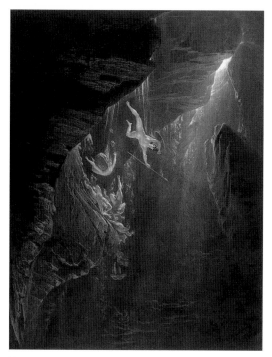

THE FALL OF THE REBEL ANGELS.
By John Martin. 1825.

CHRISTIAN AND SATAN.
By Walter Paget. Circa 1900.

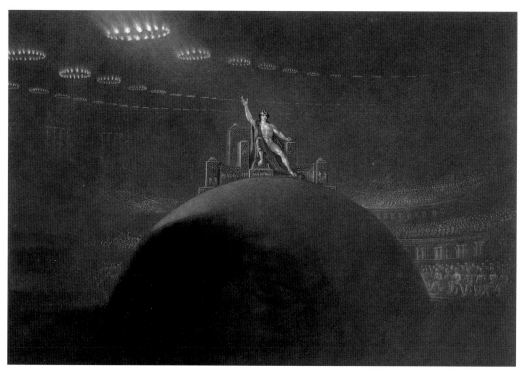

SATAN PRESIDING AT THE INFERNAL COUNCIL. By John Martin. 1825.

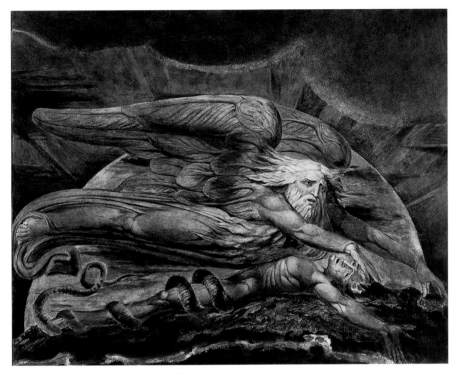

GOD CREATING ADAM. By William Blake. 1795.

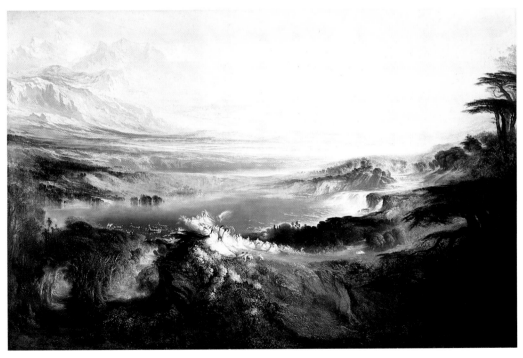

THE PLAINS OF HEAVEN. By John Martin. 1853.

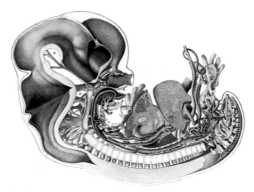

Cross section through a human embryo. The spine is curved, and the limbs have not yet developed; the anus (right) and mouth (left) face each other. The gullet, through which life passes, can already be seen; the limbs, which set the human image erect, have still to take shape.

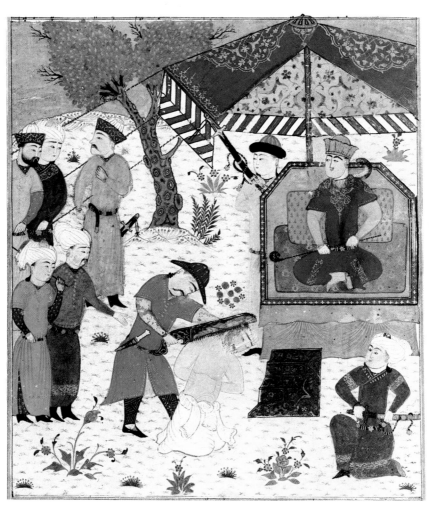

BRIGHT YIMA IS SAWN IN TWO. Persian. 1494. Bodleian Library, Oxford.
The Eternal Man.

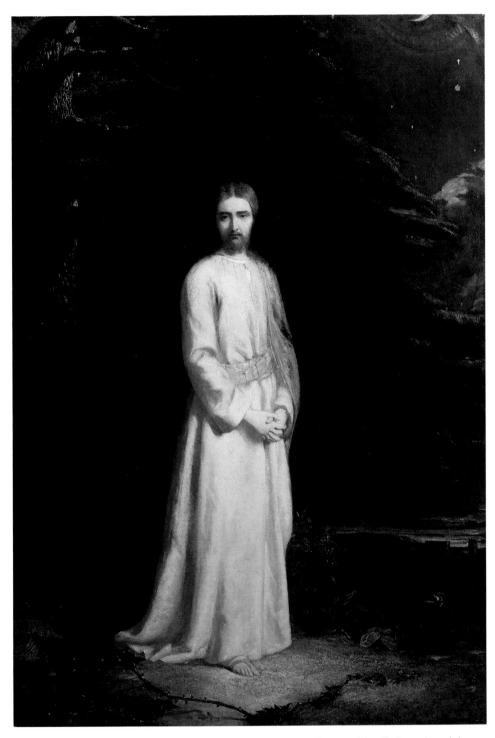

JESUS CHRIST IN THE GARDEN OF GETHSEMANE. 1828. By an unidentified member of the artists' group, The Ancients.

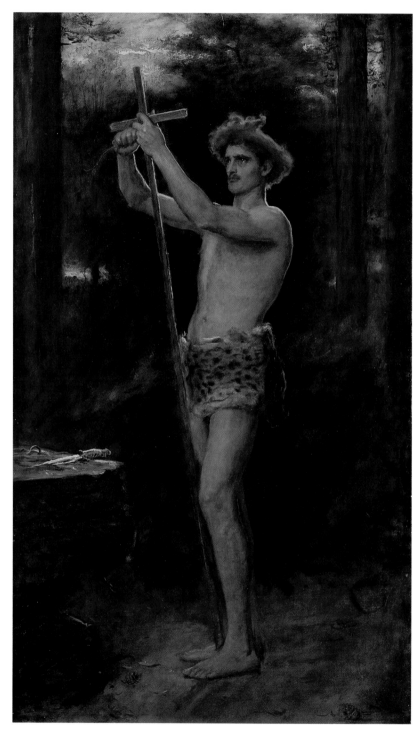

A FORERUNNER. By John Everett Millais. 1896.

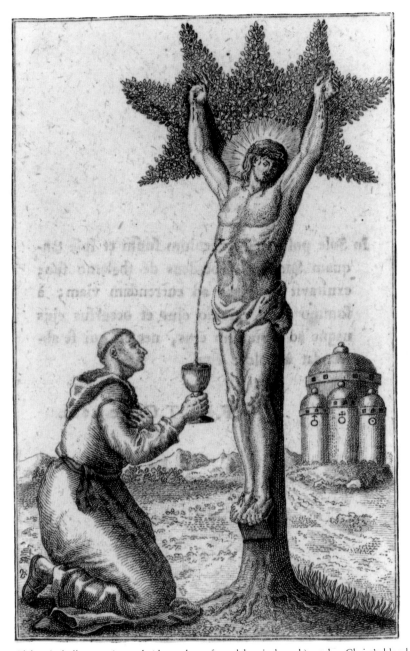

Alchemical allegory. A monk (the author of an alchemical work) catches Christ's blood in a chalice. Christ here represents the Philosophers' Stone. In the background the alchemical furnace is shown in the guise of a temple. The symbols on it stand for metals, and possibly also for male and female. Vinzenz Koffskhi, HERMETISCHE SCHRIFTEN, 1786.

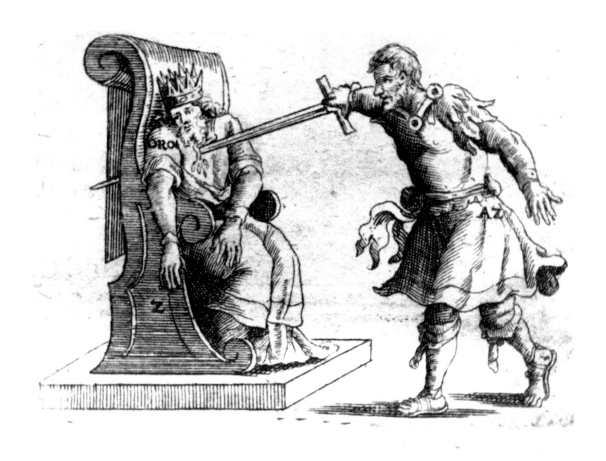

Alchemical allegory. The King's Son stabs his father to death and descends with him into the grave, only to undergo ultimate rebirth as the new ruler. The word ORO on the King's garments is a clear enough indication that what is at stake here is the attainment of gold. Janus Lacinius, PRETIOSA MARGARITA, ed. W. G. Stoll, Leipzig 1714.

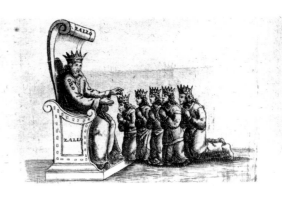

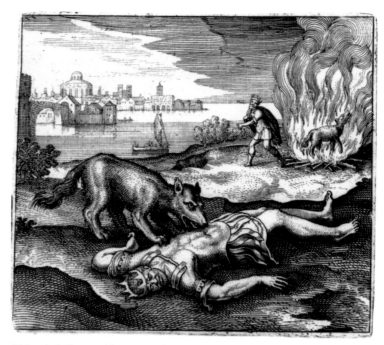

Alchemical allegory. The King is devoured by the Wolf, the Wolf is consumed by the Fire, and the King is resurrected. Here, too, the King represents gold; the Wolf is antimony, the metal that is to undergo transmutation. Michael Maier, ATALANTA FUGIENS, Oppenheim 1617.

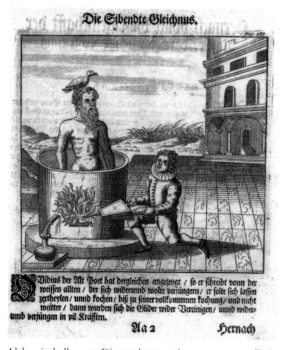

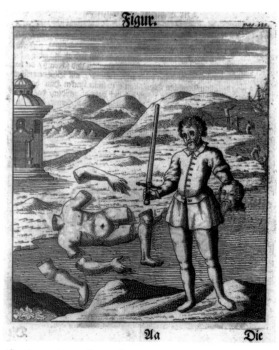

Alchemical allegory. Dismemberment is a necessary preliminary to purification, rejuvenation and rebirth. From the treatise SPLENDOR SOLIS, in Salomon Trismosin, AUREUM VELLUS, Rorschach 1599.

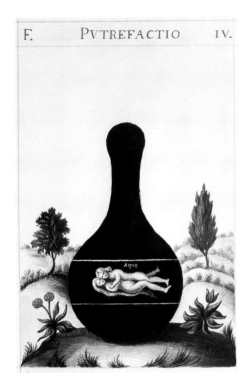

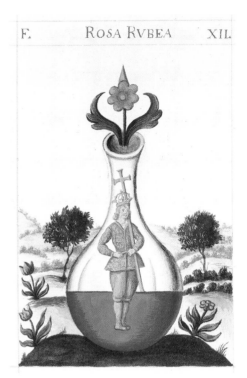

Alchemical allegory. The process of death and rebirth shown in terms of sexual union. The image on the left shows coitus taking place in the state of Putrefaction, which is followed by Black Dissolution. The image on the right shows the new-born King as Rosa Rubea. Life dies and is reborn through a succession of visible phases. Bibliothèque Nationale, Paris.

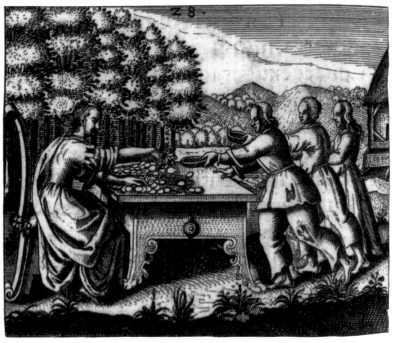

Alchemical allegory. According to alchemical theory, the objective to be gained is not life as such but the Philosophers' Stone, and thus also material things: money, in fact. From Johann Daniel Mylius, PHILOSOPHIA REFORMATA, Frankfurt 1622.

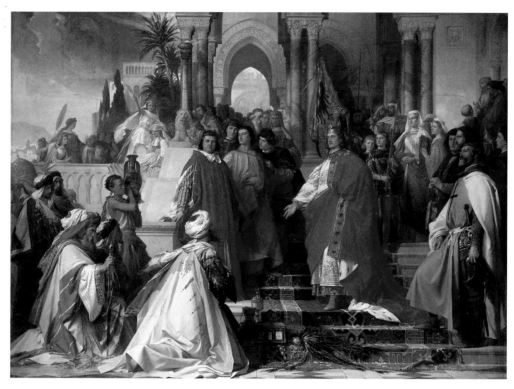

EMPEROR FREDERICK II (reigned 1212–50). Arthur von Ramberg.

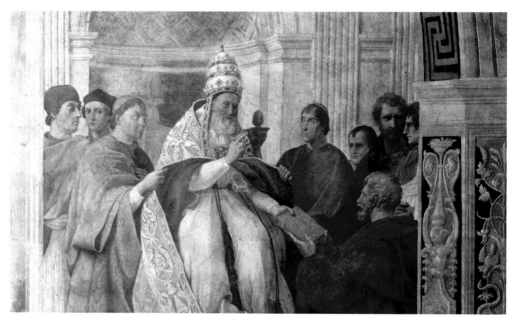

POPE GREGORY IX (reigned 1227–41). Raphael.
Representatives of temporal and spiritual power in the Middle Ages. The power of the State progressively superseded that of the Church, but in the process it unconsciously took over the Church's conception of a higher, external power governing humanity.

DESCENT

PART ONE

FATHERLESSNESS
SAMENESS
OBSCENITY

Chapter 1

Gilbert & George first met in 1967, as students of sculpture at St Martin's School of Art in London. They collaborated on joint works and embarked on a friendship on which their art and their life are founded to this day.

Art school contributed virtually nothing to their education. They left with no knowledge of art and no technical proficiency. All they had was the recognition of a total loss of imaginative power and individual creativity. They confessed that they had become empty and drained of meaning by announcing themselves to be works of art with just those same qualities.

One of Gilbert & George's first works, in which the artists' identity as hollow and abstract beings is already becoming evident, bears the title THREE WORKS – THREE WORKS (page 87). The duplication of the title points to the lack of differentiation between the two halves of the piece. Each artist is represented by three objects laid out on a table. George's table (below) has on it, from left to right, a thin reed, a cast of a brick and a cylindrical container. The objects on the other (Gilbert's) table are arranged one behind the other. Reading from the front, they are a long, narrow box, a

thin stick made of iridescent colophonium resin and a life-mask of the artist. The reed and the mask denote the artists, and the other objects represent their attributes. A comparison between the two tables shows, however, that the differences are purely formal. The objects differ in arrangement and form, but the content is identical. Its message is one of hollowness: pure and meaningless surface. In the final resort, the artists are declaring themselves, through the medium of their works, to be interchangeable and hollow. There is no sign of a differential element, such as might indicate a content. The objects in THREE WORKS – THREE WORKS take their place within the traditional definition of art: the idea of the artwork is expressed through an object. This distancing of the artist from his creation was subsequently abandoned. Gilbert & George stopped using objects to point to their own hollow state; they used themselves instead. After some initial signs of improvisation, their self-presentation as living works of art became more consistent and was extended in due course to all the departments of life. They proclaimed not only their bodies but the whole of their lives to be a work of art, and specifically a sculpture,[40] which epitomizes the total hollowness and abstractness of life.

In January 1969 Gilbert & George made their first public appearance as living sculpture under the title NEW SCULPTURE. A little later, when their sculpture began to sing, they adopted the title THE SINGING SCULPTURE. Under this appellation they presented themselves, head and hands painted with metallic paint, as a sculpture that was rigid but nevertheless alive.

From 1969 to 1973 Gilbert & George's sculptural appearances became ever more lengthy and more widespread. These self-presentations, which took place all over the Western art world, often lasted as long as eight hours a day for up to fourteen successive days. Gilbert & George showed

themselves as living sculpture not only in museums and galleries but – especially in the early days – at pop concerts and in night-clubs as well.

What form did THE SINGING SCULPTURE take? From the outset Gilbert & George laid great stress, in accordance with their shared hollow identity, on looking as nearly identical as possible – a feature that they have retained to this day. They dressed in ordinary suits, had identical haircuts, and avoided any hint of personal individuality or originality. Two further attributes and a piece of music completed the material components of THE SINGING SCULPTURE: a walking-stick, a rubber glove and a recording of the popular song UNDERNEATH THE ARCHES. Thus equipped, they climbed on to a table, which served as the pedestal for their sculpture, and started up the music, to which they moved with robot-like gestures (page 89). One held the stick, the other the glove, and together they sang the words of the song. When the music stopped they exchanged the stick for the glove and started again. The spectators often watched, spellbound, for hours on end.

THE SINGING SCULPTURE is an extreme embodiment of the idea contained in THREE WORKS – THREE WORKS. The stick, as an allusion to walking, stands for the (unending) time component of the act: marking time, endless stasis, eternal monotony. Movement here does not represent progression but its antithesis, staying put. The glove stands symbolically for the interchangeability of the artists. A three-dimensional object, it is nevertheless completely hollow, like them. Another of its characteristics is that turning it inside-out makes no difference at all. Inside or out, stretched or limp (a rubber glove!), it always keeps the same form and the same identity. And this makes it the symbol of the hollow identity of Gilbert & George.

Despite the constant and almost exclusive emphasis on

abstractness and interchangeability, it is already possible to detect here a sense of the artists' mission, and of the form of renunciation which lies at its core. This can be traced in the words of the old song, in which two tramps under a bridge sing: "Underneath the Arches we dream our dreams away." In what amounts to a programme note, Gilbert & George wrote of this line:

> Underneath the Arches is still our most impor-
> tant realistic abstract wording. It lives along with
> us as we dream our dreams away realising how
> few people have had thoughts on these our
> sculptors words for we are really working at
> dreaming our dreams away.[41]

The dream that they began to dream away, and thus to renounce, was that of the individual creative power of the artist, who sets himself apart from other people's normality by virtue of his discoveries. What Gilbert & George are after is something other than the art that defines itself by excluding what is not art. At the time of THE SINGING SCULP-TURE, however, this remained a task for the future.

Even the suits, the artists' stereotyped outer shells, were part of a mission, a quest for the human persona. They wrote in a brief text:

> …for all the suits we wear are symbols of our
> constant seeking for ways to bring about our
> renaissance of contrasting his being with his
> fellow-men look.[42]

Alongside interchangeability and the abolition of meaning, Gilbert & George took as their themes the absence of value and sameness or indifference, as manifested particularly in a

number of other living sculptures and arranged social occasions. These always focused on a specific form that exactly coincided with its own blatant lack of significance. Outside became Inside and vice versa.

READING FROM A STICK (page 71) was the title of a slide show to which they issued personal invitations. The slides were of cross-sections of the colophonium walking-stick that had already formed part of THREE WORKS – THREE WORKS. These images were described and commented upon by the artists in statements which, although apparently coherent, were utterly devoid of content: remarks such as "especially pretty" or "extraordinarily imaginative". In order to maintain the exclusiveness of the presentation, the members of the audience were sent on their way with a personal handshake and a souvenir biscuit which reproduced the colours of the slides in the show.[43]

The same vacuity marked another art occasion, THE MEAL, to which Gilbert & George invited their fellow-artist David Hockney.[44] A paying audience watched as the artists ate their way through seven courses in an exclusive atmosphere that was enhanced by the presence of a specially hired butler and cook. The conversation that took place was subsequently described by Hockney as "pretty banal", in spite of the attentive audience.[45] The guests were subsequently presented with menus. In words and in visible traces of food, these documented the art occasion with apparent artistry: a souvenir of a special kind, which constituted ocular proof that its owner was there.

In much the same format as the printed invitations to THE MEAL, Gilbert & George produced a series of messages, "postal sculptures", which they sent out to friends, galleries and collectors. THE LIMERICKS is a series of eight works, each of which deals in text and picture form with a specific theme. The title is another reference to the glove

motif. "Limerick" means not only a five-line nonsense poem but a particularly delicate kind of glove made in the Irish city of that name. This double meaning of "limerick" is adopted by Gilbert & George in order to place each of their chosen themes in a delusive light. Neither image nor text reinforces the given theme; both proclaim its loss of meaning and value.

Externally, THE LIMERICKS take the form of neat-looking folded sheets of paper (pages 92–93). On the front of each is printed the chosen motif, drawn from a photograph, together with title and date, and inside are simple, nursery-rhyme-like texts which have to do with the classic form of the limerick and with its characteristic word-play.

One of the pieces, EXPERIENCE, shows Gilbert & George in relaxed pose on the Thames Embankment in London. They are gazing at the façades of the buildings across the river. The text describes their "experience" as follows:

> There were two young men who did laugh
> They laughed at the people's unrest
>
> They stuck their sticks in the air
> And turned them around with the best
>
> Then with time they began to feel strange
> For no longer it swung in their way
>
> So to capture again that old thrill
> They started to take the life-pill

Clearly, the "life-pill" is a way of describing the artists' state of relaxed contemplation. Clearly, too, the implied promise is an empty one. Neither the river nor the townscape offers a new experience; both are known and familiar. So, just as the texts are not ordinary limericks and the drawings are not ordinary drawings, even the ostensible motif is not what it seems.

THE LIMERICKS are like gloves which maintain their form, inside and out, without ever having a content.

The procedure is the same in other items from the series whose themes include MANLINESS and WORLDLINESS. The last of them is ARTISTS CULTURE, a further reference to Gilbert & George and their loss of imaginative power. Their identity, their "culture" as artists, seems quite normal:

> The funny thing is they're really quite normal
> It's just that they seem of another order

Total indifference, and the acceptance that nothing makes any difference, are the hallmarks of Gilbert & George's nature, conduct and activity at the outset of their career. The occasional emphasis in these works on apparently ironic or humorous elements should not be misunderstood. None of this is either irony nor caricature; this is the act of becoming aware. In it, the artists become aware of their own nature as "sculptures" and of the nullity of the meanings of words and values. They themselves write: "Simplicity is a work of sophistication",[46] thus giving a neat twist to the argument: not irony but simplification is the underlying ground. To associate Gilbert & George with irony would be a tragic misinterpretation of their work. Irony is something that has never interested them.

This description of the early works and activities of Gilbert & George brings out the central importance of interchangeability, indifference and lack of difference. And not without cause. Indifference and sameness, as well as the loss of value, are grounded in an old form of awareness and perception in which Gilbert & George could no longer believe. This is based – as described in the Introduction, above – on the internalized awareness and pursuit of a Nature which is to unite and govern all mankind, and which is perceived as a

given reality. This Nature may be investigated through a voyage of discovery which goes beyond known and familiar territory to uncover the wilderness of the repressed and the unexplored; and here resides the hope of a true form of being, in contradistinction to normal everyday life.

In Gilbert & George's eyes, this undiscovered country, this supposed true Nature of Man, meant nothing. They went one step further. By first making Nature – as the epitome of a hypothetical true Nature, together with the work and awareness necessary to discover and understand it – into the theme of their work, they proclaimed it to be meaningless.

One of their first postal sculptures was in the format of an ordinary post-card (page 93). It showed portraits of the artists and, as surrogates for them, twin comic-strip figures strolling along in space-suits. The text on the card describes this as a HYDE PARK WALK JULY 21ST 1969. The date reveals the meaning and purpose of this little piece. That was the day on which man first set foot on the moon. Gilbert & George are clearly making an explicit renunciation of the quest for the unexplored. Instead they prefer the world of the long-since discovered and cultivated: the park.

Gilbert & George had absolutely no intention of embarking on any quest for undiscovered territory, as they made abundantly clear in one little text from their book SIDE BY SIDE, which in its three chapters presents the basic themes of their early period. In Chapter 2, "A Glimpse into the Abstract World", an abstract plate entitled THE SEARCHER (page 94) is captioned thus:

> Day in, day out, the search goes on and no find will stop it. Wheel, motor cars, aeroplane, space-travel and Art serve as ghastly landmarks in and on the progression of a map. It took us twenty six years to find some clear guidance from the

creative marks in art. May we propose the following list of applicants, Leonardo da Vinci, Rembrandt, Vincent Van Gogh, Pablo Picasso. And the unknown painter of the picture with the two elephants in it.[47]

The text presents the explorers, and the picture shows the goal of their endeavours, a pathetic scribble. Gilbert & George are clearly renouncing the quest for Art and Life as a form of exploration, discovery, exposure, uncovering. The map of the world has all its place names ready marked, and there is nothing left to do but scribble on it.

This provides the context for one of the four commandments that Gilbert & George have proclaimed as "The laws of the sculptors": "Never worry assess discuss or criticize but remain quiet respectful and calm."[48] The task of exploration and discovery has become redundant in another guise, that of criticism; and this too is no longer to be pursued.

The principle of no longer questioning, no longer looking behind or into things, is made abundantly explicit in a huge charcoal drawing by Gilbert & George (page 95). Beneath a representation of a house front there appear the words: "The total mystery of each man-layed brick." What has been created, in time and in space, remains a mystery, and to look for a cause or a reason is to look into an eternal void. And so the artists accept the superficial aspect as the only one that counts for them. This is the form of perception to which Gilbert & George have remained faithful. All they are aware of, and all they see, is the surface of things.

Alongside discovery as a form of artistic perception and quest, Gilbert & George took as their theme the objective of this quest: a Nature which is intrinsic to man, and of which man himself consists. They took this completely literally, by letting Nature speak for itself in words and in images. The

first chapter of their book SIDE BY SIDE is headed, invitingly, "With us in the Nature". This is the signal for a ninety-page nature ramble which the reader can easily follow in imagination. Side by side, the artists roam across meadows and fields, pause in a wood, and walk down country lanes. Every picture is accompanied by a short text. The Nature that is shown and discoursed upon in this chapter stands for the Nature of Man and epitomizes the imagined Nature which is his home. But this is just what proves it to be empty and devoid of meaning. Gilbert & George write, under an illustration of a pond whose still, dark surface conveys an aura of mystery: "we sense a mystery with no life".[49] Under a picture of flowers they write: "shining flowers say nothing".[50] In ELEGANT COMPOSITION they show themselves, in a state of relaxed euphoria, with the following commentary:

> A really elegant composition of intimate landscape and two well groomed figures. As we view each other we feel a surrounding beauty, a lightness that takes us over to the other World of magic dreams and dramas and tinkling bells. Seek no meaning from the objects for there is only an atmosphere of inhabit with the minds eye. Delve not too deeply for all is a surface charm and pleasure. Easy to relax and live it.[51]

Nature here reveals itself as an indifferent, lifeless and useless landscape, in which the artists pass their time with apparent enjoyment, and where no meaning meets their enquiring gaze. The text to an illustration of Gilbert & George sitting on a tree-trunk runs as follows:

> Frozen into the Nature for you Art. We are gazing into our thoughts. Mainly Our spirit is here

to be felt. Smiling melancholy. Clouds sail whitely past the blue sky caring for nothing but their progress.[52]

And, a few pages later: "What can we do but sit and stare."[53]

Another characteristic of the early work of Gilbert & George is that alongside photographic images they also used traditional artistic techniques, principally drawing and on one occasion painting. They renounced the use of these techniques in 1969,[54] although they were to employ them just once more before finally abandoning them in favour of photo-pieces. One way in which they marked their rejection of traditional techniques, even while using them, was through the more or less unartistic manner in which they simulated them. None of the drawings or paintings is a freehand work: all are based on photographic images.

In six triptychs in oil on canvas entitled THE PAINTINGS, Gilbert & George take up the theme of Nature as a symbol of a lost home of mankind. Judged in terms of a commitment to formal creativity, these works are manifestly unartistic in execution. They are mainly based on the photographic images from SIDE BY SIDE.

The central panel of each triptych shows the artists walking or resting side by side in the midst of Nature, and the wing panels are details of natural landscape. In Triptych No. 6 (page 96) Gilbert & George walk along a country lane past an old Gothic church. There is something forlorn and listless about this Sunday stroll in a smiling landscape. The figures seem to float palely along the lane. Nothing touches them or arouses their attention. The wings of the triptych, which show undergrowth and tall trees, contain nothing that might detain them or arouse a flicker of interest.

It can hardly be an accident that Gilbert & George have chosen the triptych form to encompass the theme of Nature.

Fatherlessness – Sameness – Obscenity

This form, originally used as part of the superstructure of an altar, has always taken Nature as a theme, although originally, of course it was the Nature of God and of the world beyond. In the central and wing panels of an altarpiece, man might contemplate the history of his salvation: the true Nature that governed his universe. Gilbert & George's triptychs are essentially the same. Here, however, divine Nature has declined into a purely mundane landscape. The artists who stand in its midst have no experience that might remind them of the former sacredness of Nature: the distinction between the sacred and the profane has been abolished. The artists are observers of and participants in a wholly profane Nature, and this ultimately means that man himself, true (divine) Nature, and profane Nature, become one. Nature no longer exists as a source of meaning for human existence.

The argument of this chapter is summed up in its tripartite title. The loss of the father is manifest, because from the outset of their career Gilbert & George had totally lost contact with concepts of value and meaning. The belief in meaning, and in an essential nature inherent in man, had been shaken to its foundations. The symbol of the father as guide and exemplar was drastically undermined. The inherited awareness of Nature as an object for exploration and discovery had reached the end of its credibility, and there was no way left to revive it. Sameness marks the loss of meaning. Everything was equivalent, interchangeable, devoid of meaning and value. No value could any longer be recognized as such. Finally, this form of sameness was obscene, because it marked Gilbert & George with the sole quality which God the Absolute alone possesses: an absolute self-identity in which all values, all times and all places become one and indistinguishable. God can manifest himself in this way, as I-AM-I-ness; man cannot, because his life is marked by time, space, sex and above all death.

This state of things marked the ultimate fulfilment of one religious and historical epoch. The dominant form of awareness of that epoch, which consisted in the search for an all-uniting, just, peaceful and real earthly existence, had collapsed. No successor was in sight, because the old ideology had obstinately rooted itself in human hearts.

To escape from this curse now became Gilbert & George's declared objective. Their response to the state of total sameness was to enunciate a wish: "To be with art is all we ask."[55] This was the title of a little pamphlet in which they confronted the decline of art, the endless succession of artistic "generations" and the unimpressive look of art in general today. Is this art, was the unspoken question. No, came the answer, and so in the works that followed Gilbert & George set out to find life a new meaning.

May we describe to you with picture and words a sculpture which began on the last Saterday in November of '69 we had just made some cocoa when it began to snow so we positioned ourselves at the window as we began to look we felt ourselves taken into a sculpture of overwhelming purity life and peace a rare and new art-piece we thank you for being with us for these few moments

Yours sincerely *Gilbert* and *George*

'Art for All.' 12 Fournier Street, London, E.1. England

POSTAL SCULPTURE. 1969.

Gilbert's OBJECT SCULPTURES displayed at the THREE WORKS – THREE WORKS exhibition, London. 1968.

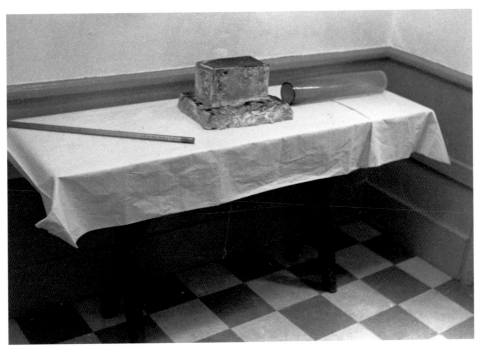

George's OBJECT SCULPTURES displayed at the THREE WORKS – THREE WORKS exhibition, London. 1968.

'Our New Sculpture'

may be viewed

at the Royal College of Art, Lecture Theatre, Main Building

Thursday, 23rd January, 1969, at 11 am

We will be honoured by your presence

Gilbert. George.

INVITATION CARD. 1969.

ANNOUNCEMENT BADGES. 1969.

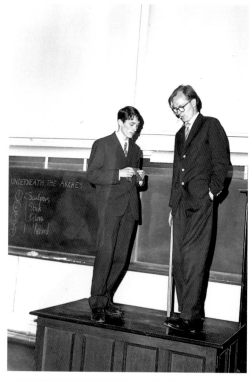

UNDERNEATH THE ARCHES. 1969. London.

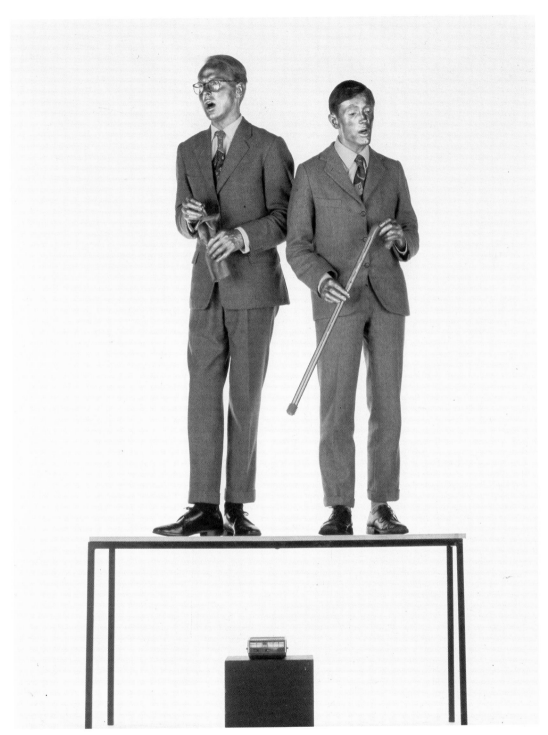

THE SINGING SCULPTURE. 1970.
We dream our dreams away.

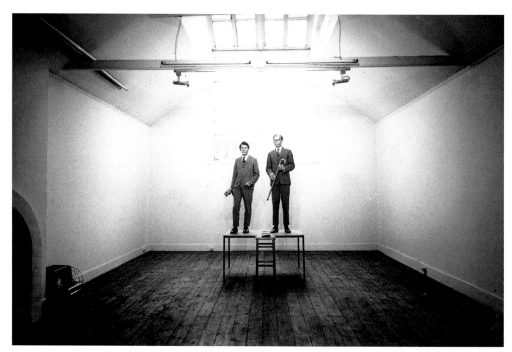

THE SINGING SCULPTURE. 1970. Nigel Greenwood Gallery, London.

Stick and glove from THE SINGING SCULPTURE.

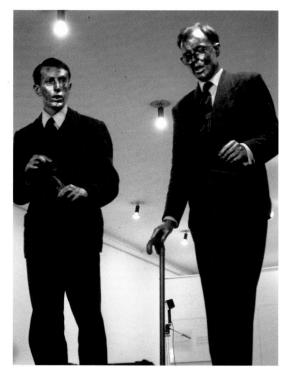

UNDERNEATH THE ARCHES. 1970. Kunsthalle, Düsseldorf.

A slide from
READING FROM A STICK. 1969.

"Reading from a Stick"

THE GEFFRYE MUSEUM
KINGSLAND ROAD, LONDON, E.2
SUNDAY, 26th JANUARY, 1969 at 3 pm

RSVP 12 WILKES STREET, E.1

Invitation card and edible souvenir from
READING FROM A STICK. 1969.

Cook and butler for THE MEAL. 1969.

Ticket for THE MEAL. 1969.

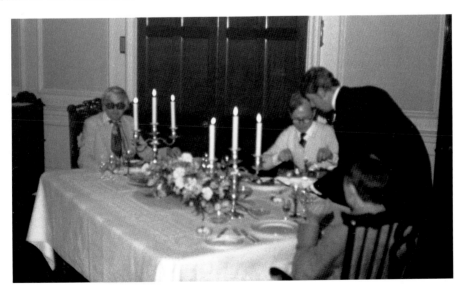

THE MEAL. 1969. A Living Sculpture.
"Exclusivity" that excludes no one. It has nothing left to hide.

Lost Day
11th March, 1971

Art for All, 12 Fournier St. London E.1 Tel 247 0161

Shyness
25th March, 1971

Art for All, 12 Fournier St. London E.1 Tel 247 0161

Worldliness
13th April, 1971

Art for All, 12 Fournier St. London E.1 Tel 247 0161

Idiot Ambition
24th April, 1971

Art for All, 12 Fournier St. London E.1 Tel 247 0161

Normal Boredom
1st May, 1971

Art for All, 12 Fournier St. London E.1 Tel 247 0161

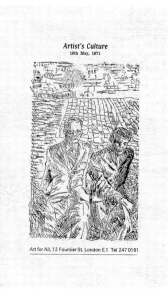

Artist's Culture
19th May, 1971

Art for All, 12 Fournier St. London E.1 Tel 247 0161

THE LIMERICKS. Spring 1971. An Eight-Part Postal Sculpture. Each recipient received a limerick each week for eight weeks.

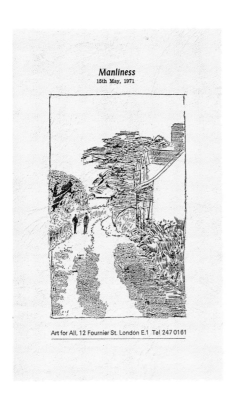

Manliness
15th May, 1971

Art for All, 12 Fournier St. London E.1 Tel 247 0161

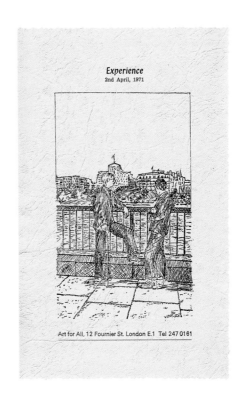

Experience
2nd April, 1971

Art for All, 12 Fournier St. London E.1 Tel 247 0161

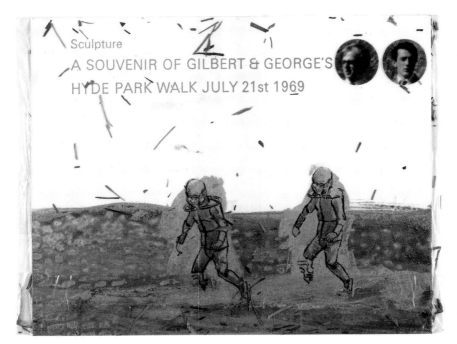

Sculpture

A SOUVENIR OF GILBERT & GEORGE'S
HYDE PARK WALK JULY 21st 1969

POSTAL SCULPTURE. 1969.
"That's one small step for a man, one giant leap for mankind," the astronaut Neil Armstrong radioed from moon to earth on 21 July 1969. With the same intention, and changing only the venue, Gilbert & George stepped out on the very same day into a cultivated landscape.

93

THE SEARCHER

102

ELEGANT COMPOSITION

32

INNOCENCE

6

FROZEN INTO

60

Four pages from Gilbert & George's book SIDE BY SIDE. 1971.

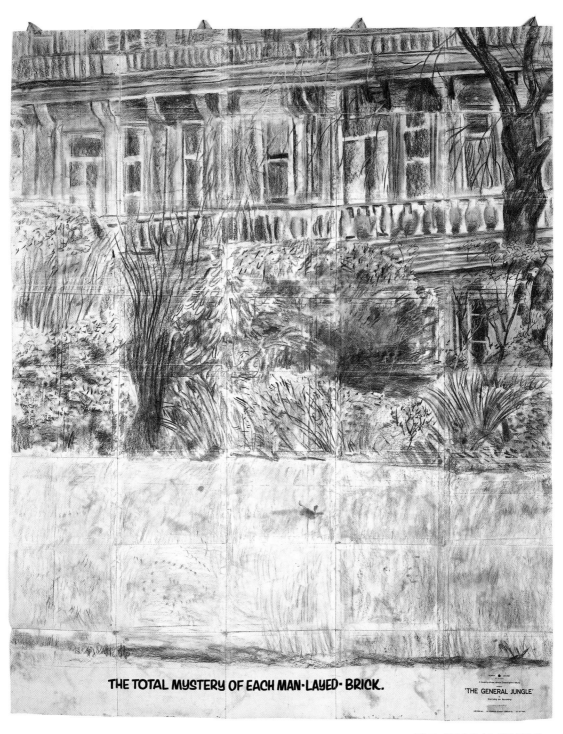

THE TOTAL MYSTERY OF EACH MAN-LAYED BRICK. 1971. 280 x 225 cm. From THE GENERAL JUNGLE.

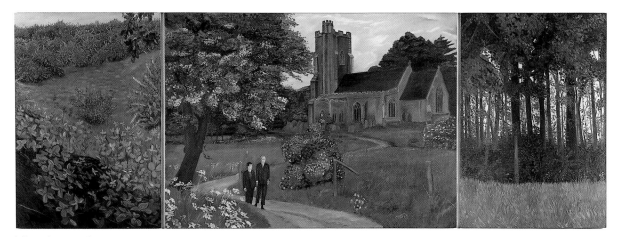

Triptych No. 6 from THE PAINTINGS. 1971. 230 x 680 cm.

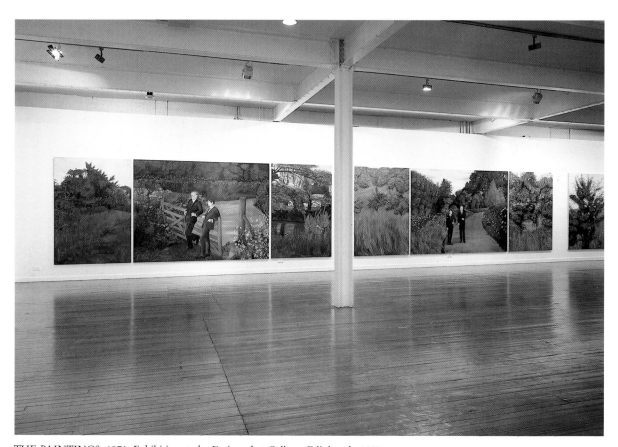

THE PAINTINGS. 1971. Exhibition at the Fruitmarket Gallery, Edinburgh. 1986.

DISTORTION DRUNKENNESS DOWNFALL

Chapter 2

To find life a new meaning was easier said than done. And the major obstacle lay in the very state of abstractness and sameness which marked Gilbert & George at this early stage of their career. The old form of awareness, with its pursuit of a general theory of Nature, remained as resistant to change as ever. Long after it had lost every shred of credibility, it still nevertheless held sway, and as long as this was so there could be no prospect of a new awareness.

In the ensuing part of their career Gilbert & George set out upon a path which led ultimately to the distortion, occultation and immolation of the old awareness. They forsook the precarious equilibrium of their initial self-identity and subjected themselves and the objects around them to a systematic process of torture. In this process alcohol played a decisive part, helping them to act out the loss of meaning and ultimately to purge it from their system. As a toxic stimulus, alcohol intensified and carried to extremes the feeling of valuelessness and utter sameness, and ultimately took the artists on a conducted tour of Hell. The old awareness was still in the blood, and alcohol poisoned it.

Another characteristic of the work that followed was an

intensified reliance on an aesthetic of the "unartistic". Already evident in THE PAINTINGS (in the ordinariness of the execution) and in the SIDE BY SIDE texts (in a faulty and, to a purist, stylistically impoverished use of language), this now became increasingly blatant. The quotation marks round the word "unartistic" are quite deliberate. As with the seeming ironies that are to be found elsewhere in Gilbert & George's work, the "unartistic" here is not a deliberate choice based on a value judgment but the endeavour to give a twist to the old awareness, with its attendant aesthetic of uniqueness and sublimity, and thereby to undermine it. This is particularly evident in the large charcoal drawings that Gilbert & George made for a time. In and through these works the disintegration of "Nature" and the downfall of the artists are made abundantly clear.

This period is marked also by an increasing use of photography: ordinary snapshots thrown together in a loose mosaic. Most of them are untitled and, in accordance with the artists' own initial abdication of values, they are kept strictly superficial. Only the juxtapositions make it possible to extract a meaning of sorts, superficial though this might also be.

Alongside photography Gilbert & George made what amounted to preliminary sketches for other works by using picture post-cards. Arrangements of post-cards became "post-card sculptures", often similar in structure and composition to Gilbert & George's later "photo-pieces". As a completely inert pictorial sign with no ulterior meaning, the post-card presented them with the ideal means of giving suitable expression to the theme of superficiality. At a later date this superficiality transmuted itself into a new form of perception, and it became possible to see post-cards differently, in the light of a new awareness.

The ostensibly "unartistic", the stylistically awkward and the deliberately superficial are united in one word which

the artists use more than once to describe the work of their phase of Descent: the word is NICE. It covers all that can no longer be sustained, and from the distortion and liquidation of which no good can come – not even an aesthetic of decadence. Its shallowness corresponds to the perfect indifference with which Gilbert & George regarded their own downfall. This expressed itself in a fascination with the monstrous, and in distorted and twisted images which finally disintegrated altogether. "Nice" – like the word "bad", which they also used – was neither an entrenched position nor a credible artistic truth: it was a means to demolish the last stronghold of the old perception, to eliminate once and for all the internalized quest for the old form of Nature.[56]

The hallmark of Gilbert & George's earliest work had been indifference, sameness, interchangeability, hollow identity and a perfect match between Inside and Outside; now, increasingly, the presiding principle was that of confusion. Where once there had been propaganda for Essence without Substance, now everything was inextricably homogenized into a soup of meaningless significances and values.

The title of their charcoal on paper sculpture THE GENERAL JUNGLE, of 1971, already alludes to this notion of impenetrable entanglement. The principal subjects of these colossal charcoal drawings are the artists themselves, usually in front of or in a forest (the drawing "THE TOTAL MYSTERY OF…", page 95), forms part of this series. The drawings are captioned with phrases from a statement by the artists which describes a day in the life of Gilbert & George in all its total alienation and unreality.[57] Fragmentary, contextless and unattainably remote, their world passes them by:

> The big happening outside the window floods
> our vision like a passing film. It leaves us with-
> out impressions, giving up only silence and

repetitive relaxation. Nothing can touch us or take us out of ourselves. It is a continuous sculpture. Our minds float off into time, visiting fragments of words heard, faces seen, feeling felt, faces loved.

Everyday events take on the likeness of a film, unfolding before the artists' impassive gaze. Even a real film, with its stories of human tragedy and drama, does not help much:

> Nothing breathtaking will occur here, but in the darkness of a picture house, where time is killed, the world explodes realistically into giant action stories, men are killed, women are loved, mountains are blown up, night falls, Volcanos erupt, john wayne rides again and caesar speaks anew to the people. All this until the reel is done and viewers drift blinking and reeling out into the bright city. And we happily go back to Our art where only tiredness and searching play big roles, where all is thin on the ground, where greatness is made at the stroke of a brush, where something and nothing are both qualities.[58]

Neither the world about them nor the tales told on the screen has any positive effect. It all flows by, leaving behind an impression of deadly boredom.

The GENERAL JUNGLE drawings give striking visual form to the theme of the diffuse, the tangled, the inextricable. AS DAY BREAKS OVER US WE RISE INTO OUR VACUUM (page 112) shows Gilbert & George in a static and unselfconscious pose amid a tangle of tree-trunks, boughs and twigs. Their vacuum is the lifeless and intrinsically meaningless undifferentiatedness of the world around them, here symbolically depicted as a jungle.

Distortion – Drunkenness – Downfall

In a number of subsequent series of charcoal drawings, THE SHRUBBERIES, DRIFTERS, FLOATING and THE BAR, alcohol comes more and more into play. The artists are now seen to have glasses in their hands. The drawings are no longer captioned with whole sentences or fragments of sentences but with words uttered at random. These all have the subject of alcohol in common, either because they directly refer to drink or because they are "incoherent" or "indecent" remarks made in a state of intoxication. THE SHRUBBERIES 2, a drawing more than 20 metres (about 66 feet) wide, shows Gilbert & George stiffly and rather forlornly posing in the midst of a forest of tall trees (page 122). At regular intervals this vast thicket is captioned with a succession of single words and passing comments: Strange Circumstances, Out of Bounds, Very Sporty, Lower the Tone, Gin and Tonic, Well Bowled, and so forth.

DRIFTERS and FLOATING force the pace of this development, and not only by virtue of their titles. In these works the forest can no longer be seen for the trees. Gilbert & George, their feet no longer visibly touching the ground, make their appearance in the midst of a tangle of branches and twigs. In THE GENERAL JUNGLE the sky was invisible; here the ground has vanished as well (page 114). Once more the drawings are accompanied by remarks, some of them rude: Rusticated Gentility, The Majors, Surface Charm, Is It Loaded?, You Ass!, etc. All these words and imprecations sound like fragments of conversation overheard amid the din of a pub just before closing time. But here too – and the drawings themselves bring this out – an unbridgeable gap separates the artists from their surroundings. They perceive, without being markedly affected by what they perceive. Instead they relapse more and more into a daze which pulls the ground away from beneath their feet.

These drawings clearly betray a chronic and worsening

state of alcoholic intoxication. The glasses they hold, as well as the choice of words, leave little room for doubt. In this way, Gilbert & George make it clear that it is they who are drunk, not the world.

Another sequence of drawings, assembled to constitute an environment, makes this state of affairs fully explicit. In it, Gilbert & George convert a room into a life-size bar (page 114). THE BAR reproduces a drinker's eye view of the interior of a pub. The walls buckle, heave and threaten to tip over backwards, curtains and panelled walls interpenetrate, and the artists stand or sit calmly at the bar. There is no longer any need for words to mark the drinkers' perceptual distortions: the setting itself does the work for them.

Besides depicting an increasing consumption of alcohol, THE BAR points to other developments in Gilbert & George's work. Henceforward, what was distorted and emptied of meaning was no longer to be the imagined unitary space of "Nature"; now the space constructed by man, his house, was to suffer in the same way. For a considerable time the scene was set exclusively indoors. At first the indoor spaces were public, in the shape of bars; later they were private and enclosed.

An interesting intersection of Nature as landscape and interior space as dwelling occurs in a drawing made later, when the importance of alcohol was already on the wane. In the last set of drawings made by Gilbert & George, THE TUILERIES (page 115), they create an interior – walls and furniture alike – with the familiar imagery of trees and branches. The "Nature" of the interior here approximates to the unmeaning Nature of the external world. Man's hypothetical first Nature has become identical with his second, which is his cultural space, in a common state of total undifferentiation.

For the moment, however, a further succession of pictures, mostly photo-pieces and post-card sculptures, shows the

continuing downfall of Gilbert & George. The first exhibition to present alcohol and drunkenness through the medium of post-card sculptures bore the telling title IT TAKES A BOY TO UNDERSTAND A BOY'S POINT OF VIEW: a clear warning against the temptation of trying to look for a serious message concealed beneath the surface simplicity.

Gilbert & George first drew attention to this way of seeing in a work called TWO POSTAL SCULPTURES in which they gave an exemplary exposition of the use of post-cards as a pictorial medium. The first of the two cards, GENTLEMEN..., shows two men standing deep in conversation at the edge of a wood (page 115). Behind them stretches an open landscape. The second card, HUMAN SCULPTURE, is a transparent fake, a copy of the first in which the two gentlemen are replaced by Gilbert & George themselves, arranged slightly differently. In place of the distant view, the horizon is masked by trees. The meaning of the work is thus narrowed down to the position of the two gentlemen as against that of Gilbert & George. What is conveyed in the first part by GENTLEMEN... and in the second by HUMAN SCULPTURE is clearly one and the same thing. By aping the first post-card in the second – although it is also possible to interpret the second as the original and the first as the imitation – Gilbert & George exemplify the way in which they make use of post-cards. What they are getting at is not some profound significance beyond the picture but simply the use of the post-card as a pictogram. What counts is what is on the cards, not what lies behind them.

In the exhibition IT TAKES A BOY..., Gilbert & George showed a number of post-card sculptures which take up the theme of alcohol and its effects on perception. One of these (page 116) centres on a smartly dressed youth, whose portrait is placed sideways. Around this appear other post-cards, the themes of which are "Alcohol", an interior and a

still-life. The mosaic composition reflects a still cheerful and convivial view of alcohol: an upturned glass makes the drinker look unhappy, a full one brings a broad smile to his face. The boy in the centre is a calm spectator of all that goes on around him. He sees nothing significant or subtle; only what a young person in his position is able to see: drinking and its superficial attractions.

The orgy of drink gathered momentum with two subsequent exhibitions of photo-pieces, THE EVENING BEFORE THE MORNING AFTER and ANY PORT IN A STORM. The titles, with their allusions to hangovers and to the multiple meanings of "port", make it abundantly clear what was going on. Whether as a wine, as a harbour or even in its third sense of "deportment", port represents a refuge when the going gets tough. But even this can no longer really hold out a promise of salvation; the invitation card was black-edged like a message of condolence. The artists' carefully maintained "deportment" was more like a calm before the storm than a refuge from the storm.

The images in both exhibitions reinforced the theme of reeling, spinning and falling which had already appeared in THE BAR. Now, however, it was the artists themselves who were growing unsteady. FALLING (page 117) consists of ten near-identical images which show Gilbert & George in a bar. These have been modified by distortion and smearing, and are arranged along a falling line, so that they suggest a chronological sequence. The picture tumbles, head over heels, into an endless spin. It turns on its axis and comes to rest for a moment in the penultimate shot, only to plunge further. The sequence could be prolonged indefinitely.

In a further series of postal sculptures Gilbert & George kept the art world informed of their increased alcohol consumption and consequent befuddlement. THE PINK ELEPHANTS – its external form like that of THE

Distortion – Drunkenness – Downfall

LIMERICKS – consisted of a series of folded cards each bearing a different image and the name of a popular alcoholic drink; inside was a brief text describing the experience of one particular "evening before". ·

As well as being the name of a cocktail, the phrase "pink elephants" of course stands for the vile hallucinations to which alcohol gives rise. And so the images in the PINK ELEPHANTS series all represent horrific visions, although not always images of carnage or the end of the world. Their horror is mostly the terror of the familiar. Each motif is duplicated, in that two different cards bear the name of each drink. Once more, one of the images of horror is man-made space, that of the house. The two versions of BRISTOL CREAM show a view of a back yard and a dusty old staircase, respectively. Another theme is that of ripeness and maturity: one version of LONDON DRY shows a young man in sports clothes, the other a poppy plant with flowers and seed-pods (page 119). Both motifs suggest life in full bloom. But neither human space – the house – nor ripeness of form is here presented as something positive. On the contrary, their form and their life are marked by a terror which exerts a satanic fascination.

This underlying menace is made more explicit by those images in the sequence that show soldiers in battle or a gloomy sky. The texts, too, share an atmosphere of confusion, befuddlement and terror. They associate the images with the blurred and distorted memories of a heavy night's drinking. The text to the BRISTOL CREAM staircase picture reads as follows:

> Went up to the bar and ordered
> these drinks, lost those
> somewhere ordered a couple more,
> found that we had forgotten

> the others so we had another
> round, found some and tended
> to lose track a shade.

Clearly, the idyllic images of home and ripeness contradict the texts, with their theme of constant befuddlement. The "Cheerio" with which each text ends signifies not good cheer but its opposite. This is confirmed, above all, by the artists" subsequent activities and exhibitions.

These works had adumbrated, but not yet fully worked out, the themes of menace, darkness and oblivion, always accompanied by a fascination with distortion. The works that now followed carried this tendency to a logical extreme. The superficially cheerful and relaxed atmosphere disappeared in favour of an increasing gloom. Titles of exhibitions and pieces such as MODERN RUBBISH, HEALTH MESS and BLACK STARE set the tone of the artists' continued downfall. The casual, mosaic-like layout of the early works was replaced by an increasingly rigid and mostly symmetrical composition.

The motif of the interior as home remained prominent, but it now increasingly took on the menacing aspect of a prison. BLACK STARE (page 120) shows Gilbert & George entrapped in a mosaic of identically sized details of pictures, all of them of a pub. The individual pieces of the mosaic show the artists, horizontally and vertically, the chequered floor and sometimes glimpses of a tiny, almost indistinguishable window. Some of them are so dark that they look pure black. The look on the artists' faces – their "black stare" – is in keeping with their dead environment. In this connection it is worth quoting a passage from Gilbert & George's second book, DARK SHADOW, which is mainly an account of the successive stages of the alcohol period.[59] In the chapter "Balls Bar" (a pub which can also be seen in BLACK STARE), a blurred image of a window is accompanied by this text:

Balls and chains in this dark confessional prison bar for we are here chained up in pleasure of the torment we consume. We reach for the daylight without hope and in a feeble way. Day in, day out we drag our heavy balls. The simple wooden bench, the diet of bread and port and the stench of fellow prisoners seeps through our minds like majors through the legs. The floor beneath our sticky soles is near to caving in with sticky splinters softly raising all their blunted tips.[60]

"Dark confessional bar" and "chained up in pleasure" mark the progress towards darkness. Drunkenness becomes a torment, the bar a torture-chamber of pleasure. With increasing explicitness, and both voluntarily and involuntarily, Gilbert & George are locking themselves into a prison which symbolizes the outworn form of awareness under which they still live. In this space, meaningless and yet full of menace, voices from the past faintly echo human passions, lusts and desires:

We count together all the things that have been said, the jokes, the plans, the gossip, the lovemaking, the little remarks, the loud insults and the many chin-wags. The ghosts are all around tonight, standing against the walls or lying in the corners. One passes us amusingly on hands and knees, we give him a friendly kick as he falls over grinning nicely. Good lord, its father. "Sorry father", is all one can say.[61]

Nothing in this prison of old imaginings and fleeting memories can inspire even a hint of respect. Even the father, one's own flesh and blood, appears crawling drunk on the

floor and is met with a shrug. The prison of drunkenness and old imaginings is as total as it is brutal.

Another picture, as striking as it is significant, introduced a new central motif which Gilbert & George have continued to employ to this day: the image of a man. MANLINESS, one of THE LIMERICKS, had already undermined one traditional form of masculinity, that of the intrepid conqueror of the unknown; LONDON DRY, one of the images in PINK ELEPHANTS, also uses an image of a young man, but in spite of his neat, fresh appearance he somehow inspires alarm rather than confidence. In TRUE MAN (page 121) Gilbert & George place their own portraits at the centre of a robot-like male figure made up of detail shots of the objects to be found in a pub. His head is a clock; other parts are glasses, bottles, notices. The brewer's name, "Trumans", on an ashtray provides a direct allusion to the title.

A noticeable feature of the individual sections in this piece is that they are deliberately presented in an old-fashioned style. The vignetting which shades the image off into the white background serves to emphasize its centrality and introduces an element of nostalgia. The theme is one of recollection, but a recollection which looks more like vindictiveness than like the cordial remembrance implied by the phrase "true man". The true man who represents and indeed embodies Gilbert & George here is a lifeless robot assembled from the props of a pub scene. This man is also a monster, whose grotesqueness and menace coincide with the futile compulsion to dwell on empty memories. The fact that he unites and imprisons the two artists in his heart makes the compulsion all the more compelling.

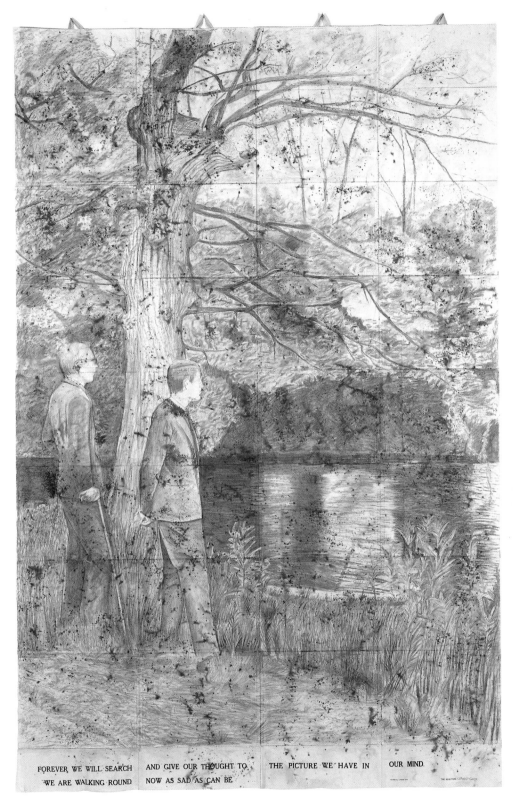

FOREVER WE WILL SEARCH AND GIVE OUR THOUGHT TO THE PICTURE WE HAVE
IN OUR MIND. WE ARE WALKING ROUND NOW AS SAD AS CAN BE. 1970. 348×236 cm.
From THE NATURE OF OUR LOOKING. A Five-Part Charcoal on Paper Sculpture.

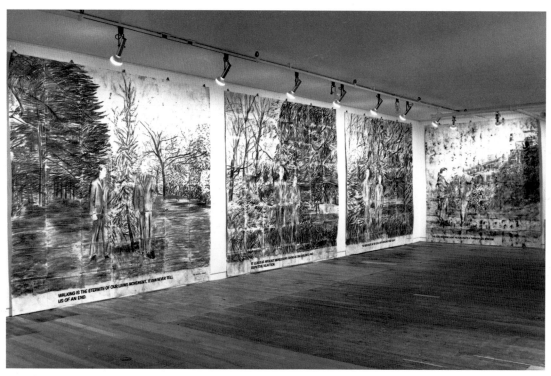

THE GENERAL JUNGLE. Exhibition at the Sonnabend Gallery, New York. 1971.

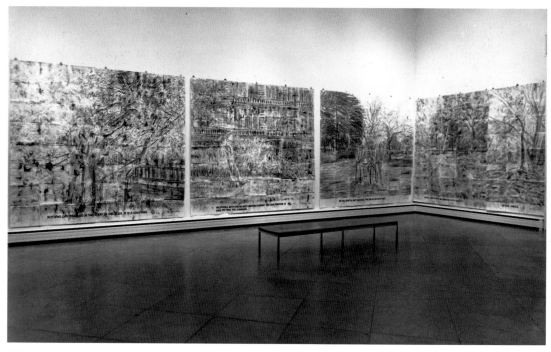

THE GENERAL JUNGLE. Exhibition at the Albright-Knox Art Gallery, Buffalo. 1976.

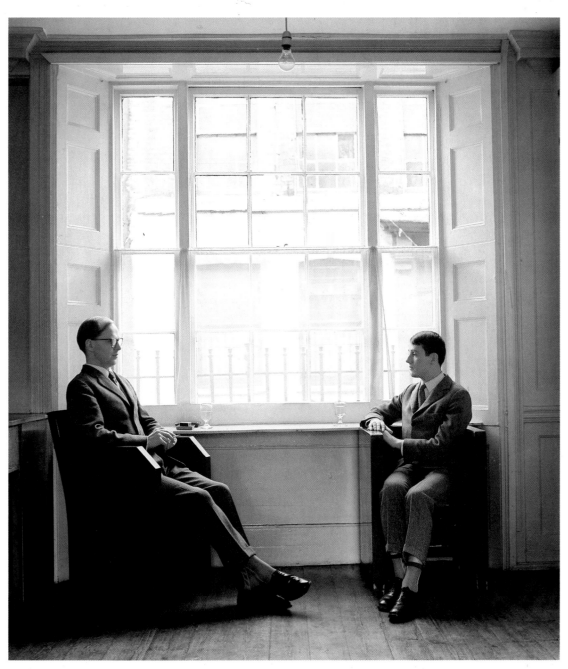

MORNING LIGHT ON ART FOR ALL. 1972. 38×31 cm. Edition of 12.

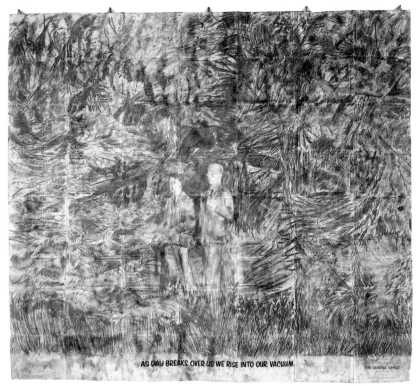

AS DAY BREAKS OVER US WE RISE INTO OUR VACUUM. 1971. 280 x 315 cm.
From THE GENERAL JUNGLE.

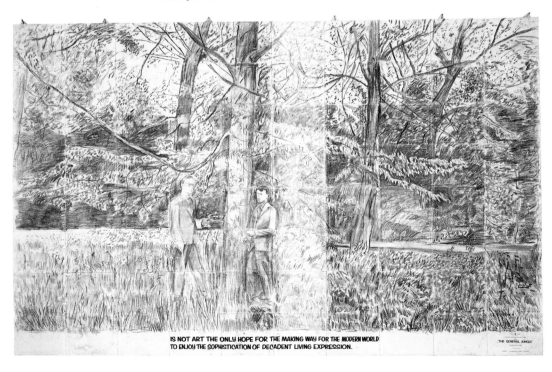

IS NOT ART THE ONLY HOPE FOR THE MAKING WAY FOR THE MODERN WORLD
TO ENJOY THE SOPHISTICATION OF DECADENT LIVING EXPRESSION. 1971.
280 x 450 cm. From THE GENERAL JUNGLE.

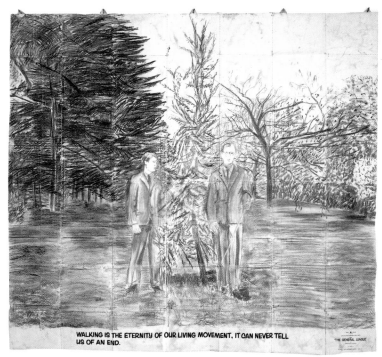

WALKING IS THE ETERNITY OF OUR LIVING MOVEMENT. IT CAN
NEVER TELL US OF AN END. 1971. 280×315 cm. From THE GENERAL JUNGLE.

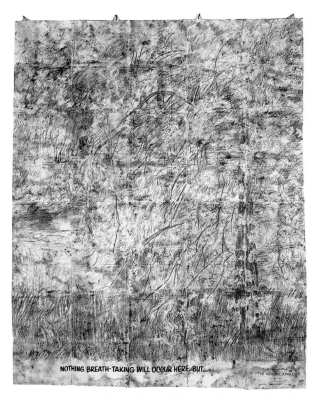

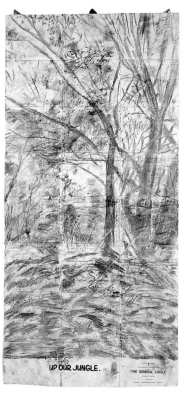

NOTHING BREATH-TAKING WILL OCCUR HERE, BUT . . .
1971. 280×315 cm. From THE GENERAL JUNGLE.

UP OUR JUNGLE. 1971. 280×135 cm.
From THE GENERAL JUNGLE.

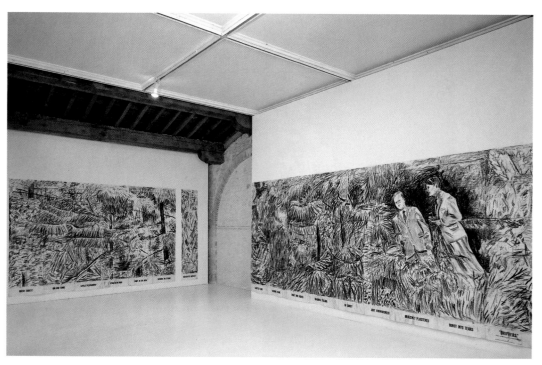

DRIFTERS. 1972. A Seven-Part Charcoal on Paper Sculpture. Exhibited at the C.A.P.C. Musée d'Art contemporain, Bordeaux. 1986.

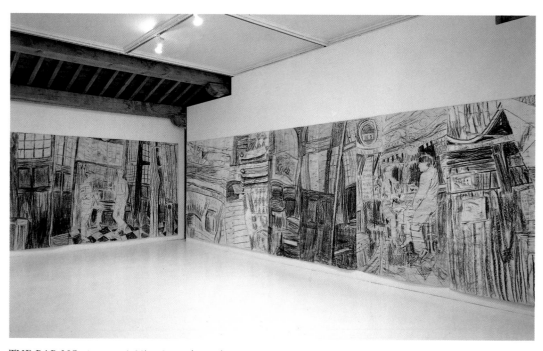

THE BAR NO. 2. 1972. A Nine-Part Charcoal on Paper Sculpture. Exhibited at the C.A.P.C. Musée d'Art contemporain, Bordeaux. 1986.

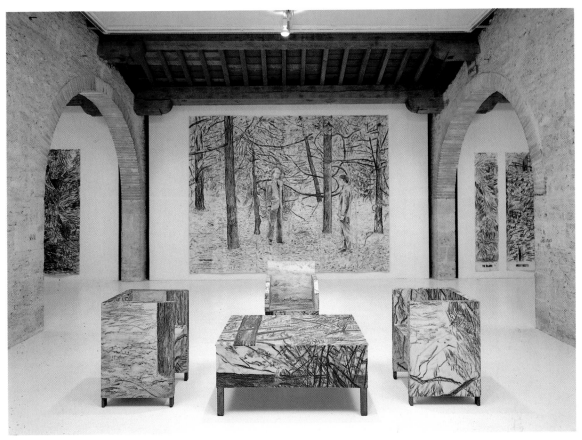

THE TUILERIES. 1974. An Eight-Part Charcoal on Paper Sculpture. Exhibited at the C.A.P.C.
Musée d'Art contemporain, Bordeaux. 1986.

GENTLEMEN . . . 1972. A Postal Sculpture. HUMAN SCULPTURE. 1972. A Postal Sculpture.

The picture post-card is treated in just the same way as the image in general. What matters is what it
shows, not what it conceals or what it simulates.

115

POST-CARD SCULPTURE D. Autumn 1972.

Announcement card. 1972.

Announcement card. 1973.

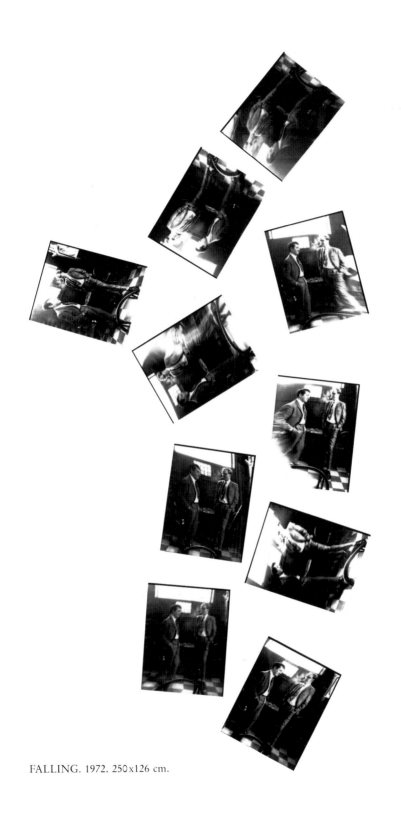

FALLING. 1972. 250x126 cm.

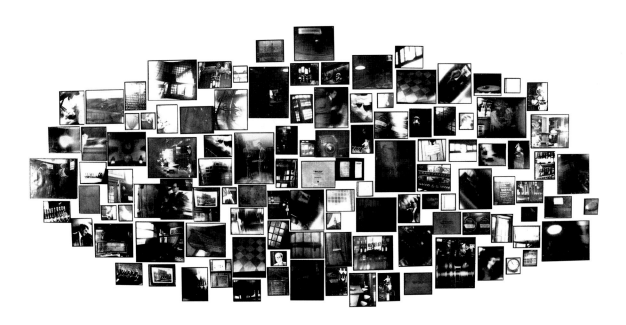

BALLS OR THE EVENING BEFORE THE MORNING AFTER. 1972. 211x437 cm.

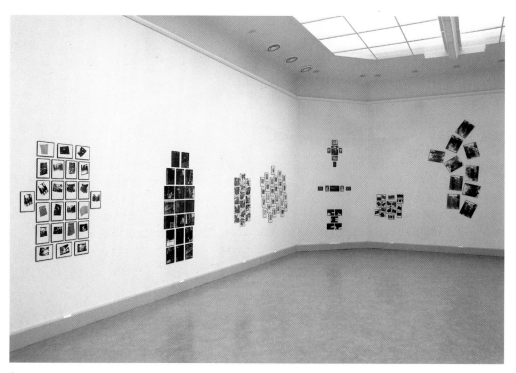

DRINKING PIECES. 1972, 1973. Exhibited at the Stedelijk van Abbemuseum, Eindhoven. 1980.

118

DOM PERIGNON

THE MAJORS PORT

DOM PERIGNON

THE MAJORS PORT

LONDON DRY

BRISTOL CREAM

LONDON DRY

BRISTOL CREAM

PINK ELEPHANTS. 1973. An Eight-Part Postal Sculpture. Each recipient received a pink elephant each week for eight weeks.

TOY WINE. 1972. 74 x 34 cm.　　　　BLACK STARE. 1973. 116 x 108 cm.

Balls bars are made for loving and for special mysterious peoples feelings. We count together all the things that have been said, the jokes, the plans, the gossip, the lovemaking, the little remarks, the loud insults and the many chin-wags. The ghosts are all around tonight, standing against the walls or lying in the corners. One passes us amusingly on hands and knees, we give him a friendly kick as he falls over grinning nicely. Good lord, its father. "Sorry Father", is all one can say.

70

WE COUNT TOGETHER

Text and plate from Gilbert & George's book DARK SHADOW. 1974.

TRUE MAN. 1973. 117 x 86 cm.
In the dungeon of pleasure, drunkenness becomes torment.

THE SHRUBBERIES NO. 1. 1972. 580×2160 cm. Exhibited at the Hayward Gallery, London. 1972.

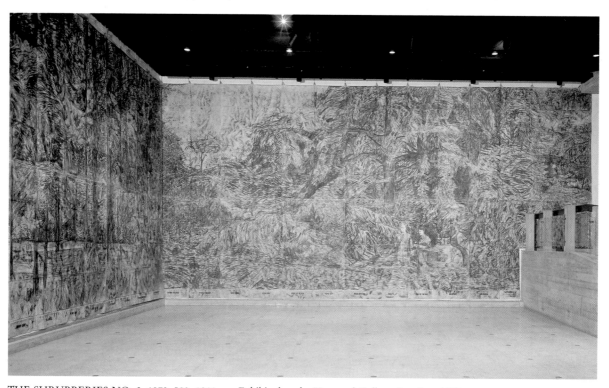

THE SHRUBBERIES NO. 2. 1972. 580x1266 cm. Exhibited at the Hayward Gallery, London. 1972.

HELL
and
CRUCIFIXION

Chapter 3

In 1974 the gloom thickened into almost total darkness. The scene changed from public to private space. Symbolically, this marks the entry into Hell, the Underworld. Inner space, increasingly emphasized until it finally becomes a prison, here represents Hell, a place of burning and bleeding.

Hell represents the sexual act, both as time and as space. Entering it is like penetrating the vagina. Within, the old life is pitilessly destroyed in a process that embodies obsession and therefore sexual desire. But before the longed-for consummation, in which death will come as a guarantee of new life, the one who enters must undergo a trial by temptation. The darkness of Hell suddenly shows itself as sweet and seductive. Satan, the personification of evil, now seeks to hold fast the one who has entered and to gain his allegiance. Only when this trial has been withstood can the hero move on through his season in Hell to ultimate rebirth and new life.

The fact that nowadays the idea of Hell means little to most people, and indeed few believe that it exists at all, is the result of the curious way in which it has been distorted. Particularly in the Biblical tradition of the West, the idea of Hell was eventually turned on its head and therefore denied

altogether. The basic misunderstanding lay in having made Hell, as the place of burning and of evil, doubly diabolical. It increasingly came to be regarded as the place in which the souls of "evil" human beings resided after death; the result was a moral take-over and eventual repression. Hell was seen as an institution that sat in judgment over human life. Understandably, this image of Hell failed to withstand the scrutiny of the Enlightenment. Hell was forgotten, and with it was lost the knowledge of its true nature as a place of healing as well as of suffering, a place which enshrines a guarantee of new life.

The subsequent works of Gilbert & George show that Hell is still a living and potent place. Its existence is subject to limitations, however, and its meaning lasts only so long as the old awareness is being consumed by its flames. Once the fire is out, Hell's time is past.

The sexual nature of the act of entering Hell is clearly evident in the work of Gilbert & George. Two pieces which otherwise have much in common are separated by sexual polarity. These are human figures which, like TRUE MAN, incorporate the artists' portraits: INCA PISCO B shows the female and INCA PISCO A the male version (page 138). On the former an embossed oval seal indicates the vagina, and on the latter a bottle represents a penis. The stylized Precolumbian forms of both figures are suggested by the title, which is the name of a very sweet Peruvian brandy. The characteristic shape of the bottle, the belly of which represents the mischievously grinning face of an Indian, is common to both figures and, together with the label and a South American decorative pattern, makes up the anatomy of the INCA PISCO figures.

The darkness of these works, the blackness of the bottle and the glasses, the outstretched arms and massive structure of the figures, and not least the face with its sly grin, add up to a Satanic, enticing overall effect. The incipient sexual act is seen

as a matter of temptation, and the face on the bottle plays the part of Satan. In the book DARK SHADOW there is a whole chapter devoted to this face and to the eponymous liqueur. Gilbert & George here begin to identify themselves with Inca Pisco, the grinning face and the sickly, exotic drink, its effects and its mood. The effect is that of a seduction, an enticement to journey to what seems like a far-off country:

> Travelling on H.M.S. Alcohol to foreign lands where smokey dark smiles and heavy strangely designed materials turn about with wonderful black contrasted quality of happy seeing.[62]

Bottle and glasses begin to take on a life of their own; as the chapter wears on, a diabolical party gets under way. Voices are heard; they grow louder and take on a tone of open menace:

> And then the conversation begins to sound horrible and angry and bitter things are said, things are thrown and a glass is broken, a fearful conversation begins.[63]

His face a mask of Satanic pride, Inca Pisco looks calmly on:

> His rockish face surveys a sea of deadly black glasses with his pleasure of filling purpose. Without youth, without age, with grand and kindly thoughts he lives for his admirers. A nod of his head serves as an introduction and an elegant low bow is his greeting to old friends.[64]

But the scenery of Hell is a surface spectacle only. The real threat, and the real temptation, for Gilbert & George lie in a

perilous and deceptive state of contentment that allows them to lose sight of their goal. Their aspirations give way to the longing for an exotic world elsewhere, or risk disappearing altogether. A picture of a black glass with steam arising from it is captioned:

> Black symbol of sophisticated decay within the tidy limits of our walking life to speak of us of fresh new days we had forgotten with our waste of times mind. That we can see some light on glass, some curtain or some pin we love is all we ask for in each day.[65]

Gilbert & George resist the blandishments of Inca Pisco. Instead of slipping away to pass their life amid the sickly-sweet delights of Hell, they press forward into the depths of the infernal, purgatorial fire. Sexual union gives way to total ingestion. Images of animal nature, of a fat and monstrous beast, point to the gaping, devouring jaws of Hell. The artists are swallowed up; they vanish, and with them the ground of the old imagination and awareness drops away.

A DRINKING SCULPTURE (page 139) marks the beginning of the end. The artists appear in the centre of this "sculpture". They are still seated on chairs, still wedded to the air of casual ease which characterized them at the outset (and which, from this point onwards, increasingly gives way to a sense of abject servitude). Their portraits are surrounded by a double row of other panels which feature their drinking and their way of life generally. Pictures of glasses, bottles and related accessories form the uprights of the frame, and in the corners there are motifs of animal and, by analogy, human life. The corner motif on the inner row is a wild boar on a bottle-cap; those on the outer row are an embroidered elephant motif and a tiny pair of stick-men.

Another quotation from DARK SHADOW is appropriate here. The first chapter, "Gordons Gin", starts with "The boars head, hallmark of our illustrious down fall and brand new imaginations".[66] "Brand new imaginations" is the slogan that announces the distortion, inversion and eventual extinction of imagination itself. For what Gilbert & George imagine in the midst of all their "well-being" is anything but new. It is the consciously superficial and inebriated aspect of imagining. In the rest of the chapter bottles and glasses are transformed into human figures who perform historic deeds. A collection of glasses becomes the architecture of a gin distillery ("a most impressive complex of modern glass factory buildings"[67]), and the flow of drink recalls that of the Niagara Falls, beside which the artists take an imaginary stroll. With all this goes a cynical, off-colour little joke which completes the image of the "brand new imaginations": "the rule is always to hold a person by the neck and a bottle by the waist, although this may be changed around depending on the hour of day".[68]

Imagining here represents a form of image-building and de-imaging; in the corners of A DRINKING SCULPTURE the stick-men, and the elephant, are embroidered on a textile, which means stitched into it, imaged in it. The figures stand for the artists, and the elephant is the false image of another image, and thus absent twice over. Elsewhere they write of the elephant motif:

> Here is old Edward the fox with his pink coat on and that silly false nose. A friend of ours but trumpeting his relaxed kindly manner jumping through the bushes of streets. Falling up the stairs and throwing off his coat with a flick of his false nose. Going through the jungle with club in foot brushing against the gaily coloured trunks. Feeling the moisture of the local foliage,

when in season. Dropping his club now and
then. Our nice pink monkey.[69]

With the naming of the phallus ("Our nice pink monkey"),
the image of maleness as the representative of a stable, given
reality is plunged into an endless whirl. The boar's head was
the sign of the loss of imagination and of the swallowing up of
images; the elephant is the symbol of the groundlessness of
images. He is elephant, fox and monkey all in one. His image
postulates no ground. It looks like a grotesquely unreal simu-
lation of another animal: a fox with a false nose.

The life's blood was now draining away from images as
they were devoured by a hungry monster. This is stressed by
the invitation card to the exhibition of A DRINKING
SCULPTURE, which shows the elephant once more, but now
the creature has been dyed with a clear red colour. The colour
red, in conjunction with the theme of devouring and animal-
ity, now became the symbol for the incipient destruction and
elimination of the pictorial ground, seen as a form of bleeding
to death; the matrix of imagining had started to fall apart.
Gilbert & George's initial preoccupation had been with pre-
senting this loss of imagination; now they took a further step
forward into Hell, and the ground, the very weave and struc-
ture of the images themselves, began to disintegrate and bleed
to death.

In a sense, INCA PISCO and A DRINKING SCULP-
TURE represented not Hell but Limbo. Temptation, seduc-
tion and bloodletting did not directly and logically affect the
artists themselves, who maintained a strict and conscious post-
ure of detachment from the images of their own downfall.
With the next series of works, HUMAN BONDAGE, this
was to change, as the works themselves show in two ways.

The first sign of change was the increasing dominance
of the cross. Almost without exception, the ensuing images of

Descent were cruciform. The cross had already made occasional appearances in the past; now, with HUMAN BONDAGE, it began to attach itself forcibly and inseparably to the bodies of the artists. It represented the instrument of their martyrdom, on which they immolated themselves and with themselves their life-blood. This was the beginning of a time of intensified suffering: the crucifixion of Gilbert & George. How painful this was to be – in terms of sheer endurance, above all – is indicated by an exclusive concentration on serial works. Until the end of the process of Descent, and with one solitary exception, Gilbert & George produced their works only in series, each with an overall title which epitomized the temporal and spatial components of its theme. Each picture bears the series name plus a number.

The second decisive change in the artists' relationship to their works lay in the abandonment of their former attitude of detachment, as manifested in the upright posture and physical completeness of their figures. The HUMAN BONDAGE series consists exclusively of images of Gilbert & George which show them on the floor amid a litter of dirt, glasses, bottles and cigarette-ends. Not one of these pictures, all structured in a left-handed fylfot or swastika pattern, shows Gilbert & George as whole figures. Parts of their bodies are always missing. Fragmentation has set in, and this is expressed in broken glasses as well as in the shattered image of the artists.

In addition to the external swastika shape, which is common to all the HUMAN BONDAGE pictures, the bondage theme is reinforced by an additional, inner cross form, superimposed on the individual images by a photogram technique. The arms of the cross in HUMAN BONDAGE NO. 5 are linked by a cross of chains, and in HUMAN BONDAGE NO. 6 rope binds the internal structure together (page 140).

Hell and Crucifixion

Bondage and the total downfall of the artists, seen as abject and degraded figures surrounded by the detritus of their own debauch, are the emblems of Gilbert & George's crucifixion. The quest for meaning, for a binding reality behind the appearances of the world, which seems to remain a compulsive need even when all faith has been lost, becomes increasingly exacting, even tyrannical in its effects. In HUMAN BONDAGE this extends to the point where it encompasses the downfall of the artists themselves in a loss of autonomy so total that it expresses itself as disgrace and captivity.

In the last chapter of the book DARK SHADOW there are commentaries on a number of images which also appear in HUMAN BONDAGE. Among these is one of a gin bottle whose label is reflected in a pool of spilt drink on the floor (page 142). The curious thing is that the image has been doctored, so that the writing on the "real" bottle, but not on its reflection, is obliterated. The reflection thus reflects a written message which has become in a real sense groundless. The accompanying text likens the picture to an autumnal landscape surveyed by a traveller: "The traveller came and admired the view, he liked the nature of things that people do."[70] The reference is evidently to the human quest for visible meaning – a meaning which its pictorial manifestation in this case clearly and paradoxically shows to be absent. But the intent examination of an empty space, and the concurrent search for a meaning, are in themselves emblems of human bondage in its most unfree and uneasy form.

This state of imprisonment by one's own thoughts and perceptions was an intensely real one for Gilbert & George. They wrote of feeling chained to the ground, like convicts borne down by the weight of their fetters:

Iron bands on heads make them feel more bound
to the floor as the pain takes over and tries to

escape the increasing pressure of the band. The leaden hands stretch out uselessly only to drop with dull conscious felt weight to the floor map of the moment and the day, making adventure an angry urgent slump.[71]

The iron servitude of an unremitting search for meaning reveals itself as torment and torture, and a hellish note enters the proceedings: "Hands are cut and suits are torn".[72] Elsewhere the infernal imagery is quite explicit:

The two reclining figures roll and turn slowly as if roasting on a spit. They make suitable cooking noises and then sometimes there is a collision or a turning over of bottles.[73]

Ultimately, and terminally, the ordeal ends in disintegration. Gilbert & George depart for regions still to be defined:

We stare, we leer, we lurch, we jeer. The human heart is marching down the driveway away from the old house of hate and friends, into the distance they go, the maniacs. Sloshing along on a wettish song with shoes.[74]

What this means is that they have left behind them that kind of morality which makes a distinction between good and evil ("old house of hate and friends"). This morality is seen as a divisive one, defining life in its own one-sided terms and condemning the other side out of hand. The way in which these moral opposites are defined or formulated is immaterial: the essential point is that divisive morality always needs an adversary figure, with whose assistance the "true" or "real" territory of life can be demarcated and kept separate.

Hell and Crucifixion

What remained for Gilbert & George was a void which, for them, was one of the most humiliating forms of bondage. The apparent freedom from moral compulsions is another form of captivity.

The physical enslavement and crucifixion of HUMAN BONDAGE marks the entry of Gilbert & George into Hell itself, as the title of the next series of works shows. Like the book, it is called DARK SHADOW: not a tautology but an evocation of the "darkness visible" of Hell: a dark flame in a confined space, casting shadows that are darker still.

The DARK SHADOW series and those that follow are marked by the gradual disappearance of alcohol and its associated imagery. The emphasis is increasingly on the fluid that alcohol has poisoned and polluted: blood. This is shown with particular force and vehemence in a number of the pictures in DARK SHADOW. Smears and splashes of blood form an important constituent of this series. The blood that flows here is not yet the lifeblood of an old form of awareness and its attendant forms of perception. It is "only" the dark fluid that flows physically through the artists' veins. But the sacrifice of this blood proves to be necessary in order to gain access to the true blood, the incarnate script of an old awareness.

The shedding of this blood can bring no salvation. Instead there begins a phase of desiccation and decay. In the chapter "Bloody Life" of the DARK SHADOW book, an image of a bloodstain, its form described as expressing "Ambition and Creativity", is captioned as follows:

Sickness takes over our soul and cleans our brains to crystall skulls through which we peer at all this running down of living time and waste of horrors. The drops drip down before our tear streaked faces and rest upon our dusty worn shoes.[75]

Hell and Crucifixion

The old, literal and physical blood streams out, consigning to oblivion the myth of its healing and redeeming power:

> The hand is driven to scratch the old wounds and make again the liquid of the blood to come in front of our blood-learned blood-shot eyes. Tiredness, dread and resent fill the picture greyly. Human touches are swimming in the blood, lost and moist and waiting for the sculptor's hand to push and scrape some hope and steadiness into their swirling stupidity.[76]

There is absolutely no prospect here of making the shed blood into a source of new life. The bloodstains are no more than the morbid decor of a creeping decline. Even the identification of blood with semen leads only to total negation. An image of black smears of blood is captioned:

> Black Sunday sperm of depressions desire streaks violently across the grey skin surfaces. Crossing lines weave the passionate picture of ideal heavy spermdom. Tiny drops spurt separately aside to decorate this obscure night sky hidden in the little window of the sweet smelling room of our picture-mind. A slaughter device for our new banner fluttering limp and sweatily in the airs stench.[77]

In DARK SHADOW NO.4 (page 143), there is a morbidly decorative use of blood: grey and lifeless-looking portraits of the artists are set in a frame made up entirely of bloodstains. The atmosphere is heavy with pestilence and corruption.

In other pictures the half-length portraits of the artists alternate with details of wooden panelling. In DARK

Hell and Crucifixion

SHADOW NO.7, for example (page 137), six portraits of the artists form a rectangle which is framed by shots of panelling. The overall impression is one of weightlessness, created by the lack of a common angle of sight. Weightlessness is also the theme of the text which accompanies the corresponding pictures in the book DARK SHADOW:

> The falling of lines our panelled life it is as though we were without a sound, gravity or solid grave. Just flying bat-like into the atmosphere with unlimited appetite. The harsh silver light from other places and corners of our senses makes us blink blindly with horrid realisation of our imagination.[78]

Elsewhere Gilbert & George liken themselves to mummies or to silhouettes, and find life only in the lifeless husk of their garments:

> Vital life giving texture exists here as in all suits, buttons, pockets. As useful as an ash tray with much less sensuousness.[79]

This bloodless life of arid abnegation, surviving only in the texture of materials, is manifested in the artists' view of the dimly lit lines, rectangles and patterns of timber panelling. Man and place are now reduced to a dry and inanimate surface, a hermetic prison. The structure of the panelling which defines the place turns it into a trap. "Place of no escape"[80] is the caption to one picture of panelling which bears the title HOMELY SADNESS. Just once more, an external image, an external structure, stands for the ignominious compulsion to seek meaning through an old form of imagination. Over the panelling pictures there hangs, like a curse, the gaze that rests

on them without finding redemption. The panelling ultimately reveals itself, with its lines and patternings, as an image of the internalized compulsion to search the outside world for some tangible sign of meaning and essence. "This is a simple map and gazeteer of our shadowing intellects", says the commentary on one image of panelling; it then goes on to describe an obsession with this same totally meaningless map:

> We can hardly bear to look upon this misleading accurate clear confusing picture. Square follows line follows lines follows squares for us to roam and if we like we can pause to tear some tone or contour from this scape for refreshment. We return like addicts, hungrily and slyly grasping that which we need at that time, or feel that we should pocket quickly.[81]

Alongside bloodshed, putrefaction and desiccation, DARK SHADOW thus takes as its themes violence, conflict and destruction, all of which set the scene for the ensuing ultimate sacrifice of the artists' own blood. The element of violence, already hinted at in HUMAN BONDAGE, represents an attempt to break free from the bonds of a still-prevalent system of imagination and awareness. In DARK SHADOW NO.8 (page 144) four pugnacious pairs of fists meet on the arms of a cross. Another cross, which marks the diagonals of the picture, shows the portraits of the two artists in alternation, both heavily shaded. The intervening spaces are filled with images of some soft, dark, porous-looking surface. In its amorphous softness it suggests vulnerability, a quality which from this point the artists were increasingly to emphasize. A picture of a fist in the DARK SHADOW book is captioned as follows: "Its path is clear, its thoughts are few but mutilation is the key-note to its clear dear sense."[82]

Hell and Crucifixion

The stress on mutilation here signifies the wilful destruction of all that still stands in the artists' way. As well as a weapon and a symbol of violence and destruction, the fist can also be raised in sign of hope. Hence the heroic terms in which they speak of it, in the hope that with its aid the prison of bondage can be broken open:

> Grace, speed and accuracy mark its course and herald its arrival. Four fingers and five nails worth of simple love and devotion. Creativity at the back of its mind and proud modest ambition to the fore. Skin taught with nervous thoughts of penetrating noisy grandness.[83]

The image of the fist marks a quantum leap in the course of Gilbert & George's Descent. Hitherto they had slid downhill more or less passively; now they took an active, which is to say a destructive, hand in the proceedings.

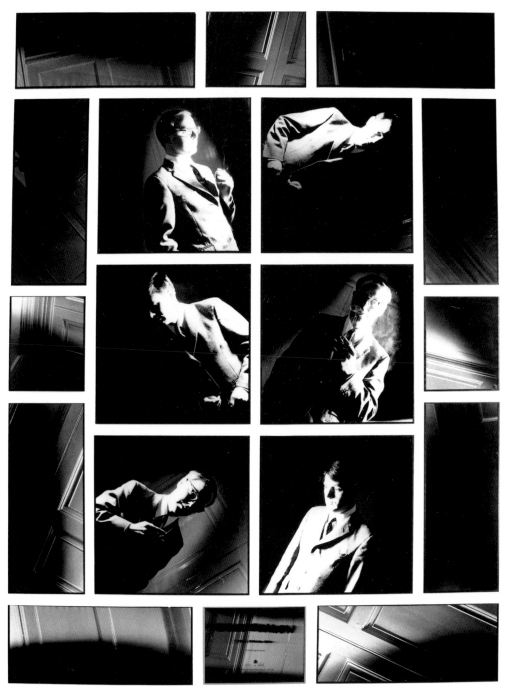

DARK SHADOW NO. 7. 1974. 211x160 cm.
Hell: a cruel and yet a salutary place, where a new life is on offer.

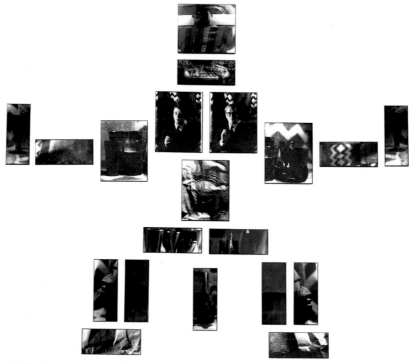

INCA PISCO A. 1974. 353×426 cm.

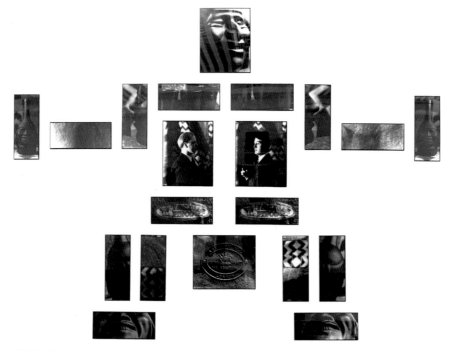

INCA PISCO B. 1974. 305×410 cm.
The entry into Hell is like a sexual act: the male penetrates the female. Accordingly, in the male version of INCA PISCO (above) Gilbert & George look forward, out of the picture; in the female version (below), they turn to face each other.

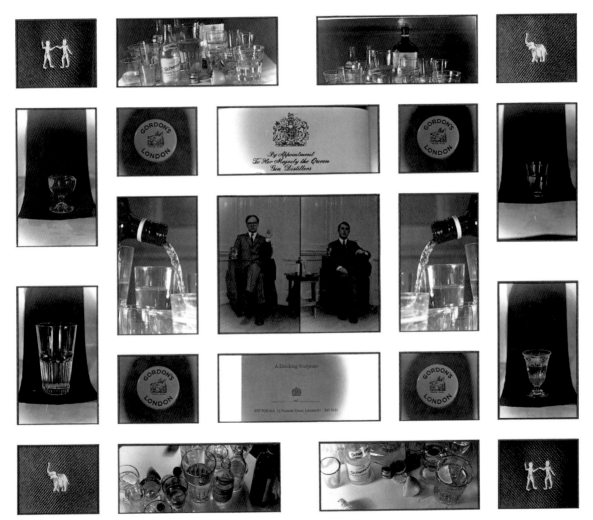

A DRINKING SCULPTURE. 1974. 183 x 213 cm.
Elephant and boar's head: animal Nature reveals itself to be devouring and rapacious.

HUMAN BONDAGE NO. 5. 1974. 175x175 cm.

HUMAN BONDAGE NO. 6. 1974. 175x175 cm.
Fragmentation, brokenness and bondage are the marks of crucifixion.

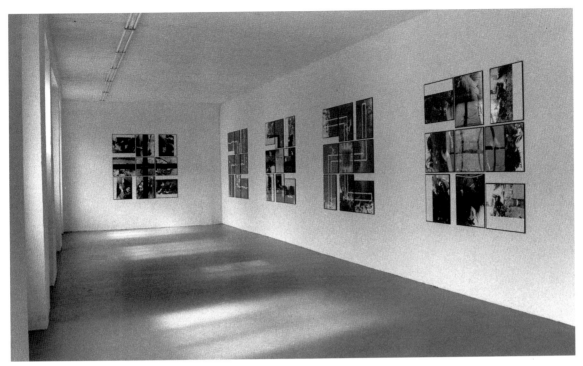

HUMAN BONDAGE exhibition at the Konrad Fischer Gallery, Düsseldorf. 1974.

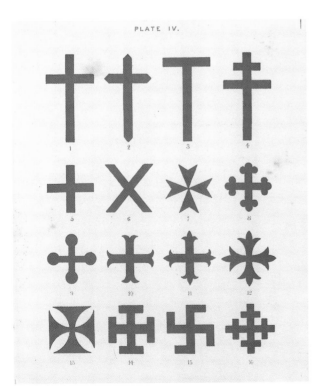

Page from W. G. Audsley, HANDBOOK OF CHRISTIAN SYMBOLISM, London. 1865.

Birthday card. English. Circa 1900.

141

AMBITION and CREATIVITY

DRUNKEN BOTTLES

HOMELY SADNESS

CRUNCHING and NERVOUS

Four pages from Gilbert & George's book DARK SHADOW. 1974.

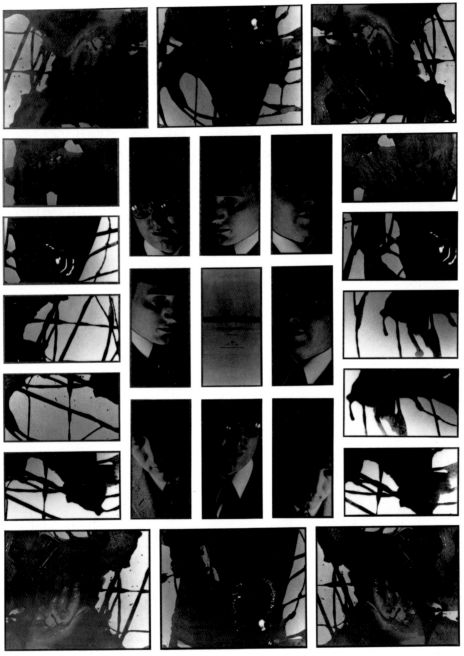

DARK SHADOW NO. 4. 1974. 211x156 cm.
An atmosphere of pestilence and corruption hangs over the scene: "A slaughter device for our new banner fluttering limp and sweatily in the airs stench." G & G 1974.

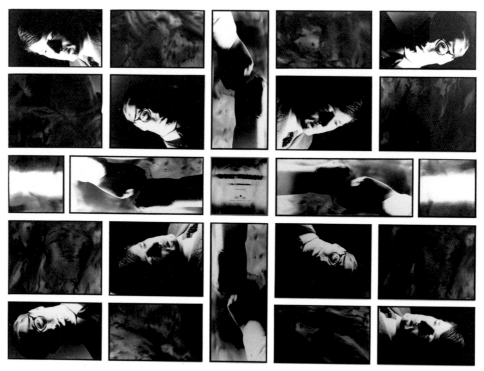

DARK SHADOW NO. 8. 1974. 151x206 cm.
The image of a fist portends an active readiness for confrontation.

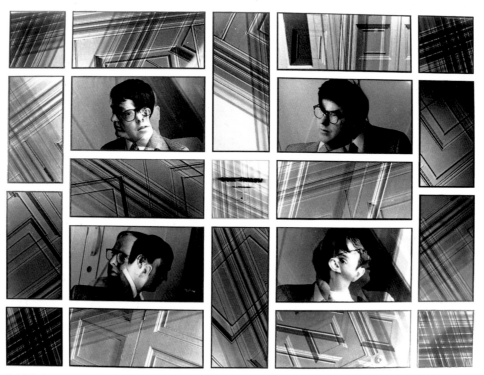

DARK SHADOW NO. 6. 1974. 151x206 cm.

HEARTBREAK
SACRIFICE
DECAY

Chapter 4

The DARK SHADOW pictures brought to a provisional close the period in Gilbert & George's career which represented both downfall and unconscious search: a search for the ground, the basis of their initial feeling of hollowness and abstraction. The crucial feature of this Descent, and the governing factor in the "search", was its direction. From the first LIVING SCULPTURES presentation to DARK SHADOW, the work transposed an outer aspect which was superficial and devoid of meaning into an inner content which had exactly the same properties. Initially there were themes – Nature and man-made space – that had an existence external to the artists; but by the time of the entry into Hell all this had changed. Henceforth Gilbert & George were the captives of their own imagination and perception. No longer was an outer world of signs, in the guise of Nature or culture, presenting itself as devoid of meaning; what was manifested now was perception itself, and this increasingly took place in terms of gloom and menace ("with horrid realisation of our imagination"; see page 134).

The logical conclusion of this development (for the time being, at least) lay in the artists' readiness to go as far as the inmost substance of all: blood. Bloodletting and the bleeding

to death of images were later to appear as a necessary precondition for the coming sacrifice itself. And yet blood as a physical substance had lost its healing power. The ancient myth of healing through blood had lost its potency.

This loss was eventually made good as a result of the artists' readiness for a fight, as evidenced by the clenched fists in DARK SHADOW. These signalled the calm before the storm, and the imminent demise of the True Blood which still stood for the remnants of the old awareness. The next two series, CHERRY BLOSSOM and BLOODY LIFE, showed its destruction. They were images of conflict and destruction, especially by burning. The burnt offering in this orgy of immolation was none other than that incarnate script or inwardly written Word which was described in the Introduction (see above, page 48) as "the logical graffiti of an ancient world-order", and which man perceives as his own captivity within a form of perception which he no longer trusts.

To break down these prison walls took something more violent than a clenched fist or a shedding of physical blood. What was needed was a renunciation, a clean break with the heart, and with love. What still stood in the way of the longed-for immolation was a love of the world, and of life, that was shared with all mankind. Only when this had been abandoned could the final sacrifice be accomplished. For the blood that had now to be shed was the lifeblood of a deep-seated longing for existence and world-order. This was the blood of love, truth and Utopia: the heart's blood of the Enlightenment.

This clean break, this heartbreak, is not depicted in any of Gilbert & George's pictures. It is confronted, and illustrated, only in the chapter "Broken Hearts" of the book DARK SHADOW. What is unique about this chapter is shown in the technique of the pictures. Here, for the first and only time, Gilbert & George have made use of black and grey

watercolours. They employ them for the sake of their intimate, romantic, anodyne qualities. The transfiguring element in a watercolour, the way the colours blur and merge, is the most appropriate device to represent the form of love which is involved here: the love which consists in oneness with the being of a world which is at peace. The subjects of the watercolours are entirely in keeping with this: still-lifes, views of river valleys, a romantic old stone bridge, a sunset, a cosy nook, the artists themselves floating in a gondola through romantic, watery Venice.

The deliberately "ordinary" execution, which has its counterpart in the occasional deadpan crudeness of the text, shows that this form of love has lost all its credibility. The text for the gondola ride, for instance (page 168), runs as follows:

> Homeward bound, Gilbert looks as though he is writing up his diary whilst George appears to be sucking the gondoliers thing. Heavy shadowy black water days of pastimes, activities and breathing. But now is that perfect lull in time when any year can inhabit the mind, when any person can sneak into the heart and any thought of any person comes drifting into ones mind-eye in the most normal way. The work is done, the die is cast and another sodding day is past.[84]

Gilbert & George present themselves here as romantically minded tourists, but their hearts have fallen prey to total indifference. An object may register for an instant, only to slip away. Nothing they see can ever stay with them as an image of love and beauty. The downward path has led them to the depths of the human heart. They can no longer respond to fascination, menace or experience: only "a perfect lull in time".

Heartbreak – Sacrifice – Decay

As well as a total renunciation of emotional response to the world and to love, BROKEN HEARTS shows itself as a powerful renunciation of the world. Their "hatred" of love finds expression where life as such is still manifest: in the world of plants, and in particular where that life takes the virile sexual form of an erect phallus. A blurred image of a pine-branch complete with cones comes to stand symbolically for life (page 168):

> Deep pine feeling provides us with a strangely poisoned pause. These needles shock us with their proud unusual look. We are embarrassed to look at them and find ourselves blushing a deep shade of grey. We become annoyed at the defiant silly power of coniferous life. We rack our brains for insults we might throw. Arrows we sneer. Desinfectant, we jeer. Surprisingly a few needles begin to fall, the cones start making noises. Gold paint, we say to him loudly and our courage restored we go our sad way.[85]

Not life but death is invoked in the presence of the living. A form of magic takes over, with tangible effect. The needles drop and the cones cry out. Life is once more likened to its time-honoured, medieval metaphoric image, the gold ground; but now the gold is a crumbling, superficial crust. The heart is broken, life is without love.

After bloodshed and heartbreak the scene was set for the impending sacrifice. It was time for the True Blood to flow, the lifeblood of the old awareness. Nothing proclaimed this more clearly than the colour red, with which Gilbert & George now began to overlay their photo-pieces. Red symbolizes all those vital forces that are associated with the image of blood as the outpouring of life: aggression, hate, death, but

also the courage to destroy. We have the artists' word for it that shed blood did now stand for a spent form of awareness. They regarded this "Bloody Life" as analogous to the Blood of Christ.[86] Just as Christ had offered up his blood, so too did Gilbert & George in the hope of a better life.

CHERRY BLOSSOM was the first series of works by Gilbert & George in which blood flowed as an emblem of the old awareness. The name and the lettering are Oriental in origin. The deliberate reference to an extra-European culture sprang from a tour of a number of Asian countries that the artists had made some time before. This Eastern influence was marked in several ways. Sometimes Gilbert & George made use of direct pictorial quotations (bamboo, script, Kung Fu postures, post-cards) or even showed the Kung Fu film SHAO LIN – MARTIAL ARTS in place of their own works. But also – and this is crucial – they became fascinated by the idea of combat and the martial arts. The will to do battle that was already apparent in DARK SHADOW now came into its own.

The techniques of the Eastern martial arts are based on an idea of combat that differs fundamentally from that current in Western culture. In the West, combat is perceived as a collision of ideologies or ideas of truth: one's opponent is an enemy because in a sense he is the enemy of truth itself. In the East, the enemy is one's own inner desire for self-assertion: one fights not the enemy but the ego, the false dominance of subjectivity. The goal of the Eastern martial arts is the subjugation of one's own ambitious will, and the ostensible opponent is a mere surrogate. There is no victor and no vanquished, only the shared respect of the combatants for each other. True individuality can arise only from the struggle against the ego, and from the achievement of perfect mastery of one's own body. "Kung Fu" means "hard work"; one works hard on oneself, to destroy one's own ego-centredness.

The title CHERRY BLOSSOM itself is an allusion to this idea of selfless combat. In Japan, cherry blossom is an emblem of courage, because at the end of winter the cherry tree is the first to burst into short-lived but copious bloom. The sacrifice of the cherry blossom is simultaneously the defeat of winter and the promise of new vital forces. It dies almost at once, and its death is the signal for spring to start. Courage here means the collapse of rigidity and the simultaneous death of the first vital forces. The cherry blossom is a sacrifice which heralds not death but the flow and resumption of life.

In several series of works, Gilbert & George now translated the symbolism of courage and martial arts into the terms of their own current situation, which was one of acceptance of an impending symbolic sacrifice. The breaking of the mould of rigidity, as first intimated in the "Broken Hearts" chapter, now finally revealed the incarnate word, the "logical graffiti of an ancient world-order".

Gilbert and George found a number of different ways of representing this. CHERRY BLOSSOM NO. 5 (page 171) shows it in the form of newsprint. The text is visible but illegible. Blood is the script of an order of being which can no longer be read, and which possesses no precise form or structure. On some of the newspapers the artists recline, and clenched fists appear above others: emblems of the "attachment" to script, and thus to blood, which is now under attack. Blots and splashes of a white pigment, subsequently tinted red, stress the connection between paper and script, on the one hand, and the flow of lifeblood, on the other. Battle is joined, and the writing flows, blurs and runs like blood.

Other pictures from this same series juxtapose script as blood with an entanglement of bamboo canes which traps and overpowers the artists. In the centre of CHERRY BLOSSOM NO.1 (page 000), Gilbert & George lie in the midst of such a

tangle, and round them is a rigid arrangement of parallel canes. But here too life and change set in, and the canes start to move. CHERRY BLOSSOM NO. 7 (page 000) shows the artists struggling to free themselves. Their bodies are rebelling against a self-imposed captivity.

Another form of "script" appears in CHERRY BLOSSOM NO.8 (page 172), where dark images of newsprint alternate with equally dark images of an urban scene. The city, once the emblem of all that was known and familiar (as in THE LIMERICKS), has now taken on a negative aspect. Once manifest, the script becomes identified with the man-made environment, and both together blur and run like blood.

There was an important departure here from previous works. There had always been distortion and disruption of urban space, but now this took place unmistakably in terms of blood. Things – or the perceptions of things – were caught up in a flow of blood through which they were perceived and incorporated in awareness; and it was in CHERRY BLOSSOM that this first became explicit. The city, as the epitome of a familiar, civilized, and in historical terms "written" environment, now blurred over, liquefied and melted away.

These works show blood as script in all its different forms: as texture, as weave, as cultural space. Other works in the same series reveal the underlying radical gesture. In them Gilbert & George carry out a classic sacrifice by burning, a HOLOKAUSTON. Images of fire and ashes, corresponding to script as texture or script as townscape, make clear what sort of a burnt offering this is. The artists are burning what has been holding them captive. In CHERRY BLOSSOM NO.3 and CHERRY BLOSSOM NO.2 (page 172), they are present as intent, but at the same time detached, spectators of the burning.

The name of the CHERRY BLOSSOM series links the

act of sacrifice, which now begins, with the bursting open of a bud which holds man's inmost essence, his lifeblood. It also marks the beginning of the most truly radical sequence of pictures that Gilbert & George have ever made: those in which the sacrifice of a dominant form of awareness is accomplished. This sacrifice nears its consummation only in the next series, BLOODY LIFE: the name itself marks the focus on blood.

In basic structure BLOODY LIFE is little different from the preceding series. There is, however, at least in some of the pieces, one important difference. Blood in CHERRY BLOSSOM was visible as script, as weave, as city; in these works these forms disappear, to be replaced by the underlying structures that sustain them. White paper, or scenes of wild, uncivilized places, indicate what lies beneath the script, beneath the built-up environment. This explains the title of the series. To destroy the support is a bloodier business than to destroy what is written or built upon it.

There is an allusion to the relationship between script and surface in the book SIDE BY SIDE, where the commentary on a drawing entitled BEGINNING runs as follows:

> In the beginning all was White and then along came the pencil. The Vanishing Desert. The pencils moving into the whiteness making signs, comments, descriptions, mystics, unhappiness, documentation, biography, criticism and drawings. It is an immensely respectable abstract form capable of a high degree of communication and persuasion. For some expression it is a definite scientific advancement in information exchange. It is believed.[87]

One page later it is time for fruitfulness at last:

On the second day, rain fell and everything would be grasped. We make every preparation for the cascading downpour. We make the lines, the spots, reason, the lightness, a spiral, some near shading, some patterns, some style, some formation, a shadow or two and a certain completeness. And then it awaits the rain for growth, to give it meaning and substance.[88]

The central distinction, in this patently fictive little Genesis ("It is believed"!), is between an empty white primary ground and the written signs that have appeared on it through human agency. Science and philosophy still to this day maintain the assumption that human existence stands between two Natures, a first and a second. Civilization is the second; the first is Nature untouched and intact. The second is consequently treated as a form of alienation from the first, true Nature, which is the womb to which man longs to return. Even where the second Nature has ostensibly supplanted the first, this model of "Nature" as the true home of man, and of the objects that surround him, still prevails; even this second Nature, in all its artificiality and supposed alienation, still bears the imprint of a Nature which unites and embodies all things. For even civilization is always interpreted in the light of a lost primal form of Nature.

THE TUILERIES (page 115) was the first of Gilbert & George's works to meld the first and the second Nature together, in an incestuous process embodied in the image of a wilderness directly superimposing itself on a man-made, urban space. This incarnate and at the same time imaginary image of first and second Nature is sacrificed and destroyed in CHERRY BLOSSOM and BLOODY LIFE. CHERRY BLOSSOM destroys man's second Nature in the form of civilization, its script and its texture. Civilization, identified

with alienation, bleeds to death and is sacrificed in the name of man's recollection of an earlier, primal human Nature. BLOODY LIFE, on the other hand, takes as its subject the primary ground itself, the white surface of Nature in its intact state.

BLOODY LIFE NO. 1 (page 173) is structured in a way almost analogous to CHERRY BLOSSOM NO. 2 (page 172). In the centre stand the artists, in front of sheets of white paper. They look alternately at the light and the dark side of the paper. The same directional lighting applies to their heads, seen at the corners of the picture. This pronounced alternation of light and shade exemplifies the only quality that a blank white surface still has. No writing now; only light and dark. But even this background is slipping away. Once more it is red-tinted splashes of paint that restore the direct link between paper as a pictorial ground and its consistency as flowing blood.

A number of other pictures present analogies to CHERRY BLOSSOM. In BLOODY LIFE NO. 6 (page 174) two images of bamboo plants, still growing this time (and thus representing Nature untouched by man), alternate with the artists' portraits. Standing once more in front of a white background, Gilbert & George hold long cylindrical tubes in their hands. The qualities of the primary ground are represented in one case by Nature (wild bamboo) and in the other by the juxtaposition of "behind" and "in front". One of the artists holds his cylinder behind his back; the other has it in front of him. A tangle of rods has given way to a single, homogeneous rod.

The assumption, ingrained in the old awareness, that there exists an immaculate and inviolate ground of being external to man – a first Nature that has, so to speak, a real existence – is particularly well expressed in BLOODY LIFE NO.4 (page 175). Several scenes of Nature in a wild, unculti-

vated state form a frame; in some of them the artists themselves are to be seen traversing the wilderness. But in the centre they take up Kung Fu postures and set about fighting their own environment, the ground itself. Red gives the whole scene a particularly bloody character. The Wild, which is Nature in its putative primal form, now itself liquefies and flows away.

BLOODY LIFE NO. 10 (page 174) links the supposed primordial nature of man with his growth in the womb. Gilbert & George lie in foetal postures on the immaculate white ground of the paper. Two views of empty rooms underline the theme of prenatal existence by recalling the imagery of the cave and the womb. Prenatal life here serves to represent an unfinished process of regression: not evolution but involution, REGRESSUS AD UTERUM.

BLOODY LIFE NO. 11 and BLOODY LIFE NO. 2 (page 174) convey the radical nature of Gilbert & George's undertaking. Here, as in CHERRY BLOSSOM, they are burning away the ground which is still an impediment to them. In BLOODY LIFE NO.11, burning paper is seen falling, and the artists are shown in the surrounding frames combating the ground. In BLOODY LIFE NO. 2, the dynamics of the fight are intensified by the distortion of some of the images. The shots of the Kung Fu contest with the white paper are slightly pulled out of shape, the artists' bodies twisted, stretched or bent. In the centre of the piece the bamboo rods, now firmly grasped, are consigned to the flames. A background which suggests flickering flames is there to destroy and consume them. The incarnate blood, in the form of a ground of being on which man has allowed himself to become dependent, is destroyed without trace.

With CHERRY BLOSSOM and BLOODY LIFE the central issue in the Descent of Gilbert & George had been grasped and at the same time eliminated. They had burned

away the ground, the original impediment that immobilized them as LIVING SCULPTURES. It was "only" an imaginary ground, but that made it all the more refractory: it was embedded, embodied, incarnate, within the artists themselves.

After this act of sacrifice, the most radical in twentieth-century art, the Descent continued towards ultimate decay, dust and ossification. The blood of life had dried up, so that the healing process of dying could proceed.

The analogies and parallels that can be traced between CHERRY BLOSSOM and BLOODY LIFE are present also between larger categories of works: on the one hand, HUMAN BONDAGE and DARK SHADOW; on the other, CHERRY BLOSSOM, BLOODY LIFE and the next series, BAD THOUGHTS. In both sets of works blood flows, the physical blood of life and that of a historical form of aware-ness; and in both the bloodshed ends in a process of decay and desiccation. In the DARK SHADOW series this is exem-plified by pictures of wood panelling, revelations of a mean-ingless surface; and in BAD THOUGHTS it is once more woodwork – mostly mouldings, glazing bars or bare interiors – that stands for the dying and desiccation of the life force.

There now began a period of extreme confusion and fear of death. These "bad thoughts", as the title has it, no longer reflected the darkening or distortion of the imagination but the fear aroused by the loss of a foothold, a loss that was now an accomplished reality. Now that the ground of percep-tion and imagination (orientation) had been burnt away, the image of an overturned order gave way to that of no order at all. In the chapter "Bad Thoughts" of the DARK SHADOW book, a river flowing through woods and meadows is printed upside down with the following commentary:

Distortions in our tortured clean brains wrestle
to have an arrangement of order and rest as here

we represent our hope for small luxury of moment with fear of discovery. The different qualities of substance neatly balanced with their human values layed in the crisp order natural to the position of all things used. Let dark damned disappointment show its sparkling smile and we will laugh as all things fall down in place all to be seen in our twisted dear straight and personal style.[89]

The implication is that an inverted picture permits no valid conclusions as to its true position. This robs the inversion of its meaning. "The different qualities of substance", being dependent on "human values", are absent precisely because those values do not exist. The consequence is anxiety; or, as Gilbert & George call it, "fear of discovery".

As in the DARK SHADOW series, feelings of absolute superficiality and weightlessness come to the fore. Gilbert & George float wraithlike through meaningless interiors. An image of one interior, with a markedly stylized, two-dimensional effect, is captioned:

Marvelling at the simple good meaning we move slowly over the furniture knocking our shins very tastefully and bumping our heads very much in keeping. We slide photographically from surface to surface in perfect accord with the unnatural perfection of this room. The distilled superior light defines our tailored selves with wood grain and nicely patterned carpets.[90]

The surface no longer has anything to convey; the artists have lost their substance and are now themselves all surface. This is also the message of the works in the BAD THOUGHTS

series, in which shots of wooden mouldings or bare interiors, some of them tinted red, alternate with portraits of the artists. BAD THOUGHTS NO. 1 (page 176) shows them, glass in hand, with cruciform windows circling round them. In BAD THOUGHTS NO. 2 (page 177), strips of moulding form two crosses, vertical and diagonal, with the artists at the centre, back to back. Here too both are holding glasses. Both pictures are images of the blood, which was tainted at the outset by alcohol, and which now congeals in the form of a red overlay. The blood of the old awareness has spilt, burnt, and is now decaying. In this state the artists and their setting have become virtually identical. Substance is absent, and what remains is the stagnant surface of the old blood as it slowly seeps away.

In these works the fatal blow has already been struck, and it is as if the dying creature were to rear up in one last vain sign of life before passing into final corruption. Alarmed, but maintaining their detached viewpoint, Gilbert & George look on. BAD THOUGHTS brought to an end the phase of fatal bleeding. What followed was a sequence of images of death itself. Once dead, the old awareness began to decay and ossify. The title of the next series, DUSTY CORNERS, in itself describes what came next: a crumbling into dust. Red as the sign of blood now disappeared; the pictures came to be dominated by harsh contrasts of black and white. In them, as foreshadowed in BAD THOUGHTS, the artists no longer move but stand, separate, still and rigid, in the bare rooms of their house. Although light sometimes penetrates from outside, all remains blurred and dim. In DUSTY CORNERS NO. 20 (page 179), for example, Gilbert & George stand in front of windows too milky-white to see through. The other two sections in the piece – two closed doors – convey the same feeling of an impassable barrier.

Other pieces in this series, such as DUSTY CORNERS NO. 4 (page 180), show books strewn at the artists' feet.

These books, at which the artists never actually look, are further allusions to the script and the white paper which in a number of earlier series represent the blood of sacrifice. Here nothing is left but the desiccated shell, doomed to crumble into dust. There is no longer anything left to fight.

Before death passes from dust to its last phase of total rigidity, an act takes place which at first seems surprising but can then be seen to be perfectly consistent. In COMING (page 178) Gilbert & George present an image which neither belongs to a series nor follows the general sequence of sacrifice and death. It shows, in alternation with the artists" portraits, four spurts of semen. A hitherto bloody life is now enriched by a second, alternative blood which is also a sign of new blood and new life. The sexual act of entry into Hell (see INCA PISCO A and B, page 138) is now amplified by that of fertilizing that parched and bloodless Hell, the uterus. The old blood is exhausted; and straight away a new blood makes its appearance in the form of the fluid that makes blood. Semen does not in itself yet denote a new awareness; but it is the seed of one.

With the series that now followed, DEAD BOARDS, the process of decay turned to rigidity. In these works, views of bare boards, mostly floorboards, are coupled with images of the artists, gazing at the dead, wooden casing that constitutes their environment. The atmosphere evokes an "inner life" which might be taking place inside a coffin (see DEAD BOARDS NO. 7, page 181). But the death which is shown here in all its rigour is nevertheless experienced in full consciousness. Gilbert & George closely inspect the wooden walls of their "coffin". In the two upper images of DEAD BOARDS NO. 19 (page 179) they use their senses to perceive death at work amid the arid stillness. They are watching and listening to death.

The sensory perception of death is the theme of a

postal sculpture sent out at about this time. THE RED BOXERS, 1975, consists of eight folded cards, the fronts of which make allusion to the "woodenness" of the contemporaneous photo-pieces. The motifs, taken from the photo-pieces and printed from blocks, look like woodcuts. In these red and black images (page 184), Gilbert & George, and their surroundings, have a hard, chiselled look. The texts inside convey the creeping onset of death in all its arid rigidity (the words in capitals are the titles of the individual cards):

> In the room we looked across
> The WOODEN AIR between.
>
> Leaning on the window sill awhile
> Two STONE-ISH faces on the floor.
>
> STILLNESS breathing through our
> air makes us still breathe.
>
> Back on back and shooting through
> the closed STUDY.
>
> They moved and paused a little
> Not seeing ANYTHING.
>
> And tilted, MOVED on with dry
> boards and then to STAND.
>
> Walking across the window glass
> Dry figures COME to them.
>
> Two in the CHAPEL with life
> around the suits.

The death that is described in these texts, as in the series DUSTY CORNERS and DEAD BOARDS, shows itself as dry, hard, blind and still. But it is just this that makes it

noticeable and in a sense even alive. The repose of death allows the artists to become aware of their own breathing, but stillness remains a sure sign of the presence of death. They become aware of it not as a void but as a palpable quality which exists in the midst of life. The artists' Descent has come to its conclusion. Awareness of death is knowledge of the death of the old awareness. The fight has been fought, the sacrifice is accomplished.

A comprehensive view of the phase of Descent in the career of Gilbert & George looks as follows. From beginning to end, it is marked by a hard, rigid quality. However, whereas in the LIVING SCULPTURES this rigidity marks the artists' total submission to rationality and routine, in DEAD BOARDS it takes the form of a hardening, a petrification, of the ground that underpins the whole of this same rational awareness: the incarnate, utopian image of a mode of being that would unite all mankind. In the LIVING SCULPTURES the old blood, the old awareness, was still potent, even if no longer credible; now its potency is comprehensively and corporeally destroyed.

Not very long ago there was a philosopher, Theodor W. Adorno, who saw "the mimesis of rigidity" as one of the most logically consistent manifestations of modern art.[91] By superficially conforming to the mechanical norms of a desacralized society, the artist could make one last gesture in the direction of the alternative reality which is the antithesis of given objective fact. Unable to give an image of this alternative reality, he could illustrate the disparity between life – as an unfulfilled metaphor – and mere mechanical fact, and could thereby convey an intimation of the "other" world.

What a difference between this view and that of Gilbert & George, who started out from a total "mimesis of rigidity" but ended by destroying the very ground or base that underlies the quest for an "alternative" reality. Not that Gilbert &

George do not wish for a better world – that has all along been the object of their sacrifice – but for them this can come about only after the old longings have been totally stilled. Only then can a new form of awareness take shape.

What this new awareness looks like is documented in the second half of this book, which is the record of their Ascent. This takes place, like the Descent, stage by stage. It is, indeed, largely the sacrificed "Matter", the dross left behind by the processes of Descent, that Gilbert & George use to build up their new awareness. Anyone who looks closely at the artists' work will find abundant evidence of analogies of this kind between the downward and upward paths. Here are a few of the more salient ones:

1. RED, in the successive series from CHERRY BLOSSOM to BAD THOUGHTS, was the colour that signalled the shedding of the old blood. Conversely, in the works of 1977–78 it is once more red that signals the advent of a new "blood" in the form of new forms of awareness and perception.

2. SURFACE vision and sensation have been adopted by Gilbert & George as their sole mode of perception. Surface sensation is characteristic of the new age, as of the old. Now, however, that sensation is cast in a positive light: what is on the surface no longer reflects an implicit underlying essence but simply lends significance to the sexual forces of the form. Governed now by a new form of awareness, sensation itself has none of its former easy-going quality: on occasion it can be downright painful. In a word, it consists in the power to visualize.

3. The CROSS continues to act as an important structural element; in the Descent phase it represented the instrument of the artists' martyrdom, and in the Ascent it becomes the structural armature around which the new life articulates itself as it develops.

4. PLANTS and ANIMALS, which in the Descent represented an element of menace, now become a source of life. Plant motifs in particular, images of branches, twigs, buds and blossoms, play an increasing part in the artists' work.

5. The ostensibly "UNARTISTIC" quality of the early works, which there constitutes a denial of the existence of an elitist aesthetic, is maintained in the later works. Now, however, it can no longer really be described as "unartistic", because the criteria by which it might be judged have gone. The denial of a transcendent aesthetic now takes a completely different form. Thus, in their new works Gilbert & George increasingly employ images of urban scenes. They do not seek out particularly fine houses, or streets or other features marked by good design. The dominant architecture is rough, dirty and often crude. This is partly to be explained by the artists' rejection of all pretence to superiority. They address themselves to the lay person, the ordinary human being, and so they incorporate in their art only the everyday aspect of the city.

6. Finally, the artists' self-declared status as LIVING SCULPTURES remains a decisive

feature of their later image of the human figure. More and more, from the initial conception of man as isolated and objectified, devoid of meaningful connection with anything else whatever, there emerge qualities which endow him with an autonomous and intensely personal existence.

So much for the more obvious parallels between the descending and ascending curves of Gilbert & George's career; it would be possible to go on almost indefinitely. The second half of this book will show how, from the dross of the old body – the corpse of a rationality afflicted with insane delusions of omnipotence, which had attempted to swallow up the world conceptually – a new life unfolds. It is a life quite oblivious of the old quest for "objective" reality; it is a life that is aware only of the promise of osmosis and organic growth.

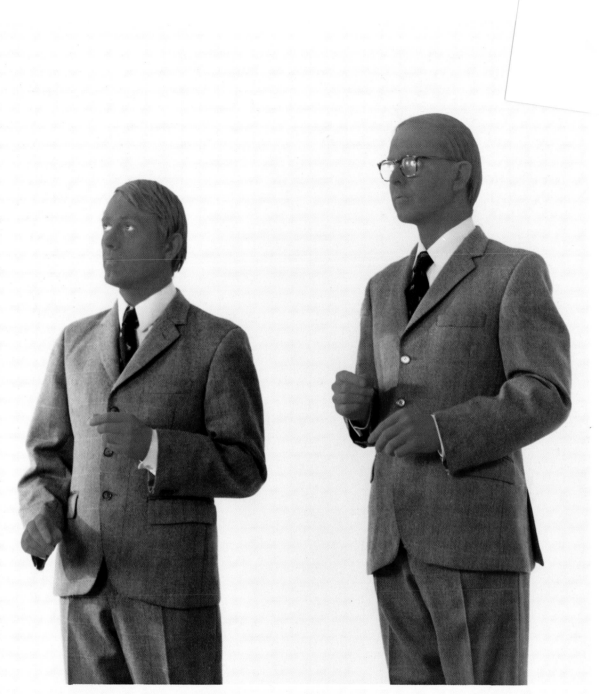

THE RED SCULPTURE

THE RED SCULPTURE. 1975. A Ninety-Minute Living Sculpture. There are nine distinct sections.
The artists' heads and hands are coated with a solid red colour, and their movements are strictly
controlled by words from a tape recorder. Each section has a different mood, with movements and
words to match.
The colour red is the clearest sign that a form of awareness is beginning to bleed to death.

DEAD BOARDS 1976 and DUSTY CORNERS 1975. Exhibited at the Stedelijk van Abbemuseum, Eindhoven. 1980.

DUSTY CORNERS 1975 and DEAD BOARDS 1976. Exhibited at the Stedelijk van Abbemuseum, Eindhoven. 1980.

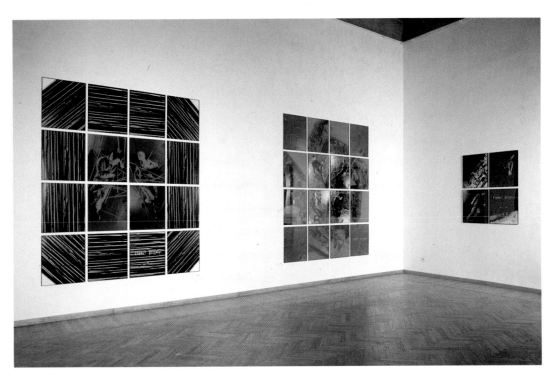

CHERRY BLOSSOM. Exhibition at the Sperone Gallery, Rome. 1974.

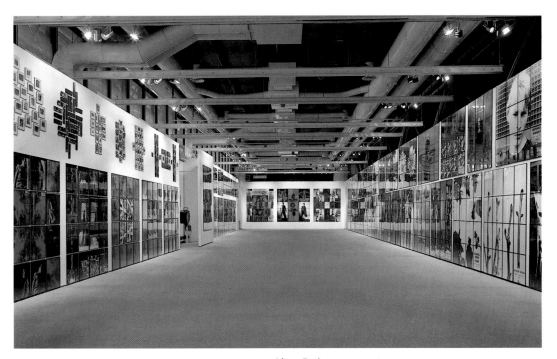

Gilbert & George exhibition at the Centre Georges Pompidou, Paris. 1981.

THE GONDOLIERS THING

THE DEFIANT CONIFER

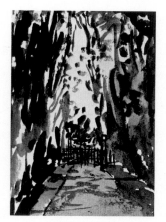

THE BACK DRIVE

BEGINNING

124

OUR CLEAN BRAINS

OUR GOOD FORM

Five pages from Gilbert & George's book DARK SHADOW. 1974.
LOWER LEFT: Page from Gilbert & George's book SIDE BY SIDE. 1971.

168

Gilbert & George in the Rhododendron Dell, Kew Gardens, London. 1972.

A TOUCH OF BLOSSOM. Spring 1971 With Best Wishes to You the sculptors

A TOUCH OF BLOSSOM. 1971. 30×42 cm. Art & Project Bulletin 47.
Blossom symbolizes rebellion and the flow of blood.

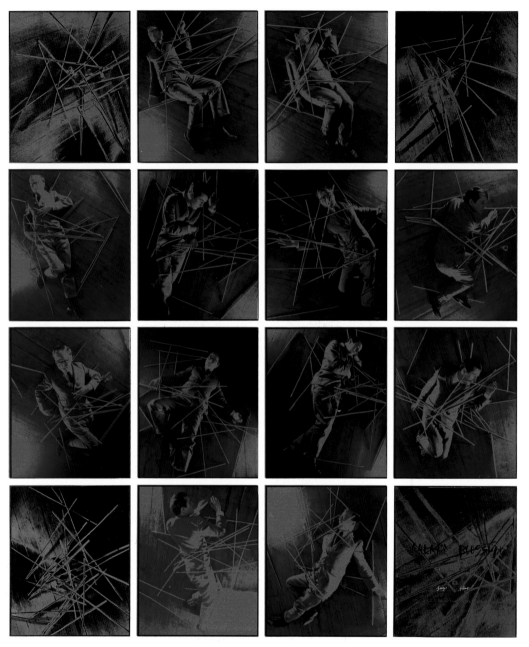

CHERRY BLOSSOM NO. 7. 1974. 247 x 206 cm.
Break out from rigidity and the blood of awareness will flow.

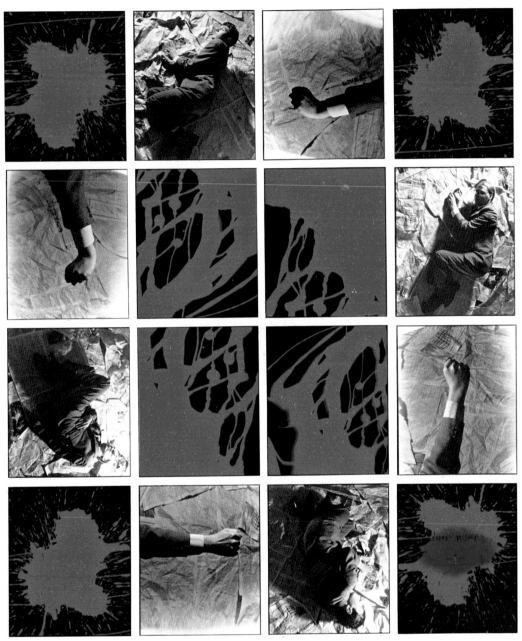

CHERRY BLOSSOM NO. 5. 1974. 247 x 206 cm.

CHERRY BLOSSOM NO. 1. 1974. 247x206 cm.

CHERRY BLOSSOM NO. 2. 1974. 247x206 cm.

CHERRY BLOSSOM NO. 3. 1974. 206x247 cm.

CHERRY BLOSSOM NO. 8. 1974. 185x154 cm.

Fire burns out the blood of the old form of awareness. The First Nature (wilderness) and the Second
Nature (civilization) are consumed by the flames.

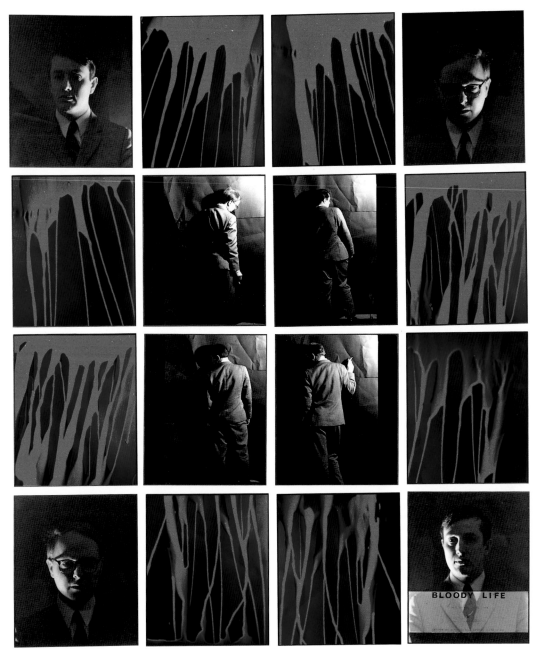

BLOODY LIFE NO. 1. 1975. 247 x 206 cm.

BLOODY LIFE NO. 2. 1975. 247×206 cm.

BLOODY LIFE NO. 11. 1975. 247×206 cm.

BLOODY LIFE NO. 6. 1975. 122×102 cm.

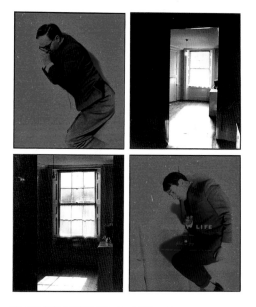

BLOODY LIFE NO. 10. 1975. 122×102 cm.

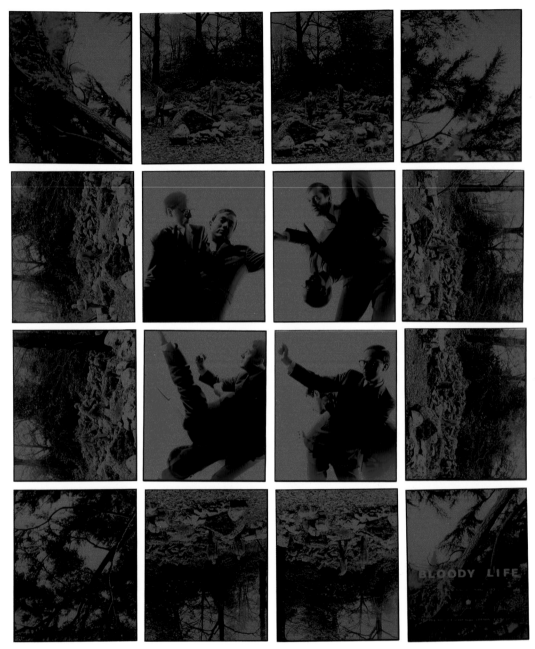

BLOODY LIFE NO. 4. 1975. 247 x 206 cm.

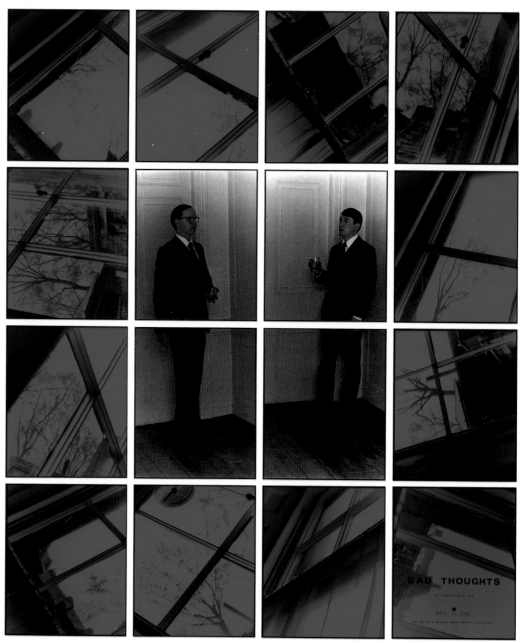

BAD THOUGHTS NO. 1. 1975. 247 x 206 cm.

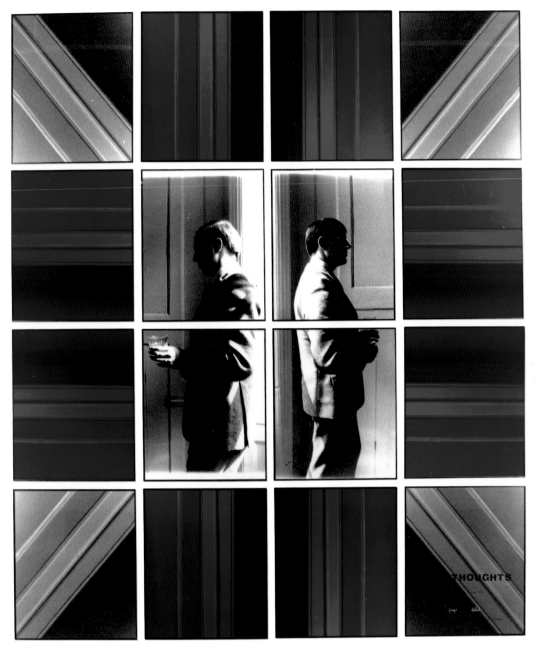

BAD THOUGHTS NO. 2. 1975. 247 x 206 cm.
The final throes of death.

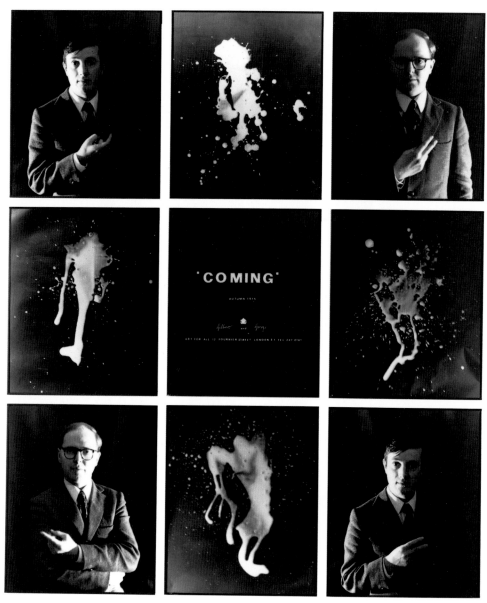

COMING. 1975. 185×154 cm.
The blood has drained away, and arid Hell is made fertile.

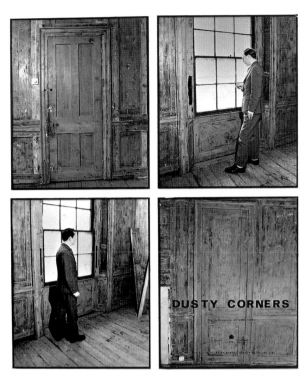

DUSTY CORNERS NO. 20. 1975. 122x102 cm.

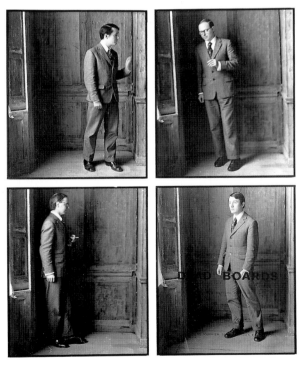

DEAD BOARDS NO. 19. 1976. 122x102 cm.

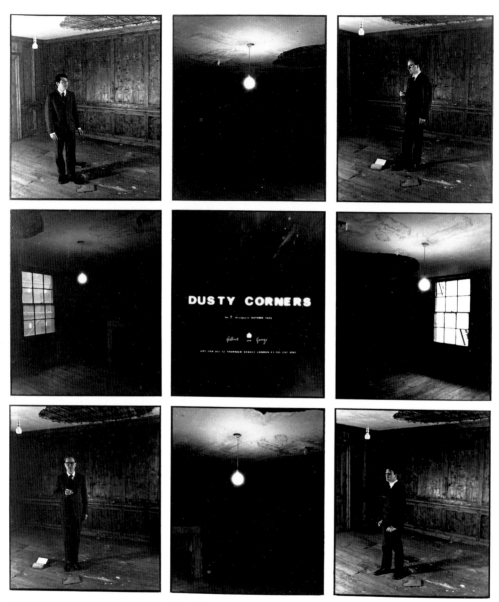

DUSTY CORNERS NO. 4. 1975. 185x154 cm.

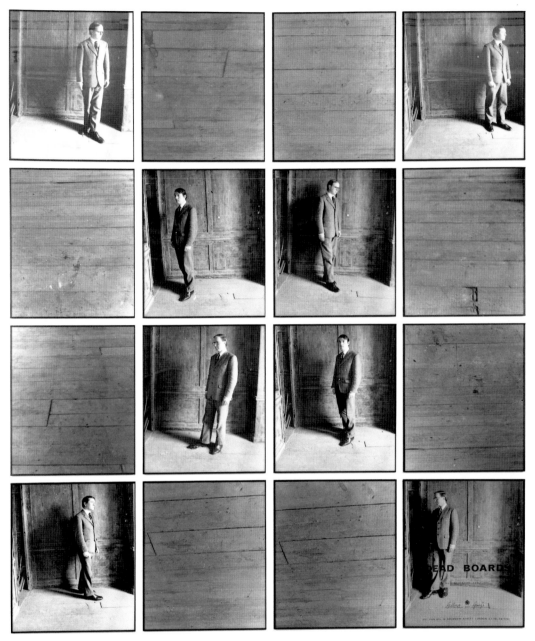

DEAD BOARDS NO. 7. 1976. 247 x 206 cm.

THE RED SCULPTURE

HUMAN BONDAGE AND DARK SHADOW

READY

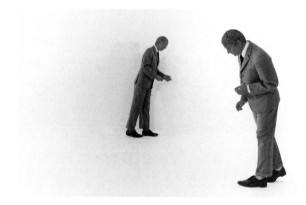

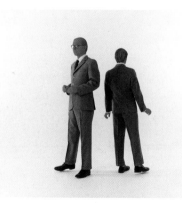

CHERRY BLOSSOM

BAD THOUGHTS AND BROKEN HEARTS

THE RED SCULPTURE. 1975. A Ninety-Minute Living Sculpture.

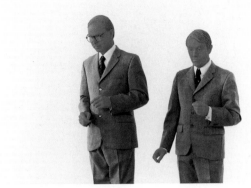

COMING

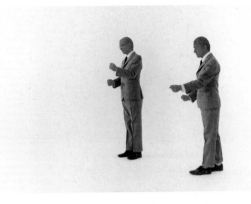

WOODEN AIR

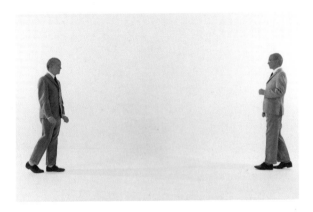

BLOODY LIFE AND DUSTY CORNERS

GONE

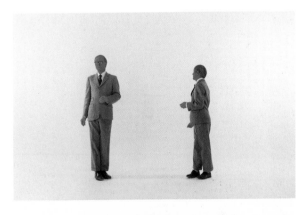

RED BOXERS

For the third time, following LIVING SCULPTURE and SINGING SCULPTURE, Gilbert & George once more present themselves to the public direct, without the mediation of pictures. In a succession of sequences, THE RED SCULPTURE is a visual evocation of a time of bleeding, sacrifice and dying.

183

WOODEN ANYTHING STONE-ISH

MOVED STILLNESS

COME STUDY CHAPEL

THE RED BOXERS. 1975. An Eight-Part Postal Sculpture. Each recipient received a Red Boxer each week for eight weeks.

ASCENT

PART TWO

A NEW
ORGANIZATION
OF PERCEPTION

Chapter 5

There is one series within the work of Gilbert & George that cannot immediately be assigned to either of the two directions that their evolution has taken: this is MENTAL, the series which followed DEAD BOARDS.

MENTAL conforms, at least structurally, to the pattern of the preceding series. Since CHERRY BLOSSOM, each individual piece had consisted of related pictorial elements placed, without ever touching each other, within a rectangle marked with series title and number; and all the series manifest the artists' fondness for contrasts of light and dark, or night and day. Because these characteristics reappear in the MENTAL series, it would be tempting to ascribe it to the Descent phase; but the content is quite different. Red is again used to mark the alternation of the three basic elements that make up each piece; but it no longer stands for old, shed blood. Instead, as the title of the series implies, it denotes a mental reorientation of perception.

The individual pictorial elements show the artists, the city, architecture or streets, and plant life in bloom. Always coinciding but never meeting, these motifs recur in every one

of the pictures. MENTAL NO. 8, for instance (page 214), displays a cross of trees in bloom; in the centre is a street scene. The four corner rectangles are filled by portraits of the artists. They stand, separately and alone, in front of a completely neutral white background. In MENTAL NO. 9 (page 214), a cross once more functions as the structuring element of the piece. This time it consists of the artists' portraits and a blossoming twig; the other rectangles contain nocturnal street scenes. The first thing that strikes one here is that the artists are now at last once more moving or deliberately adopting postures. In MENTAL NO. 9 they are standing still; in other works in the series (page 215), they are walking. Sometimes they look to one side or down at the ground, or gesture with their hands (see MENTAL NO. 8). This deliberate use of body language clarifies the ulterior meaning of the series. Still in front of a neutral background, but within the context of urban life, Gilbert & George are using hands, legs and eyes to explore and take in hand their chosen field of operation.

This field is the city, which, once more through the analogy of spring blossom, is perceived as a new and "fresh" space. In CHERRY BLOSSOM, flowering denoted the death of an old life and the prospect of a new; here, in MENTAL, this burgeoning life is represented pictorially as a field of operation for the future. Its unfolding is still to come, but its locale – the city – has been identified, at least "mentally". In MENTAL the artists turn away, once and for all, from the Nature which has lost its meaning (see THE PAINTINGS, page 96) to the city, now seen in a positive light. The fact that "mental" can also mean "crazy" reinforces the connection. Not because the artists have become deranged – or the city itself, for that matter – but because the image of urban space has undergone a mental dislocation.

Here, for the first time in the artists' career, the city is

regarded positively as a space fit to live in. It is characterized neither by familiarity nor by menace, but by an alluring fascination expressed in terms of its mineral quality. The presence of plants in bloom in these works serves only to mark the unfolding of the urban space. For this reason if for no other, MENTAL can be assigned with certainty to the upward trajectory; it belongs to the artists' Ascent.

The following series, RED MORNING, marks a break with the Descent phase in purely technical and compositional terms. The numbering of individual pictures is abandoned in favour of specific subtitles. The pictorial elements now move into direct contact, so that a unified pictorial structure appears. As a by-product of this unified structure, the images are overlaid by a grid of vertical and horizontal lines.

Although this grid is a by-product and nothing more, a necessity imposed by the artists' wish to work on a very large scale, there has been a great deal of speculation about the "use" to which it is put. It has been alleged that it reflects some hidden plan or weighty symbolic content. There is no call to pursue such speculations further. However, on one occasion, Gilbert & George did say that the grid serves as a barrier to hold the eye back from penetrating into imaginary depths.[92]

This remark of theirs leads on to another comparison that opens up a whole basic approach to Gilbert & George's pictures. In perceptual terms, if the grid shown in a woodcut by Albrecht Dürer (page 212), through which the artist is shown measuring and objectifying his motif – taking a rational, critical look at it – is compared with the grids in Gilbert & George's works, an essential distinction becomes apparent. Dürer's artist seeks to capture his motif through objective analysis; Gilbert & George perceive objects by their surface. Their "grid" is in direct contact with the motifs, and these cannot be seen through. Gilbert & George experience

what is seen, without looking through it. Things are known by their outer selves; or as the artists put it in an earlier statement: "only through the feeling of the eye".[93]

Of more immediate importance than the formal aspect of RED MORNING is the content. The title itself suggests a new awakening, a new "awareness", and a new life; and the scope of this is already clear in the post-card sculptures made directly before RED MORNING. Like sketches, these outline the essential elements that RED MORNING formulates with greater precision and under definitive titles.

Two of these post-card sculptures, both untitled, exemplify the process (page 212). One shows at its centre four post-cards, two of which show the Household Cavalry and two the Houses of Parliament. Around these is a frame made up of ten identical cards showing a flow of red-hot lava. The other piece has the same composition as the first except that there is a two-tier frame. The central images are once more of the Household Cavalry, alternating this time with the lava flow. The inner framing tier of cards consists of identical shots of a pagan sculpture. Its bent and twisted form, with penis ostentatiously on show, is a mockery of all aspirations towards harmonious proportion. The figure's deformity is in keeping with its subject matter: it represents a man pissing, voiding his waste water. The cards in the outer tier show lava again, but this time the seething mass is a uniform grey.

The message of these two post-card sculptures – as of the others in the group – is one that already appears in the use of contrast in earlier series. It may be summed up in religious terms as sexual polarity on a profound level: in a word, duality. The "male" and "female" principles are represented in their cosmic sexual guise. What is shown here is not human sex but the world, defined in terms of the competing but mutually dependent sexual energies that create and maintain it. On the one hand the "male" principle: weapons, the

sovereign's escort, all that is built and formulated in concrete visual terms, and indeed form itself. On the other hand the "female" principle: all that burns, flows, kills, misshapes, mocks, scorns, deforms.

The cosmic sexuality outlined in these post-card sculptures was transposed in RED MORNING to the setting that had been established in MENTAL: that of the city. Gilbert & George's environment was no longer the pallid, uncommunicative Nature that lies somewhere beyond the pale of civilization; nor was it now civilization itself as an apparently known and charted territory: it was the sexually charged space of urban life. RED MORNING DROWNED, for instance (page 217), shows, alongside the artists' portraits, townscapes of a particularly bleak and brutal kind of architecture alternating with branches of trees and the reflections of both in puddles. The murk of the puddles does not so much mirror the forms as dissolve them. Apparently reflective, it is seen in exclusively surface terms, as the point of transition from one sex to the other. RED MORNING DEATH (page 218) is a particularly clear allusion to this process. Here branches lie in puddles which in turn reflect leafless trees. The Formed is absorbed – or, as the title implies, done to death – by the Formless. Reflection here has nothing to do with "mirroring", either conceptually or figuratively. This is demonstrated when Gilbert & George give another picture the title RED MORNING REFLECTING and thereby find another name for the female sexual aspect. Reflection, for them, is synonymous with the process that takes place on the watery surface of a puddle: the dissolution, or bleeding to death, of the male.

In RED MORNING BHUNA (page 216), for the first time ever in Gilbert & George's work, other people appear. Alongside the images of Gilbert & George and of urban sexual polarity, people are seen walking down the street. The artists are explicitly recognizing other human beings as direct par-

ticipants in the urban complex of sexual polarity, and not as "products" of historical developments.

In all the RED MORNING pieces, images of dirt, stony soil, puddles or wet paving serve as images of the "female" aspect of urban space, and shots of bleak, inhospitable architecture and leafless trees as images of the "male". Sexual polarity thus appears in its raw, not in its elaborated forms.

The fact that a wholly new form of awareness is involved here is exemplified by the portraits of Gilbert & George themselves. For the first time they have dispensed with their jackets. They follow the directions and qualities of this RED MORNING in shirts, trousers and ties. They look up and down, sideways and forwards, and stand in light or in shade. Emerging like insects from their cocoons, they contemplate the varied manifestations of sexual polarity. The fully mature insect is known as the imago, the image; and here Gilbert & George confront the image of the city in its new, sexual reality. As in MENTAL, their own backgrounds are kept neutral, but the world confronts them in the guise of urban and sexual space. Gilbert & George here manifest their awareness of sexual qualities as creative and destroying forces. To accept this as, for the time being, the only "ground" on which the world can be based, and to concentrate on it, is to adopt a form of awareness wholly distinct from that which is always asking what is real and what is not real. In the cosmic sexual context such a question has no point. The presence of the "female" aspect guarantees that the real will constantly be eliminated, but also that it will constantly be re-created.

The opposing poles of sexuality are perceived in these works – and this is crucial – within the contemporary, urban context. This has meant that, in the whole of the artists' later work, life and its imagery emerge not from historical memory and discourse but exclusively from sexual polarity as man-

ifested in the concrete world. It has also meant that the pictures, based as they are on the timeless constants of sexual interaction, can be understood without any form of prior knowledge. The world takes shape without reference to what has gone before. This makes Gilbert & George's work accessible to the lay person, the person supposedly ignorant of art. With a trace of exaggeration it might be said that such a person, by his very lack of "knowledge", can come closer to the pictures than the art expert with his heavy burden of learning.

The titles of the RED MORNING series almost all emphasize the "female" side. Words like DIRT, BLOOD, SCANDAL, HELL, HATE, VIOLENCE, DROWNED, BHUNA (the Hindi name of a dish that cooks so long that the ingredients disintegrate) or DEATH indicate that the new awareness is directed for the time being towards the female. Although there is no such imbalance in the pictures themselves, in which "male" and "female" images are equally prominent, the titles stress the aspect of disintegration and burning. This is because this imagery is precisely what is new in the new sexual awareness. It represents all that the old awareness increasingly repressed and distorted. It was always there, of course; but instead of being taken for granted as an aspect of sexual polarity, a given fact of life, it was stigmatized as something morally reprehensible. It lived on in the perverted forms of images of horror, terror and moral evil. This repression of the "female" has culminated in the total absence of images of death which characterizes our contemporary culture. The existence of death is denied and repressed, and it has consequently come to seem a monstrous evil against which the individual is totally defenceless.

The more the old exploratory awareness was able to discover, and the more urgently it aspired to see all men united and at peace, the further it went from its goal – and,

consequently, the more it had to repress the ideas of death, flux and destruction. The quest for a ground of being, a reality, to which all mankind might owe allegiance, ultimately revealed itself as a wilful blindness to the cruel and destructive aspect of life. Life itself came up against an absolute block; its inseparable opposite, in the form of "female" sexuality, had been painted out of the picture.

When Gilbert & George gave the RED MORNING pieces names like VIOLENCE, DEATH or DIRT, this was not out of any hankering for cruelty or death, or indeed in any spirit of moral censure, but in the new-found awareness that these aspects of life are there to be cultivated rather than repressed.

In this context – that of the collision between old and new awareness – mention should be made of two works that were made in 1980, three years later than RED MORNING. The lapse of time in itself aids the two works to focus their central message of the transition between old and new awareness. DEAD KING (page 218) shows the dead, but once sovereign, form of awareness. The metaphor of kingship makes this clear. In it, a crucifix is shown at an angle which cuts off the left arm of the figure of Christ. This serves to emphasize the right arm, behind which is the firmly demarcated grid pattern of a latticed church window. Jesus Christ, right arm and lattice pattern are the three points which encapsulate the whole dead form of awareness.

The ideology that reaches its summation in the name of King Jesus Christ, the King of Kings, has long been dominant in our culture. In his name the right-handed, male aspect of life has been constantly stressed and given precedence. In concrete terms this means that the wishes of individuals have been directed towards setting up a society in which all might be for ever united, at peace, protected and provided for. In epistemological terms it means that Western man has always

craved knowledge of the "real", the spirit; the object of the awareness to which he aspires is the male aspect of sexual duality. He has attained his object, but only at the cost of seeing the real become more and more realistic until it attains the quality of the Absolute. To achieve awareness of the real is ultimately to make everything equally real and also equally non-real: a state of universal self-identity.

In consequence, the opposing aspect, the one that DEAD KING does not show – the left-handed, female side of life, which runs counter to all unifying aspirations and all "one world" rhetoric – has fallen into neglect. And so, in ANTI-CHRIST (page 218), Gilbert & George reveal its fundamental nature. In this view of a puddle, in which the male form of a church tower disintegrates into a blur, the neglected left-hand aspect shows itself in all its nakedness. What is to be seen here is not the antagonist of Christ but the antagonist of Christendom, and of its message of universal peace: this is the embodiment of dirt and cruelty.

The rise to consciousness of the "female" aspect in the urban environment constitutes a decisive and logical shift of emphasis. There has always been an endeavour, however vain, to counter the familiar and thoroughly explored realm of civilization by holding up an image of the "wilderness" beyond its frontiers. This wilderness is the emblem of a resistance which aims to subvert traditional moral values and existing power relationships; it also serves as an imaginary setting in which true life, as distinct from civilized life, can be located (EXPERIENCE, from THE LIMERICKS, page 78, is an ingenious allusion to this). This conception has never been abandoned, but the rational, critical awareness proper to civilization has never found difficulty in identifying these images of "wilderness" and transgression as manifestations of suppressed desires and accordingly discounting them. In the series RED MORNING, however, which points to the cruel, dirty, burn-

ing, flowing aspects of life within the heart of urban civilization, the "wilderness" as the epitome of destruction and subversion is no longer seen as being beyond some imagined frontier. This is not a "wilderness" that exists in opposition to some coercive force on which man feels himself to be dependent: this is a wilderness that is more intimately part of his life than all the familiar tedium of civilization.

The sexual polarity of urban space is so central to Gilbert & George's subsequent work that it is worth looking here at one more later picture. Its title, VIEW, points to the sexual viewpoint that characterizes these artists (page 219): they show what they see and how they see. They have placed their faces side by side. Above them are branches against a blue background; beneath them is a wet roadway in yellow. Both motifs, together with the artists' faces, are framed by a number of areas of colour demarcated by red-thorned branches. Gilbert & George thus convey that their "view" is worth defending, something to be protected and maintained.

VIEW alludes to form above and flux below. The wet street underfoot increasingly takes on for Gilbert & George the role of a "female" symbol of urban life. In the film THE WORLD OF GILBERT & GEORGE, which like the books is a compendium of themes, a picture of a street has the following commentary:

> Scarred cobbled street we see you for your worthless worthiness made miserable by nature and your lust you reek now of your history of use beyond your purpose. Your blood stained surfaces of charm and alarm of daily work that comes to you and leaves you dry with the destructiveness of your years. Romantic and unhappy you rot to serve no person but your friends and servants, us.[94]

A New Organization of Perception

There is in this no hatred, no repression, no rejection of this unsightly, bloodstained piece of townscape; what is expressed is the awareness that even this wet blur is worth looking at. VIEW brings this point of view into the picture. At the same time it incorporates the opposite sexual aspect of life: the male form of the branches.

RED MORNING committed Gilbert & George, irrevocably, to a new start. In it they found sexual polarity in the external world around them. Later, however, the qualities of the sexual opposites increasingly came to be embodied in the artists themselves. It is therefore possible to take the following self-characterization entirely at face value:

> We are unhealthy, middle-aged, dirty-minded, depressed, cynical, empty, tired-brained, seedy, rotten, dreaming, badly-behaved, ill-mannered, arrogant, intellectual, self-pitying, honest, successful, hard-working, thoughtful, artistic, religious, fascistic, blood-thirsty, teazing, destructive, ambitious, colourful, damned, stubborn, perverted and good. We are artists.[95]

DIRTY WORDS

The title of this chapter, "A New Organization of Perception", draws attention to the essential aspect of the works of 1977–78. In these works, through the use of red, the colour of new blood, the artists emphasized a new and ultimately sexual awareness of their urban environment. All the way through their Descent they had been fighting against an established form of perception and imagination, dependent upon a "ground" or "Nature" which was the object either of faith or of critical scrutiny; now they made a fresh start, and a new perception of truth began to emerge. This new perception

clearly showed itself in the artists' faces. Every one of the works that now appeared shows them in an attitude of looking, watching and registering their environment. In these works they do not intervene, but they have become aware of their world in a fundamentally new way.

As the new perception emerged, it became clear that this was no joyous awakening or moment of euphoria, but quite the contrary. What had happened in RED MORNING remained evident in the later pictures also: in place of a new dawn rich in blossom and colour, the awakening took the form of a growing awareness of things in their bleak, bare and unformed raw state.

The new perception did, however, permit a greater variety of subject matter. Other people increasingly appeared at the centre of Gilbert & George's pictures. The old, declining awareness had been bound up with the search for firm ground, and this had made it almost impossible to show another person, because the quest for reality had to be pursued in isolation from the world in which this other lived; now he could make his appearance within the framework of a perceived universal sexual polarity. RED MORNING BHUNA (page 216) was the first picture to show other people; in the ensuing period, and into 1978, they were to be found in almost every piece.

Gilbert & George invented for the works that followed the collective title of "Dirty Words". This is presumably because graffiti constantly appear in these works, alongside human figures and urban scenes, and indeed provide the titles for them. Nearly all these inscriptions are aggressive and brutally coarse in their import, and there is an obvious "dirty" and sexual element in them, as in titles like FUCKED UP, CUNT SCUM, PROSTITUTE POOF and BENT SHIT CUNT. However – and this is of decisive importance – Gilbert & George use the "dirtiness" of these words not for the sake of

their ostensible vulgarity, or to exploit their value in a spirit of irony, but purely and simply in the same way as the images of dirt in the RED MORNING pictures: as names for the sexual polarity that has now reached awareness. Graffiti seem predestined to convey this idea, because it is they that consistently articulate the sexual. In addition, these words were found in the public places which were to be the principal objects of Gilbert & George's new perception nd awareness.

A characteristic instance of the association between dirt and sex is FUCK (page 221), which has the sexual act at its centre. Beneath a towering architectural vista are two views of puddles. What is "male", i.e. fixed and constructed, is juxtaposed with what is "female", dirty, damp and formless. The fact that the theme is indeed sexuality, the sexual polarity that pervades the world, is demonstrated by the inscription "FUCK" above the centre of the picture, a direct indication that the city, as a sexual space, does not only consist of erect, established form but of all that is shapeless and washed-out, all that obliterates form. Within this sexual process – as the redtinted side panels of FUCK show – humanity lives, moves and looks on. The sexually polarized urban scene here reveals itself as the setting for human life. At the bottom of the picture Gilbert & George have placed their own faces. They are seen in diffused light, eyes lowered, still and watchful, taking note of the inescapable fact that dirt exists and there is no living without it, only with it.

The pictorial construction of FUCK is echoed in CUNT SCUM (page 228). Here the picture is divided into four horizontal strips. The two in the middle are further references to the sexual polarity of urban space. Two scenes – one of a wet, empty street and the other of a modern high-rise building – mark the sexual components of the townscape. Alongside them are images of people: individuals, crowds and scattered figures. Their faces, where they can be seen, betray

dejection rather than joy, as befits the bleakness and crudity of an environment whose brute sexual polarity holds no promise of a state that might ever be called "beauty".

The word "CUNT" runs along the top of the picture; "SCUM" is beneath the central group of scenes and between the portraits of the artists. The words serve here, once more, as a reference to the dirt that the artists perceive. They do not represent an object of hatred or one of desire, still less an insult directed at the opposite sex, but simply something that exists and impinges on the sexual awareness.

Another of the DIRTY WORDS pictures is less a thematic allusion to the "female" pole of sexuality than a demonstration of the excesses of the "male". In COMMUN-ISM (page 224) Gilbert & George link the one-sided dominance of the "male" with the life-destroying power of ideology. They take its claim to universal validity literally, by illustrating it with images of total control.

The word "COMMUNISM", at the top of the picture, is flanked by "SHIT and "CUNT". Below these, the vertical side rows are made up of shots of a high-rise facade with parallel vertical ribs. Between these, at the bottom, are three frames showing the letters of the word "PIG". All these images, which make up the outer tier of the work, are dominated by strong rectilinear patterns which suggest enclosure and rigidity. The black and white of the sides and top contrasts with a red centre containing human figures. Its upper third consists of three views of a life-size wax figure. A medieval king, mortally wounded by an arrow in the chest, is dying on a bed of straw. With his head propped on a friend's knee, he awaits his end. Below this death scene are three shots of a young black man. From left to right, he turns towards the spectator, so that in the third view his face is in oblique profile. With slightly parted lips and a wary expression, he looks out of the picture, conveying concern, bewilderment and even

a trace of fear. Beneath the left- and right-hand portraits of him, the artists themselves appear. Harshly lit, their features flooded with light, they sit leaning slightly forward, hunched and still. Their bowed heads convey an expression of dismay, even consternation, which may be inspired by what is happening in the frame between them. This is another death scene, so harshly lit that only the outlines can be made out. A man is on his knees before a coffin on a bier; on it is a cross.

The central part of COMMUNISM addresses two themes: that of death and that of the consternation and fear which its perception inspires. What provokes consternation here, however, is not death as such but the cause of death, as can be seen in the framing images of the work. The word COMMUNISM is meant to be taken quite literally, as epitomizing ideology and its claim to universal standardization and control: an ideology that sets out to force everyone on to a common ground of "truth". Lines interlock and force the whole into a rigid structure. Even the letters of the word "PIG", which is itself a reference to dirt, are overlaid and held fast by horizontal and vertical lines. The words "SHIT" and "CUNT", too, which also refer to the aspect of sexuality which is opposed to rigidity, are rendered indistinct by reflected light and structured and confined by rectilinear surfaces. The whole outer frame of COMMUNISM is thus a linear edifice rigidly enclosing the figures. Over-emphasis on the "male" aspect, with its stiff, interlocking structure, spells death to the human beings in the centre of COMMUNISM.

In some ways COMMUNISM presents analogies to the picture DEAD KING, described earlier (page 218). Both address the subject of death, and in both it is directly associated with a rigid emphasis on the "male" aspect as the conscious basis of normal life. For this reason both works are among the most political that Gilbert & George have produced; they strike at the very heart of all those ideologies that

still seek to impose, under the banner of progress, a universally valid mode of being.

As well as a clearly defined theme, the works in the DIRTY WORDS sequence share a very free handling of images and signs. Because they represent a new awareness of their world – which is to say that they perceive it in sexual terms, and no longer seek to reduce what is seen to a hypothetical common ground, or else to toy with such a ground on some meta-level of discourse – they enable familiar signs to be seen quite differently from before. This is what happens when, for example, the language of graffiti is used as a way of alluding to sexual polarity, or when, as in COMMUNISM, what looks like a historical death tableau simply betokens death in general.

This last idea – the use of sculptures and lay figures – takes on great importance in the later work of Gilbert & George. In many of their subsequent works they use toy soldiers, public monuments or other sculptures in much the same way as real people. These figures are never introduced for the sake of their historical or artistic significance but solely for their external appearance. The "inner" qualities attached to a historical period or to a supposed theoretical value remain completely beside the point.

It must by now be a truism to say that things and entities have no intrinsic value that defines them once and for all. On the other hand, to say that they have an outer appearance which CAN tell us something about them is radically new. The outward look of the thing has always been classified as mere appearance, "seeming" in contradistinction to "being". Understandably, as "being" became increasingly elusive, "seeming" began to wear rather thin. The outer aspect was mistrusted because it was already classified as illusion. No such dichotomy exists in Gilbert & George's pictures. In the knowledge that the world and all the entities therein are con-

stantly under attack from the devouring and destroying aspect of life, and that a valid and comprehensible "being" is in fact conspicuous by its absence, they perceive only what is there on the surface.

ARTICULATION

RED MORNING and DIRTY WORDS presented Gilbert & George's new start in terms of sexual polarity: in them, the world is divided into two sexes which are defined by their essence and between which humanity has its place. These works were followed in 1978 by a third group, individually titled this time, which pursued the process of division. More and more other objects came into view. The pictures themselves consisted of fewer elements, and their structure had become clearer and pithier. The individual motifs accordingly became larger and clearer.

Like the images, the titles revealed a first attempt at "articulation" in the sense of clarifying by separating out. Now typeset, most of these titles began with an article, as in THE TREE or THE BUILDING. An enumeration will give some idea of what was now to be articulated, perceived and aimed at: THE OFFICE, THE GARDENER, MORNING, EVENING, THE TREE, THE CENTRE, KITCHENER, THE SITTERS, THE BRANCH, THE DECORATORS, NIGHT VIEW, PAKI, DAY, THE MOON, THE PENIS, THE BASKET, THE MAN, TAXI, THE ALCOHOLIC, THE QUEUE, THE BUILDING.

Places, times of day, architecture (structure, form and tectonics), sex and people, who are now more closely defined: these make up the thematic material that runs through these works. It is presented, as in the preceding works, in a bare, rough form. There are a lot of branches, twigs and trees to be seen, but the overall effect is arid and bleak.

A New Organization of Perception

The views of trees and buildings suggest that here, for the first time, the emphasis is on the "male" pole of the sexual duality, the epitome of all that is structured, formed, full-grown. The stress had initially been on the "female" sexual aspect of urban life; now its "male" side came increasingly into focus, in that things and beings began to manifest themselves in terms of the sexual polarity that was the object of the new organization of perception.

In one of the pictures, THE PENIS (page 225), the male sexual aspect takes concrete form. In the centre Gilbert & George stand side by side in front of a bare white wall. A red overlay sets them apart from the rest of the picture and causes them to be noticed first. They are not returning the viewer's gaze but are looking to his right. On that side, as on the other, their bodies are flanked full-length by images of puddles. Below is a found graffiti scrawl incorporating the word "SUCK". It shows an erect penis spurting semen on to a woman's tongue.

For the first time in one of Gilbert & George's pictures, the sexuality that appears is not so much universal (or urban) as human, and in particular male. Gilbert & George here stress the awareness of the male organ as a "sex" which penetrates that of the female and there – in formal terms – dissolves into a blur. The graffiti drawing represents the act of penetration as a process of being sucked in; the puddles show the disintegration of the male form. The branches dissolve in their wet ground; and from this in turn arises maleness, or rather the male, as represented by the images of Gilbert & George.

THE PENIS is not to be confused with an image of a sexual act between persons, an image of sexual life. Gilbert & George went on to produce images of this kind, but not until much later (see Chapter 10, "Sex"). THE PENIS shows rather the overall perspective within which Gilbert & George regard

the male sex. In isolation from all sexual desire, or fantasies of power, they find the male sex in the image of the penis, whose fertility and life-giving power is the source of its own decay. Maleness, and all form, must for its own sake wither and dissolve. This is what Gilbert & George are looking at in the picture THE PENIS.

A number of works in this group present individuals who are identified in the titles as THE GARDENER, for instance, or KITCHENER. PAKI (page 226) is among these. In a composition of extreme simplicity, it presents a person together with the name by which he is known.

The two artists place between them a third person whom the title unambiguously designates as "Paki". The attention of the artists and of the viewer is concentrated on him. With a grille behind him and the artists on either side, this person, obviously a foreigner, is almost isolated. His posture too emphasizes that here a person is presented purely as a person. His hands in his trouser pockets and his feet close together, the man stands for himself alone. With nothing apparently to do, and nowhere particular to do it, he takes his place between the artists.

Clearly, in PAKI Gilbert & George are presenting another person without making any explicit statement about him. This pictorial isolation makes the title seem more, but also (as will be shown) less, significant. In English usage, "Paki" is a very derogatory name for a Pakistani, more a racist and xenophobic insult than a neutral term of nationality. It is precisely this aspect of the word that is called into question in this picture. By presenting the man's image in a deliberately neutral way, Gilbert & George nullify the generally understood semantic content of the title. Paki, here, is no more and no less than a name, such as every human being bears from birth. Just as Gilbert is called Gilbert and George is called George, the man shown here is called Paki. The whole seman-

tic context of the word is thereby reduced to nothing. In general terms this means that Gilbert & George regard the giving of a name as a value-free activity, even when the prior connotations of that name are entirely negative.

Just as Gilbert & George make use of graffiti for purposes of their own, they do the same with commonly used and conventionally defined words. They lay bare the power of words, not by dispensing with their connotations, and thus being left with the mere basic sense, but – and this is crucial – by giving them a new sense which is independent of the former value-judgment. Fighting an established power does not mean making its forms taboo, or arguing that their content does not exist, but accepting them and giving them a new meaning. In other words, what is seen as morally evil can be driven out only by using the evil itself. This is what happens in PAKI. The insult has transformed itself into a straightforward, value-free name.

A third work in the same series, and one which employs the same pictorial structure as PAKI, is MORNING (page 227). Like other works in the series it takes a time of day as its theme. In the vertical axis stands a bleak modern office tower. At its foot are elements of a much older and more modest townscape, and its superstructure is still ringed with building cranes. The chilly austerity of the building is underlined by the glare of sunlight that is reflected from the lower half of its immaculate surface in such a way as to white out that part of the image. Equally starkly lit, the full-length portraits of the artists flank the tower on either side. Light from a lateral source floods their bodies in such a way as to eliminate all detail in favour of harsh contrast. The intensity of the light is enhanced by the dark background and by the red overlay which covers these two lateral images.

The harsh light, the cold rigour of modern skyscraper architecture, and a cutting stridency, are the characteristics of

this particular morning. It is neither friendly nor hostile; it is there to be experienced in its inescapable reality as a time of day in the city. Gilbert & George place themselves in the building's reflected light, and thereby accept its existence and its chill. Their stance is neither one of desire nor of defiance, but of silent assent to the new awareness of an initially cold and abrasive reality.

MORNING and PAKI, with their deliberately neutral – which means above all non-condemnatory – awareness of urban reality, sum up the works of the period which began with MENTAL. In them, Gilbert & George register a new awareness of their environment in terms of sexual polarity. The fact that raw, bleak, and to some extent rough elements are common to all the pictures should not be misunderstood. Nor should the occasional appearance in them of outsiders – drunks or tramps – be taken to indicate an indictment of society. The form of perception which is at work here, and which can be detected in the use of red and in the figures of the artists themselves, concentrates on the awareness of urban space. That this space is not in the very least beautiful, and that its inhabitants' faces reflect no joy, is hardly surprising.

This period is important for one reason above all. In their new awareness of the urban environment, raw and barren though this was, Gilbert & George were laying the foundation of their later work. For they too, as their faces show, were anything but happy with the world about them.

What could be created out of this given material, what images of hope or fear could be held out in the face of this newly perceived world, remained for the future to show. One thing that was already certain was that no possible change in their world or in its structure could ever be anyone else's doing. Gilbert & George address no appeal for justice to anyone, whether a social institution or some other political organization; they situate the point of change in the individual

human being himself, by creating for him images of new values.

With the group of works just described, Gilbert & George brought the new era in their work to a temporary close. In the following year, 1979, they produced no new works. This caesura was marked by a brief text which sets out the programme for their later work.

We believe in the Art, the Beauty and the
Life of the Artist who is an eccentric
Person with something to say for Himself.
We uphold Traditional Values with our
love of Victory, Kindness and Honesty.

We are fascinated by the richness of
the fabric of Our World and we honour
the High-Mindedness of Man as the
Ultimate Form and Meaning of Art.
Beauty is Our Art.

Gilbert & George depart here from English convention by capitalizing certain words, such as Art, Person, Himself, Victory and in particular, twice over, Our. They consistently stress the individual who perceives and who acts. They show no interest in aspirations to universality, as expressed in phrases like "one world" or "our world" (lower case), in which "we" or "us" includes people in general. They make no factitious assumption of a universal form of brotherhood based on unquestioned social bonds.

The traditional course, that of making statements about society and social relationships, is totally rejected by Gilbert & George. This is not escapism; quite the contrary. Only by creating the world anew as "Our World", remaking the very core of social existence, can an encounter with humanity at large once more take place. Gilbert & George do not interpret

the word "world" as something objective and given, something all-encompassing, but as a space which man must constantly create anew.

The emphasis on "Our World" in this text meant that a trinity had now come into existence. At the outset of their career the artists had established their own identity as absolute; their new start with RED MORNING introduced sexual polarity and thus dualism; now they established a threefold world within the urban environment. At its centre stood a pair of figures, Gilbert & George themselves, who thus established their own World on the foundation of the sexual polarity of the city. That World was far from all-encompassing, but it was already on the horizon: it was a paradigm of a world.

From this point onwards a man-made, cultivated World began to take shape, as the last sentence in the statement makes clear: "Beauty is our Art." The phase of Descent had been marked by the vacuous word "nice", because the old awareness, with its pretence of an omnipresent common ground, had lost all credibility, and beauty had thereby become impossible. Now, on the contrary, "Beauty" became the keynote of the emerging World of Gilbert & George. This meant, among other things, that not only the "male" aspect of life but also the "female", the devouring, destroying, pitiless aspect, could be made beautiful. Increasingly, Gilbert & George were to devote their attention, and their creative concern for "Beauty", to this aspect of life on equal terms with the "male".

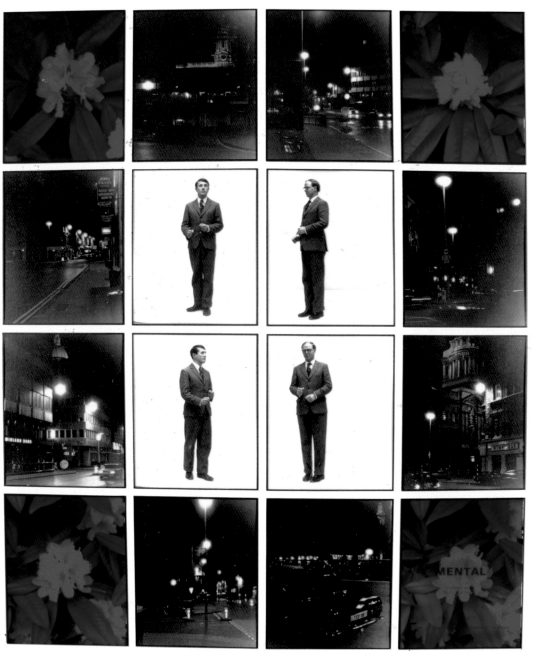

MENTAL NO. 5. 1976. 247 x 206 cm.
The prevailing image of urban reality is rearranged – not to say deranged.

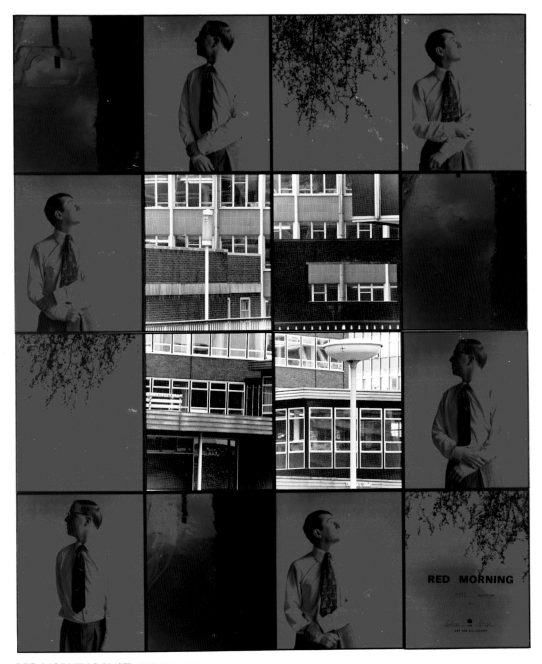

RED MORNING HATE. 1977. 241x201 cm.
Once again, the colour red serves to represent a form of awareness: this time, however, the awareness
is a new one.

Albrecht Dürer. A grid aids the artist to grasp his subject analytically.

A POST-CARD SCULPTURE. 1976.

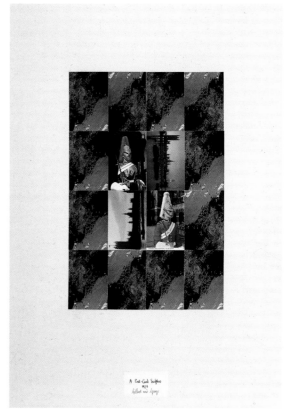

A POST-CARD SCULPTURE. 1976.

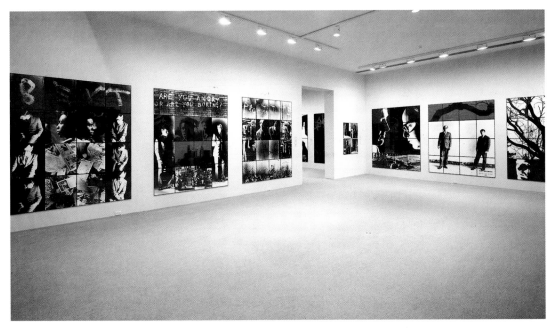

Gilbert & George exhibition at the Baltimore Museum of Art. 1984.

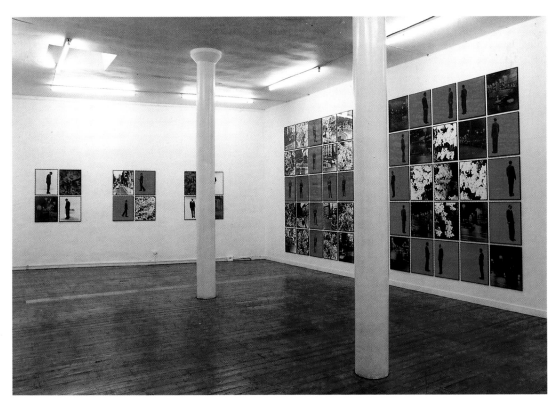

MENTAL. Exhibited at the Robert Self Gallery, London. 1976.

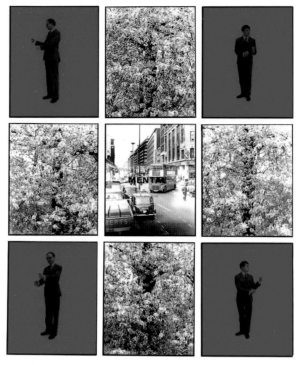

MENTAL NO. 8. 1976. 185 x154 cm.

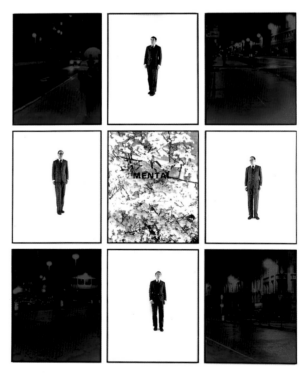

MENTAL NO. 9. 1976. 185x154 cm.

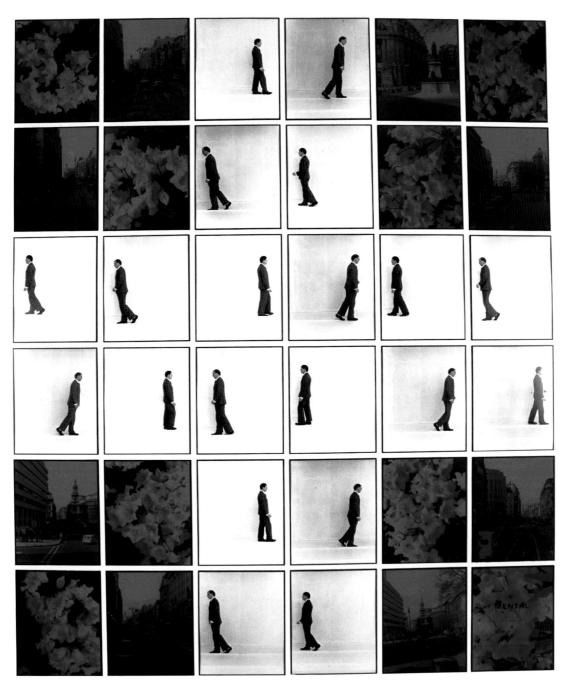

MENTAL NO. 1. 1976. 372 x 310 cm.
Urban space, to Gilbert & George, is the setting for human action.

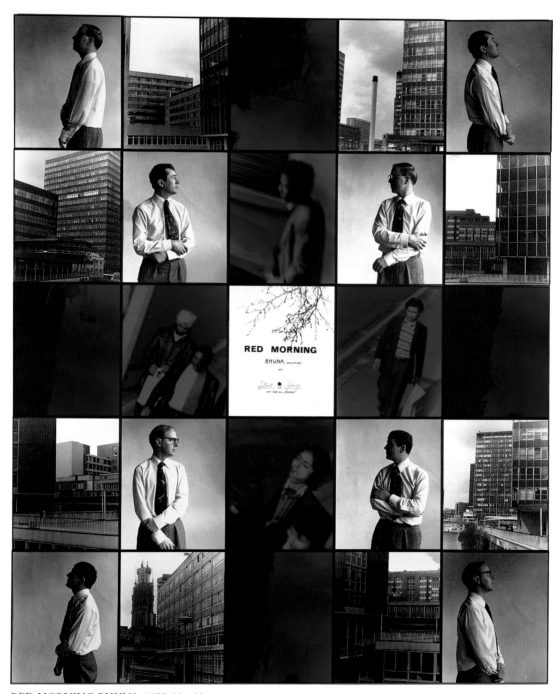

RED MORNING BHUNA. 1977. 301x251 cm.
The world, and the city in particular, is the product of two sexual principles: the male and the female, the formed and the erased, the builder and the killer.

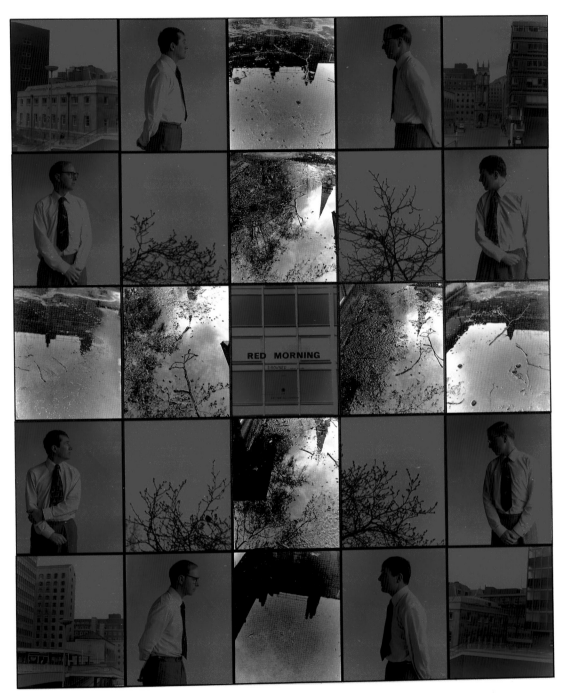

RED MORNING DROWNED. 1977. 301×251 cm.

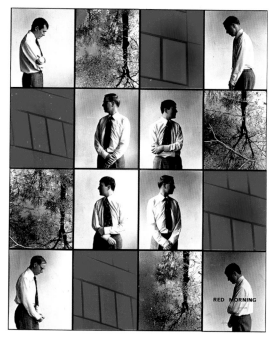

RED MORNING DEATH. 1977. 241x201 cm.

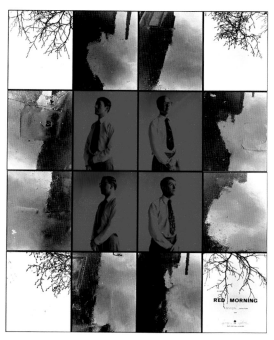

RED MORNING REFLECTING. 1977. 241x201 cm.

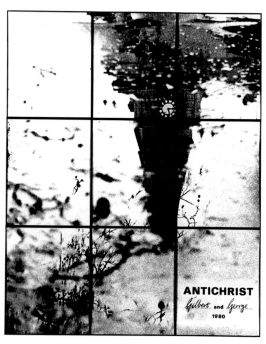

ANTICHRIST. 1980. 181x151 cm.

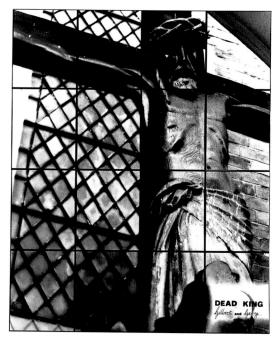

DEAD KING. 1980. 241x201 cm.

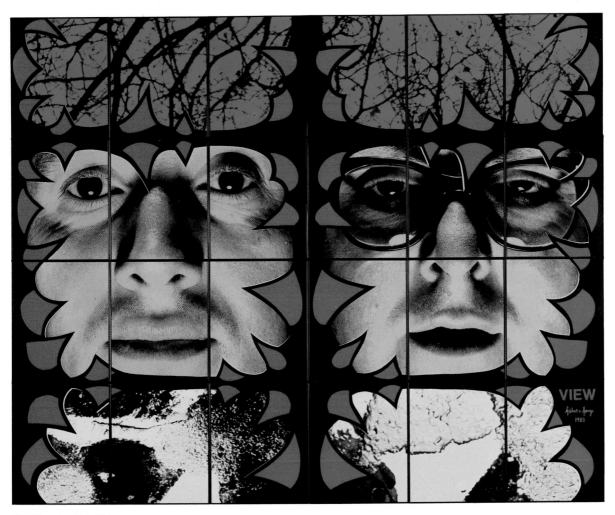

VIEW. 1983. 241x301 cm.
Branches and wet street signify sexual polarity; and so do the colours blue and yellow, the marks of
form and flux.

"Scarred cobbled street", from Gilbert & George's film THE WORLD
OF GILBERT & GEORGE. 1981.

Gilbert & George exhibition at the Kunsthalle, Düsseldorf, 1981.

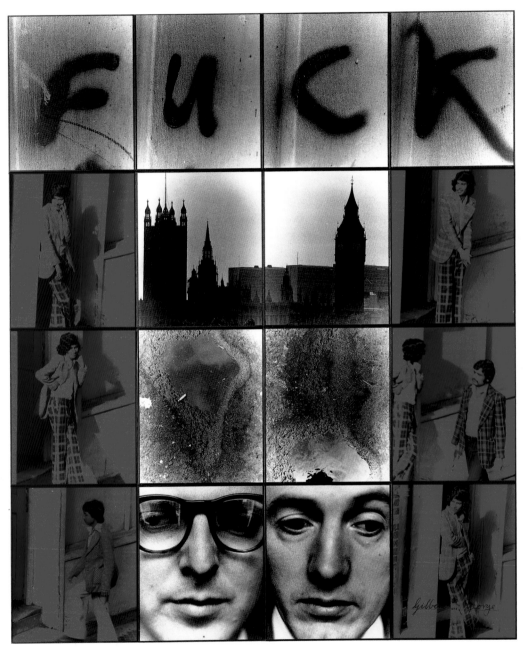

FUCK. 1977. 241x201 cm.
Graffiti: finding a name for the sexuality of urban space.

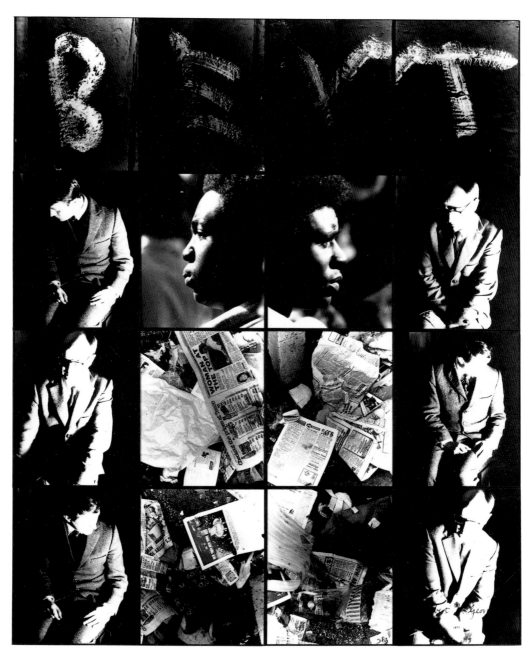

BENT. 1977. 241x201 cm.

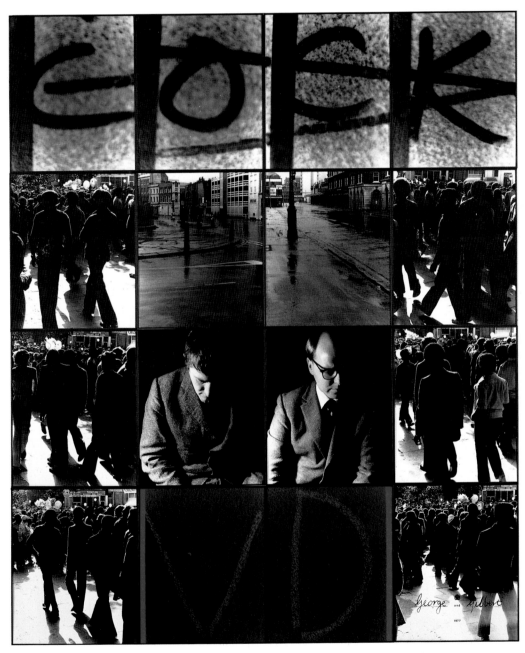

COCK V. D. 1977. 241x201 cm.

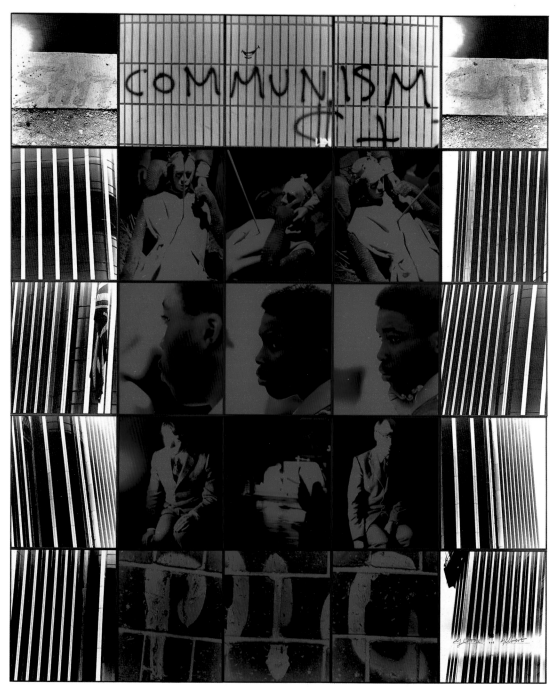

COMMUNISM. 1977. 300 x 250 cm.

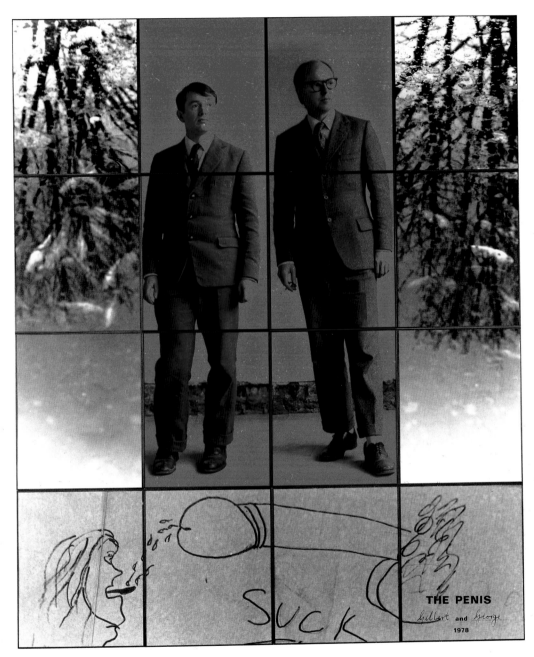

THE PENIS. 1978. 241×201 cm.

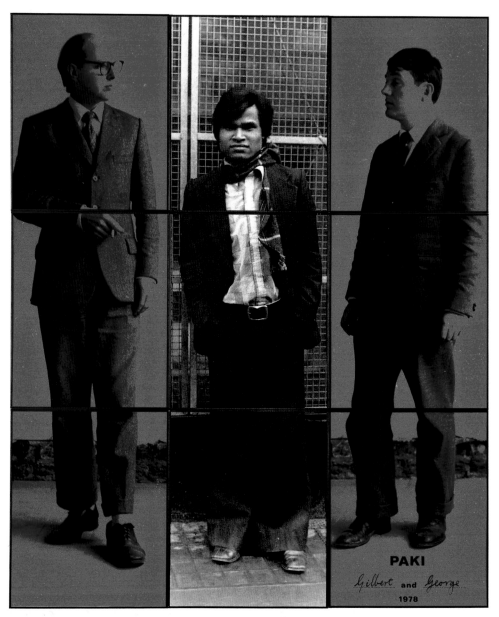

PAKI. 1978. 181x151 cm.

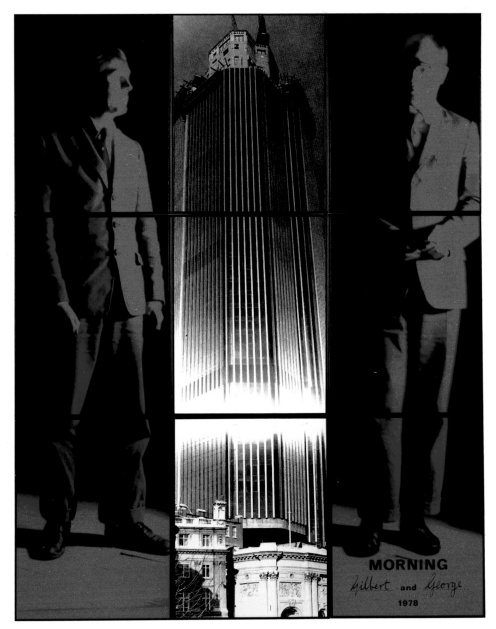

MORNING. 1978. 150x120 cm.
From 1978, Gilbert & George's habit of putting titles on their works became an invariable one. This is a sign that – given the awareness of the sexual polarity of urban space – objects, beings, spaces and values now began to differentiate and articulate themselves.

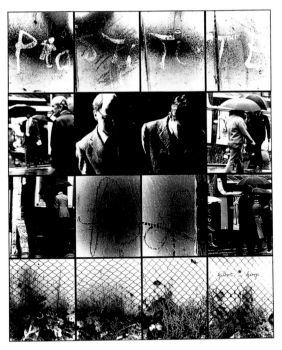

PROSTITUTE POOF. 1977. 241x201 cm.

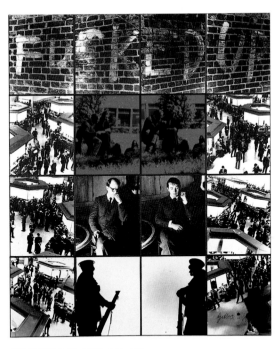

FUCKED UP. 1977. 241x201 cm.

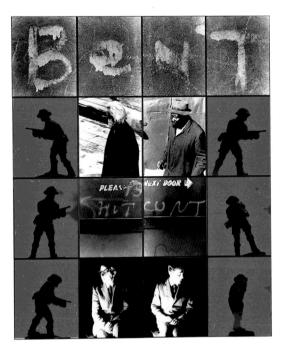

BENT SHIT CUNT. 1977. 241x201 cm.

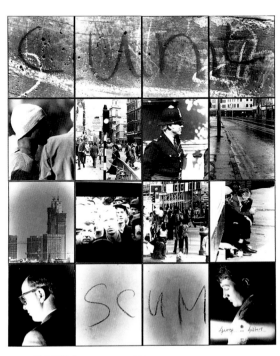

CUNT SCUM. 1977. 241x201 cm.

228

MONARCHIA

Chapter 6

For Gilbert & George, 1980 was one of the most productive years since the beginning of their career. Alongside numerous pictures they produced a film, which embodied the first description of THE WORLD OF GILBERT & GEORGE. The phase dominated by the use of red as a symbol of a new awareness (or new blood) was at an end. Other colours were introduced: first yellow, blue and green, later an extensive palette which also included the noble metals, silver and gold.

The enriched use of colour marked a radical expansion of their thematic repertoire. A creative process that had begun in the "articulation" works now intensified, and there now emerged the values, the meanings and the ways of seeing that went to make up the artists' World.

This new development, like the last, was proclaimed and epitomized in a series of post-card sculptures. Unlike previous works of this type, these had individual titles. In theme and structure they announced a number of the photo-pieces of the period that followed. Not all the titles can be listed here, but here are the main thematic categories:

Monarchy (e.g. PHARAOH, EMPEROR)
Conflict and destruction (e.g. PROCESSION, WAR)

The human image (e.g. HENRY AINLY, BEERBOHM TREE)
Religion (e.g. METHODISM)
Qualities and emotions (e.g. SAD, UNHAPPY)
Nationality (e.g. LONDON, BRITAIN)

The increasing variety and disparity of the themes calls for a slightly modified approach in the text that follows. Hitherto Gilbert & George's works have been described in chronological order. This approach would still have its uses for the later work, especially as some groups of roughly contemporaneous works have titles which reveal their thematic unity. For example, in 1980–81 there was the group MODERN FEARS and in 1982–83 the group MODERN FAITH. It soon becomes apparent, however, that themes once created undergo a constant process of expansion and differentiation. Thus, the postcard sculpture FEAR deals with a theme which is repeatedly reformulated in subsequent works (see pages 243, 435). For this reason, and because it is impossible to keep all the themes in play, the account that follows is divided into chapters which have a considerable chronological spread but which concentrate on one thematic aspect at a time.

The theme of this chapter will not be discussed in pictorial terms to begin with, although it is the richest of all the themes in terms of images. Monarchy here signifies not a kingdom ruled by a king but rather the imagery that defines and constitutes the world of those who live in and with it. It means what Gilbert & George call "Our World", or in other words the trinity which emerges from the duality revealed in RED MORNING. Whether the images are those of fear, of death, of faith, of particular qualities or of entirely new themes, all of them characterize the qualitative world in and for which Gilbert & George live their lives.

To avoid any misunderstanding from the outset, it is

worth looking at the underlying etymological meaning of "monarchy" as "Rule by One". The progressively declining status of monarchy in Western history is the result of a reduction of the whole monarchic idea to one specific form of it: an exclusively political institution, in which people are ruled by one individual or by a dynasty. Seen in this way, monarchy has come to denote nothing much more than the abject dependence of the many on the one who curtails their freedom.

This limited definition in terms of dependency does at least retain the essential aspect of monarchy, which is that it is Rule by One. It is this that really defines monarchy, not any of the numerous possible forms that such a rule can take. The nature of the One varies from one instance to the next. In terms of secular politics, the One may be the dynastic idea in whose name a king governs, protects and guides – or enslaves – his people. In the age of "individualism", the One was the indwelling will of the individual, which caused him to see himself as unique and to set himself apart from and above the crowd, defining himself by abasing others.

In terms of epistemology, the One is the structure of perception and awareness itself through which the individual acts and feels. Even when – as often happens today – the talk is of a total freedom in which absolutely anything goes, positive or negative, this ostensible freedom is still based on the Rule of One, in the guise of a single historically conditioned form of awareness. This awareness, as explained in the Introduction, involves an insistence on distinguishing between what is real and what is not real. It leads ultimately to the idea that nothing is real and all is sameness, indifference, indistinguishability. The notion of the absolute arbitrariness of values thus depends on a prevailing form of awareness which is not identical with the One itself: it is merely one of its possible forms.

It is this form of Rule by One, in the guise of a domin-

ant system of awareness, that constitutes monarchy in its truest sense. This is because any human system of perception, feeling and thought (the components of culture) is far more momentous and influential than a mere dynasty could ever be. Monarchy as the essence of a form of awareness or epistemology is the only monarchy that man can never overthrow. He can destroy the prevalent form of awareness, of course, as Gilbert & George have set out to do IN PROPRIA PERSONA; but he must always replace it with another. The need for monarchic awareness is thus less a form of dependency and unfreedom than an inherent aspect of the human condition itself. Man is not able to live in a state of nature, just like that. He must and will have his own form of cognitive awareness in order to be able to assert his own humanity. In turn, this awareness must needs take a specific form, which then becomes his monarchy.

Gilbert & George's whole World is a monarchy or Rule by One; and that One is a single dominant insight, the awareness of the sexual polarity of urban life. From this emerge the images which quite literally constitute the artists' World. The "One" can be extremely diverse, colourful and open-ended; it remains One, simply because there can be no twofold awareness.

To seek in the work of Gilbert & George for a King in the sense of a literal person would be unrewarding. DEAD KING is the image of the death of an old form of awareness; but there is no image of a living or otherwise potent individual who might stand for their work as a whole, their World. An exception of a kind is provided by the post-card sculptures, but the regal figures here are not representative of Gilbert & George's work as a whole, although they do – like the RED MORNING pictures – set guide-lines that can be traced in subsequent imagery. Such post-card sculptures as KING GEORGE V or QUEEN ELIZABETH II, for example,

establish the theme of kingship quite explicitly in their titles. These and other works manifest an intensified concern with this theme, whether expressed through human figures or through great public buildings. The sculptors once paid tribute to the Queen as the greatest "living sculpture" of all.[96] This was said in all seriousness and without a trace of irony. She, along with other representatives of kingship, bears the characteristic signs with which Gilbert & George now increasingly came to endow their works.

When Gilbert & George show Kings on their post-card sculptures, therefore, this is not out of any nostalgic regard for the outworn institution of kingship but for the sake of their sheer presence. What counts is not the authority of a King but his majesty, which in its turn becomes exemplary. In QUEEN ELIZABETH II, for instance, the Queen's portrait is accompanied by three other motifs: a sculpture of a red elephant, an eagle, and a dandelion head full of seed (page 247). All four motifs refer directly to the figure of the monarch as a self-contained, august and majestic person. Totally independent of others and without power over them, she stands alone in her own space, a fully evolved, mature being. All these figures are sculptures in the most positive sense of the word: beings whose ripe individuality bears no reference to anything external to themselves. Their forms stand for themselves alone without any common factor except their autonomy. Whether plant, animal or person, all these emblems of majesty represent and prefigure the living creature in the fullest unfolding of its intrinsic form.

In the course of their Descent the artists had remained unable to find anything positive in the image of a fully evolved being (see page 119, LONDON DRY); now that positive response began to be adumbrated. The monarchic splendour which is its expression is part of their own monarchic awareness: it is not the monarch's power over others but

another quality of kingship that increasingly comes to constitute Gilbert & George's whole image of man (see Chapter 11, "Human Image").

It is worth mentioning one more post-card sculpture with monarchy as its theme. EMPEROR (page 243) shows the monarch less as a living person than as an ideal figure of a King, or in this case an Emperor, whose domain has nothing to do with ownership. The general theme is first set out in three post-cards, side by side, all showing empty rooms. Beneath them three others depict animals: from left to right, a fieldmouse, a frog and a hedgehog. The room in the middle is totally empty; the ones on either side contain a few pieces of furniture. The same central emphasis is reflected in the positions of the animals in the lower row. The mouse and the hedgehog are looking down at the ground, but the frog in the centre is looking up at a drooping flower.

All this leads one to miss the figure of the Emperor himself at the centre of the work. An empty room as a symbol of the Emperor? This is not a statement of emptiness, as such, but rather of the absence of ownership, whether of material or ideological possessions. The imperial presence in EMPEROR reveals itself on the one hand in the erection of a space shaped by conscious human agency, and in the other in the renunciation of having, grasping and owning. The appropriation of property, of whatever kind, is not in evidence here. This Emperor's "empire" is the space pre-eminently created by man, his culture, his architecture; but his dominion over all this is not expressed through attaching and appropriating things to his own person.

In contradistinction to the centre of EMPEROR, the lateral images show a drop in intensity. A little furniture now appears in the rooms, and the animals are looking downward. What is shown here is not the Emperor himself so much as his subjects, those who have set up the Emperor's image and

taken it as their guide: Gilbert & George, in fact. Like heraldic supporters, they display their Emperor's coat of arms between them, demonstrating their loyalty through his image. His image, as a person totally devoid of possessions, cannot be realized, but it can be implemented: hence the sparseness of the furnishings.

The post-card sculptures which deal with kingship and other themes establish the direction which the artists were to pursue thereafter. They articulate and structure the World of Gilbert & George in pictorial terms, defining its accents, its values and its distinguishing marks. This is not the kind of World that, like a body, encloses and enfolds those within it, delimits them and pictorially defines them. It is a two-dimensional World, through which such principles as that of cosmic sexuality, or that of the autonomy of the fully evolved human individual, can be given formal expression. Monarchy, seen in this light, does not mean a uniform world but one that is precisely and elaborately formulated in terms of imagery.

There are, finally, three Gilbert & George pictures (two photo-pieces and a portrait of the artists) which deal with a central theme of every form of monarchy: coronation. In them a crown is placed on the head of specific individuals; they are crowned with the sign of their own existence. Crowning here is thus an action that defines a limited number of "crowned" persons, rather than as an action that gives all mankind a single "head".

In FOUR KNIGHTS and BLACK CHURCH FACE (pages 244–45) Gilbert & George treat this theme twice over. In one piece they present the model of a kingly company; in the other they crown the head of a young black man with a view of religious architecture.

In BLACK CHURCH FACE the young man's crown consists of a row of Gothic arches, with five lancet windows at its centre. The use of a church building, and of the word

"church" in the title, is not an allusion to the Christian community of believers. There is no implication of a religious message, and the iconographic content of the stained glass is deliberately out of focus and unidentifiable. The combination of "black" and "church" in the title confirms this. The word "black" applies to the church and not to the young man: it denotes the unformulated, that which has not yet acquired a colour (see also the account of colour in Chapter 8). The image of the crown as the definitive formulation of a meaning is not yet visible in BLACK CHURCH FACE; all that can be seen is the essence of the act of crowning: placing upon the face, the head, of a human being the image of a life which is sacred to him.

The second piece, FOUR KNIGHTS, goes one step further than BLACK CHURCH FACE. Portraits of four boys are shown, each twice over in different ways. In the lower part of the work, which dominates it visually, the boys are seen in black and white, full-length, standing side by side. Above them their portraits reappear, this time faces only, and the order is changed so that none of the faces matches up with the full-length figure below it. The faces contrast with the lower row by being coloured in hues which range from green by way of blue and yellow to red. And so the coloured strip of heads turns into a crown, in which each individual face becomes a crown jewel.

FOUR KNIGHTS is the title of this extremely simple composition; and the King whom these four knights serve is the image of their own heads. The change in the order of the portraits indicates that none of them serves himself, but that all together crown themselves with a crown studded with their own faces. Solidarity and social cohesion are thus shown in the light of a crowning. FOUR KNIGHTS presents kingship as an emblem of a social entity crowning itself: the model of a group which both serves and rules.

Monarchia

The third of these images of kingship is not part of Gilbert & George's oeuvre at all. It is a commissioned portrait by the photographer Iain McKell of the artists in their house (page 246). They sit side by side on a bench, in identical poses. Above their heads hangs a painting which has the title of THE FLAMING RAMPARTS OF THE WORLD.[97] It shows a rocky landscape of mountains bathed in a red sunset glow. Positioned immediately above the artists' heads, it forms their crown.

The title and subject of the painting embody once more the cosmic sexual polarity of which Gilbert & George have been more and more keenly aware since RED MORNING. The words "ramparts" and "flaming", as well as the mountain range and the blazing evening sky, are male/female pairs. In the title the male has taken on the attribute of the female: the ramparts are on fire. The two are interdependent: the female burns the male and the male emerges from the female. The crown that the artists wear is none other than the knowledge of this sexual polarity, which is cosmic ("of the World"), and which also means that their own formal creations are subject to the forces that burn and destroy form. This is a sad crown, but it is the only crown that lives by the certainty of an unending progression within the world and within mankind. It is the crown of one who burns the world.

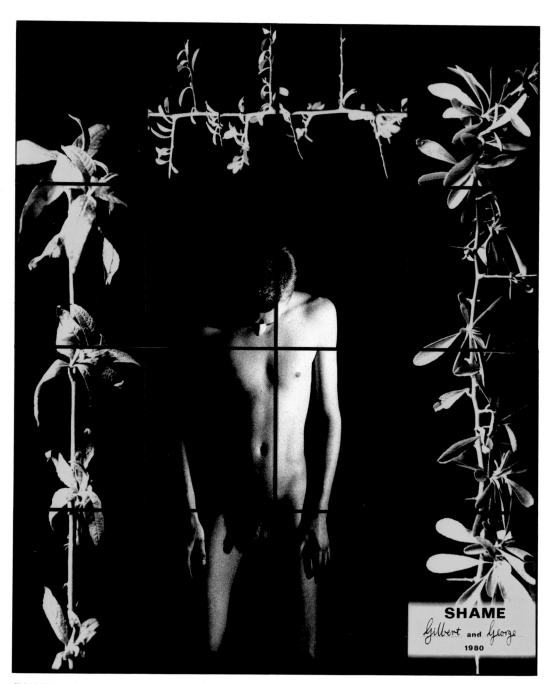

SHAME. 1980. 241x201 cm.

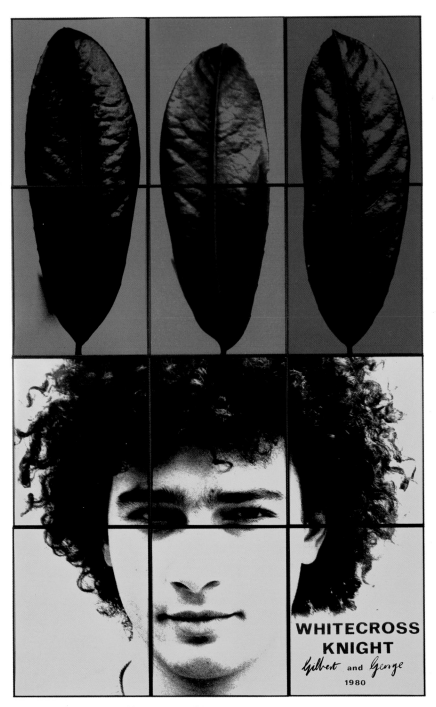

WHITECROSS KNIGHT. 1980. 241x151 cm.
Crowning: an intrinsic part of monarchy in all its guises.

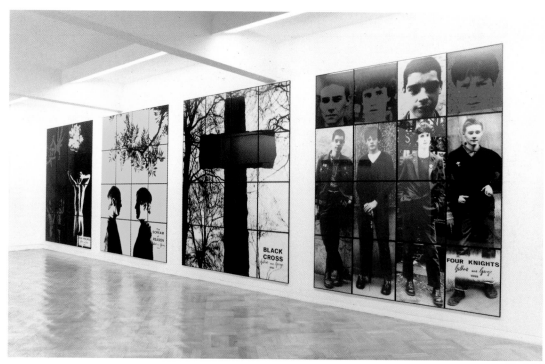

MODERN FEARS. Exhibition at the Anthony d'Offay Gallery, London. 1980.

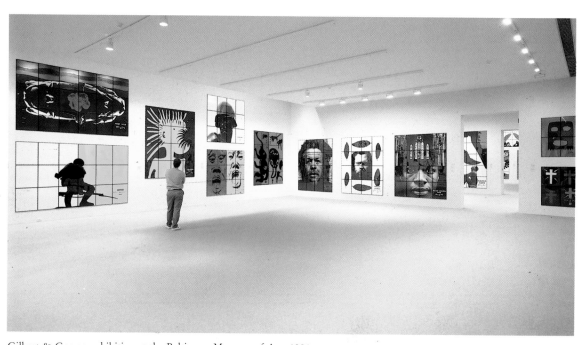

Gilbert & George exhibition at the Baltimore Museum of Art. 1984.

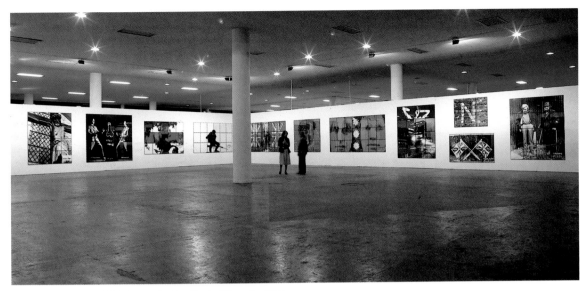

Gilbert & George exhibition at the São Paulo Biennale. 1981.

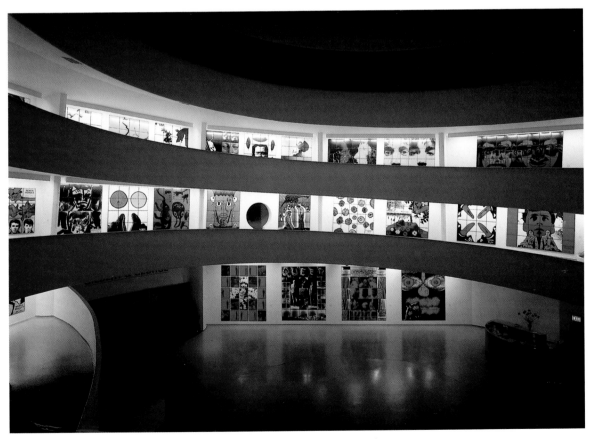

Gilbert & George exhibition at the Solomon R. Guggenheim Museum, New York. 1985.

WAR. 1980. A Post-Card Sculpture.

PHARAOH. 1980. A Post-Card Sculpture.

SAD. 1980. A Post-Card Sculpture.

242

EMPEROR. 1980. A Post-Card Sculpture.

FEAR. 1980. A Post-Card Sculpture.

PROCESSION. 1980. A Post-Card Sculpture.

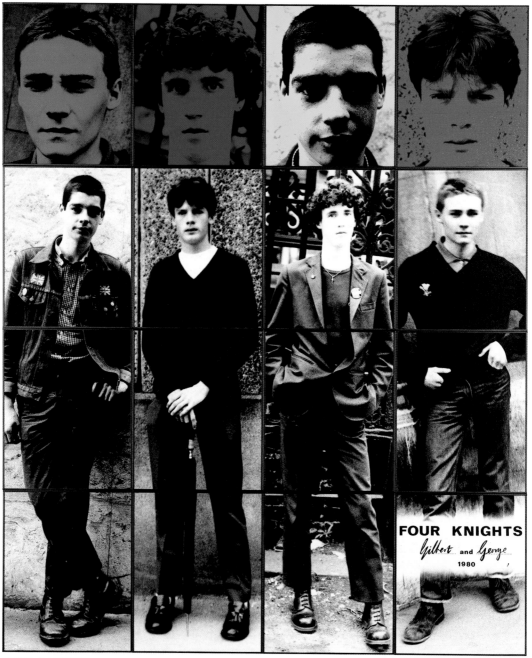

FOUR KNIGHTS. 1980. 241x201 cm.
The coloured row of heads becomes a crown, in which each face becomes a crown jewel.

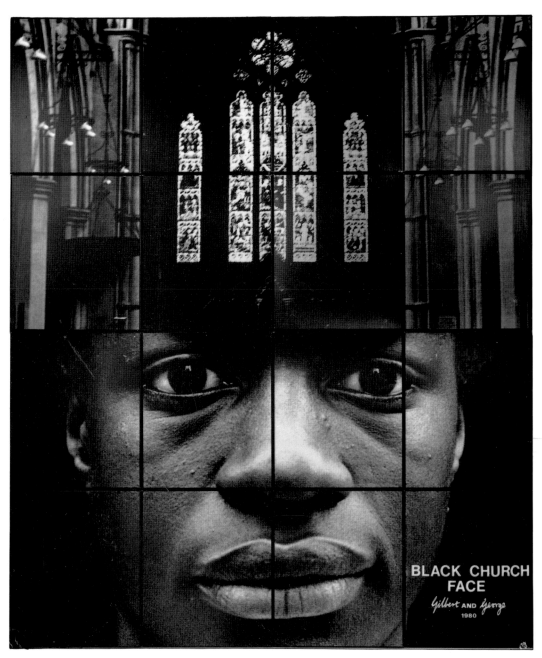

BLACK CHURCH FACE. 1980. 241x201 cm.

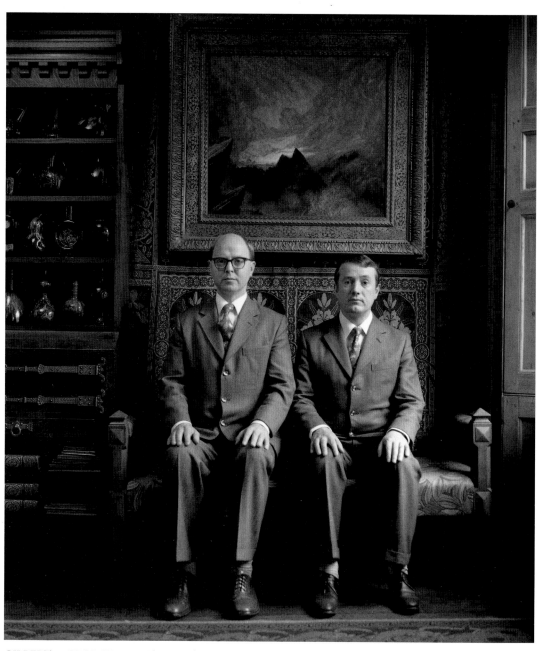

GILBERT & GEORGE. 1985. Photograph: Iain McKell.
The crown of one who burns the world.

QUEEN ELIZABETH II. 1980. A Post-Card Sculpture.
Majesty resides in all those figures – whether animal, vegetable or human – that crystallize the archetype of the living creature.

KING GEORGE V. 1980. A Post-Card Sculpture.

METHODISM. 1980. A Post-Card Sculpture.
A religious feeling that does not exclude mockery, scorn and recalcitrance but includes them.

THE SIGN
OF THE CROSS

Chapter 7

In the sign of the cross Gilbert & George's path of Descent came to its end. HUMAN BONDAGE took the form of a swastika, and other works were consistently structured on a cruciform pattern. The cross was the instrument of the artists' martyrdom, on which a superseded form of imagination, and an old awareness that was now past reviving, suffered dismemberment and death.

In the works of the Ascent the cross reappears in numerous guises. It no longer serves to articulate the formal structure but is shown in its own right as a Tree of Life on which the artists' new life unfolds. A 1978 piece, THE TREE (page 460), adumbrated the use of the cross as Tree of Life. In CRUSADE, on the other hand, Gilbert & George for the first time place the cross between them as a bare, empty sign (page 266). They sit flanking it astride identical chairs, each holding the upright of the cross formed by the chairback, and their faces continue the line of the same upright. Between the artists, and set off from them by a different colour, is an enlarged close-up of the same cross that they are holding. This central image takes up twice as much space as each of the lateral images of the artists themselves. The focal element in CRUSADE is thus a bare, untenanted cross.

Before we come to a detailed account of CRUSADE

some discussion of the symbolism of the cross in general is called for. In the life-history of the God-Man, on which Gilbert & George have embarked almost unawares, the cross is the central human structural element, the place where death and life take place. It is the symbol of life. At the cross (crotch is the same word), old life dies and new life arises. It is one of the few basic signs that belong to all cultures. It may take different forms, but its basic structure as the intersection of two straight lines is universal. In its horizontal-vertical orientation it constitutes an abstract image of the structure of the tree.

The meaning of the cross resides in the conscious act by which man sets his life erect. By setting up and imposing the cross he drives a stake through the chaos of an untended Nature, an uninhabited space, and establishes the first sign of cosmos, which means a space that is both ordered and embellished.[98] (Cosmos, in fact, means not so much an all-embracing space or universe as the opposite of chaos: chaos being the world uncultivated and unordered by man.) The cross is the architecture of the world, which man perceives and adopts as his own. When the Romans built a town or a camp they first of all laid out the crossing of two main streets, the CARDO and the DECUMANUS. These thereafter formed the main axes of the settlement, around which its social life was organized. The cross was the backbone and the PHYSIS, or natural configuration, of the social organism.

Later Western culture adopted the cross in a central role, that of the Cross of Christ which represented the promise of a better life after death. But with the gradual desacralization of life this transformed itself into a cross of co-ordinates, defining a field of vision within which earthly reality was to be found. With the addition of a third axis, that of depth, it became the vehicle of objectivization and analysis. The further it penetrated into the nature of things and into

unexplored space – the more it set out to reveal their true nature – the more remote it became from man. It no longer represented the physique of man but the physicist's co-ordinates.

The cross in this unnatural guise invaded the world of perceived things and persons, all now subject to objective judgment, and it perverted human beings, that is turned them aside, from their true home in the physical body. The result is that there no longer exists a cross that can represent the basic architecture of man, or give structure and organization to his social existence.

Another look at CRUSADE will make this aspect of the significance of the cross more easily comprehensible. By its position, the cross in the centre of the chairback symbolizes the human spine. Gilbert & George grasp this cross in their hands and position their heads, representing intellect, in line with its structure, thus emphasizing the impulse to adorn and complete the bare form of the cross by inserting life of their own into it. This is what underlies the title of the picture: CRUSADE, an expedition under the sign of the cross. Crusades in history were endeavours to recover the Holy City; CRUSADE is an endeavour to recover the values of human life, as they manifest themselves on the cross. This crusade is not a journey through geographical space but is bound fast to the place where it begins, as the use of the chairs goes to show.

CRUSADE also signifies the creation of a culture, a social organism, which has set up a cross of its own. Around this cross the life of that society gathers and organizes itself. The nucleus of social life is the one-to-one pair, and the cross forms the third factor which gives it meaning and enables it to be defined as culture. This has always been Gilbert & George's aspiration, whether in their shared desire for Art, in the pictures that they exhibit together, or – as for example in

The Sign of the Cross

EMPEROR – when both pledge allegiance to the same monarch. CRUSADE goes one step further, in that it sets up the sign around which social life with all its values can emerge. The cross is man's house, his dwelling-place. And so a theme reappears which – in reverse – took shape more than once in the course of the artists' Descent.

CRUSADE was followed by a large number of works dominated by the theme of the cross: crosses of branches, of blossoms, of body parts such as the backbone, the tongue, the penis. In one case a white cross is incorporated in a tree, to draw attention to the function of the cross as the architecture of life. The title COMING TO THE CROSS (page 267) reinforces this connotation. Life erects itself and takes shape around the form of the cross, like a tree. Another time there is a bewildering multiplicity of crosses under the title CURSE OF THE CROSS (page 269). A crusade is no easy matter. The path is not smooth; the values are not predefined; and so it sometimes happens that the crusade is blighted by a curse: not the curse of doubt so much as the unanswerable question of where it will all end.

Not all the works with cross motifs can be discussed here, but it is worth describing two more in which Gilbert & George place themselves in the sign of the cross: once in a social and once in a socio-religious context.

In SPEAKERS the artists form the cross with their arms (page 272). They stand side by side on a leaf, cross their outstretched arms, and raise the two free arms, elbows bent, into a red sky. From their mouths spring green fronds which run towards the lower corners of the picture and divide the background into two zones: the sky above and the city below. The city, in its turn, incorporates the leaf which marks the artists' own standpoint.

The significance of SPEAKERS is twofold: the artists' speech (hence the title), and its presentation as a social pact or

bond, marked by the crossing of their arms. This bond is defined in some detail. It includes (exclusively) the artists, as the closed form of the leaf indicates, and its location is within the city. Just as the leaf is one among many, lost in the undergrowth of the city, Gilbert & George show themselves as one social bond among many.

By showing themselves in terms of a social bond the artists provide an illustration for the description of themselves that has already been quoted (page 197). One of the self-chosen epithets in that description was "fascistic", which has more than once led to the accusation that they are indeed nothing more than crypto-fascists, and that their work is fascist propaganda. This is not at all what they mean by describing themselves as, among other things, fascistic. SPEAKERS, in particular, shows just what they do mean.

What is presented here as fascistic is not a fascist ideology, nor a Nazi-style "blood and soil" myth, but the ancient symbol of the FASCES themselves, the bundle of rods used as an emblem by the Romans (page 272). This sign defines the message and the self-presentation of the artists in SPEAKERS. It is in this image alone, that of an axe bound in with a bundle of rods by criss-cross ties, that Gilbert & George acknowledge the meaning of a fascistic presentation. In SPEAKERS they show themselves in the guise of two battle-axes united in a fascistic pact by the crossing of arms. They form a combative unity which demarcates itself sharply from the rest of the world and thereby prohibits the inclusion of others. They write "we" and mean themselves alone. The stress is laid on their uniqueness, their self-definition, and not on what other people ought to do or be: the unity and the combativeness refer exclusively to themselves and are not presented as something that might apply to others. Their alliance involves setting themselves apart from those outside, as the closed form of the leaf emphasizes.

The Sign of the Cross

In SPEAKERS the cross serves as the symbol of union, as asserted by the artists with their symmetrical gestures and their identical colouring. Social cohesion means a voluntary acknowledgment of mutual dependence. Pagan cultures of the past were familiar with this form of two-way social bonding – as can be seen, for example, in an ornament from a helmet found at Sutton Hoo (page 270), which shows two warriors in a ritual dance.[99] Their dress and posture match symmetrically, and they cross arms in a martial gesture of comradeship; in their free hands they hold lances and spears. The two figures are related in the same way as those in SPEAKERS: the cross formed by their arms manifests their mutual dependence.

It might be said, in very general terms, that the cross is a symbol for a pagan form of social bond. The specifically Christian symbol would thus be the ring which encloses both partners. The cross marks the voluntary junction of the individuals concerned, because both have to make a deliberate gesture by stretching out their arms; the ring marks common identity by binding and enclosing. The ring is an external structure, imposed from without; the cross is inherent.

Finally, as the title indicates, SPEAKERS refers to the artists' message as well as their unity. Figuratively, this message is the battle-axe tied by the criss-cross bonds of the social pact which is Gilbert & George. It is made visible through the foliage which sprouts from the artists' mouths, the organ of speech. It is not a message in the linguistic sense of accents, words or sentences; it is a message of growth, proliferation and osmosis. "Growth" in this context has nothing to do with following some preordained ideology, school of thought or social theory; it means simply respecting the powers within human nature which hold the promise of organic, plant-like growth and development. Why should not a human being grow like a plant? Such an analogy is not to be confused with the notion of a presumed criterion of "natural-

ness" to which a human being is expected to conform. The plant metaphor in SPEAKERS refers to the human capacity to grow and develop in total independence of any form of ideology.

While Gilbert & George's fascistic bond is very explicitly set apart from others and cannot be extended to include them, it does, conversely, constitute an exhortation to others to espouse organic growth, whatever form that growth may take. The fascistic pact on one hand, and the otherness of all others on the other, do not conflict in any way; both are called for, both are desired. Gilbert & George are demonstrating that the fascistic idea – in its pictorial sense – is not inherently dangerous. Its purely hypothetical and potential danger lies in the forcible imposition of one unitary bond on everyone; and this is the eventuality that SPEAKERS very precisely seeks to exclude.

Lastly, it is worth discussing in detail one more picture that centres on a cross. In WE it embraces the artists together with a timeless human face (page 268).

Four yellow, red-bordered fingers mark the arms of the cross, and the face appears in a circle at their intersection. All that can be seen of it are the nose, the mouth and the eyes, which in contrast to the monochrome of the rest of the face are coloured red. Under the arms of the cross and flanking the upright, Gilbert & George are seen three times over, in the same colours as the cross itself. In a V-configuration whose point coincides with the foot of the cross, they appear once standing, once squatting, and once as heads only. Each time they swap sides, and the colour scheme changes simultaneously. The cross and Gilbert & George share a set of colours; the only relief from this is in the plain blue background.

In order to clarify the meaning of WE it is once more necessary to refer to a work of art from elsewhere (page 270). This is an Early Christian representation of a human face

which appears, like that in WE, at the intersection of the arms of a cross. It occupies a central position in the apse of S. Apollinare in Classe, near Ravenna, where a number of earthly and heavenly scenes are depicted all around the cross. The cross itself is seen against a dark blue circle, set with stars, which represents the sphere of eternity. The face at the intersection is that of Christ, and at the four ends of the cross there are inscriptions. To left and right are the letters Alpha and Omega, Beginning and End; above is CHRISTUS and below SALUS MUNDI, Salvation of the World.[100] Beneath the cross, in a paradisiacal garden, are St Apollinaris of Ravenna and a number of sheep which stand for his faithful flock, following their saint and bishop as the Disciples followed Christ. Above them is the divine sphere against a gold ground. The sphere above and the sphere below, heaven and earth, are joined by the cross through its vertical axis, which is that of SALUS MUNDI and the bringer of hope (Christ).

The cross here is not so much the instrument of Christ's martyrdom as the cosmic cross[101] beneath which his Gospel prevails and the human world takes shape. On a dark blue ground, the emblem of eternity, it denotes the Son of God both as emblem and exemplar; his Gospel; and his capacity to bring salvation. His face represents only the eternal face of humanity, which is the image of the Son of God. Man here recognizes himself as God's image through his Son. This face represents the Eternal Man who is both the prototype of human existence and the guarantee of its divine origin. From this man is born, and to this he returns. In other words it stands for the hidden Face of God. And because this face of the Son of God stands in so "divine" a position, it functions simultaneously as the image of the Word of God, that same Alpha and Omega which unites the cosmic horizontal axis with the image of Christ. In that image, God's Word is to be fulfilled on earth.

The Sign of the Cross

The affinities of principle between WE and the cosmic cross of Ravenna are unmistakable. The cross, the image of the Eternal Man, and the figures who gather around the cross appear in both. The fundamental difference lies in the claim to universality that is inherent in the earlier image: its clear purpose of imposing one divine truth as always and everywhere valid. It is the herald of a historical impulse to unite all men through a single version of truth. The Alpha and Omega at the lateral ends of the cross assert this claim to universality. Still unattainably remote against a dark blue ground, they stand for a teaching that aspires to reconcile all nations. Later, with the disappearance of the firm distinction between the divine and mundane spheres, the claim to universality will be raised on earth as well: no longer as God's Word but as a quest for the unitary objective reality which alone can afford man a universally valid basis for certitude on earth.

WE adopts a different position. The cosmic cross has become the cross of the artists alone. It represents them – WE, in fact – and their faith in the image of the Eternal Man. Their faces are subordinated to his face, as the almost uniform monochrome of the faces in the picture suggests. From and around the face of this Eternal Man – anti-individual and sexless as befits the face of Man in God – the world takes shape. From the face fingers point in all four directions, but no definitive conclusion, no incontrovertible teaching, stands at the fingertips. They form a cosmic cross, one which conveys to those whom it governs not the defining limits of space but its sheer openness.

Gilbert & George are subordinated to the image of Eternal Man in another sense. Beneath him they show themselves three times over in different postures. Waxing and waning, but always in his image, they build themselves upwards from below and bury themselves in the earth as disembodied faces. The individual human being (here Gilbert or George)

finds in the image of Eternal Man his own life-cycle of formation, ripening and death.

WE also clarifies a fundamental characteristic of the Greek word ΚΟSΜΟS in its dual connotation of order and ornament (see also above, page 250). Quite apart from its association with the idea of the Universe and Totality, ΚΟSΜΟS stands primarily for the indispensability of ornament as the framework on which man structures his world. Ornamented, his world no longer hangs bare and featureless in space. In WE this connection is particularly evident. Gilbert & George adorn their cross with their own bodies, to which they have applied traditional techniques of ornamental design: alternating motifs and changes of scale, marked by colour. Their use of ornament makes the cross their own, and speaks of the way in which they live and move within the image of Eternal Man. Ornament here becomes meaningful.

In their phase of Descent, Gilbert & George had already made ornament, or rather decoration, into a theme of their work – as exemplified by their use of loose mosaic compositions, and by the title of the exhibition NEW DECORATIVE WORKS. Decoration could at this stage do nothing but depict the progress of the artists' Descent. It had no language of its own, because the surface to be decorated was the ground of a world-order that had lost its credibility. Gilbert & George used this decoration only to illustrate – and to further – the inexorable progress of their downward path. Decoration corresponded to the indifferent word, "nice", which they used to denote all their work. In the Ascent, on the other hand, mere decor gave way to ornament, because there was now something positive to adorn: something with a credible and above all a living structure of its own, in the shape of the cosmic Cross of Life.

The design of very many of Gilbert & George's works is basically ornamental, although this is by no means evident

at first sight. The ornamental structure is always embedded in the content of the pictures, and thus inseparable from their meanings. Ornament makes a statement about the meaning of the picture, while at the same time elaborating or adorning that meaning and giving shape to its expression.

The significance of the cross thus lies in its twin functions as architecture and as the Tree of Life. Almost without exception, every cross in Gilbert & George's work after CRUSADE embodies life through its diverse sets of values. This remains so when not only the male but the female aspect takes on its form. Dirt and shit (see page 379) are recognized as values in their own right and incorporated in the sign of the cross. A number of these crosses will be presented and discussed in the chapters that follow.

One fundamental difference between Gilbert & George's crosses and those from other cultural contexts is that in earlier times the cross was always used as an image of some transcendent world-order, an order written in the heavens which was regarded as God-given and eternal. Churches were – and still are – built with cruciform plans oriented towards the holy city of Jerusalem, the image of the Heavenly City; and the Romans' right-angled street intersections were aligned on the four cardinal points of the heavens. It is precisely this function of reflecting a higher order, and thus declaring man's dependence on that order, that is absent from Gilbert & George's crosses. They represent no microcosm of a macrocosm; they refer to nothing outside themselves; they are simply the crosses that these artists have set up. They live and die with their creators, so that others may set them up anew.

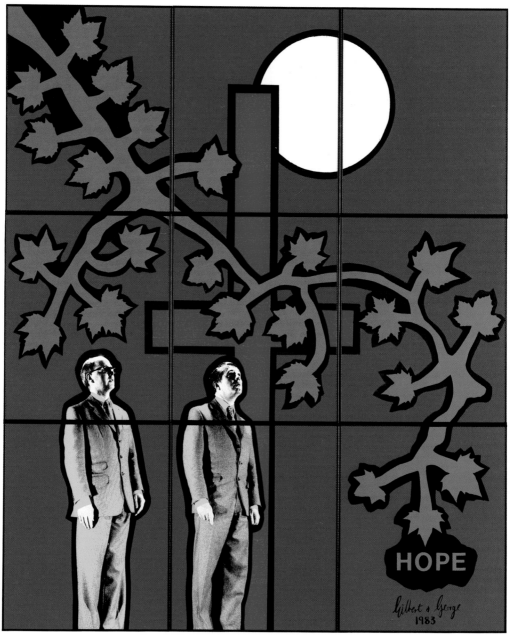

HOPE. 1983.181x151 cm.
The cross as the Tree of Life, upon which new life unfolds.

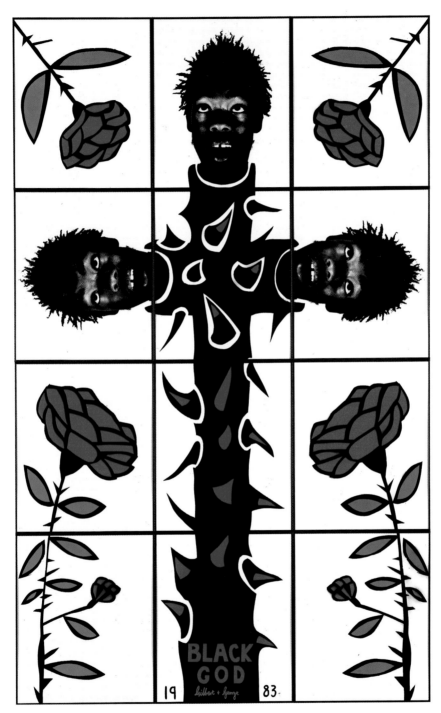

BLACK GOD. 1983. 241x151 cm.

CRUSADE. Exhibition of Post-Card Pieces at the Anthony d'Offay Gallery, London. 1982.

Gilbert & George: "The form of the Post Card Piece lends itself to the expression of finer feelings, stirring thoughts and beautiful views. Through our hearts, brains and bodies the cards crystallise into our crosses of Monarchical, Christian, Nationalistic, Violent, Pagan Floral, Sexual Post Card Pieces. They are our shields, our swords, our emblem, our vision, our tombstone and our life-masks."

TOWER BRIDGE FLAG. 1981.

BALMORAL CROSS. 1981.

WESTMINSTER LOVE. 1981.
The cross categorizes and organizes all values.

HUNG, DRAWN AND QUARTERED. 1981.

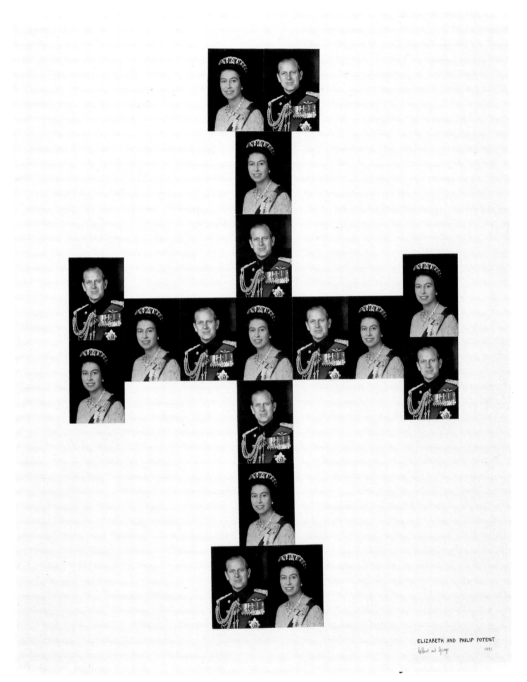

ELIZABETH AND PHILIP POTENT. 1981.

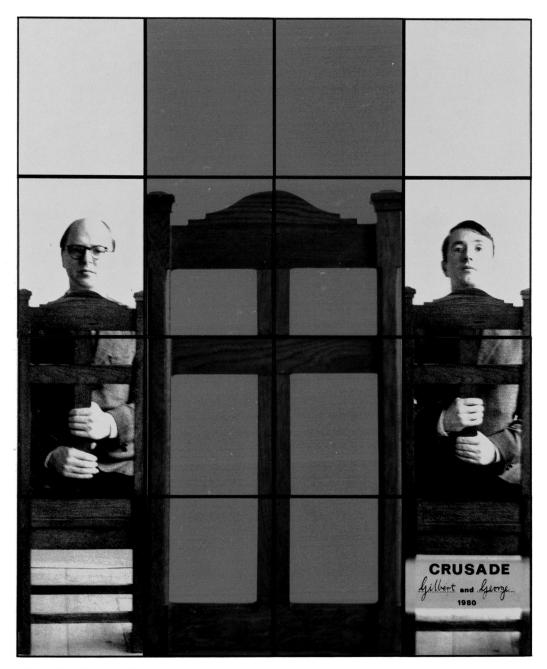

CRUSADE. 1980. 241x201 cm.

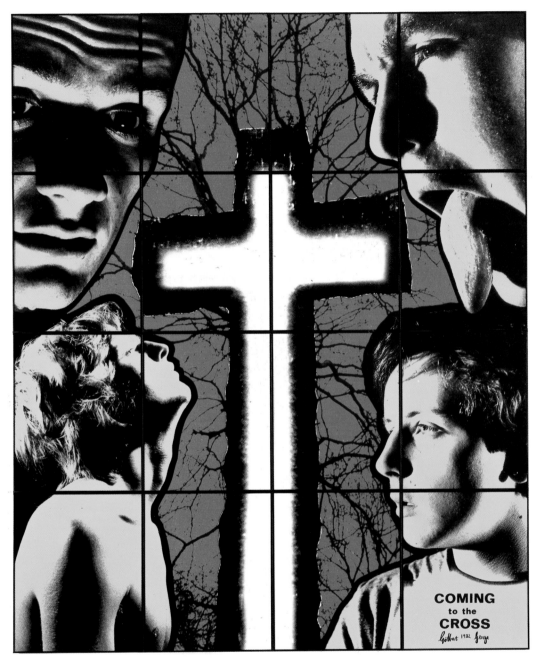

COMING TO THE CROSS. 1982. 241x201 cm.
The cross as a pictorial abstraction of the tree.

267

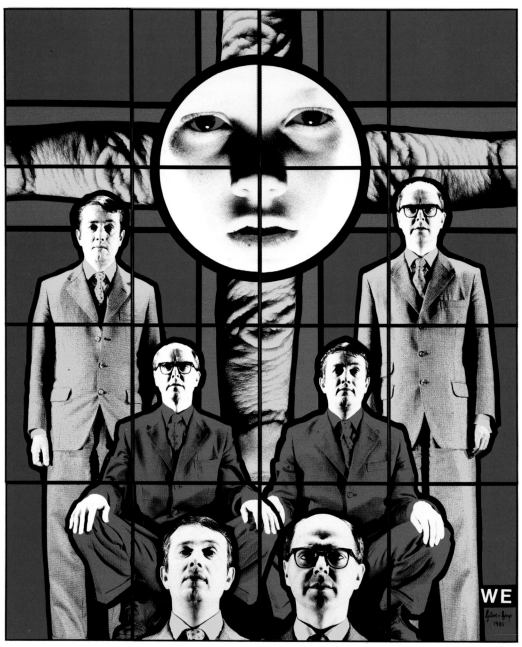

WE. 1983. 241x201 cm.
At the crossing point: the face of the Eternal Man.

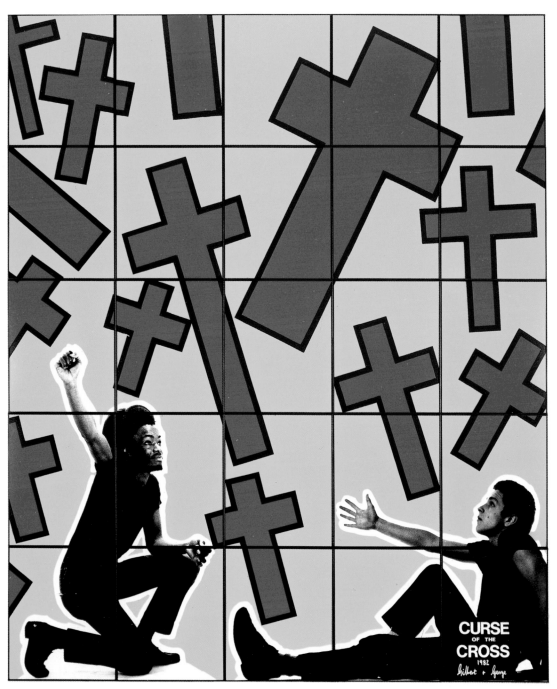

CURSE OF THE CROSS. 1982. 300 x 250 cm.
For every image there is a counter-image; so too for the cross.

Ritual warrior dance from the Sutton Hoo Helmet. AD 600.

The Cosmic Cross. Mosaic in the apse of S. Apollinare in Classe, Ravenna. AD 500.
The hand of God points to the face of the Eternal Man, Jesus Christ.

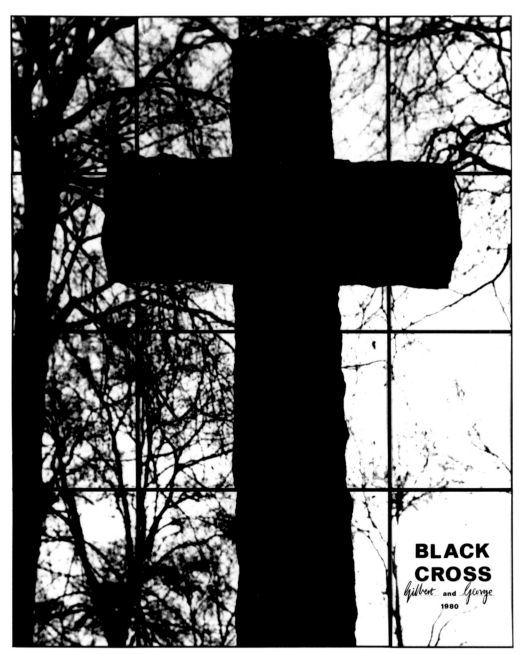

BLACK CROSS. 1980. 241x201 cm.

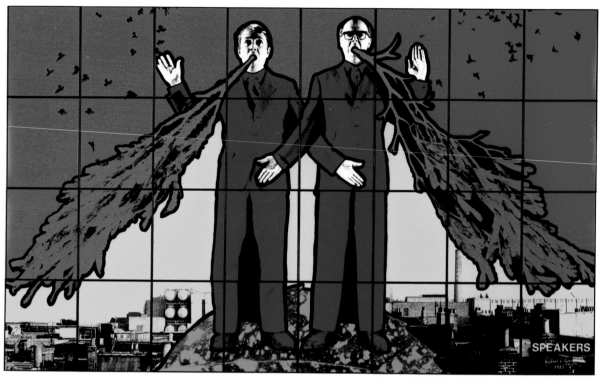

SPEAKERS. 1983. 241×201 cm.

FASCIO. 1914–1918 War Memorial at the Italian Church in London.
The artists' language: a battle-axe that does not destroy but is a summons to growth.

272

GIN AND TONIC. 1973. 71x42 cm.

POST-CARD SCULPTURE N. Autumn 1972.

YELLOW CRUSADE. 1982. 302x451 cm.

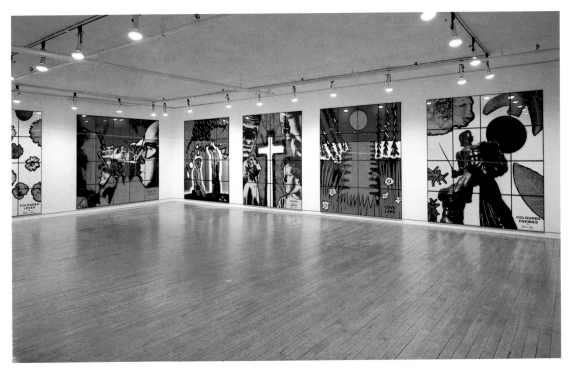

MODERN FAITH. Exhibition at the Sonnabend Gallery, New York, 1983.

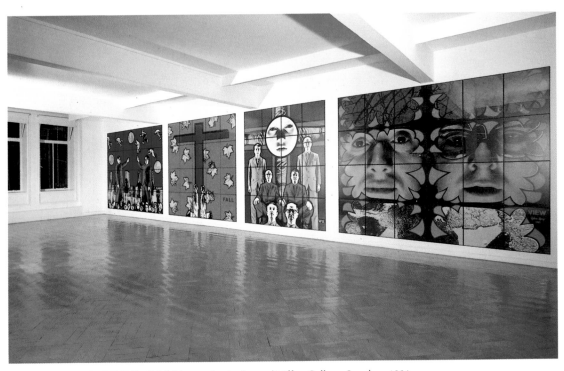

THE BELIEVING WORLD. Exhibition at the Anthony d'Offay Gallery, London. 1984.

COLOUR

Chapter 8

Since 1980 colour has played an increasingly important role in
the work of Gilbert & George, and almost all their pictures
since 1981 have incorporated it. In purely technical terms,
they did not switch from black and white to colour photogra-
phy, but added overlays in other colours just as they had
previously done in red. At first the individual components of
the composition were marked by flat areas of colour (see page
292), but later the application of colour became more deliber-
ate and specific, with colour accents emphasizing parts of
bodies, or marking qualitative distinctions, or setting up a flat
monochrome background. Where the subject requires it, that
background is gold or silver.

The enhanced use of colour was followed by the fram-
ing of the objects shown with a black line. Like the rectangu-
lar grid, this is a by-product rather than a deliberate part of
the design, but it gives the pictures something of the look of a
stained glass window in which each figure, each motif, is out-
lined in lead. The motifs thus become transparent and isolated
from each other. There is no link between them, whether
"given" or contrived. They do not relate to each other directly
but through analogy.

Colour

The advance of colour was a gradual, cautious process. It began with a non-colour: black. This was not black as material substance, nor was it the black which had earlier accompanied the artists' entry into Hell (DARK SHADOW, page 143; BLACK STARE, page 120). Black now conveyed no sense of mourning or burning, no void, no darkness; none of its usual symbolic associations. It stood for the state of being un-evolved, not-yet-active; it took on the quality of a contour, a silhouette, and in so doing it heralded the future evolution of the theme itself, and of colour.

In BLACK BUDS (page 291), four branches in a row rise from below with tightly closed buds at their ends. None of the stages of the tree's life – seed, blossom, leaf, or their successive withering – is shown here. Both title and picture emphasize the buds in their black, i.e. unevolved, state. They enclose, but they do not imprison: they encapsulate a flowering that is to come. All four have been carefully chosen for their form, and specifically for the arrangement of their buds. The one on the far left has its bud positioned differently from, for instance, the second from the right. All four, in their diversity, point to a coming diversity of manifestations of life. The buds are black because their life is not yet visible, but they reveal its first lineaments as in a silhouette.

Another picture, BLACK JESUS (page 292), makes it quite clear that black is not used here for its quality as a colour. The whole piece is blanketed with a yellow overlay which entirely negates the "colour" connotations of blackness. The picture itself shows a detail of a stone crucifix, including only the face, upper arms and chest of the crucified figure. A conspicuous and, in the present context, highly significant feature is the face of Jesus. It is so heavily weathered as to be unidentifiable except as a human head. The organs of sense – eyes, ears, mouth and nose – are present only vestigially. The face is inturned, deprived of its sensory outlets.

Colour

Both pictures emphasize the head, the uppermost and crowning extremity of an organism; both also suggest the "architecture" of life – branch or body – which supports it. In both cases, however, the head as such is invisible, because it remains in an unevolved and undifferentiated state – the state that Gilbert & George denote simply by "black". Not that black represents a void; that would be going too far. What can be seen here is the germ of future pictures, their colour and differentiation still unmanifest. BLACK BUDS holds the promise of the diversity of life; BLACK JESUS directs attention to the face of the crucified figure, which stands prototypically for a general principle: that the human face conveys awareness of God (in this connection, see WE, page 268). BLACK CHURCH FACE, already discussed, belongs within the same context (page 245). There "church" stood for "black", and thus for the still-unmanifest image of sacred being. Like the other works just mentioned, BLACK CHURCH FACE pointed the way forward; all foreshadowed an interest in human beings and in life which was to find concrete realization only later.

Black stands symbolically for undifferentiation and inchoate evolution; colour is the instrument of differentiation and diversity. In CRUSADE (page 266), the cross and its supporters Gilbert & George are distinguished by the use of colour. Yellow and red serve to emphasize the cross on one hand and the men who are subordinate to it on the other. WE repeats the use of yellow and red to distinguish the cross from its attendants, but here both elements incorporate both colours. This is possible because this is not, like CRUSADE, an initial presentation of the cross, in which the cross is the sole focus, but one in which it and the artists have a shared image, that of the central face.

Increasingly, the combination of yellow and red seems to denote a pair-bond as the basic social unit. Many works

involving Gilbert & George themselves – or in some cases a pair of unidentified figures – incorporate this colour combination. It would however be a mistake to equate yellow and red entirely with this social theme: for example, the same combination is used in SPEAKERS (page 272), but here Gilbert & George's social union is indicated by a single plain colour, blue, while yellow and red distinguish the two regions traversed by the organic flow of their speech: the urban landscape and the sky above.

Gilbert & George do not use colour simply as a means of making thematic distinctions. Colours stand for a whole range of meanings, which they serve to characterize in detail. For example, they were introduced to define more closely the world of feeling and emotion which Gilbert & George went on to elaborate from 1980 onwards. The artists' concern here was with feeling and not with sentiment; what Gilbert & George felt directly was the external object, not their own emotional response. What counted was not how the person "felt", the manifestation of his inner emotional world, but his empathetic perception of the outer world. The artists had always taken the surface to be the locus of perception; they now began to feel that surface, emotionally, and to define it more closely. Colour was a welcome resource to this end.

In FOUR FEELINGS (page 293), Gilbert & George take as their theme four different feelings. One is expressed through their own figures, a second through another person, a young man, and the third and fourth through plant motifs. The picture is divided into four sectors. Above left is a spreading, delicate-leaved plant, coloured red, and to its right is a leaf, coloured yellow, hanging from the top edge of the picture. Almost circular, with a jagged edge, the leaf is a tranquil and, in contrast to the plant on the left, a mature form. Beneath the red plant stand Gilbert & George, seen at night in a glare of light which is emphasized by a green overlay. Arms

folded, the artists spread out their fingers. The atmosphere of somewhat frenetic self-absorption is intensified by their facial expressions: one gnashes his teeth, the other puts out a pointed tongue. On the right is a naked young man with his back to the viewer. His hands behind his head, he holds his arms well clear of his body. Shown in black and white, he represents the only one of the four feelings that can dispense with definition by colour.

These feelings can be identified with the aid of the work's combinations of colour and form: red for climbing, growth, proliferation; green for awkwardness and unhealthy contortion; yellow for mature and stable form; black and white for opening but already defined form. The young man's form is erect and stable, resembling a cross rather than the encroaching chaos expressed by the artists' postures.

FOUR FEELINGS expresses the analogies between plant and human form, with red opposed to green, and yellow opposed to black and white. There are two themes, each identified with a feeling, and each embodied twice over: that of twining, inchoate form and that of stable, achieved form.

It is in the context of achieved form that POWER AND GLORY (page 292) points the way forward. Here two flowers are shown in close-up side by side. One is simply black and white; the other is tinted yellow. Like the yellow leaf and the young man in FOUR FEELINGS, the white (or black and white) and the yellow stand for mature, established form. The power and the glory here consist in the achievement of definitive form after the hectic scramble of the proliferative phase. Power is a goal, and glory is a distinction, which stand for the culmination of a process of organic plant growth; and this in turn is a model for human growth and development.

In FOUR FEELINGS and POWER AND GLORY, colour and plant form, along with the human figure, are

279

means of representation which serve to apply discrimination to the world of feelings and to give them pictorial expression. Feeling, in this context, always means a state of life in which a being subsists, whether as a process or as a static condition of repose. The colours serve to underline the character of the feeling involved, and the feeling is always attached to a form. It would be pointless to try to reverse the process and to identify, say, green with awkwardness and red with clambering and proliferation. Any such attempt to equate one colour with one predetermined value in Gilbert & George's work would soon run into difficulties. This is not to say that colours can be used indiscriminately, so that blue or red, say, could be applied to anything whatever; it is just that each colour has a range of meanings. The use of red towards the end of the phase of Descent and in the early stages of Ascent illustrates this flexibility perfectly. In every case it reflects a whole gamut of meanings: conflict, bleeding, aggression, the destruction or reconstruction of a mode of perception.

The use of colour reflects the operation of the profound sexual polarity which Gilbert & George take as their theme in RED MORNING. Just as the "female" sexual aspect possesses a number of different qualities, such as "burning", "flux", "killing", and so forth, likewise each colour has its own range of connotations, both within the sexual context and elsewhere. Thus, blue can stand for night; or for the male, defined form; or for the ground of intelligible being. In addition – and this is crucial – what is there at the inception of the picture is not colour but the motif, which is coloured only later. The use of colour in the work of Gilbert & George runs parallel to the basic process of building up an image: first the black and white image and then, if necessary, the further elaboration through colour.

The application of colour is a conscious act of marking, irrespective of any naturalistic criterion. A number of titles

draw attention to this fact, such as COLOURED COCKS, COLOURED ENEMIES, COLOURED SHOUTING. Each of these titles contains two elements: the central theme and its definition and description as "coloured". This term does not imply the use of any one specific colour, or indeed of a cock-tail of several colours, but the precise opposite: the division of a theme, its variation and diversification by means of colours clearly demarcated from each other. Those used for this pur-pose are mostly green, red, blue and yellow.

In COLOURED BLACK the background is quartered into four areas of colour (page 294). On this, by the photo-gram technique, Gilbert & George have superimposed what looks like a stencil of a black man's face. The coloured ground shows through the open areas of the stencil, so that the black man has red, blue, green and yellow features.

The drawing of the face in COLOURED BLACK is worth examining. It would be all too easy to be misled by the fact that it looks like a crude and blatant caricature. The "sav-age" features, the cavernous nostrils, the wide, thick lips and the farouche expression recall an all-too-familiar style of cari-cature. It looks, in fact, like a racist insult. Here, however, as in PAKI, the artists are pursuing a strategy which deliberately negates traditional associations of ideas. In PAKI (page 226), this was done by means of a word (a name); in COLOURED BLACK, the artists use an image, and specifically a face that looks like a caricature. But the "mask" is not a mask, the "caricature" is not a caricature, and the "primitive" is not primitive. Such negative definitions are valid only for someone who knows the history of a traditional conception of an image, and who consciously or unconsciously allows a par-ticular ideal of the human face to influence his assessment of the picture. In other words, the exaggerated "thick lips" and "wide nostrils" here are an insult to black people only in the eyes of someone who sees the picture in the light of the Euro-

pean tradition of the idealized human face. This remains so whether he blames the artist for the defamatory intention or still has faith in the magical potency of the apparent caricature.

No black person, looking at the work in ignorance of the European pictorial criteria which define the features as caricature, would see it as hostile. To him or her, thick lips would have a significance utterly different from that which depends on total contempt for the picture's subject. African sculptures often show deliberate exaggeration or distortion of particular parts of the body, but of course these are not libels; they simply emphasize the attributes that are relevant to the occasion which gives rise to the work.

The fact that the black face in COLOURED BLACK has nothing whatever to do with caricature is emphasized by the colours of the background. They divide the picture into quarters, like a coat of arms, and turn the face into a heraldic emblem. It is not a naturalistic representation – and therefore not an antinaturalistic one either – but a signal which simply conveys the message "black man". The colours give variety to this message by evoking further possibilities. They, not the black facial outline, constitute the drawing of the black man as such. The colours are far more important than the "natural" physiognomy or its supposed distortion: they give the face its individual character by marking the character of the individual facial features – eye, mouth or nose – in a differentiated and completely value-free manner.

Another level of meaning is opened up by the use of the word "coloured". This too is often used to refer to black people. And if, as is the case particularly in the U.S.A., the word has pejorative overtones, then it becomes clear that here, as in PAKI, a habitual use of language is being negated. "Coloured" here denotes the background that gives meaning to the face; so "coloured" as a term for a black man becomes irrelevant. The word "coloured" qualifies the word "black" by lend-

ing it its own quality. Through the visual representation of both "coloured" and "black" in this picture, the pejorative connotations of "coloured" are excluded and cancelled out.

In itself, COLOURED BLACK is one of the most anti-racist works that the artists have done. It is anti-racist above all because in it an apparently racist image is transformed into its opposite. Racism has always hitherto been combated by a taboo on racist imagery, accompanied by demands for research into its true history and meaning. But this in itself is a highly racist attitude, because it makes the arbitrary claim to know the true significance of the images concerned; it thereby lends implicit credence to caricature and defamation, thus becoming blood-brother to its deadliest ideological foe. Gilbert & George reverse this process. They accept any imagery, while systematically eliminating its presumed historical associations and meanings. They too strike up blood-brotherhood, not with imaginary underlying meanings or associations, historical or formal, but with the image itself. This blood-brotherhood goes so far that it replaces the former meaning with a new one.

Colours play an important part in this, because they impose completely different accents. Instead of a meaning based on classification and condemnation, colours restore the meaning which resides in contemplation of the image. Colours characterize and distinguish, but they do not judge. A colour could hardly be described as "good", "evil", "racist", "genuine" or "artificial". Their essence lies in their value as hue and not their value as judgment. Gilbert & George's use of the word "Coloured..." in titles of pictures, and their use of more and more clearly defined colours, makes it clear how much a subject changes its nature as soon as colour is applied to it. Colour depends on the will of the colourist, not on any preordained idea of naturalness.

Alongside the colours that Gilbert & George select

according to their nature and employ as a means to establish distinctions or to contribute to deliberate design (where no feeling demands definition and the colour actually constitutes the subject), they also occasionally use the noble metals, gold and silver, mostly as a background which reinforces and clarifies the theme of the picture.

To explain the significance of the noble metals it is necessary to refer once more to the sexual polarity which has reappeared in all possible guises in the artists' work ever since RED MORNING. The noble metals have their place in this. In many pictures they serve as indications of the "female" and "male" elements in what is going on; in so doing they appear, of course, in their most abstract guise, as "colours". The essence of these particular "colours" is of course their sheen, and their sexual polarity is the ancient one of sun and moon.

Nearly all cultures attribute sexuality to these celestial bodies, in forms that vary from one religion and one pantheon to another. Gilbert & George assign the sexes in accordance with the qualities of sexual polarity which are visible in the sun and moon themselves. The sun, or gold, serves as the abstract ground of the "female". This eternally burning body, which destroys all and thereby prepares the fertile ground for future life, has its most brilliant manifestation in the "female" symbol of gold. This sexual complex has many attributes, but all of them meet in gold, which makes them palpable through the medium of one single "colour". Silver relates to the moon in an analogous way. Its phases, from new to full and back again, and the silvery coldness of its appearance, are perfect expressions of the nature of the "male" principle. In contrast to the eternal flame of the "female", it is conditioned by time and takes shape through gradual addition and subtraction. The "male" has its own form of eternal life, but only at the price of eternal self-destruction. Just as the moon wanes, the "male" decays, only to be reborn.

In order to eliminate from the outset any possible misconception as to the sexual polarity of sun and moon – a subject bedevilled by our modern civilization's false idea of sexuality in general – it is worth going into a little more detail. Rationalist patterns of thought have always been hostile to the idea of recognizing an inherent sexual identity in objects. Rationalism, with its commitment to the techniques of verification and quantification which it has itself created, is bound to abominate the idea of finding sexuality in a quarter where it can never be detected by measurement. The logical consequence of this has been the virtual elimination of sexual polarity and its "unmasking" as myth. But in the present context this is entirely beside the point: when Gilbert & George come once more to assign a sexual identity to gold and silver in reference to these same celestial bodies, they know perfectly well that in objective, i.e. measurable, terms the moon has no sex. Nor do they make any verbal allusion in their works to the connection between the noble metals and the sun and moon. They perceive and acknowledge only the surface appearance of things; and so they recognize the "female" and the "male" in the surface aspect of sun and moon. What matters here is not whether things can be verified but the sexual polarity and interaction that is their essence. Whether the sun and moon are "really" sexual entities is beside the point: the sex that human consciousness perceives in them is relevant to human life, not to the hard facts of astronomy.

The pictures THREE WAYS and FIRED afford examples of the use of gold and silver (pages 360–61). Both are described in a later chapter; for the moment what is relevant is their metallic backgrounds.

The upper left-hand sector of FIRED has a gold-leaf background against which three tall monumental structures appear. To the right of these a succession of heads tumble into a mass of flame below, which billows out into the centre of

the picture and encloses a number of portraits of boys. In this part of FIRED the prime subject is the process of burning. The fire burns the monuments, which in formal terms sink into it from above. They in turn, in their rigidity and stability, are symbols of the old, unregenerable "male" sexual aspect: father figures, still dominant but already obsolete. That is why they are burning together with the boys (the sons) in whom they have physically manifested themselves and from whom they must be totally eliminated. The central pictorial action in this part of FIRED thus concentrates on burning, melting and destruction. The gold ground stands for this process. It shows that the essence of the action is burning.

THREE WAYS, in its turn, is almost filled by a silver ground. Three boys are associated with three plant forms, in front of which they stand or sit on a narrow strip of blue floor. Their respective attitudes, colours and plants embody, as the title indicates, three ways; and these three ways in turn express the emergence of life. Thrice over in the three boys, and by analogy in the three plants, a form of life is seen to define itself. The boys are beginning to take on a form of their own.

The theme of THREE WAYS is life in all its diverse potential growth. The silver ground serves to allude to the form-giving aspect of life. Subject to time, but endowed with the capacity to evolve and differentiate, this aspect provides the framework of all life. Silver, with its reminder of the lunar (male) aspect of sexuality, provides the most effective background for the overall theme of the picture, which is that of the growth and evolution of form within finite temporal limits.

The use of colour in Gilbert & George's work can be summed up as follows. Firstly, the artists use all colours purely for their value as monochrome. There are no mixed colours composed of two or more hues. Each colour charac-

terizes the value, in terms of feeling, of the motif to which it is applied. Apart from the generalized capacity of colours to differentiate objects from each other, and to relate them through analogy, colours possess values of their own. These values do not depend on a system of classification, a dogmatic theory of colour, but point to a range of possibilities. Like gold and silver, which stand for the abstract "colours" of an underlying sexual polarity, other colours can also function as grounds, suggesting unfathomable depth.

Every individual colour represents a single complex value from which its various meanings emerge and in which, in turn, they constantly merge. Blue, for instance, serves in SPEAKERS (page 272) to isolate the entity "Gilbert & George" from the rest of the picture and to give it a unified form; in VIEW (page 219) blue completes the definition of "male" sexual polarity in formal terms. Colours in Gilbert & George's work open up the possibility of a free use of form in the treatment of subjects. The procedure first used in the COLOURED... pictures becomes more and more current; the artists invent a person by giving him a colour, even though that colour has no basis in reality. Colour is a wall with nothing behind it and a multitude of potential meanings in front of it.

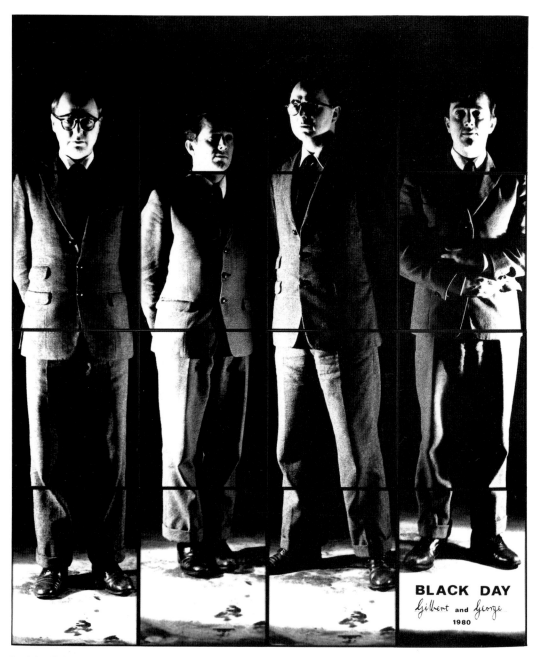

BLACK DAY. 1980. 241x201 cm.
The blackness of Descent is followed by the blackness of Ascent, from which
emerge the shadowy outlines of future themes.

BLACK MARE. 1981.

COLOURED FAMILY. 1981.

Gilbert & George exhibition at the Baltimore Museum of Art. 1984.

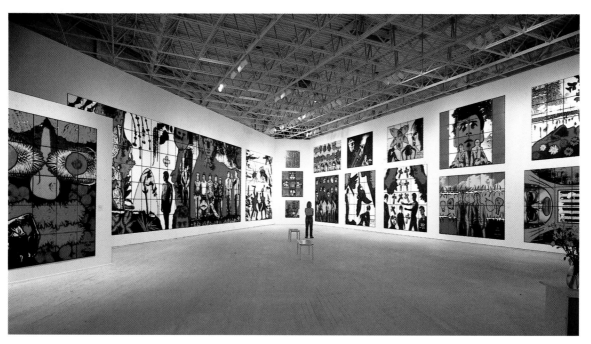

Gilbert & George exhibition at the Contemporary Art Museum, Houston. 1984.

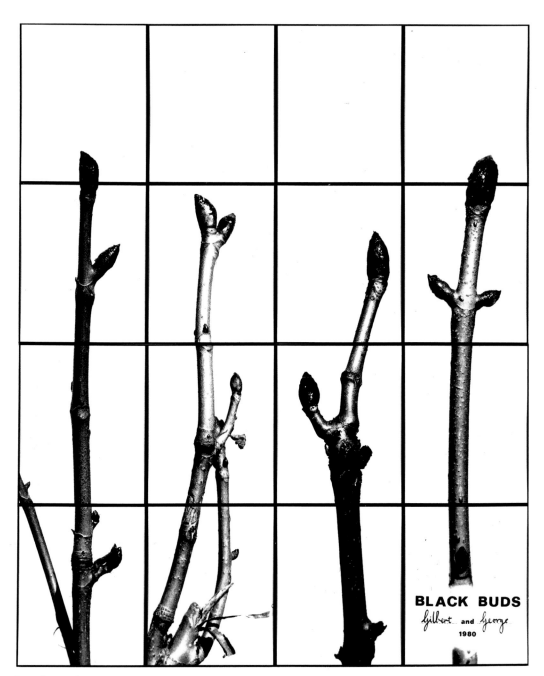

BLACK BUDS. 1980. 241x201 cm.
Black heralds the burgeoning of life.

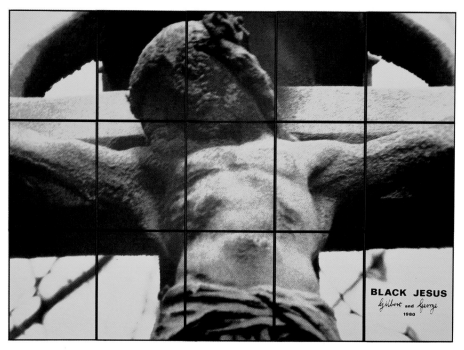

BLACK JESUS. 1980. 181x250 cm.

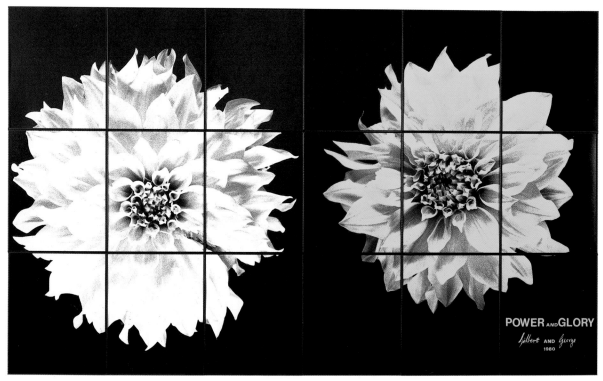

POWER AND GLORY. 1980. 181x300 cm.

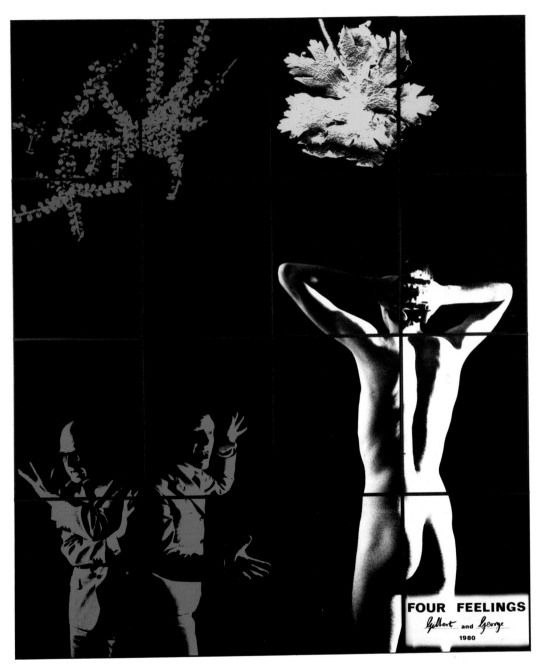

FOUR FEELINGS. 1980. 241x201 cm.
Colours differentiate feelings.

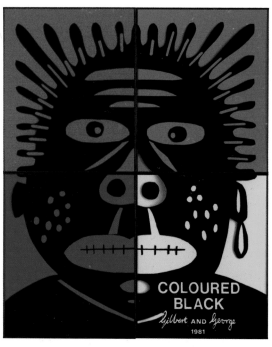

COLOURED BLACK. 1981. 121x100 cm.

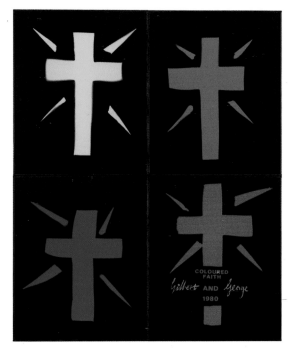

COLOURED FAITH. 1980. 121x100 cm.

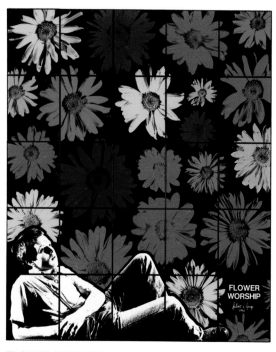

FLOWER WORSHIP. 1982. 300x250 cm.

COLOURED FRIENDS. 1982. 181x151 cm.
Colours are not there to pass judgment but to distinguish
and to give variety.

COLOURED ENEMIES. 1982. 241x201 cm.

FRUITO DROPPO. 1983. 241x201 cm.

COLOURED SHOUTING. 1982. 241x201 cm.

AKLIS LEAVES. 1980. 241x201 cm.

WINTER HEADS. 1982. 241x250 cm.

QUALITIES
and
VALUES

Chapter 9

Alongside colours, Gilbert & George's work since 1980 has increasingly emphasized statements of quality and value. These are an essential component of the World that Gilbert & George are engaged in exploring and at the same time constructing. Within this World, on a variety of levels and in many different spheres, action, feeling and thought manifest themselves through qualitative distinctions.

The first value concepts to mention are of course GOOD and BAD, the titles of two of Gilbert & George's pictures (pages 312–13). Of all value judgments, these look the most suspect. What is there, these days, that can objectively be called "good" or "bad"? It was largely the Enlightenment itself that undermined these criteria and ultimately declared them to be meaningless and void. No "good/bad" judgment has ever stood up to rational analysis. The rationalist pursuit of an underlying reality that will stand up to examination and assessment leads to a non-committal conclusion. Nothing possesses any value in its own right. This is how even moral criteria of value have come to disintegrate. Once values have lost their validity, and nothing makes a difference, anything goes.

Qualities and Values

This general devaluation of "good" and "bad" can be traced throughout the Descent phase of the artists' career. At the time when they were declaring words and concepts to be meaningless, they produced a set of short texts, accompanied by their own portraits, which they entitled THE TEN SPEECHES. Each of these speeches follows the same pattern, and all that changes is the appellation assigned to Gilbert & George themselves. In one case they are elevated to the status of artists; in others they are seekers, writers, thinkers. As sculptors they describe themselves as follows:

> They weren't GOOD Sculptors
> They weren't BAD Sculptors
> But, My God, they were SCULPTORS.

The use of two different founts of type in itself serves to stress the questionability of the value judgment. The classification of human beings as "good" and "bad" cannot be maintained, but it is still possible to describe them as "writers", "thinkers" or "artists". What is lacking is any criterion for assessing a person, for judging his or her quality as "somebody".

The nub of the issue of "good" and "bad", which has here deliberately been left aside, lies in the old distinction between "good" and "evil" as morally defined: a judgment that seeks to bend human behaviour to an ideal. One aspect, usually the destructive and aggressive one, is then dismissed as "bad" or "evil", while the other, harmonious and peace-loving, aspect is set up as a desirable goal. Applied in another way, the "good/bad" distinction is an endeavour to maintain a dichotomy between social tendencies – usually between those definable in crude terms as progressive and reactionary. Or, even more simplistically, "left" and "right" are posited as contrary, mutually hostile movements. To make such a distinction is to sit in judgment on other people's actions while claiming

that one's verdict has validity in terms of social relevance, and hence of principle. This criticism of others based on the co-ordinates "good" and "bad" or "true" and "false" is supposed, by those who engage in it, to lead to the betterment of society.

When Gilbert & George leave the question of "good" and "bad" unanswered – when in fact they negate it – the reason lies in the impossibility of lending credence to this kind of hierarchy of values. They have abandoned that way of looking at things, but not the words "good" and "bad" them-selves. In the works of their Ascent, indeed, they formulate these very words anew. "Good" and "bad" now make their appearance as values springing from a new interpretation of thought and action and – in a certain sense – also of hope.

BAD (page 312) shows the heads of Gilbert & George, each duplicated like the head on a playing-card, with one fac-ing its mirror-image on the horizontal, one on the vertical axis. Reduced to eyes, noses and mouths, their expressions convey a sorry state of mind and body. Eyes and mouths are oriented towards an imaginary point at the centre of the pic-ture. Black areas between them echo the theme of the human face: on them, red patches and lines form faces that recall death's-heads. These too point to the centre, by means of red lines.

This collection of faces is superimposed on a vague blur of tangled branches. The individual boughs intersect to form lines, channels, links, that still create no unified background. In undefined space they weave a nebulous, purposeless web.

It is this disorienting, criss-cross background space that inspires the disconsolate, even deathly, expressions on the faces. As in COMMUNISM (page 224) and DEAD KING (page 218), it is lines that represent the bad, the negative aspect. In the pattern of intersecting lines, as in the faces with their concentration on a single point, there is a fundamental state of dependence which is denoted by the word "bad".

Qualities and Values

This dependence is primarily mental. This means that any thought with which man sets up attachments and lines to link him to the external world – ties that then become compulsions – is defined here as "bad". These compulsions can be of many kinds. Examples are: the habit of thinking in terms of socio-philosophic discourse; the delusion that one is involved in historical developments, along with all submission to the historical forces that man identifies as his own inalienable roots; the pursuit of someone else's morality instead of one's own; the belief in the need for criticism and its necessary link with amelioration; the obsession with what other people do, coupled with the assumption that it presents a danger, justifying rigid policies of demarcation and exclusion; in general, any way of thinking that concentrates on one point in time and dismisses everything alien to that time as false. BAD is an image of man's propensity for drawing the line, and of the ill-defined – and thereby all the more comprehensive – area of coercion and compulsion into which it leads him.

Conversely, GOOD is a picture entirely devoid of imaginary space, free of linear entanglements, even though it centres on two lines (page 313). This time, however, they form a cross instead of hanging vaguely in space. Against the background of a brick wall, a cross of roses occupies the whole height and width of the picture. Its arms divide the picture into four sectors, each occupied by a boy's head. Stylized leaves and thorns around the heads provide a pictorial analogy to the cross: the boys, like the elements that make up the cross itself, are roses. In contrast to BAD, the heads do not face the centre but look out to the front. All four are placed on the diagonals that pass through the crossing-point, but their "organs", whether thorns, leaves, eyes or mouths, are oriented differently within the space defined by the cross.

In contradistinction to "bad", "good" can now be defined anew in terms of value. Instead of an imaginary spatial

point of reference, in GOOD there is only the wall with its rosy cross. This is not a notional configuration of lines but deliberately constructed, living architecture. This is shown by the flowers, which are shared between the architecture and the human beings who live with it. Instead of looking back, or inward at some compelling common point, the faces are looking forward, sharing a common field. This is defined and structured by one very simple symbol of life: the rosy cross. GOOD denotes a perceptual structure and a life structure in one. Life unfolds with and along the arms of the cross, which sets up a deliberately constructed space forward of itself. BAD characterizes the state of dependence on ready-made or even imaginary systems of relationships; GOOD lays its stress on the deliberate design and erection of a new space for life, independent of any other system.

Gilbert & George have produced a number of other pictures named after terms of value; like GOOD and BAD, these sometimes form antithetical pairs, such as DEAD and ALIVE. Not all these pictures have such simple titles, however: some titles are neologisms, and others use existing words in unfamiliar ways. This manipulation of words reappears elsewhere in Gilbert & George's work – as when they call one piece simply NEWLAND. None of this should be taken as reflecting a taste for fantasy, free association or random effects. The neologisms stand for pictures that show previously unknown motifs. These motifs are not there to be discovered, like unexplored territory; they have to be postulated, because the territory is new.

The construction of the World of Gilbert & George, in all its diversity, can be traced through a number of other individual works. In MARCHING, a very clear and simply composed picture, Gilbert & George make it clear that the military idea forms part of their repertoire of qualities and recognized values (page 316). Three views of troops on parade

are placed one above the other. The different colouring of the three zones, and the different uniforms, mean that the emphasis is not on any specific parade or group of marchers but on the march itself: the state of being armed, of being a human carapace, of stepping out, the state of uniformity and self-containment.

This combative, combat-ready mood recurs in two sequences from the film THE WORLD OF GILBERT & GEORGE. One shows two young men in uniform marching in a circle; the other shows the artists themselves. With medieval spears in their hands they mime a miniature but intensive combat.

These two images exemplify the way in which Gilbert & George incorporate the warlike, military aspect of life in their World. Instead of localizing it in terms of a threat, or identifying a specific adversary, they present it simply as an area of human life, and of the human will, that must not be repressed but acknowledged. In the phase of Descent the artists had brought combat into their artistic repertoire with a specific enemy in mind, the old blood. Now they retained its outer forms to represent one of life's numerous qualitatively different aspects. The context of marching, weaponry, the manifest will of a warlike social entity, also embraces a number of pictures concerned with patriotic and nationalistic motifs. The theme here is not war but the desire to create one's national identity for oneself, instead of simply acquiescing in it. Gilbert & George have approached this theme in many different ways over the years. It is alluded to in the titles of pictures such as LONDON, ENGLAND, NATIONALISM, BRITONS, BRITISH LION, BRITISHER or PATRIOTS; other works show heraldic beasts, and still others present the British flag or adopt its colour scheme. But here, as in the warlike pictures, what matters is not the emphasis on any specific nation – even though British or

English motifs predominate – but on the presentation of national feeling and national identity as such. This is shown by those pictures that deal with other nationalities, such as GERMANIA, VIKING and JAP GUARDS. The predilection for British or English motifs is explained by the fact that the artists live in London; British nationalism stands for nationalism and patriotism in general.

ENGLAND looks like a flag, on which Gilbert & George appear together with other motifs (page 319). Shown in two different positions, they flank a central cross made up of three rose leaves pointing upwards and three pointing downwards with a rose at the centre of the horizontal axis. The leaves have a green overlay, and that of the rose is red. To left and right are Gilbert & George: above they squat in demonic red; below they stand looking combative in black and white.

In ENGLAND, once more, the qualities of sexual polarity reappear. The artists themselves manifest them in the way they are portrayed. The black and white figures represent the male aspect; the red ones show the female. The leaves and the flower are related in much the same way. The rose itself is a negative, and the red alludes to burning, destruction, all that is monstrous. The leaves, by contrast, present a positive form, majestically clear against emerald green, and emphasize the right-angled co-ordinates of the cross.

In the heart of ENGLAND, at its centre, resides a rose which is both form and, in its negative representation, a "burning" flower. It devours, burns, destroys; and yet from this infernal centre, this burning nucleus, there arises a cross of leaves, symbol of expansion and life. These form the cross that gives structure to the "flag" of ENGLAND. Adopting their structure, and conforming to the basic attributes of the cross, Gilbert & George take their place in the composition. The cross supplies their orientation; they echo the information that the cross conveys.

Qualities and Values

The male-female imagery of the "erect" (the cross) and the "monstrous" reappears in NATIONALISM (page 318). Contrary to the normal meaning of the word, this is not a celebration of the power of one nation; it conveys no rigid ideology of national identity. The barb-tongued griffin and the red cross on a white ground are the emblems of a city, London. The cross structures the whole picture surface; the griffin rears up in its centre, and leaves provide an animated frame.

ENGLAND and NATIONALISM interpret the idea of national identity within the context of universal sexual polarity. The home country, or nation, characterizes and embodies both sexual aspects: the "erect" and the "monstrous". Both are central to the idea of nationhood as presented here, and both have been endowed with a form that makes their essence apparent to the senses. This process gives meaning to the "nation" by endowing it with an image: an image which also functions as an emblem. The image expresses the state of belonging to a nation in two ways: on the one hand loyalty, as expressed in the cross which represents the architectural core of communal life, and on the other the readiness to fight in its defence.

Both pictures are concrete and visible expressions of the artists' statement, quoted above: "We uphold Traditional Values..." Among these values, of course, is that of national allegiance. And according to these same traditional values, the country in which one lives is a home, marked by the same fundamental qualities that serve as the model for the social entity "Gilbert & George". Individual and nation stand in a direct and equal relationship in which no enmity is possible: one will not rebel, the other will not "oppress" him.

In NATIONALISM, in particular, Gilbert & George take as their theme a concept of value which has come under increasing attack in the course of recent history. National and patriotic consciousness has been classified as undesirable

because it is thought to rest on a "wrong" impulse: the impulse, that is, to foist national identity on the human individual; the megalomaniac insistence on a unity which can only be maintained by force, and which blocks the individual's aspiration to be free. The consequence of this view is the prevalence of a deep-seated hostility to anything that bears the name of nationalism. National consciousness itself tends to be regarded as a thinly veiled ideology whose aim is the enslavement of the individual or the restoration of the evils of the past.

This widespread and deep-seated inability to cope with the positive side of national consciousness is countered by Gilbert & George, as in SPEAKERS (page 272), by simply accepting the image at face value. In SPEAKERS they do so by presenting themselves, and themselves alone, as a "fascistic" social compact. By leaving the word "fascistic" to be defined by those who use it, they thus emancipate themselves from an apparently predefined image and redefine as positive something that appears entirely antipathetic. It is not the image or the word that represents a menace, but the presumed deeper historical significance on which the customary awareness of the image is based. Gilbert & George give the image a new function by responding to it from their own point of view.

In all their pictures, including those on the theme of nationalism, the impulse that they manifest is not imposed from above or from outside; it is their own. Not for nothing do they themselves form part of the ENGLAND picture. The nation is the image of those born in it (the word is derived from the Latin NASCI, to be born); it is not an image that has to be branded into the natives' flesh.

The pictures just mentioned concentrate largely on the "male" aspect. The other side is never absent, but battle, armour, marching and nationalism are the preferred themes of a masculine view of life. The "female" aspect, with its iden-

tifying marks of burning, flux, osmosis and organic growth, finds its expression in a large number of Gilbert & George's other works.

SHITTED announces its subject in its title (page 320). Gilbert & George sit facing each other in front of a wall of vastly magnified turds, and put out their tongues in different directions. These are coloured the same intense orange-brown as the excrement and the title of the picture. The artists' heads, hands and bodies are alternately blue and green. The explicit use of colour makes it clear that filth is being placed in the artists' mouths. In their mouths they have what normally emerges from the anus as the putrescent product of digestion.

SHITTED looks like an image of revulsion. But instead of treating the sensation of disgust as something to be shunned – or to be desired, for that matter – Gilbert & George simply give it pictorial expression. They formulate it as a taste that now and then comes one's way. Shit in the mouth or on the taste-buds signifies the entry into the body of all the foul, rotten, amorphous matter that ought to be on its way out instead of in. Gilbert & George thus acknowledge the existence of a daily, but mostly ignored, fact of human life which is part of the body's interchange of substances with its environment: what the body absorbs is not always the pleasant, easy, enjoyable and noble things of this world but also, on occasion, shit, filth and all that is repellent.

Another picture which emphasizes flowing, penetrating matter has the title BLOODED (page 321). Divided horizontally into two halves, BLOODED has a green background below and a blue one above. From the lower sector a yellow branch spreads its twigs upwards into the blue, and from the top there flow red trickles of blood which partly obscure the branch. On either side of the branch sit Gilbert & George, back to back. Their hands and heads are marked with the colour of blood, and they look up as more blood flows down

from above. Two purple roses with dark centres, level with the artists' heads, complete the theme of erotic flow and flux.

In BLOODED the erotic process of blossoming is also one of dispersal and disintegration. The plant form between the artists — like a symbol of their own bodies — is bathed in blood. They mark their own hands and heads with red; and the calyxes of the flowers mark an erotic place of entry. All this indicates that what is shown here is not bleeding-to-death (or ultimate desiccation) but a salutary bleeding which carries the significance of constant renewal. The blood is like rain, which soaks into the ground in order to begin the process of regeneration. The pictorial juxtaposition of blood and blossom reinforces the analogy.

In this connection there is a forgotten etymological relationship between blossom and blood, through a root which is shared, for instance, with the Middle High German BAL, incorporated in a variety of words that refer to welling up, flowing, spraying and budding.[102] BLOODED fully reflects this link — although this was certainly not the artists' conscious intention. It is not blood itself that is the point here so much as the osmotic processes that take their origin in it. BLOODED does not name the attribute proper to an entity, an Other, but the essence of bleeding in its various organic manifestations.

The picture ALIVE (page 314) bears some analogies to BLOODED. But where BLOODED stresses the flowing and dispersing aspects of life, ALIVE refers to a specifically nocturnal, almost clandestine process of creating form anew.

ALIVE shows Gilbert & George asleep in front of a green urban landscape. Above, in a dark blue night sky, shines a red full moon which has lent its colour to all but the faces and hands of the sleeping figures. In front of this nocturnal scene the artists are shown for a second time, standing at the sides of the picture and pointing at their own sleeping forms.

Qualities and Values

Each indicates the other's sleep and thus alludes to the title of the piece. The one on the left, in particular, draws attention to the scene in conjunction with a tree-branch that hangs down from the upper edge of the picture. He points with his finger; the branch points with its tip. The space between man and branch is filled by a moonlit image of cobwebs.

What is alive in ALIVE is a world of calm, nocturnal, silent growth and motion. Sleep is promoted by sensitive, gently formative influences, which are evident in the spiders' webs as well as in the branches and leaves which point to the sleeping forms. In sleep, life takes shape in total seclusion, far from all noise and hectic activity. The red of the moon, and of the sleeping forms, is another allusion to this nocturnal process. Within their strong outlines, the bodies rest in a state of inner flow and motion: not a motion that hastens from one place to another but one in which the bodies regenerate and re-form themselves.

Another passage from the film script of THE WORLD OF GILBERT & GEORGE is relevant here. It conveys the idea of life as a paradoxical, tranquil, secret process through an enumeration of plant species, which are deliberately given their vernacular names. The poetry of these names enriches the evocation of burgeoning life with a sense of all that is silent, damp, venomous, bedabbled, coiling, delicately ramified:

> Here with straggled weeds and planted ivy our various thoughts grow gently. Perversion of plant life threads delicately our intellect. Green friends for us to play with and care for. Moist pubic moss and dragon sow-thistle with milk bitter juice combine to express with us our feelings. Purple Chinese elegance with chickweed fluted adderwort mix tones and thoughts and structures for our bad games with people-study.

Qualities and Values

Almost all the qualities and values that Gilbert & George emphasize in their pictures are presented in isolation. There is hardly one quality that applies to anything but itself, and there is no value that represents anything but itself. For this reason the artists use for their titles, wherever possible, the past participle of a verb instead of the more common adjective or noun: BLOODED instead of BLOODY, SHITTED instead of SHIT. The attribute or quality in itself, and not its application to something else, determines the content of the pictures. The artists themselves confirm this when they say that each of their pictures is a "frozen representation".[103] It is in precisely this sense that their work is "sculpture": it speaks for itself without involving any other object.

There are, of course, some titles that include a qualifying or characterizing element. The qualities indicated are mostly colours (PINK DILEMMA, COLOURED COCKS, BLACK DEATH, etc.), or a few epithets such as YOUNG, HOLY, in one case even BAD. The epithet in this case does not apply to a person but to a BAD GOD (page 310). Badness as a quality is thus given a transpersonal dimension rather than used to pass judgment on another person.

Gilbert & George accept colours as descriptive and denotative qualities, and indeed use them only for this purpose; there is no picture that bears only the name of a colour as its title. This again points to the unique significance that is attached to colour. Colours can name, describe and define what can be perceived only on a sensory, not on a conceptual level.

BAD GOD. 1983. 241x151 cm.

LONDON. 1980. 241x201 cm.

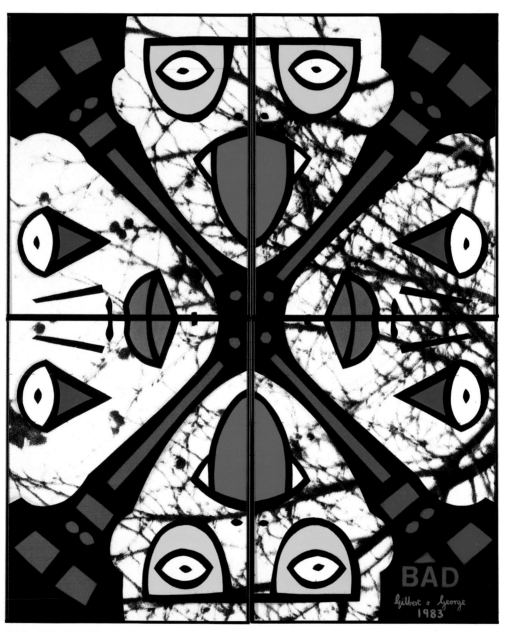

BAD. 1983. 121x100 cm.
Thinking in lines, links and stereotypes engenders mental states of dependency that are BAD.

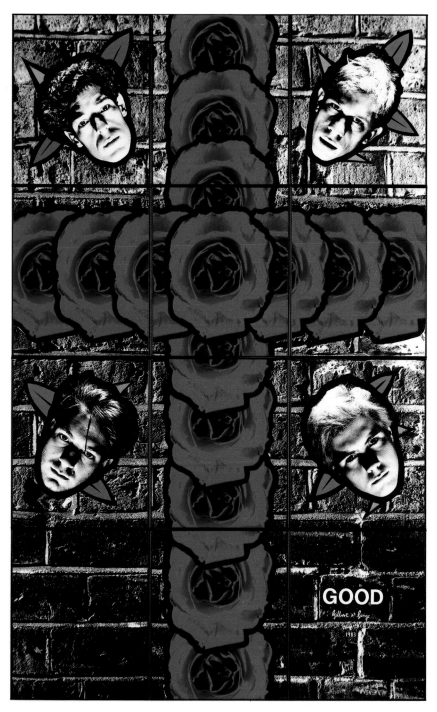

GOOD. 1983. 241x151 cm.
To set up an architecture of life is a GOOD sign for humanity.

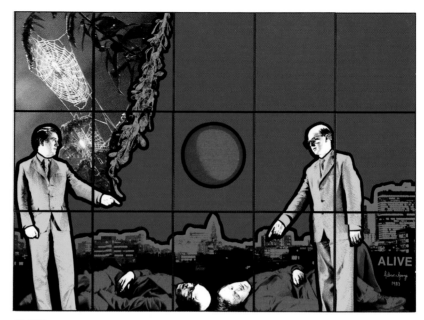

ALIVE. 1983. 181x250 cm.

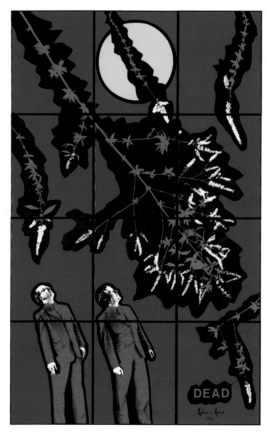

DEAD. 1983. 241x151 cm.

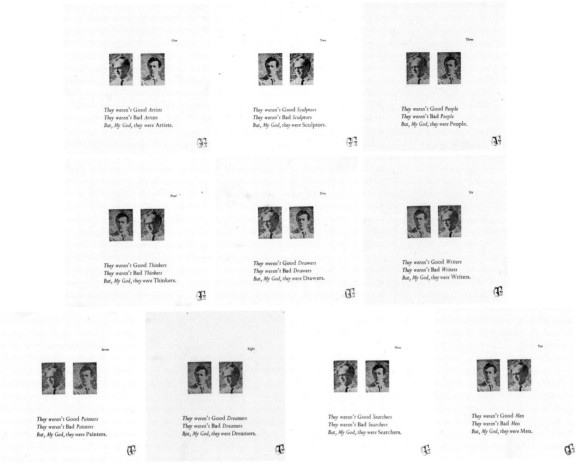

THE TEN SPEECHES. 1971. Edition of 10.

"Feeble fighting" and "Soldiers marching" from Gilbert & George's film THE WORLD OF
GILBERT & GEORGE. 1981.

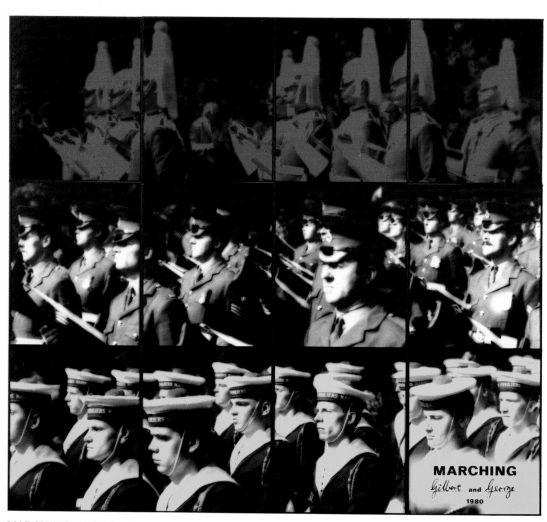

MARCHING. 1980. 181x201 cm.

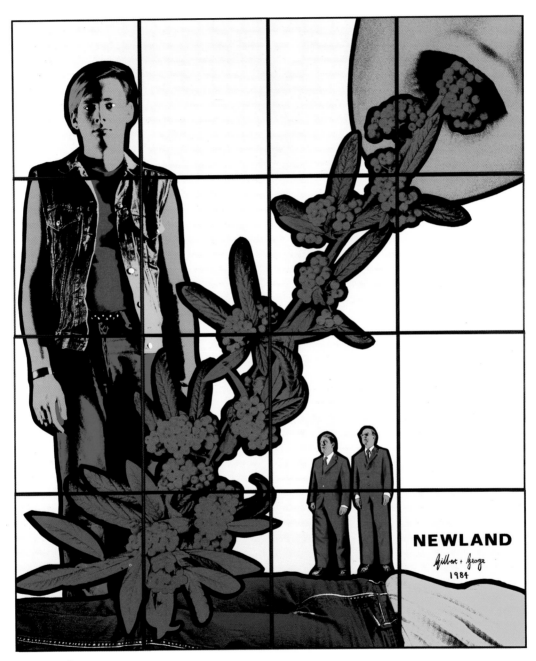

NEWLAND. 1984. 241x201 cm.

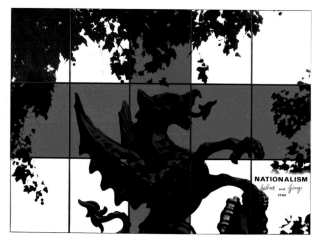

NATIONALISM. 1980. 181x250 cm.

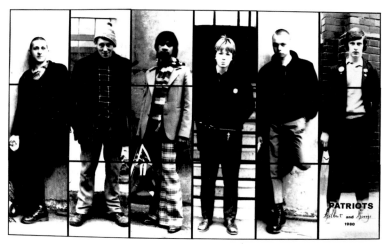

PATRIOTS. 1980. 181x300 cm.

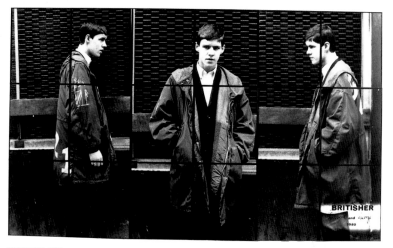

BRITISHER. 1980. 181x300 cm.

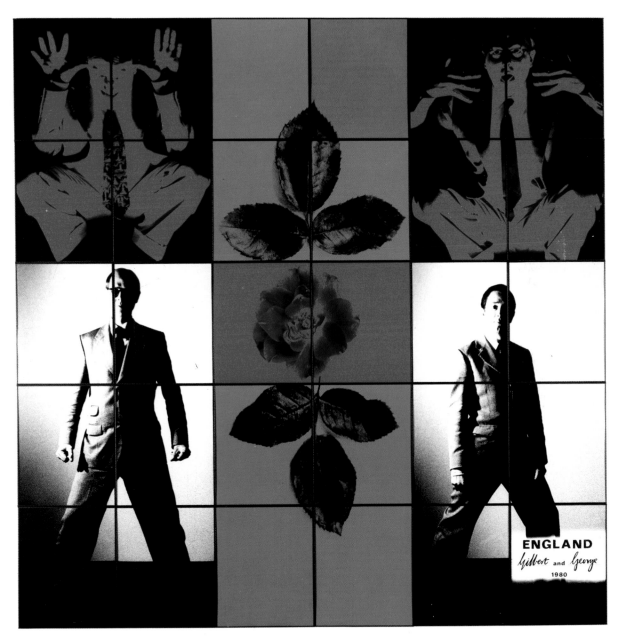

ENGLAND. 1980. 301x301 cm.
All values, including martial and patriotic ones, have a place in the world of Gilbert & George. What is crucial is that the artists never simply adopt them but always reformulate their content.

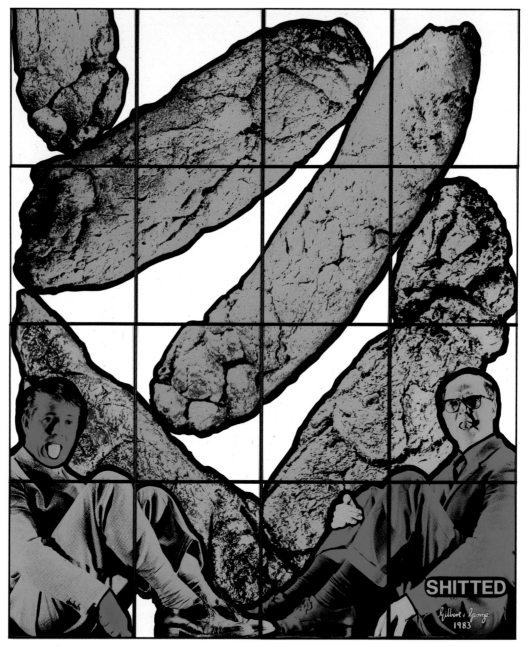

SHITTED. 1983. 241x201 cm.
Where the title is a past participle – an epithet – this serves to allude once more to the sculptural
presence of the picture; it emphasizes a quality in its own right.

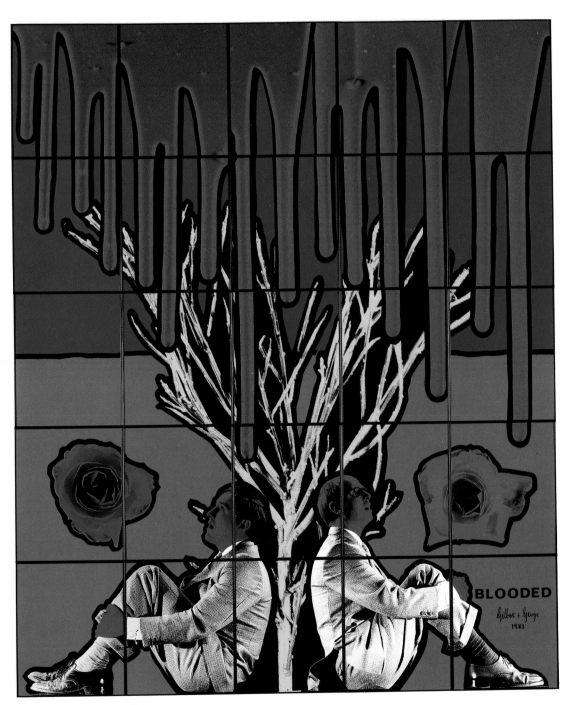

BLOODED. 1983. 302 x 250 cm.

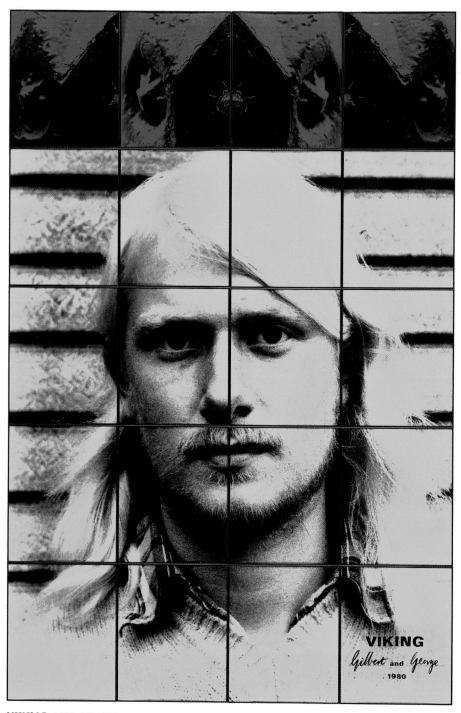

VIKING. 1980. 300×201 cm.
Gilbert & George handle nationality rather as they do qualities in general. They provide an image of what it is that pertains to a nation; they have no interest in establishing a ranking order as between one nation and another.

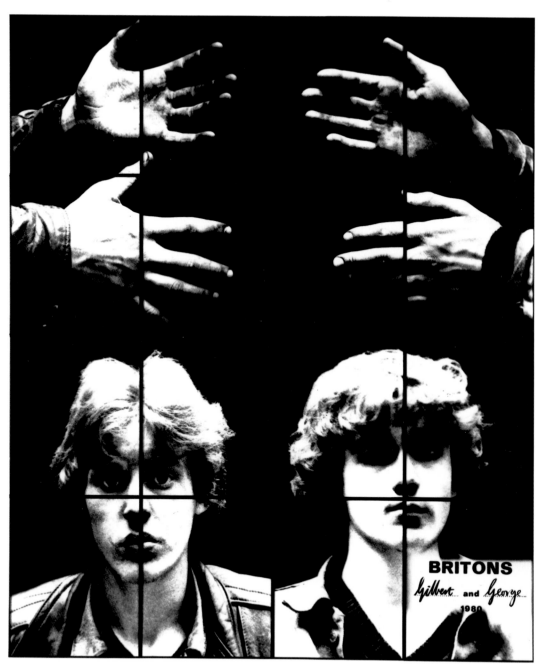

BRITONS. 1980. 241x201 cm.

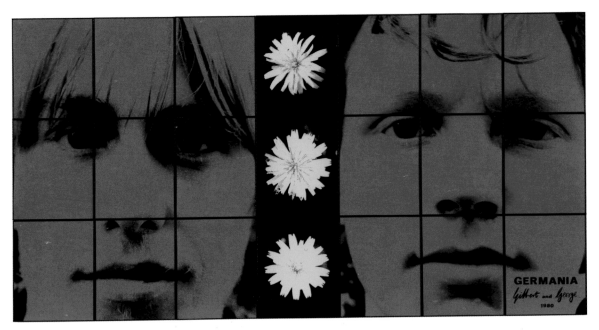

GERMANIA. 1980. 181x351 cm.

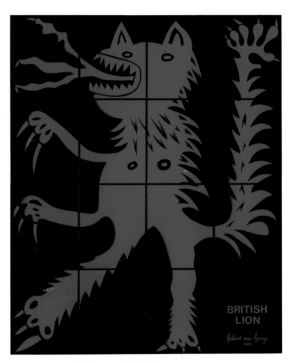

BRITISH LION. 1980. 241x201 cm.

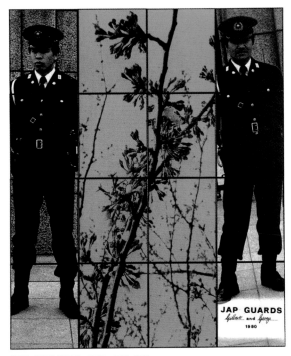

JAP GUARDS. 1980. 241x201 cm.

SEX

Chapter 10

That the art of Gilbert & George is essentially sexual has been evident since RED MORNING. The sexuality in that and subsequent works, however, primarily pertained to the world itself, and specifically to the urban world with its two complementary aspects. There was no place in this scheme of things for a human being's actual sex, as represented either by erotic form or by the organ of sexuality itself. This last, and specifically the male organ, made its first appearance in THE PENIS (page 225). In the following period a number of pictures were produced which centred on the penis, on male sexuality, on sex between men, and on sexuality in general.

From these works female sexuality is deliberately excluded. There are no pictures of sex with women, or of women at all. This is not from any hostility to women, nor from a deliberate negation of the female. It is just that Gilbert & George in their pictures speak only for the sex to which they belong. They thus succeed in bypassing the age-old tradition according to which Woman has served to represent more or less every wish-fulfilment fantasy of which the male mind is capable, from sex object to personification of Truth and Mother of God.

In spite of this evident absence of the female sex, there

is a whole series of pictures in which the eroticism may well potentially include heterosexuality, if only because on a superficial level there is no sex in them at all. These works express an eroticism, a love, that refers in an open and poetic way only to itself, without reference to one sex or the other. VARIOUS LOVES, for example, shows four flowers complete with stamens, differently coloured and overlapping each other (page 338). The implications of sexual union are for the viewer to deduce; and so the question of heterosexuality or homosexuality need not arise. The eroticism that finds expression here is something quite different: flowers locate the erotic where it belongs, in the domain of Eros. The stamens and calyxes revolve not so much around the image of the union between man and woman as around the image of sensual, physical attraction – Eros itself, in fact. Sexual categories and boundaries disappear; what remains is love-play. Sexual identity is immaterial.

This is the light in which LOVE LAKE (page 337) should also be seen. Here, again, two sexual forms are the theme; they are seen in the guise of the Fluid and the Fixed. A glowing red moon hangs in a dark blue night sky. Beneath it lies a lake whose surface turns the form of the moon into a long, rippling red carpet. The moon, which is the male, fixed form, dissolves in the water in a liquid glow of love. Plant motifs to left and right emphasize the sexual theme. From above, spiky black branches dip themselves in the lake; flowers and grass spring up from below.

The theme that was already present in the side-panels of THE PENIS reappears in LOVE LAKE, more precisely formulated and beautified by colour. In the earlier work, bare branches dissolved their rigid forms in puddles; here it is the moon and the lake, shrouded in the red of Eros and the blue of the night, that give themselves up to the act of love.

VARIOUS LOVES and LOVE LAKE, like some other

works described earlier, display a degree of abstraction. Not because they correspond to the common idea of the abstract as something non-representational or imageless, but because they render love and sexuality visible without reference to the human figure. Without being abstract themselves, they create an abstraction of Eros through motifs and metaphors that lie outside the limited repertoire afforded by human life. What kind of specifically human, inter-human or inter-sexual eroticism may be involved is a matter for the viewer, not for the picture itself.

There is a great difference between the works just described and those in which Gilbert & George take the male sex as their explicit and exclusive concern. Here, where the artists speak for themselves and for their own sex, there are images of the penis, of semen and of sex between men. However, in connection with the latter area in particular, Gilbert & George adopt a pictorial form which precludes direct access to "real" events: the pictorial language of heraldry. As in COLOURED BLACK (page 294) or LOVE LAKE (page 337), they use the photogram technique for this. Stencils in the shape of the chosen motifs imprint their outline on the light-sensitive paper. The application of colour follows. Bold colours and forms direct attention to the intended significance of the picture. For example, if a penis is made disproportionately large in relation to the rest of the body, this is not done out of fetishism but as a way of defining the relationship between the picture's major thematic element and the rest of its content. This way of dealing with form, placing it on the picture surface and then distinguishing it by the use of colour, has important affinities with heraldry: its purpose is not realistic depiction but clear signalling. Coats of arms need to be instantly recognizable from a distance; and Gilbert & George's sexual pictures are equally easy to read. A number of them will be discussed in the section that follows.

The first time Gilbert & George depicted the male sex was during their phase of Descent. COMING, 1975 (page 178), shows not the penis itself but its fruitful product: semen. This work marked the conclusion of the Descent – for the time being, at least – by proclaiming the advent of new life in the form of semen or white blood. After the sexual entry into Hell, and the decay and desiccation of the old blood, COMING heralded the regeneration that was still to come.

In HOLY COCK, Gilbert & George once more convey the life-giving power of the male sex, this time through the image of the organ itself (page 336). A red, erect penis is flanked by two testicles which look rather like chestnuts. It stands in front of a background of flowing droplets of water. The red of the penis and the white of the watery background express the nature of the vital flow that has its source here. The spiky testicles that enclose and guard the seed are the origin and fountainhead of life, as the background indicates. Through the penis, life flows outward.

This picture is not about sexual gratification, male dominance, occupation of the female, or potency fetishism. HOLY COCK goes far deeper than this: its central motif is a fundamental aspect of life, expressed through the form of the phallus, which embodies the vital pulse itself. Well may the penis as bestower of life be called holy.

Because Western culture, after centuries of suppressing its sexuality, still has difficulty in seeing pictures of genitalia as anything but an incitement to lust or a voyeuristic joke, it may be useful in connection with HOLY COCK to take a look at something from a non-European culture. This is a so-called Tree of Life from the South Pacific (page 340).[104] A number of figures are here placed one above the other to form a stem. The uppermost figure is that of a man, whose outsize erect penis points upwards. Its form is laced with ornament, and inside it is a diminutive human figure. Both the ornament

and the little figure are references to the flow of life that issues from the penis. Life flows from this organ of generation in the form of unfolding diversity (the ornament) and in the form of humanity (the little figure). Its outsize dimensions do not therefore signify a glorification of the male but an emphasis on his role as a giver of life. This is the affinity between this object and HOLY COCK.

Of course, from a scientific point of view it would be easy to take exception to this masculine emphasis on the grounds that it neglects the substance which is the complementary opposite of semen. But the forming and bestowing of life is not simply a matter of procreation; if it were, then the concentration on the penis would indeed be one-sided. Life is bestowed by erecting, setting up, re-creating, re-forming; and all these energies and processes are "male" ones. COMING, 1975, in particular, concerns itself with these qualities as they reside in semen. And a new life has indeed come: not in the form of a new human individual but in that of a new awareness of life.

Other pictures emphasize the male sex in the guise of physical desire. HUNGER, SPERM EATERS and THIRST suggest the nourishing and nutritive properties of desire even in their titles (page 338). Sexual lust is seen here in terms of physical absorption and physical need.

In HUNGER, two erect penises mark the intersecting diagonals. In the upper corners are the heads that correspond to them; each mouth holds the other's glans. The reciprocity of the act is emphasized by the alternating use of red and yellow, which differentiates the participants without placing them in any order of precedence. What one has in red, the other has in yellow.

Similar in composition and colour to HUNGER is SPERM EATERS. Here too two men face each other; each holds the other's cock, and their mouths gape wide to receive

the spurting semen. Each is swallowing his own, while helping to feed the other.

The third picture in this group, THIRST, differs in colour from the first two. Here both figures are coloured in the same way. As in HUNGER, one penis crosses the other; this time each is black with a red glans. Yellow jets of urine shoot from them into the open mouths of the two black heads which are, once more, in the two upper corners of the picture. The absence of a colour distinction between sex and head, or between one figure and the other, sets THIRST apart from both HUNGER and SPERM EATERS, with their emphasis on the interaction of two different figures. THIRST stresses thirst without necessarily implying a mutual act of drinking, and thus acquires an emblematic character which alludes to the thirst for sex in the abstract. Thirst is shown as the bodily craving to ingest a fluid that in its turn is the essence of another body.

Alongside the pictures which show sex in terms of hunger or thirst Gilbert & George have produced others which belong to an apparently familiar context: that of penetration, fucking. This is not shown in the familiar, traditional guise of a penis thrusting into another body. Instead the decisive sexual quality is assigned to the tongue, an inner organ which can also be an outer one. Its varied characteristics as a soft, hard, inner, outstretched, dripping, wet, tasting, gobbling, darting, penetrating and mobile member expand the sexual context by involving the most vital principle of sexuality: namely the reciprocal osmotic contact between bodies. And so WINTER TONGUE FUCK shows a wide open mouth into whose black cavity a rigid tongue extends from above (page 339). Across the centre is a background of water-droplets, trickling down towards the lower mouth; and this draws attention to the adjective "winter" in the title. Like the winter moisture that soaks the arid ground, the water drips into the

waiting mouth. The other two words in the title, "tongue" and "fuck", reflect the specifically sexual character of the picture: the fertilizing physical act of penetrating into a hollow.

Another picture, TONGUE FUCK COCKS, centres once more on the tongue (page 341). But whereas "winter", in WINTER TONGUE FUCK, served to describe and qualify what was taking place, i.e. the tongue fuck, in this piece "tongue fuck" is there as a qualifying epithet of "cocks". Attention is thus directed to the cocks by way of the tongue, which serves to emphasize the characteristic that distinguishes each of the cocks.

A stiff red tongue, observed from both sides by two young men, stretches upward from an open mouth. The Mohican haircuts of both men, and their faces, are alternately coloured, much as in HUNGER. Beneath this scene stand five erect penises in a row. Each glans, a fleshy ball, is coloured the same red as the tongue. The tongue points upward, not downward as in WINTER TONGUE FUCK; and there is nothing for the tongue, or the penises, to point at. Everything, including the men's hair, seems to point upwards in one shared erection.

The male erection is the central theme: a pointed, upwardly mobile genital outcrop of the body. The red of the tongue and the cocks makes this connection explicit. TONGUE FUCK COCKS stresses the male organ as the representative of an outward, occasionally aggressive sexuality. Its urgent and at the same time undirected (outcropping) aspect is the focus of the pictorial action.

The pictures in which Gilbert & George address the vast theme of sex and sexuality are strikingly varied. Instead of singling out one narrow aspect of sexuality and defining it through its distinctness from some other form of sexuality, Gilbert & George show it under its diverse aspects: erotic Nature; physical desire as the urge to ingest; sexual aggres-

sion; sex as osmotic interchange; sex in the guise of a sacred, because life-bringing, icon. "Real" sexual activity, of the sort that is the subject of pornography – which organ works with which, and how – is beside the point. The focus is on the various images of sexuality and sex. Gratification, that over-taxed word, is not the point either; nor indeed is liberation from sexual oppression. The prime theme is the explicitly cor-poreal aspects of sex, in all their multifarious imagery.

Homosexuality of course plays a part in some of these works. In SPERM EATERS, for example, the homosexual nature of the transaction is obvious. Other pictures place heavy emphasis on the male sex. But however homosexuality may manifest itself here, this has nothing whatever in common with traditional forms of homosexuality. These have always more or less adhered to the framework of male-female sexual-ity, in that they amalgamate or re-enact the traditional roles of man and woman. They have also consistently laid claim to a kind of political status: by subverting the institution of marriage as sanctioned by the Church, they have acquired the aura of an anti-bourgeois revolt.

The homosexuality that appears in Gilbert & George's work is not anti-anything; nor is it a re-enacted union of two persons; nor does it represent a relationship of dependency. The only term for it might be "warrior homosexuality": not because it sets out to be destructive but because its characteris-tics are those of the warrior. For just as he fights alongside his peers, lives with them and shares his all with them, so the two men in SPERM EATERS or in HUNGER cross over and share their sexual hunger.

Quite aside from all the imagery of desire and impulse, sex does after all pose a question that is absolutely central to human life: a question of life and death. In THE WORLD OF GILBERT & GEORGE a sequence showing fruits in constant orgiastic motion is accompanied by these words:

Here in the dreamland of our anxious night the fruits behave. They speak and turn and roll with us in unending orgasms. Incest with varieties proud in main line pedigree, distorted in closed thought and seperated sense. Life in the cut-down object pieces groans for new turns and movements frustrated with their limited beings, they bump together yearning for new chance in action. Heavy with doomed history, optimistic with their cranky dream, they push fruitily on through the old orgiastic hours. With us they love and we through their night-dream love, reason with our passion. Strange weights, textures, flesh and seed move here for the scream of reason.

The questions implicitly raised here concern the nature of sexuality itself, as seen both in the light of the finiteness of life and in the light of reason. They are not questions that can ever be answered. Sexuality dwells within a field of tension whose poles are lust, desire and death; it takes the hard-won form and erectness of life and surrenders them to its urge for bodily interchange. Bodies break open and abandon themselves to a state of osmotic flux in order to regain their form. How these first principles of sexuality are to be dealt with, and how they may be formulated in human terms, is revealed in the pictures of Gilbert & George. The primary concern of these works is not with "gratification" or "satisfaction" but with the fundamental issues of love, sexual thirst and hunger.

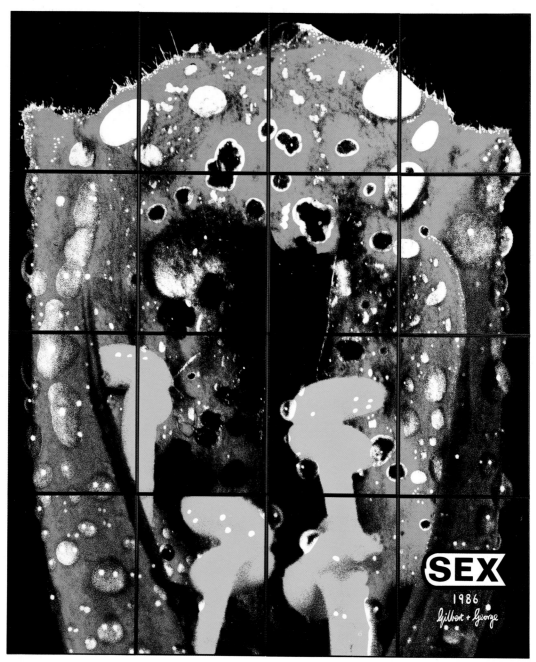

SEX. 1986. 241x201 cm.
A metaphorical use of plant forms can convey sex, and the workings of sexual
polarity, mory effectively than any human figuration.

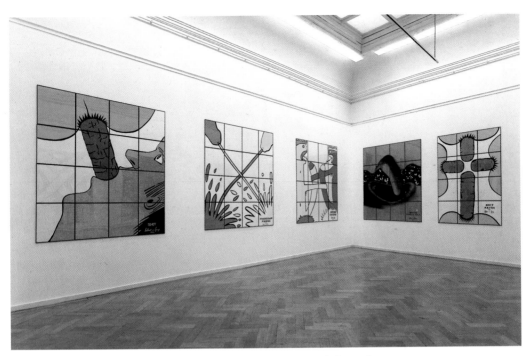

THE SEXUAL PICTURES. 1982–83. A special display at the Kunsthalle, Basle. 1986.

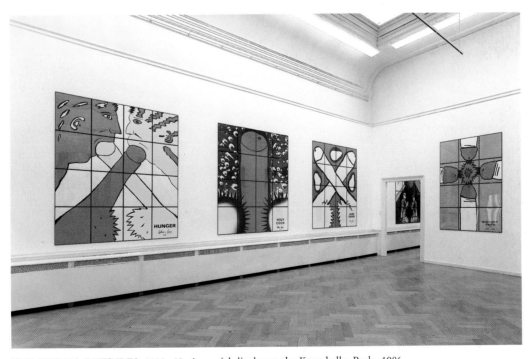

THE SEXUAL PICTURES. 1982–83. A special display at the Kunsthalle, Basle. 1986.

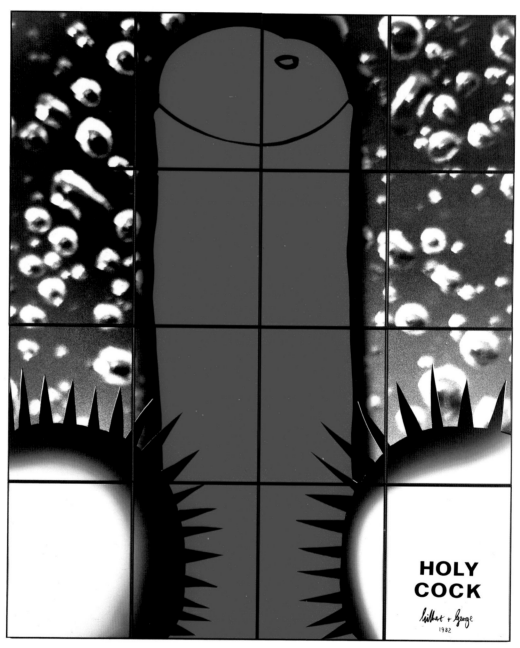

HOLY COCK. 1982. 241x201 cm.
Sexuality seen in the guise of the penis.

LOVE LAKE. 1982. 241x201 cm.
Sexuality seen in the guise of sexual interaction.

SPERM EATERS. 1982. 241x201 cm.

THIRST. 1982. 241x201 cm.

HUNGER. 1982. 241x201 cm.

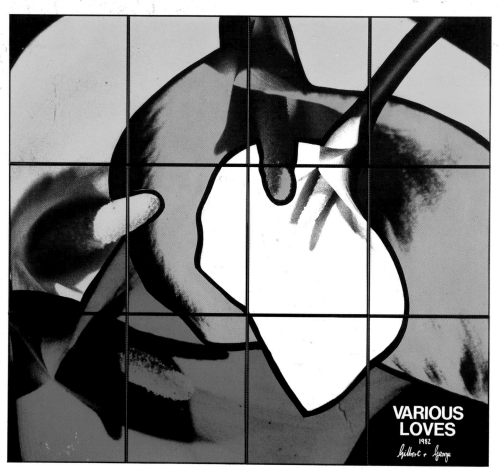

VARIOUS LOVES. 1982. 181x201 cm.

338

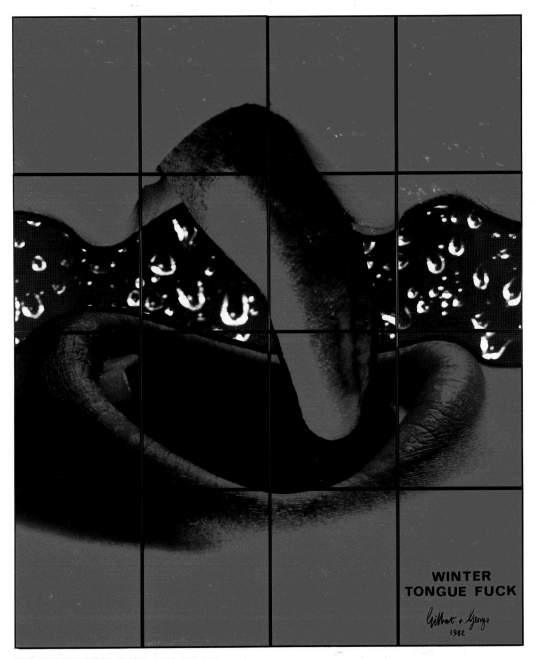

WINTER TONGUE FUCK. 1982. 241x201 cm.
The disciplining of sex, its forcible categorization into hetero-, homo- and bisexuality, is entirely
absent from Gilbert & George's pictures. Their concern is with the physical phenomenon of sex: the
osmotic process between bodies.

A phallic Tree of Life from the South Pacific.

"Rolling fruit" from Gilbert & George's film THE WORLD OF
GILBERT & GEORGE. 1981.

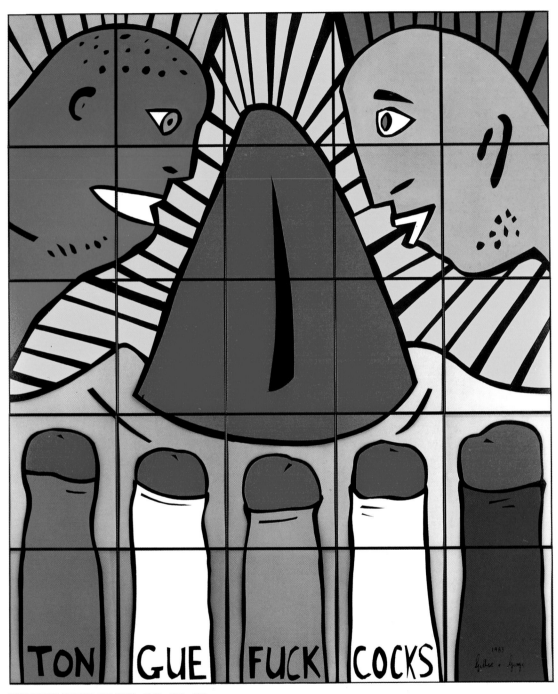

TONGUE FUCK COCKS. 1983. 300 x 250 cm.
The tongue stands for a multitude of sexual characteristics.

PARK SEX. 1981.

EXCITEMENT. 1981.

HUMAN
IMAGE

Chapter 11

The phase of Descent in Gilbert & George's career was marked by an almost exclusive concentration on themselves. Other people never appeared in any of their drawings, paintings or photo-pieces, with the exception of a few post-card sculptures, messages and invitations, and of the illustrations in the book DARK SHADOW. There, an upside-down image of a dapper young man is accompanied by the following text:

> We show the dark side of a pleasant character. A person of whom not one would speak unkindly. But here in the valley of the shadowy photographic angle the forms show definition of luck and concealed are movements of qualities of flesh and person.[105]

The acknowledged subject is the TRISTESSE of a fortunate existence; what is concealed, and at the same time sought after, are the qualities of flesh and person. No wonder this young man is standing on his head. He lacks the human "substance" that the artists seek; and this is essentially why other people are virtually absent from Gilbert & George's art in the early period.

Human Image

In the course of the Ascent phase there is increasing evidence of an image that sees and knows the human individual afresh. PAKI (page 226) and the other works of the same group give the person a central role. But WE, too – or rather WE above all – places the human face at the dead centre, the point of intersection of the cross, from which life unfolds (page 268). It is this face that accounts for the "we" of the title. The image of a human being, the visage (or vision) seen in God, defines Gilbert & George as a social unit. They acknowledge the image of man, which is in God, as the emblem of their shared identity.

The centrality of the human face in the art of Gilbert & George is further demonstrated in a picture with the title MAD (page 359). The only thing in the picture is the outsize face of a tramp. His features and his hair make his past history only too clear. A similar man turns up in the film THE WORLD OF GILBERT & GEORGE. To camera, he says several times: "I'm a mad man." The following spoken commentary accompanies his portrait:

> I am the mad man that nobody loves. My hair is filthy with grease because no one cares for me. MY MOTHER HAS LEFT ME BEHIND IN THIS WONDERFUL STATE TO LOOK AT YOU LIKE THIS. My teeth are rotten and I don't have nothing to care because I stumble from corner to corner and every place is my place of rest. The eyes are bad and I cannot see very well but it doesn't matter because I have nothing to care. I was in the war and got hurt twice, but I had no friends. But I love my Queen and Country and I DON'T HATE ANY ONE BECAUSE I DON'T KNOW ANY ONE SO HOW CAN I? [Emphasis added.]

The emphasized passages here will serve to cast light on the meaning of MAD. What exactly is mad about it? The man's appearance, or the man himself? Neither, would be the shortest answer. What is mad is not the man but the attempt to find in his face anything special, different or deviant from a supposed norm. The last sentence of the text, "I don't hate any one because I don't know any one so how can I?", turns such an endeavour on its head. What is truly normal is to look at another person uncritically, without preconceptions, and not to look into his face, his clothes, his behaviour, his thoughts or his feelings for something that demands an external explanation. The text says: "My mother has left me behind in this wonderful state to look at you like this." This means no more and no less than that his appearance is totally normal. It no more sets him apart from others than, for instance, hair colour would do.

MAD is about the judging, assessing look that has become excessively dominant in Western culture. Quite often a person's exterior, whether it be his appearance or his conduct, serves as a pretext for attributing to him a "false" mental attitude or a personal development that has gone "wrong", and which is therefore to be criticized. This kind of attitude is an intrusion, in which one person inserts himself into another's identity and employs it as a vantage point from which to pass judgment. Now this really is mad, especially if – as so often – the intention is to correct or reform the other, and to make one's own personal judgment and criticism, whether well-meant or not, serve the ends of a hypothetical but (in the critic's eyes at least) better society. MAD is a firm rejection of such a belief, and of its superstitious reliance on the notion of a unitary "Human Nature", an internalized truth which entitles human beings to call each other to account. So bankrupt and inhuman a superstition can only be described as mad.

Human Image

In pictures such as MAD, PAKI or COLOURED BLACK, the central theme was still the face of man. His visage was VISUM, a thing seen, and not the image of some hypothetical underlying reality, whether an ideology or a remnant of obsolete iconographic convention. Gilbert & George took it literally at face value. It would be disastrously wrong to read into this the notion that a significance once believed to be real had become superficial and empty. This is not what the artists had in mind at all. They were not mocking some obsolete way of seeing; they were simply perceiving the human face.

It is partly for this reason that Gilbert & George subsequently formulated a visual treatment of the human face and its presence that endowed the individual with a self-contained, autonomous validity. This was man perceived and formulated as sculpture. An idea that had initially served to express a negative, because exhausted, identity could now be seen anew in positive terms. Man as sculpture now meant that his appearance, and his essence, constituted a form independent of others and valid in itself.

The postures of the individual figures, above all, are emblematic of this. They sit, squat or stand without reference to anything external to themselves. There are no expressive gestures, no twists or turns of the body that might indicate inner conflict or desire for freedom. Man exists; he presents his form as his essence, his identity.

This new presentation of human beings as sculptures is often emphasized by the use of lighting. An example is MAN, which shows two distinct images of the human male. Five boys stand in a row, seen from the knees upward. The exposed parts of their bodies – heads, hands and arms – are red; their clothes are yellow. Between them, at the top of the picture, are the dark purple faces of four boys. In contrast to the standing boys, who seem mute and impassive, the faces

above have open mouths. Lividly coloured and lit from below, they look like demon masks.

Like the faces, the standing figures are united by uniform colouring and lighting. The standing boys are all lit from both sides to produce a line of shadow down the middle of their faces and bodies. This can be seen particularly clearly in the line of black that runs from the forehead down the nose to the neckline between the brightly lit halves of the face. The result is that the hollow under the lips, the bridge of the nose and part of the forehead are dark.

The consistent schematic use of light in MAN serves first and foremost to distinguish between the two qualities which are here attributed to man. The first is his relaxed, stable, erect form; here man is like a sculpture because only his finished, elaborated appearance counts. The other is the overtly demonic, destructive aspect expressed by the faces above. Man can be firm, finished, upstanding; he can also be aggressive and destructive. Both qualities, shown not in a single individual but in several, go to complete the image of MAN.

The uniformity of lighting, colouring and composition serves to emphasize the meaning of MAN, and to give the figures a sculptural appearance; but the picture still conveys the uniqueness of each of the individuals in it. It is precisely because they are identical in posture, colour and lighting that their own features are all the more noticeable. The deliberately ornamental arrangement of the figures, and their uniformity, go to make the "man" of the title, and each individual then refracts him through his own personality.

What happens in the formal design of MAN is repeated in a number of other works in which the artists use a repetitive pattern to emphasize individual features, the look that distinguishes every person from all others. This is a new view of individuality. Traditionally, individualism has been the belief that the individual (by virtue of independence of

thought or otherwise) is the unique custodian of an inner, eternal truth. Being different from others has thus entailed deliberately setting oneself apart from the crowd: one elevates oneself by lowering others. Gilbert & George counter this pretentious form of individualism by putting forward an entirely different image of the individual. Each is distinguished from others not by attitude or gesture but by his face and by the way he looks.

Another picture principally concerned with the individuality of the person and of his development is THREE WAYS (page 360). Here the person, his nature and his evolution are illustrated by three boys and three plants.

The boys are placed in a variety of positions on a blue base and in front of a silver wall. Those to left and right are standing; the one in the middle is on his knees. Behind them three enormous plants spread across the silver wall, each associated with one of the boys and corresponding with him in colour and to a certain extent also in form. At top left a green branch with red berries extends downwards. The boy in front of it stands with his legs slightly apart and his arms by his sides, looking upwards; he conveys an impression of stability and reliability. He echoes the form of the sprigs of leaves, and of the berries with their message of ripeness and fruitfulness. The boy in the middle is completely different. Still in a state of awakening and growth, he kneels on the ground, turns slightly and looks upward to see the world for the first time. This budding, opening quality is reinforced by the large flower that is seen above his head. Lastly, the third boy, on the right, steps forward. His arms, held a little away from his body, and his forward gaze, underline the idea of progression and motion. His plant, again, conveys the same quality. It spreads vigorously across the silver background, and its pointed leaves and innumerable blossoms carry the impulse to seek and to find.

THREE WAYS presents three ways in which a person may be constituted: ripeness, fruitfulness, stability; or blossom, opening, awakening; or advance, seeking, extension. The silver ground emphasizes the finding and growth of form, also the brief duration of both as compared with a human lifespan.

The deliberate association of plants with people in THREE WAYS points to the diversity of individual development. Each plant indicates what matters most for the individual concerned. But this has nothing to do with the arbitrariness of tying man to an external and universally valid Nature – the very concept of Nature, in fact, in which Gilbert & George in the course of their Descent could find no meaning. The plants represent an exhortation to growth, like that which formed the central focus of SPEAKERS (page 272). In that work, green fronds symbolized the artists' words. Here clearly distinguished plant motifs embody the aspect of life which each figure expresses. Nature is not some homogeneous stockpot into which everything is poured, but the foundation of a many-sided life. Its diverse forms and manifestations reflect the equally diverse formulations of the nature of human life.

THREE WAYS thus presents an image of personality that can best be explained, again, through etymology. "Person" is ultimately derived from the Latin PERSONARE, PER + SONARE, "to sound through". And through each of the three figures there resounds, in a way that is individual to him, the form, colour and individuality of the accompanying plant form.

The constitution of personality as it occurs in THREE WAYS is a highly moral and ethical issue. This may seem confusing at first sight, given the commonly accepted idea of morality and ethics as a set of quasi-legal formulas. The idea that morality is like a framework imposed from on high to

regulate and control human behaviour has a great deal to do with Christianity and nothing whatever to do with morality as such. Michel Foucault pointed this out when he made his comparison between the moral codes of Antiquity and Christendom:

> The will to be a moral subject, and the search for an ethic of existence, resided in ancient times above all in the effort to affirm one's own freedom and to give life a certain form in which one could recognize oneself, could be recognized by others, and in which posterity might also find an example worth following.
>
> This elaboration of one's own life as a personal work of art, even when it was lived in pursuance of collective canons of behaviour, was at heart a moral experience, a will-to-morality in the ancient world. In Christianity, on the other hand, with its religion of the written word, its concept of a Divine Will and its principle of obedience, morality came much more to resemble a rule-book...
>
> The transition from the ancient world to the Christian world is one from a morality which is essentially the search for a personal ethic to a morality which takes the form of obedience to a set of rules.[106]

At some risk of overinterpretation, it might be added that THREE WAYS puts forward a comparatively personal approach to morality and ethics. Instead of a system of rules or a code, three different moralities prevail, each according to the age, nature and interests of the person involved. Why should morality not be a picture and a work of art?

Human Image

As far as the individuals depicted are concerned, the works discussed in this chapter might with very few exceptions be described as sexless. It is true that all the people shown in them are male, but the themes do not primarily concern man as a sex. The men in them stand symbolically for Man, and these are images of the human race. THREE WAYS, for instance, is not tied to the male sex in any way. Its meaning and content are open to all, of either sex.

It is however noticeable that Gilbert & George do incorporate only the male sex, and of late mostly youths and boys, in their work. Quite aside from the general consideration that the artists' personal history and aspirations (the creation of their World) present them with exclusively male themes, there are two decisive reasons for this.

The first concerns the circumstances in which women have traditionally appeared in art. As the recipients of the love of men, as the objects of their desire, or even as the personifications of the Cardinal Virtues, they have remained in a state of dependence on male wishes, monopolized and in a sense trapped by the fantasies of men. In addition, they have continued to live with men in a state of historically founded and scripturally sanctioned mutual dependence – marriage – which provides the social nucleus from which the family grows. In order to exclude from the very outset the whole of this context of demand and desire, in all its ramifications, Gilbert & George use male models even where their sex is immaterial. This has more than once brought them accusations of covert pederasty.[107] Although there is no truth in this, and the artists use boys as they use other motifs – plants, for instance – purely as symbols, such an accusation serves to exemplify the persistence of those old-established modes of perception according to which persons represented in pictures must be the objects of the artists' private desires, whether as friends or as foes.

The fact that women encounter no women in the work of Gilbert & George has for them one decisive advantage. They can now approach values that are seen by men, without themselves being taken over and defined by the images that are used to express those values. It is open to women to accept the picture THREE WAYS, to find its pictorial content applicable to the female sex, or to reject it. It remains open in any case, for whichever sex; particularly as the title is THREE WAYS and not THREE MALE WAYS.

The second reason for the exclusive use of male figures – and this may now sound paradoxical – is indeed that the artists' concern is with a new, still-to-be invented form of friendship, love and sexuality between men. Although not all the artists' pictures deal with this – those that do so, such as HUNGER (page 338), are few in number in the context of their whole output – it is clear that the artists do take an interest in their own sex. It was, after all, "maleness", or male sexuality, that could find no fulfilment in the course of their phase of Descent. The item MANLINESS in the postal sculpture THE LIMERICKS (page 93), and the work TRUE MAN (page 121), had in common an evident lack of firm support. The traditional image of a man could no longer be worn or borne. Gilbert & George's crisis was a heartbreak, the abolition of an old image of love: the love that always harks back. As the love of "Nature" this was the yearning for a society that would unite all men in peace; as love between individuals, whether heterosexual or homosexual, its aim was the blending of identities through a mutual commitment to confession and self-revelation.

It is through their breach with this form of love – their heartbreak – that Gilbert & George have achieved a new awareness and a new vision of their own sex. Above all, this means not picturing it exclusively in relation to a sexual opposite number, or on the basis of an outworn form of love.

Human Image

In Gilbert & George's work, the main parts tend to be played by boys. It is through them that the artists formulate their vision of a new life and its imagery. The concern with youth, as expressed for instance in titles beginning with YOUNG or YOUTH, has its origin in the hope of a new life. The freshness, the unjadedness, the very immaturity of these boys stands symbolically for the future unfolding of a life that has as yet no existence. They are the heralds of an achieved reality that is to come. Youth is thus neither fetishized nor in any way desired. Nor are the artists flirting with a new generation, currying favour with their juniors, or patronizing anyone at all. Gilbert & George employ their male models exclusively to provide what any imagery of life must have: the human image.

Because this image is such an infinitely various thing, however, not even youth can always remain synonymous with images of flowering, purity and intactness. Even youth is used to convey ideas that bear no relation to the cliché image of youthful levity and freedom from care. Thus, the left-hand half of DYING YOUTH (page 358) shows a naked young man who is facing, on the right, a death sequence consisting of two apparently mummified children's faces, a pair of sightless eyes and a death's-head. The emphasis on the eyes – two pairs of infant eyes above, unseeing eyes in the middle and empty eye-sockets below – traces the whole process of regression that brings a young life to the grave. The youth is confronted with the prospect of an early death. This should not be interpreted as an admonition; but it is an unequivocal image of the death that sets its mark on every life, however youthful.

Three possible versions of an adolescent's growth to full personhood are shown in THREE WAYS (page 360). FIRED, which along with THREE WAYS has already been discussed in an earlier chapter under the heading of colour, prefaces growth with a process of burning (page 361).

Human Image

In the centre of FIRED stands a boy whose youthful nakedness is emphasized by the scanty white undergarments that he wears. To his right a great flame billows out of the lower left-hand corner of the picture. Its blue and yellow inner zones consist of a number of boys' faces; its outer red zone is an outgrowth that looks like coral. Into the flame there fall from above a number of faces, inverted and with open mouths; these may be the same boys who already appear within it. The same flame is consuming three great towers, all of them London landmarks (including in the centre the Monument, a commemoration of the Great Fire of London). The effect of this conflagration is enhanced by the use of a gold background, a direct reference to fire.

To the boy's left, Gilbert & George loom behind the buildings of a nocturnal townscape. In their cupped hands they carry the heads of two sleeping boys, and from their mouths, once more, sprouts the speech that conveys growth, in the shape of fruit-bearing branches at which the boy looks. The artists are separated from the boy, and from the fire, by a river; but this is crossed by a bridge.

In FIRED, Gilbert & George quite deliberately cast themselves in a "paternal" role. They convey to the growing boy an image of his own potential development and evolution. On the one side they indicate the necessity of fire, in which old, rigid and established forms are consumed. The fact that these forms are burning together with other boys is a further allusion to the father theme. The towers stand for the father figure, established and outworn. In the flames to which both fathers and sons are committed, the fathers are burnt. The product of combustion is represented in its ashy, white, naked rawness by the boy in the centre. He wears undergarments instead of normal street clothes. His own potential further evolution is alluded to in the branches as well as the heads borne by Gilbert & George. The boys' sleep, as in ALIVE

(page 314), is a process of silent growth in which life – as the branches in the artists' mouths proclaim – draws nearer to its goal of form, fruit and ripeness.

And so, in FIRED, father stands against father. But whereas one, the old father, is a rigid, ossified form, the other is a herald of developing form, free of preordained and prefabricated structure. The boy is still on the near side of the river, the side on which the old father perished; but he can cross it and thereby further the plant-like, organic growth of his own form.

The fact that in FIRED Gilbert & George preface the image of growth and individual development with that of consuming flames may possibly sound like a hackneyed piece of myth-making. But FIRED comes into its own when it is seen in the context of Gilbert & George's evolution as a whole. It is because the artists themselves have incinerated a rigid and outworn father figure, and evolved a new life from his ashes, that FIRED is anything but a perfunctory application of myth. This picture contains their own history and their own experience. Burning the father means killing not one's own bodily father but the father who has implanted himself in oneself as a form which governs thought and perception. Having experienced for themselves the value of such an act of destruction, they can afford to recommend it to others. Seen from a historical perspective, they are thereby offering a traditional way of killing life to give life: this is what has been discussed in the Introduction (see pages 27–31) under the name of sacrifice.

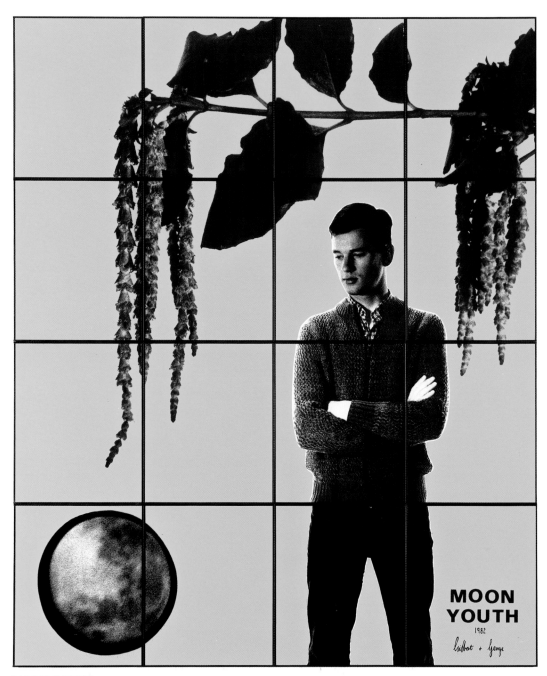

MOON YOUTH. 1982. 241x201 cm.

The man we sometimes see is smiling nicely. His hair well groomed, his heavy suit and neat fashionable appearance make him a friend of ours. He is quiet and still and has a shadowed portrait face of handsomeness. We see in him the feelings, subjects and materials of the living person. He reminds us with heavy heart of our need of years life sense without the normal misery of grey time with people that we always dread. We would not know of something to say to anyone but this fellow now here.

82

OUR FASHIONABLE FRIEND

Text and plate from Gilbert & George's book DARK SHADOW. 1974.

"Happy drunk" from Gilbert & George's film THE WORLD OF GILBERT & GEORGE. 1981.

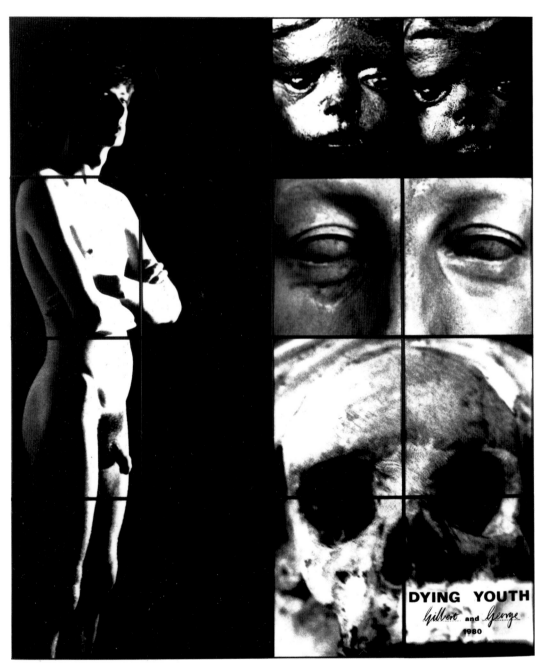

DYING YOUTH. 1980. 241x201 cm.
The image of youth is not all carefree high spirits.

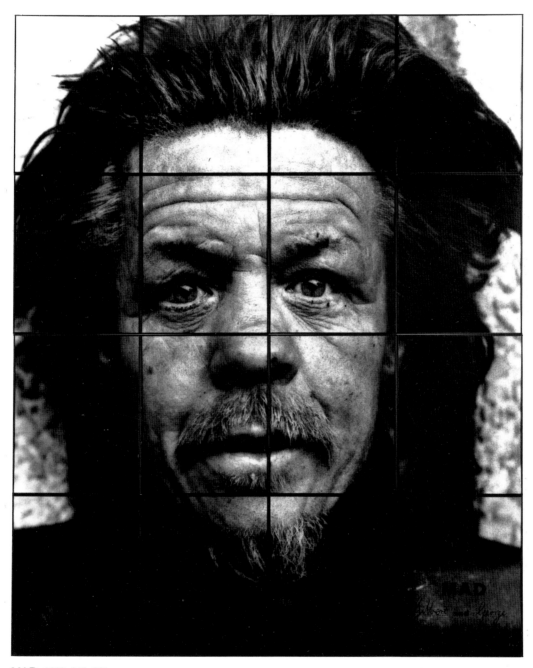

MAD. 1980. 241x201 cm.
"My mother has left me behind in this wonderful state to look at you like this."

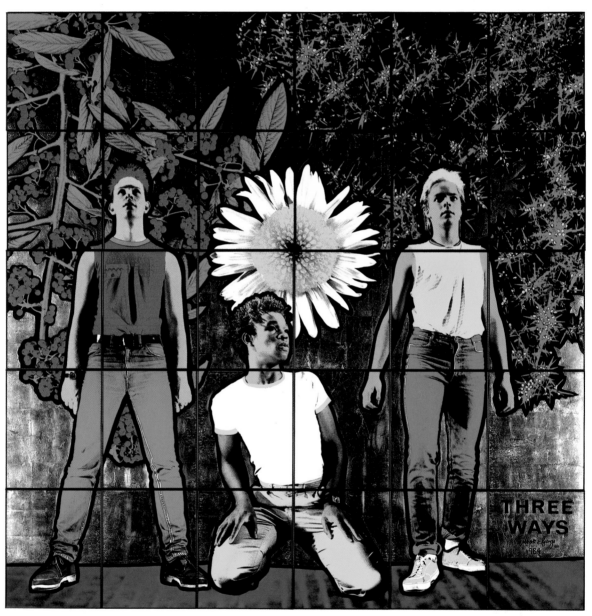

THREE WAYS. 1984. 302 x 301 cm.
Three personal ways to an aesthetic of existence.

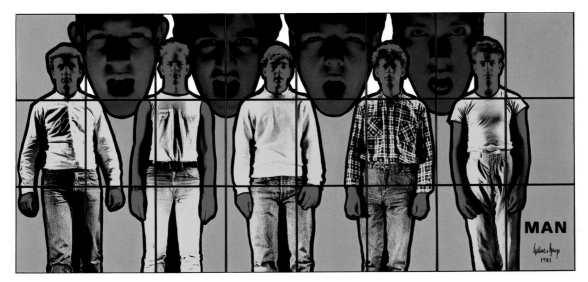

MAN. 1983. 181x401 cm.

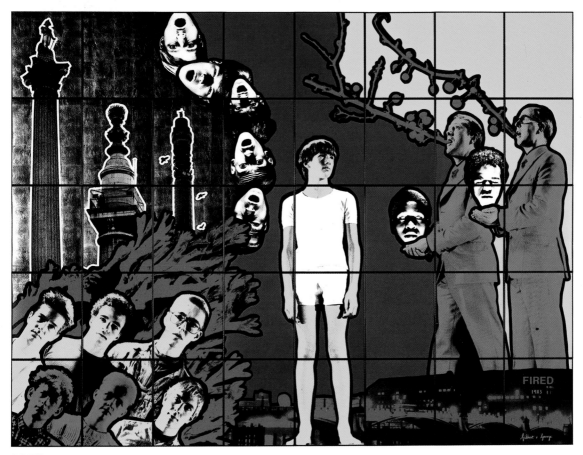

FIRED. 1983. 302x401 cm.
A great flame (left) consumes an array of father figures. After the fire, the son in his white garments
of purification represents the ashes. He stands and watches the advent of a new life in the form of
branches and fruit.

POST-CARD SCULPTURE. Summer 1974.

POST-CARD SCULPTURE. Summer 1974.

FAITH

Chapter 12

In the course of Western history there has been one profound upheaval in religious faith whose consequences persist to this day. One of its causes was the collapse of the geocentric view of the universe. First the earth, then the sun, and consequently also man himself, were compelled to yield up their central position in God's universe. Man has since eked out a manifestly limited and permanently unfathomable existence alongside billions of other astronomical objects in a more or less infinite cosmos. The impact of this realization on religious faith was all the more shattering because it deprived it of an important supporting structure. The reality of a divine kingdom beyond and above the earth was progressively demolished.

By degrees, Western man nevertheless found a way to absorb this shock. He compensated for the loss of God-given certainty by discovering and exploring his own world. Through the Enlightenment, and the consequent dismantling of traditional structures of power, he sought to establish on earth his own definitive and binding system of reality. All this took place in the blind confidence that his discoveries would give him back what he had lost: a valid sense of being, a

universal truth in which he would feel himself to be at home. This hope of finding an ultimate reality in this world took the place of the earlier belief in an other-worldly, God-given reality (or Nature).

Seen in this perspective, the sacrifice enacted by Gilbert & George reveals itself as a second and still more fundamental upheaval. In their World, the ground of being which underpinned both the former extramundane reality (or Nature) and its later mundane counterpart no longer exists; they have purged it by fire. What was an upheaval has become total destruction. For them there is no firm ground anywhere to underpin life or give it meaning or shape. All that counts is the cosmic sexual polarity from which life emerges and in which life dies.

Of course there already existed – at least in the domain of philosophy – a theoretical understanding of the nullity of all being: this was Nihilism, an intellectual construct that set the seal on the invalidity of all concepts of hierarchy and value. What sets Gilbert & George apart from all Nihilist, or indeed Existentialist, currents of thought is their faith in life. Instead of resting content with the declaration that all is a Void – a declaration that can of course be made at any time – they invent and create life anew. The Void is too poor a thing to base a life on: it is in fact nothing but an admission that one has failed in the search for a comprehensible, verifiable, certain existence. Gilbert & George are not concerned with such a search. And for this very reason the apparent Void, the loss of firm ground, becomes the source of a plenitude of life.

Faith has an especial significance in Gilbert & George's new awareness of life. It brings with it the hope of all that is unfathomable but nevertheless livable and above all seeable. Faith is at times the principal motive force in the work of Gilbert & George. Ever since what in conventional terms can only be described as a catastrophic start to their career, faith

and the hope of a better life have remained their true strength. There is in them no foreknowledge of their own future evolution: only the faith in another, undefined life has sustained their new awareness, their form of perception, and the consequent formulation of images. Faith is life. What it is not, is the certainty that there exists a life beyond this world; nor is it a commitment to some extra-human and superhuman world-order.

Faith for Gilbert & George does not involve subscribing to any imposed doctrine of salvation and belief; and they show this through the image of a man of religion. The face of MULLAH (page 378) is assembled from images of planed planks of wood; the graining and knots make up the eyes, nose, mouth and cheeks. The overall effect is that of a lined, wrinkled countenance. More mask than face, MULLAH is a rigid structure of lines and dots, an all-encompassing linear pattern traced in the dead wood. Here, as in a number of previous pictures (such as BAD, page 312), an assemblage of lines dominates and defines the picture and imposes a coercive and inflexible state of servitude, stamping and creating the face. The face of MULLAH is the epitome of every kind of religious teaching that claims the absolute prescriptive right to control human behaviour.

With means that are very similar to those employed in MULLAH, FLOOR PLANTS (page 378) conveys a completely different concept. Here strict linear discipline is deliberately undermined. Four adjacent floorboards form the background of the picture. Across the grain of the wood lie a number of twigs tipped with berries. Some of these intersect, some are crooked, and one is obviously broken (top left). The picture itself is divided horizontally into two zones, and on close inspection it becomes apparent that the lower zone is a continuation of the upper one. The twig at top right is the same one that appears at bottom left. So here too there is a

break, a hiatus that stops the flow of a normal reading of the picture.

FLOOR PLANTS is thus the exact antithesis of MULLAH. In MULLAH, lines impose form on a face and strictly govern its physiognomy; in FLOOR PLANTS the plants lie athwart the horizontal lines of their ground, and their manifold and incestuous intersections defy its directional force. Incest or no incest, they bear fruit, an indication of their capacity to further life. This is countered in its turn by the deliberate breaking (killing) and superimposition of some of them.

MULLAH and FLOOR PLANTS are not images of faith. In neither case does title or content embody any such message. What they do is to symbolize two fundamentally different approaches to the primary essence of faith, which is life itself. In MULLAH the approach is that of obedience, the observance of a teaching which is accepted as sacred. The face here is not the human face as such – like the one in WE (page 00), for example – but a rigid, inflexible, inorganic-looking structure. The organs of sense are connected by a set of lines. This image of interconnection and linkage exemplifies all those teachings that seek to bend humanity to the observance of a set of precepts (whatever the specific precepts may be). FLOOR PLANTS negates such an idea absolutely. The plants cross and are crossed without allowing any one direction to be prescribed or imposed.

In FLOOR PLANTS the fruit, specifically berries, stands for contact with life. PRAYING (page 378), too, shows fruit; this time it is shown above images of the activity proper to faith, which is prayer. Gilbert & George have put themselves into the picture twice over, frontally in the centre and in profile at the sides. Their palms are placed together in a gesture of prayer. They are looking at their hands, which point upwards towards a fruit-bearing branch placed horizon-

tally across the top of the picture. In contrast to the black and white of the rest, the branch has a yellow overlay. It represents the object of the prayer, which is hope, and the petition for fruit, or, in general terms, for fruitful life.

One of the sequences in the film THE WORLD OF GILBERT & GEORGE is directly related to PRAYING. It begins with profile shots of the two artists, as in PRAYING, and they gradually turn until they are seen frontally. Then Gilbert & George say the Lord's Prayer, each phrase being accompanied by an image from urban life. Here is the text of the prayer with the appropriate visuals, as given in the script:

LORD'S PRAYER	VISUAL
Our Father	Stone Jesus.
Which art in Heaven	Sky.
Hallowed be	Graffiti Christ.
Thy Name	
Thy kingdom come	Townscape.
Thy will be done	Soldiers fighting.
On Earth	Church reflected in puddle.
As it is in Heaven	Church spire.
Give us this day	Sun through trees.
Our daily bread	A dinner.
And forgive us our trespasses	A drunk on the floor.
As we forgive those who trespass against us	A youth.
And lead us not into temptation	Rubbish and dirt.
But deliver us from evil	Gilbert & George frame townscape.
For Thine is the kingdom	Victory Sculpture.

Faith

The Power	Battersea power station.
And the glory for ever and ever Amen.	Sunset.

It is immediately apparent here that, as well as finding visual equivalents for the seven specific petitions of the Lord's Prayer, Gilbert & George also do so for certain key words. Heaven, Earth, power, glory and temptation are all illustrated by urban imagery. Even the name of the Father is a scrawled "Christ" on a wall. It is precisely this – calling the Father by the name of the Son – that constitutes the essential mark of Gilbert & George's version of the Lord's Prayer. The Father himself, together with his extra- or supraterrestrial kingdom, is virtually absent. The Father is a "Stone Jesus", his name is the name of Christ, and his kingdom is an earthly townscape. Just once, the image of an empty sky refers directly to the Father "which art in Heaven"; but he himself has just been equated with a stone Jesus. The Father has no image beyond that of his dwelling place, his impenetrable origin. The artists pray only to the Son, and to his place of operation, the Earth – here shown as the city.

It is a moot point whether the implied equation of the Son with the Father raises the old question of the identity of the two. But the Son is here set in the Father's place for other than theological reasons. The prayer, in its text and in the imagery that accompanies it here, is not directed towards a life after death; it expresses no hope of being taken into the presence of God the Father, but concentrates almost exclusively on this world. Accordingly, only the opening invocation of the Father appears without an urban image. Otherwise the prayer emphasizes earthly life and seeks to make it prosper in the places where man has his dwelling. And this is precisely

why Jesus Christ functions in this particular Lord's Prayer as the Father. His work on Earth is praised as a divine event which is also human. The divine will is represented by soldiers in battle array (or, more precisely, on the march), divine power by a power station, and temptation by ordinary dirt on the street. What Jesus Christ performed on earth as a divine man, men may perform in the name of divine power on earth.

These direct parallels between divine will and divine power, on the one hand, and human activities on the other, are not to be mistaken for blasphemy or irony. It is truer to say that the interweaving of the divine and the human in the Lord's Prayer sequence is a reference to another fact altogether: the absence of God on earth. God as Prime Being, or as Father of the Son Jesus Christ, is and remains a being of the imagination. His existence is as dubious as it is uncertain, taking shape only when it manifests itself on earth and becomes incarnate. But this is no longer the Prime Being or the Father but God as Son, or broadly speaking as Man. This means that the Son exists because of the non-existence of the Father, or because of the impossibility of knowing him. This raises an ancient, intractable paradox of faith. Man can experience his world, his activity and his creation as divine, without ever knowing the prime cause of all this as God.

Consequently, when Gilbert & George juxtapose the work of God with the work of man in a direct pictorial and textual parallel, what they are doing, virtually, is presenting the knowledge of the unknowability of God. And when they honour God in the image and in the name of Jesus Christ, the awareness emerges that the God of transcendence belongs to the realm of imagination, if not illusion. And yet the more God himself is absent, the more the divine is revealed in the human. This is why Jesus is central to the artists' prayer. He is the symbol of the more or less total absence of God, and of the operation of the divine will in the deeds of men.

Faith

Human activities and behaviour have always been regarded as, in varying degrees, profane as distinct from sacred. This is mainly the consequence of a traditional conception of God according to which God – and indeed his Adversary – were regarded as transcendental powers holding sway over mankind. However, as the other-worldly existence of these powers increasingly came to be recognized as an illusion, people tended to leap to the conclusion that God and the divine were not there at all. Man found himself facing a totally profane universe. He himself, his world and his cosmology were profane, desacralized, rationally comprehended. But God is like a hollow vase. Inside he is empty, but through his outer, transitory, mundane shell he manifests his divine activity for good and ill. He himself has no life, because he imparts it to others who he is not. It is to this life, this activity and this growth that the artists are offering their prayers in PRAYING, and also their Lord's Prayer in the film THE WORLD OF GILBERT & GEORGE.

In connection with the Lord's Prayer more needs to be said about the figure of Jesus Christ. He has an important place in the work of Gilbert & George in two ways: firstly as the Saviour figure in whose name a historical development took place; secondly as the man who gave his life for men.

In the former aspect, Christ is cast in a decidedly negative light. Not because of his life or actions, but because his Resurrection and Ascension gave rise to an ultimately untenable and unworkable form of awareness. As described in the Introduction (see page 44), this aspires to unite and liberate all men in the name of a rational form of justice. Its profane forms, Communism and Socialism, reveal themselves on the contrary to be ways of enslaving humanity. For all their lofty social aspirations, both are doomed to failure because they can conceive social existence only in terms of equality before the law, not of an imagery which leads to life. To long for a

society that will unite all men in peace is to ignore the sexual pole of death, which is an equal aspect of life: to ignore it so totally that death is no longer perceived. Pictures such as DEAD KING or ANTICHRIST (page 218) thus present Jesus Christ in his negative, invalid manifestation.

In his second aspect, as a man, Jesus Christ takes on an eminently positive guise. The Lord's Prayer sequence in Gilbert & George's film is one of many works in which they take the human Christ as their theme. He is seen here as the man who shed his blood for his fellow men. His suffering, his self-abnegation, his cry to God, serve to epitomize human life in all its hope and its hopelessness. He offers up his own life in order to free mankind from a curse. When he suffers death, he is taking a leap in the dark. On the cross itself he cries out in despair: "My God, my God, why hast thou forsaken me?" His faith has no warrant, his hope is not certainty. Nevertheless he has faith in faith, learning to trust in life instead of entrusting life to some higher judge.

As well as being an inherent motive force of the artists' life and evolution, faith is also part of the substance of many of their works. Titles not infrequently include the word, as in SHIT FAITH, DEATH FAITH or FRIENDSHIP FAITH. The word "faith" itself adds to the idea of simple belief that of confidence and trust, which in turn refer to particular aspects of life and of death. Any view of life whatever can be a matter of faith. This whole aspect of faith and belief is related to the original, i.e. pagan, meaning of the word "belief" itself. Its root, which it shares with the Old English GELEAFA and the German GLAUBEN, means to hold dear, or ultimately to love.[108] It expresses a friendly relationship to a deity instead of the attitude that the Christian conception of faith demands, which is one of worship and moral obligation towards God.

FAITH as a mode of access to life is balanced by those other works that have the word FEAR in their titles, such as

Faith

LIVING WITH FEAR, MOUTH FEAR and DAY FEAR. Faith on the one hand, and fear on the other, represent basic attitudes to life itself, which can inspire confidence or anxiety. This view, which takes as its point of departure not so much people as things in themselves – the things that inspire the anxiety or the confidence – also finds expression in two major groups of works. In 1980–81 there was the group MODERN FEARS, in 1982–83 the group MODERN FAITH. Not every picture in these groups deals with fear or faith specifically, but the general tenor emphasizes, respectively, the anxious and the confidence-inspiring aspect of life. A third group on the theme of belief is THE BELIEVING WORLD (1983).

SHIT FAITH once more employs the cross as its central pictorial structure (page 379). On the four edges of the picture are four pink bottoms. From the anuses with their black radial creases, brown turds emerge perpendicularly. These form a cross without actually touching at the centre.

The cross form and the title run the risk of misleading the viewer to see the picture as a denunciation of the Christian faith and its central symbol of hope. In the light of the fact that Christianity has increasingly come to repress all that is dirty, as represented by shit, such a view is understandable. But this is not a denunciation, nor is it an attack on the Christian symbol. What SHIT FAITH sets out to do, with the aid of the cross, is to inspire some faith in something that has hitherto been treated simply as a swearword or as something to be swiftly disposed of. What to the body is a foul, stinking mass has been placed in the form of a cross. This is the broken-down, exhausted, digested, malodorous residue of what was once pleasant and colourful food. To see it as a cross is not to desire it or to glorify it; but the cross of shit raises to the status of form something that was once in itself necessary to raise and shape life itself. SHIT FAITH gives expression to the hope that new form and life will arise from corruption.

Faith

"Faith" is a very general word. In itself it suggests very little. It is only in conjunction with something else that its implications of trust and confidence take on their full meaning. The bandwidth of "faith" is as great as that of "life" itself, and so the word appears in a number of quite distinct and disparate contexts. Thus NAKED FAITH (page 381) places the theme of faith in a completely different frame of reference from that of SHIT FAITH.

The naked human figure at the centre of NAKED FAITH represents a theme that has been prominent in Gilbert & George's work since 1980. In that year, FOUR FEELINGS (page 293) showed a naked boy from behind. Other pictures give other views of nakedness, which is often mentioned in their titles, as in NAKED, NAKED BEAUTY, NAKED FOREST or NAKED LOVE. Clearly, NAKED FAITH belongs to this class of works.

In formal structure NAKED FAITH is precise. Figures and plants correspond symmetrically in size and colour. The central motif, a naked boy with a yellow overlay, is the same size and the same colour as the two flowers at the sides which divide the field of the picture into a central red area – a cloudy sky – and a dark blue ground at either end. Backed by the red sky, the central, powerfully built youth is flanked by two others, shown in black and white and markedly smaller in scale. The one on the left is looking upwards; the one on the right is trying to take off his shirt. He is evidently undressing to follow the example of the figure in the middle. Finally, Gilbert & George appear in front of the two flowers; they are the same apparent height as the two boys. Coloured pink, they stand guard stiffly.

NAKED FAITH focuses on the state of nakedness, one of the most difficult, perhaps, for human beings to endure: not because there is anything complicated about being naked, as such, but because it throws the human individual back on

what he cannot alter. He can dye his hair, choose his clothes, change his voice through elocution lessons or even tattoo his skin. but none of this changes the fact that he has a naked body. With his body he is on his own, and there is no changing it. If some prevalent norm seeks to force the human body into the image of an ideal, the individual's predicament is a lonely one indeed. If he subscribes to the norm, he will have to try to shape his own body accordingly, whether by concealing it or otherwise.

Irrespective of any ideal of physical perfection, NAKED FAITH seeks first of all to inspire faith in nakedness itself. The picture shows the nakedness of a young man. He is neither showing off nor practising exhibitionism. Not he but his nakedness in person looks out at the viewer, just as the two flowers show their outward form. Nakedness here presents itself as a figure (a god, one might also say) that demands to be perceived in the absence of value judgments, as part of a human truth. Just as the two boys look at it, and one of them begins to assume the same state, the viewer looks at it too. There is no room for voyeurism. Nakedness presents itself while offering faith in itself: faith, in fact, in the nakedness of every individual. NAKED FAITH means Faith in the Naked; "naked" is not an epithet applied to "faith".

The new awareness in Gilbert & George takes on a wealth of qualities, images and values, all of them worthy of faith. But faith, even when it takes the form of believing in something, cannot be placed on absolutely firm ground. Faith raises questions that always remain unanswered and which consequently call faith itself into question. These are the questions of life itself, its meaning and its purpose. In THE WORLD OF GILBERT & GEORGE the artists put these questions to a number of youths. With one exception all the questions are concerned with purpose and intention, i.e. the question "What?"

"What do you wish for most?"

"Who would you most like to be?"

"What is your definition of happiness?"

"What is your definition of unhappiness?"

"What was the most interesting thing that ever happened to you?"

"What was the worst thing that you ever did?"

"What makes life worth living for you?"

"What would make life unliveable for you?"

The answers come rather uncertainly. Some questions are answered, some are met by silence. The questions seek something that strictly speaking can never be defined. Neither the youths themselves nor their supposed ignorance should be blamed for their failure to give a clear answer to an apparently straightforward question. The basic question that is being asked is whether life is worth living. If there is no certainty that any meaning exists before and after the individual's life, then what is life worth? What is the point of living for a period of time which has no Before and no After and which is itself marked by scarcely one value worth living for?

The questions that Gilbert & George put to these young men are certainly not intended to evoke some facile assertion of the meaninglessness of life. The attitude is neither one of apathy nor of existential doubt. Nor is this an attempt to justify living from day to day and leaving life as it is. The questions represent the antithesis of faith, but also the motive power of faith. They embody neither doubt nor glib reassurance nor condemnation of life; only the curse of faith. Faith is an essential qualification for being alive; and faith alone makes it possible to formulate an awareness of life. But it invariably brings with it the question of life's meaning. It is the unanswerability of this question that is the curse of faith.

Alongside the pictures that in their different ways give

expression to faith in life, there is one that shows the shadow side of faith. Its title is the only one in which the word FAITH stands first, thus placing an emphasis on faith which is further reinforced in the picture itself by a stone head of the ultimate representative of faith, Jesus Christ. FAITH CURSE (page 384) shows him in black and white, half in light and half in shade. Accompanied to left and right by a blue and a green clump of blossom, and above by a single red bloom, the head looks the viewer straight in the eye. In front of him, and beneath his chin, there crawls a procession of insects. These, like the blooms, are marked by a colour overlay, in this case a brownish orange. Both together form a sort of frame through which Christ seems to be peering.

The curse pictorially formulated in FAITH CURSE is an image of endless, aimless crawling. Like the insects, mindlessly moving on towards their unknown destination, faith too sometimes seems like a blind perseverance in some purposeless routine. Faith seeks life – in all its form, bloom, colour and design – without ever knowing why. This is its curse, manifest in the shaded side of the head. However, as the brightly lit, seeing side of the head shows, this is also its motive impulse.

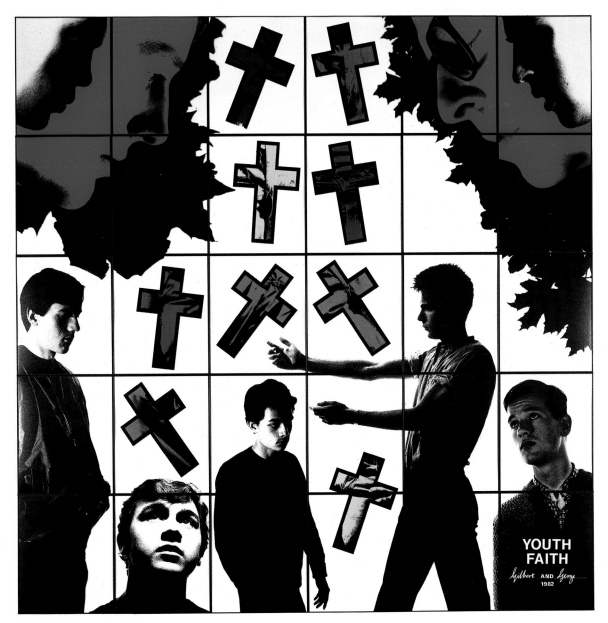

YOUTH FAITH. 1982. 302 × 301 cm.
The unfolding of life, and its supporting structure, are symbolized by crosses. These crosses have
contents which indicate that this is a sexual path.

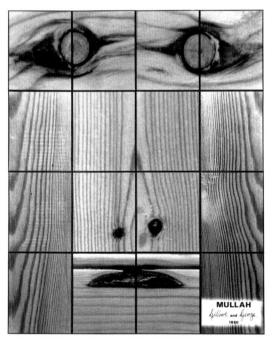

MULLAH. 1980. 241x201 cm.

FLOOR PLANTS. 1980. 241x201 cm.

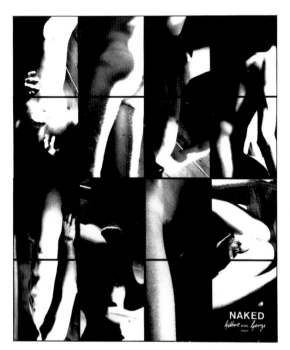

NAKED. 1980. 241x201 cm.

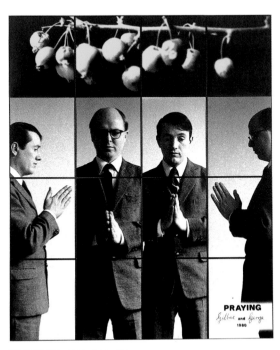

PRAYING. 1980. 241x201 cm.

378

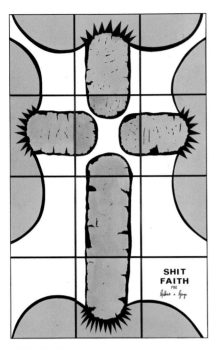

SHIT FAITH. 1982. 241x151 cm.

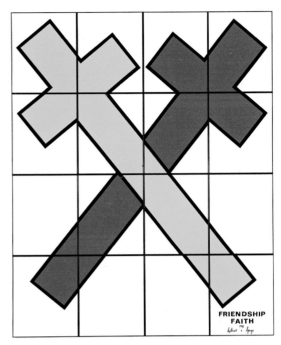

FRIENDSHIP FAITH. 1982. 241x201 cm.

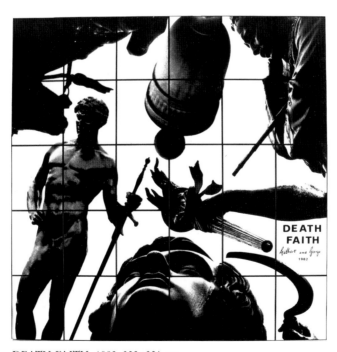

DEATH FAITH. 1982. 302x301 cm.
The value of everything – be it excrement, friendship or death – is accessible to faith.

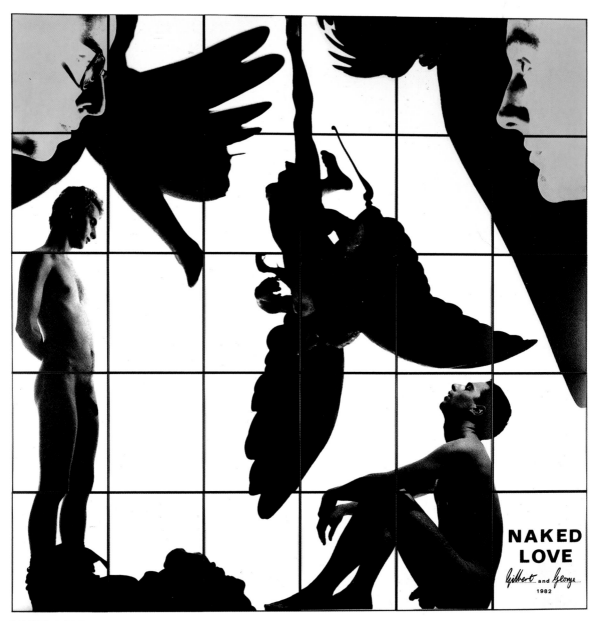

NAKED LOVE. 1982. 302×301 cm.

Nakedness has as wide a spectrum as colour. This becomes apparent in NAKED FOREST (right),
with its seven icicles in six different colours. Like the leafless trees in the background, all the icicles
are bare; but they are nonetheless differentiated. This hints at the quality of "naked", as embodied by
the young man. "Naked" does not imply a reductive state but a positive quality.

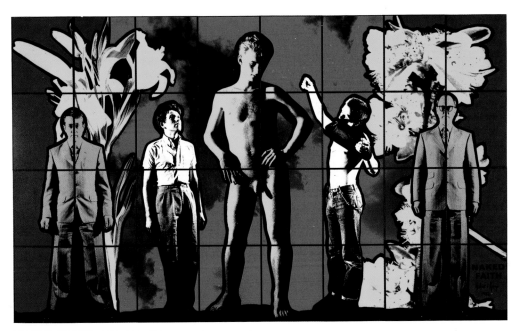

NAKED FAITH. 1982. 241x401 cm.

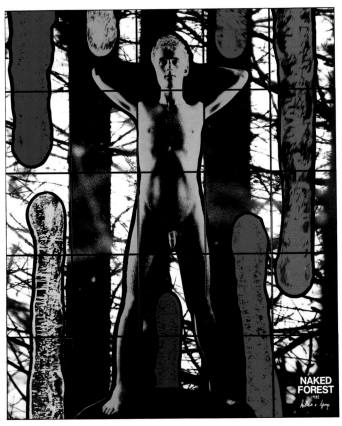

NAKED FOREST. 1982. 302x250 cm.

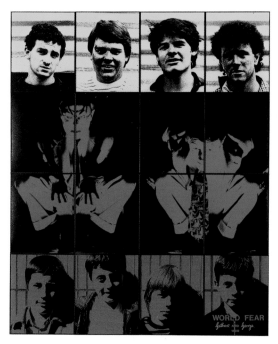

DAY FEAR. 1980. 241x201 cm.

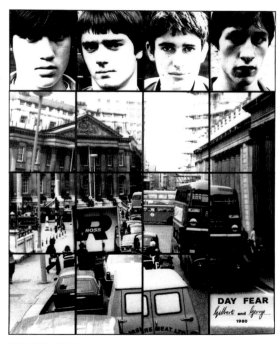

WORLD FEAR. 1980. 241x201 cm.

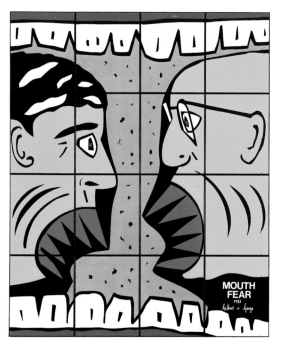

MOUTH FEAR. 1983. 241x201 cm.

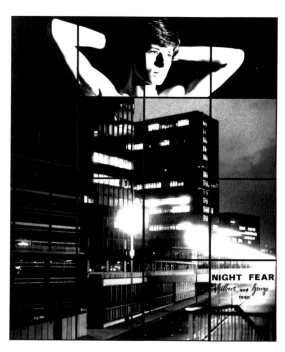

NIGHT FEAR. 1980. 241x201 cm.

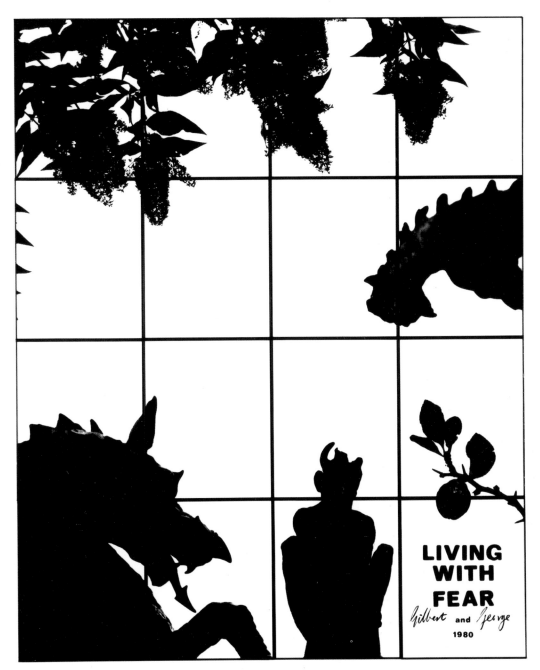

LIVING WITH FEAR. 1980. 241x201 cm.
"Fear" is the polar opposite of "faith"; and, just as the world and its multiple manifestations are
accessible to faith, the same applies to the antithesis of faith.

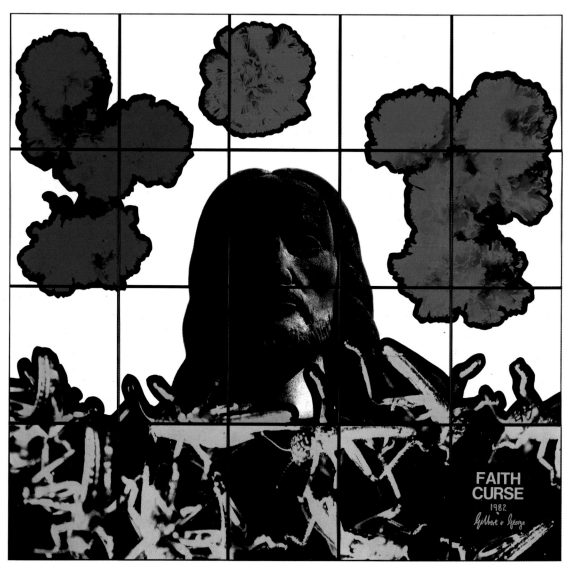

FAITH CURSE. 1982. 241x250 cm.
Every image and every value has its negative side; so has faith. Sometimes it labours under a curse:
the curse of losing its destination.

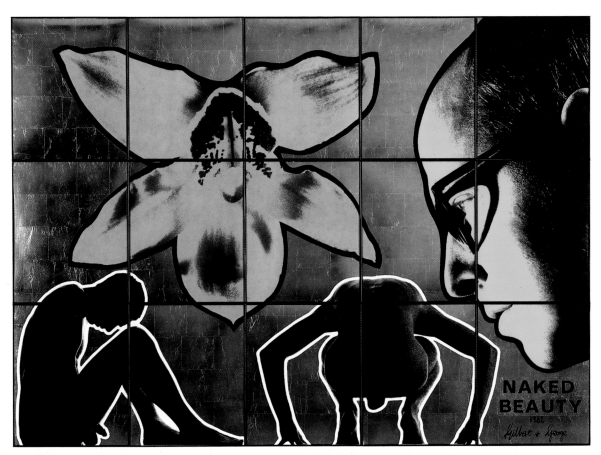

NAKED BEAUTY. 1982. 181x250 cm.

Our Father.

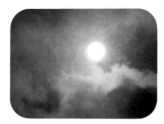

Which art in Heaven.

Hallowed be thy Name.

Thy kingdom come.

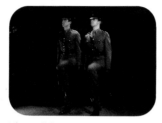

Thy will be done.

On Earth.

As it is in Heaven.

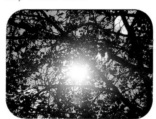

Give us this day.

Our daily bread.

And forgive us our trespasses.

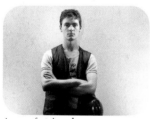

As we forgive them
Who trespass against us.

And lead us not into temptation.

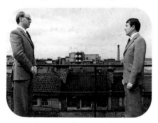

But deliver us from evil.

For thine is the kingdom.

The power.

Stills defining the Lord's Prayer,
from Gilbert & George's film THE
WORLD OF GILBERT & GEORGE,
1981.

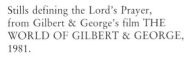

And the glory, for ever and ever. Amen.

In Gilbert & George's version, the Lord's
Prayer concentrates exclusively on the
human being and his world.

IMAGINATION
and
INVENTION

Chapter 13

The worsening state of confusion that prevails on the subject of creativity, its meaning and its purpose, makes it appear well-nigh impossible to make any firm statement about the creative energies of the human individual. The word "imagination" gives no insight into the productive visualizing power within every individual which evokes and narrates that person's life. The degree to which individual creativity seems to have been lost, consumed and exhausted by the art of past centuries, goes far to suggest that nothing is left of man's creative powers. But this is only half-true. It is indeed the case that those of Western man's creative powers which lived on all that was suppressed, hidden, unexplored and tabooed, and which now eke out what can only be described as a post-mortem existence by simulating the artistic attitudes and styles of the past, are irredeemably extinct. The very idea of the individual, as an indivisible being in whom a compelling, unique truth resides, is acceptable only in that it focuses on the fundamental diversity of human beings.

It would, however, be fatal to deny the existence of individual creativity on these grounds. It has exhausted itself,

but only in so far as it remained dependent on one historical form of awareness. Gilbert & George have shown how productive this same individual creativity can be when it acts in the name of a new awareness, based not on subjectivity but on sexual polarities which are in the service of human life.

This fact, in particular, gives occasion to pose once more the question of the nature of creativity. It is quite possible, for instance, to speak of a primal, profound, imaginative faculty which recurs in almost all the traditions of religion and mythology. Such traditions nearly always start out from the imagery of man's origin in an absolute and impalpable God. The first images are those of sexual duality: the female and male principles. Although these are not tied to any concrete object, the definitions of them as "water", "serpent" or "spirit" lend themselves to interpretation in terms of imagery. Through their sexual interaction, in death, sacrifice and procreation, there finally emerges a world of diverse, many-coloured life in which the mineral, vegetable, animal and human realms appear in turn.

The creation myth which extracts from the unknowability of God a human world that is transitory but for that very reason knowable – i.e. tangible – is man's prime imaginative feat. It is itself an act of creativity, because it gives form to his world and explains his own origin in God.

A comprehensive view of the work of Gilbert & George shows that in it the world's Genesis and man's primal imaginative act are recapitulated. Here too, an Absolute – and this ultimately means a form of awareness under whose dominion everything has become absolute and self-identical – gives rise to duality, and ultimately to a world in all its diverse images, viewpoints and potentialities. From the unhallowed dross of an outworn age (the picture post-card, for example, that utterly devalued pictorial sign), and from that of a once divine Nature, Gilbert & George evoke a world based on the

awareness of sexual polarity. They create, just as in the beginning the world was created from the corpse of a sacrificed deity.

The essential distinction between this and the initial Genesis lies in the one who creates. The traditional accounts always attributed the Creation to a god, thus attributing the emergence of everything to other-worldly forces, in a space still unpopulated by man. With Gilbert & George this is reversed. Here it is human perceptual and active awareness that has assumed the status of the Absolute, and the objects that build up the World of Gilbert & George are exclusively human and earthly ones. This is clearly seen in those pictures of the RED MORNING series that serve to create and manifest duality within the human environment. Duality evidenced itself in the preceding sequences through the prevalence of day and night, light and dark, in the design; but in RED MORNING these contrasts give way to the awareness of sexual polarity in urban space. This is highly significant.

In the traditional accounts duality makes its appearance before the creation of man, and is personified by deities; this same vision is transposed in RED MORNING to a setting already shaped by man. Sexuality is recognized in the place where man has lived for millennia, the city, and the principles at work do not bear the names of gods and goddesses but of earthly facts with equally earthly names. Gilbert & George give the female principle the name of MURDER, DEATH (page 218) or KILLING, and the male, just once, is TREE-TOPS. The artists never use the epithets "female" or "male". They prefer a direct pictorial representation to an abstract concept. This is partly, perhaps, to avoid misunderstandings: the awareness of duality has nothing to do with defining the sexes and everything to do with fundamental cosmic forces.

Duality is not the only theme of the primal creative imagination to find reflection in Gilbert & George's art. Other

significant parallels are to be found at the very beginning, when man and cosmos emerge from an Absolute. In the traditional accounts this Absolute is God; in the early work of Gilbert & George, its place is taken by a formerly sacred but now – thanks to the exercise of reason – totally desacralized divine "Nature" (see THE PAINTINGS, page 96).

Even the material of which man and world alike are made, and which progressively differentiates itself, is the same in both accounts. For Gilbert & George it consists of four essential elements. Collectively these might be called the forces of life itself, because they encapsulate man's world. One is the human environment, the home world of city and house; another is man himself; then come animal and vegetable Nature. This, the stuff of life, composes both man and world.

For Gilbert & George, in their phase of Descent, all this material represents a threat. "Nature" is without meaning, the urban environment seems arid, sated with civilization, man is without substance, animal Nature greedy and voracious, vegetable Nature an emblem of the transitoriness of life. Conversely, the artists' Ascent constitutes the gradual conquest of a new life. This means above all that the nature of these same images undergoes a reversal. What was previously a threat now becomes an evolutionary factor, pointing the way to a new awareness of life. Religion here appears in its etymological sense of "re-reading" or recapitulation. When life can no longer be renewed under the old awareness, it must be read anew under a new awareness.

The creative root-stock of Gilbert & George – townscape, man, animal and vegetable Nature – finally enters a process of ever subtler formal elaboration. As well as colours, its tools are the attributes of sexual polarity, which is to say those of "maleness" and "femaleness". Both have life-bestowing and life-destroying qualities. On the negative side, the obsolete, ossified, encrusted aspect of the "male" corresponds

to the burning, eradicating, destroying aspect of the "female"; and both reciprocally condition each other. The same is true on the positive side of the equation, where the youthful, subtly differentiating, budding aspect of the "male" is supported by the fresh, nurturing, moist, flowing, proliferating qualities of the "female". All in all, the stuff of life, which Gilbert & George recognize as their material, is subject to a constant process of flow and osmotic interchange.

The material of life may be fluid, but the World of Gilbert & George consists entirely of sculpture. Every image, every acknowledged value, every attribute and every pictorial statement is sufficient unto itself. It refers to nothing outside itself, involves nothing but itself, and presents itself alone. Here, too, an important distinction is to be made between this and earlier interpretations of the world. Traditionally, one thing was directly connected with another: as when a person asserted that his behaviour was dependent on omens or constellations external to himself. In the World of Gilbert & George there are no binding causal relationships. There may be analogies and parallels between one picture and another, but there is no narrative context, causality or derivation to connect them. All that unites the pictures of Gilbert & George, all that reduces their world to a single common denominator, is the fact that every single thing is a sculpture. The multiplicity of their World is matched by its unity as sculpture.

Much of Gilbert & George's imagery reveals analogies, although no direct debts, to traditional interpretations of the world. Among these analogies are the emphasis on duality, the sign of the cross, and the linguistic concentration on the sexual essence of things. It is this last point that can so often be illustrated by reference to philology. The traditional awareness reflected in the structure of the Germanic languages often coincides with that of Gilbert & George. An example is the

word TANG, the Norse for "seaweed". It conveys the ideas of growth, flourishing, firmness, densifying, and also has the sense of clay.[109] A comparison between these meanings and the use of seaweed as an image in Gilbert & George's work reveals a number of analogies. In LIFE (page 434) and HOPE (page 435) Gilbert & George employ images of seaweed, and in the latter they actually show a layer of clay beneath the seaweed layer. In both cases they use the images to point to the very same concepts once covered by TANG, those of flourishing, growth, becoming firm (see also Chapter 14, "Death Hope Life Fear"). This owes nothing to conscious recall on Gilbert & George's part but simply represents part of the process of their Ascent, which brings with it a new awareness of the sexual forces of life.

In spite of such affinities and analogies to the world-views of the past, it would be perverse to regard the work of Gilbert & George as a direct copy of any of them. It is only because the artists never explore the past, because in spite of certain similarities they see and formulate everything anew, that their pictures possess such youth and freshness; they constantly invent and formulate images that bear no relation to anything in the past. A large proportion of their work may be called totally new in the sense that it reflects a way of seeing that was previously quite unknown. In a certain sense these works correspond to a thought form: something that is modelled on no precedent and can only be visualized. An example of this kind of invented form would be that of the table. It has no precedent in Nature; its origin lies solely in human needs and the human imagination.

Essentially, thought forms are invented pictures. But they have nothing in common with earlier kinds of pictorial invention, which was mostly dependent on an infinity of chance combinations, and whose purpose was to counter the familiar with something that would disorient and shock the

viewer. The pictorial inventions of Gilbert & George reveal no such intention. Their concern is with meaning. They are invariably constructed from the material discussed above, and they seek to postulate new fields of action within life and its sexual polarity. HUNGER and SPERM EATERS (page 338) provide examples of the application of thought forms. Both present something which is meaningful but has no precedent.

The rest of this chapter deals with a number of other works in which thought forms, i.e. forms invented from scratch, play an essential part. What counts first of all is the form, the image that is new to the artist's awareness, and not the name that has to be formulated. Most of these pictures have familiar-sounding titles, even when the actual word that is used is not part of English usage. The picture NEWLAND (page 317) has already been mentioned. Its title is a neologism, but an instantly comprehensible one; invented pictures are not to be equated with made-up names, but must be seen as new images with more or less familiar titles. NEWLAND is actually typical of a large number of works in this category. Many show tiny figures — mostly, as in this case, the artists themselves – dwarfed by colossal plant and human forms. The title NEWLAND itself clarifies the intention: the demand is for a new pictorial territory which will encompass living bodies, but which is not there to be discovered: it must be invented anew.

Gilbert & George's increasing tendency to show themselves, and sometimes others, as miniature figures has a number of causes. The first lies in the artists' own understanding of themselves. The pictures of their Descent showed them and no one else, because they stood for the individual who works and suffers in a state of conflict with himself and with an old incarnate awareness; in the course of the Ascent, attention came increasingly to be directed towards their fellow human beings and the objects of the new awareness. The pic-

torial emphasis accordingly shifted away from the artists themselves; in some cases they were not present at all, in others they made themselves small. The essence of the picture is thus appropriately perceived in terms of those who perceive it. The differences of scale are essentially perceptual; they do not, as might erroneously be supposed, represent a fetishistic emphasis on the objects that are shown large.

A further reason for the disparities of scale is that the "little" people can walk about and meet each other in and around the colossal scenery. They not only perceive it but sometimes traverse it like a city or a landscape. The "little" people are distinguished from the rest of the picture not only by size but by colour; and, especially where Gilbert & George themselves are concerned, it is evident that they are deliberately setting themselves apart from the rest by their colour scheme, or alternatively identifying themselves with a particular part of the composition (this also happens in pictures that show no discrepancies of scale).

In NEWLAND the tiny figures of Gilbert & George stand on a living body, of which we see only the trouser legs and part of the torso, and which forms the landscape on which the artists locate themselves. From this vantage point they look up at the standing figure of a boy, on the left, who fills almost the whole height of the picture. While Gilbert & George look at him, he looks straight out of the picture at those who meet his gaze (or that of the picture). This complex of forms is completed and paraphrased by a branch laden with berries which sprouts from a mouth at top right and points straight to the intersection of the standing and reclining bodies at bottom left.

In NEWLAND Gilbert & George return to a linguistic device used previously (see SPEAKERS, page 272): that of the frond that emerges from the human organ of speech. This is a symbol of the figurative components of speech and directs the

viewer's attention to a part of what the picture is saying: in this case, the desire for growth that will bear fruit (the berries). In direct juxtaposition with the rest of the pictorial content, this device transfers the theme of fruitfulness on to the human bodies, which here match each other in colour: the reclining body and the upright body. Gilbert & George have their eyes on the standing boy. They bear no fruit; it is he who IS the fruit, the laden branch. New land thus means the human body, which is called upon to flourish and grow as the plants and their fruits do.

This call for man and his body to grow and develop in stages analogous to those of plant life – maturity, blossom, fruit – immediately recalls an earlier picture by Gilbert & George, BLACK BUDS (page 291). In this piece four twigs with buds on them appear side by side in silhouette. The word "black" in the title is an indication that the theme is still generalized rather than fully differentiated. What matters is that buds are perceived as heralds of the life that has yet to unfold.

NEWLAND (page 317) and successive pictures take up this theme again, transposing it to the human body, adding colour and differentiating it in successive and specific ways. In these works the human body appears in a constant state of budding and burgeoning. One picture shows shirted and trousered rear views on an almost production-line scale, another only heads; others, like NEWLAND, set human figures in relation to plant or animal motifs. Every time, the focus is on the human being and his manifold potentialities for growth. In particular, the frequent depiction of a number of corresponding body-parts (heads, trouser-legs, faces etc.) shows that this is a process of budding, like that of a plant. These repetitions are not constant juxtapositions of the identical, as in industrial production, but the representation of like forms with individual features. The four faces in BLOOM (page 407),

grouped round a single bloom, embody this principle. One flower marks the centre, four others the periphery, on which the faces are placed like petals. On their foreheads are more flowers. One bloom evokes another, and this evokes yet another. The human face is involved in a constant process of blooming.

NEWLAND and BLOOM deal with human beings in terms of sensual imagery; with their language of budding and blooming, these works afford a telling and complex comparison with traditional forms of eroticism. Not because the eroticism here is the same: it is radically different. The old eroticism perceived other people mostly as something to be consumed, and subjected their bodies to a fetishistic process of fragmentation. A woman's leg or bosom, a genital region, or some other part of the body was there to be devoured. The desirer desired the other as the object of his desire. He wanted to possess him (or her). Even the voyeuristic enjoyment of a garment that alluringly covered some edible nakedness was ultimately the desire to enfold and consume, spider-like, the chosen object. This was an almost vampiric treatment of the other, a systematic eroticism whose policy was to divide and rule.

Gilbert & George's pictures work quite the other way. There is no question here of taking possession of the object, no voyeuristic dismemberment, but the impelling of the human body to bud and blossom. Instead of pouncing hungrily on the other, plunging ever deeper into him, the perceiver knows him, becomes aware of him, in sexual terms. This does not mean that these figures are sex objects, but that their bodies blossom in the course of a sexual process. Hence, once more, the title NEWLAND. The human body is presented as new territory, as a landscape in endless bloom. It starts to grow before the viewer's eyes (hence its size in NEWLAND), instead of being devoured by him.

Imagination and Invention

Invented images, such as those discussed here, always imply one precondition: prior need. From this point of view all Gilbert & George's pictures are invented ones, because they are made in pursuit of a new imagery of life whose non-existence is the artists' point of departure. The works just discussed set out to view the other – one's fellow man – in a new and different light. Sexual activity, in the sense of growth and proliferation, is certainly involved; but for this very reason the human individual is not treated as a sex object. These pictures find a new kind of access to him, in which he is not an object to be looked at but elevates himself, through the newly reformulated eye of the beholder, into a multiple being.

Two further pictures concern themselves also with the human individual and the way he is perceived. The titles HIM and ME use the accusative form of the pronoun, suggesting an approach to "him" or "me", rather than the nominative form which the artists had used in presenting themselves in WE. In HIM and ME they present a third party, and thus direct scrutiny upon him, or show how he is reformulated under their scrutiny.

In HIM (page 409), Gilbert & George look up at a young man from either side. Standing on the same level as the artists but considerably larger than they, he rises up the vertical axis of the picture. His size and his position in the picture cause everything else in it – the artists and two other motifs – to seem to recede behind him. One of these other objects, a dishevelled head of hair, rises like a hill between the artists; the other, a large, armoured-looking seedhead, looms behind the young man's back. There are three colours in the picture: blue for the background, red for the figures and yellow for the two other motifs.

In HIM, Gilbert & George very evidently relate to the young man, both through the fact that they are looking up at

him and through their colour scheme. He, by contrast, simply stares ahead without betraying any awareness of what is behind him. This serves to concentrate the whole scene on him. He registers twice over: once because Gilbert & George adopt his colouring, once because two other motifs make reference to him and his identity. Identity here is used in its true sense of intrinsic oneness. The seedhead, the second dominant motif in the picture, provides an analogy to his strong and compact appearance. Just as he is characterized by his shaven head and his robust build, the seedhead is marked by its symbolic suggestion of an armour, a shell, an indwelling will. The scalp below matches the colour of the seedhead. Its luxuriant tresses, twisted in places into corkscrew locks, echo the multiplicity of shield-like segments on the seedhead: a multitude of sharp, outward-pointing cells, as against a multitude of hairs in untrammelled growth. Both define the young man in his capacity as a mature person, ripe to bear fruit.

In spite of a number of points of resemblance, ME (page 408) differs radically from HIM. Instead of being characterized through the accompanying motifs, the "one" who is seen here shows himself several times over. There is no uniform colour scheme; the figure is coloured differently from the artists, is not in their line of sight, and is not in front of but behind them. Only the size differential between the protagonist and the artists is similar to that in HIM. The age is different: whereas HIM showed a full-grown young man, ME shows a boy. He is seen four times in all: twice as a head – asleep and awake – and twice as a full figure. In a kneeling pose he looks down at the ground, and as a standing figure he looks to one side. Lastly, in front of him, Gilbert & George look at and walk towards each other.

The fact that Gilbert & George are not looking at the boy but at each other marks an important difference between this work and HIM. Equally conspicuous is the way they

deliberately distance themselves from him through colour. He seems alone, with no one and nothing present to define him. Only he can present himself, which he does through two basic qualities: repose and wakefulness.

ME concentrates attention on the self of the "me" whom it presents, by analogy with the attention directed at each other by Gilbert & George. By contrast with HIM, therefore, this is an image of self-knowledge or self-awareness. This means primarily that the interest of the still-growing, young individual is self-directed, whereas the mature personality, as in HIM, can arouse the interest of others. Youthful being still has itself as an object; mature being falls within the scope of other people's perception.

Both these pieces, HIM and ME, belong to a group to which Gilbert & George give the title NEW MORAL WORKS. Morality is the issue, then. Not a morality that runs along the lines of the old moral code, judging and criticizing others, but one which has still to be invented. In the context of the works, this means that morality is primarily seen as a matter of age. No universally valid morality is proposed, but one which, without promulgating laws or setting up dogmas of value, shows each human age its own image.

In HIM this morality is figured as a matter of attraction. The identity of a person begins to be perceived by others. Without interrogating other people or forcing itself on them, the individual identity enters a phase in which it lives with others. Morality thus presents itself as an image of maturation and incipient adulthood; the individual's actions will henceforth be directed towards multiplication and growth rather than, as before, towards the conquest of his own identity.

In ME, on the other hand, the young life is still cast back on its own resources. Not that it is simply ignored; but it is represented by two basic images of this state of self-

preoccupation. Unobserved by others, it can constitute and establish its identity by degrees. The boy is not presented with any rules of conduct but with the bodily powers through which he himself begins to make his own decisions. Morality here is still directed towards the conquest of identity and self-hood.

HIM and ME, like others of Gilbert & George's pictures, formulate antitheses or distinctions within a single theme. They make no demand for morality as a system of law or judicial evaluation. Morality as a precept for action remains, for the moment, conspicuous by its absence. Morality here means something else entirely: to be aware of life in the successive specific states that are distinguished by age, and to assign to it appropriate powers, abilities and potentialities. It is only from this point of departure that the individual can evolve his own morality. HIM and ME present the individual positions from which moral behaviour will emerge in a second stage which remains to be defined autonomously by the individual himself.

To conclude this chapter on images and imagery, one more work by Gilbert & George, LIGHT (page 413), remains to be discussed. Its significance lies in the fact that it presents light unequivocally in relation to an image, that of a Gothic Revival tower. Light presents itself here as form, which then exemplifies image.

In this context it is worth recalling just once more the course that Gilbert & George's career has taken. Whether it is called the life-cycle of the God-Man or, in rather more worldly terms, a heroic saga, is a secondary matter. What counts, in this evolutionary progress through Hell and rebirth, is the victory and the new awareness that the heroic individual brings with him. This is what entitles him to be called the Bringer of Light, one whose light holds a treasure within it. He does not bring light to illuminate and plumb the

darkness; he brings out of darkness a light that could not shine before.

It is specifically in relation to LIGHT, and to earlier works by Gilbert & George which play on and paraphrase the theme of light, that something fundamental can be said about the form that light takes in their work. DARK SHADOW, the series and the book, quite deliberately allude to light by taking its counterpart, shadow, as their theme. LIGHT takes as its central motif the tower of a Gothic Revival building (the Houses of Parliament), and thus points to a recurrent theme in Gilbert & George's work: Gothic architecture. Triptych No. 6 of THE PAINTINGS (page 96) showed a Gothic church in the background, and in the DARK SHADOW book there are several illustrations of Gothic architecture, including the Houses of Parliament and the neighbouring Westminster Abbey. Of this last they write under the title "OUR THING in the NIGHT":

> The thing in the night with systematic splendour and dead unhappy making shapes. To pass, to blinking sea, to think a moment heavy hearted of things not lovely but speaking odd languages and making frowns on handsome brows. So leaden legged we see the abbey slide with weight of shyness with form and situation. Having past in turns and catching up confronts us with appealing hope, the tears streaming down its sleepless night tired windows. It wants to be friends.[110]

The last sentence is crucial. The "thing in the night" wants to be friends, but it cannot, because its looks are gloomy and forbidding. This is not its fault but that of a dominant form of awareness which still governs Gilbert & George's perception of its Gothic architecture. The tower still stands for the splen-

dour of past ages, recalling a world-order that united all mankind, and proclaiming a return to a former state of human togetherness. The building cannot be seen in isolation from its historical associations with a style, a form of religious feeling, a type of social organization. It remains, archetypically, an enemy – even when its tears stream down.

Their act of sacrifice has made it possible for Gilbert & George to see historic, or simply old, things in a new light. Hence the tower in LIGHT, and its unmistakably neo-Gothic architecture. It stirs no memories, stands for no historical style or other associations of meaning, but simply and solely conveys the awareness of sexual polarity. In LIGHT, the tower is perceived in terms of its timeless sexual identity. Gothic or neo-Gothic architecture suits this purpose perfectly, with its allusions to intricate plant growth, leaf, stem, cross and crown. This tower in its flowing coat of yellow epitomizes a wholly artificial process of growth and proliferation which exemplifies, and so to speak casts light on, that of human growth and life.

On either side of the "light" in LIGHT stand Gilbert & George. Their heads and hands echo the yellow of the "light" itself; their shirts and collars are red. The same red is the colour of a full moon, behind them and above the "light", and also of the heads of two boys who look upwards, from the foot of the "light" and through its yellow glow, towards the red moon. The glow of their heads thus shines through the "light" to reach the glow of the perfect, self-contained full moon. The moon has already reached the end of the process of enlightenment, or as it has traditionally been called the Path of Light, and has attained his perfect form. The boys still have this path before them; they look towards the "light". The artists have already set foot on this path, but have not completed it, so they stand between the "light" and the moon and bear the colours proper to both.

LIGHT is a picture of the male principle in flux. Its emblem of light and life is not the rigid, established male form but the male which receives constant new life from the pulsating forces of the glowing stream: from the female.

Seen in this way, LIGHT appears as the birth of the vital process that was foreshadowed in FUCK (page 221). In that work too, there was a neo-Gothic building, and there puddles marked the "female" aspect. In LIGHT this aspect has taken on colour. It does not negate the "male" form of the tower but suffuses it. A new and vigorous life is born, to serve as a shining example for human life.

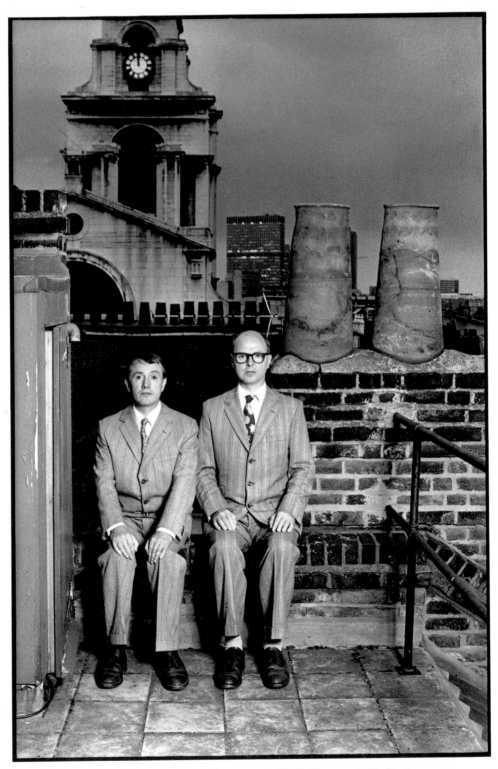

GILBERT & GEORGE ON THE ROOF OF THEIR HOUSE. Photograph: Herbie Knott.
Gilbert & George themselves are the best illustration of the principle that human creativity constantly renews itself and finds new ways in which to operate.

THE BELIEVING WORLD. Exhibition at the Anthony d'Offay Gallery, London. 1984.

NEW MORAL WORKS. Exhibition at the Sonnabend Gallery, New York. 1985.

REST. 1984. 241x201 cm.

COMING. 1983. 241x201 cm.

SLEEPY. 1985. 241x201 cm.

CALL. 1984. 241x201 cm.

Contrasts of scale within the picture help to bring content and perception into due proportion. (See also the following two-page spread.

BLOOM. 1984. 241x250 cm.
Bloom upon bloom: the budding of humanity never ceases.

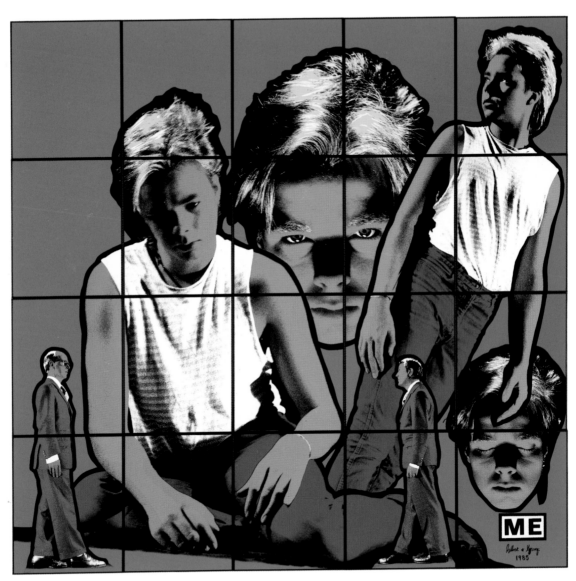

ME. 1985. 241x250 cm.

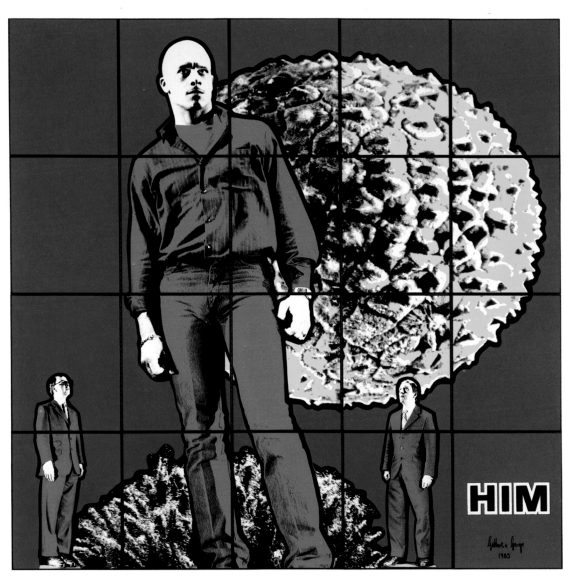

HIM. 1985. 241x250 cm.

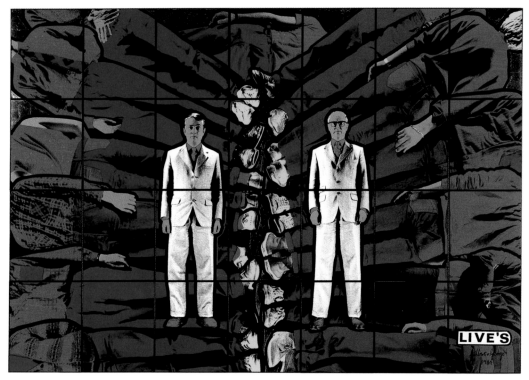

LIVE'S. 1984. 241x351 cm.

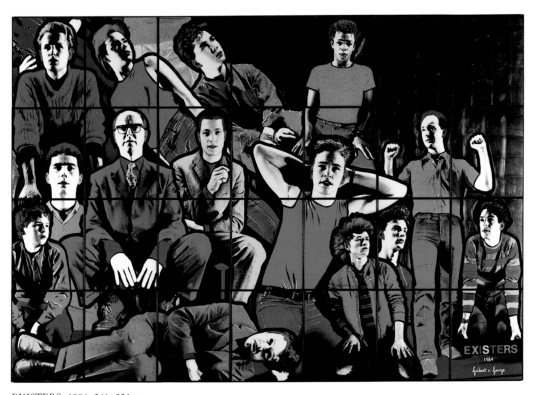

EXISTERS. 1984. 241x351 cm.
Plural titles indicate the proliferation of life. In all its disparate values and manifestations, life multiplies.

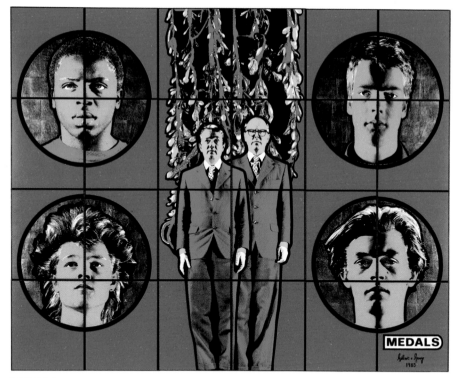

MEDALS. 1985. 241x301 cm.

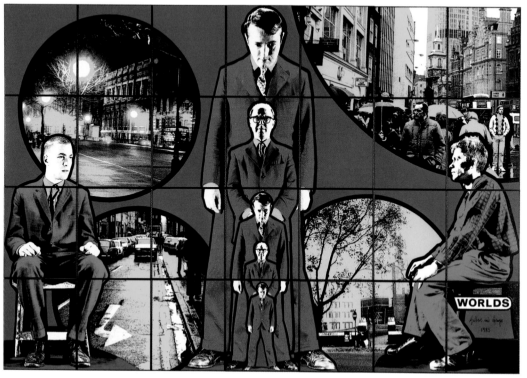

WORLDS. 1985. 241x351 cm.

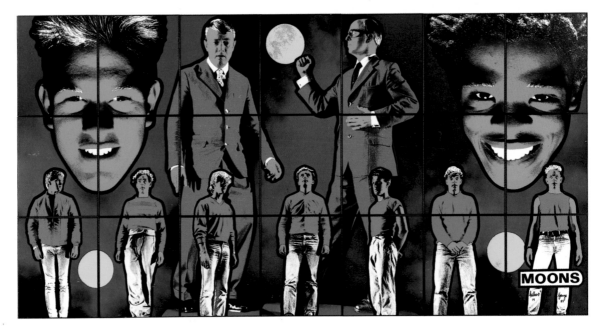

MOONS. 1985. 181x351 cm.

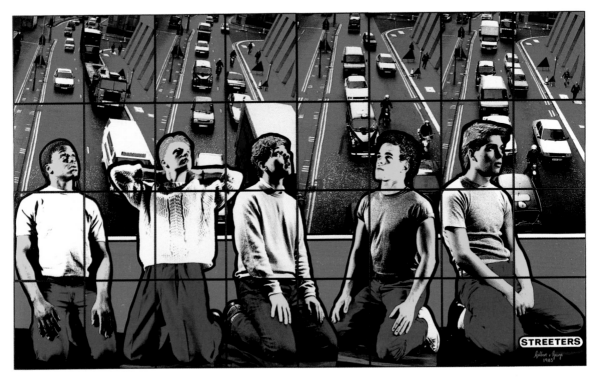

STREETERS. 1985. 241x401 cm.

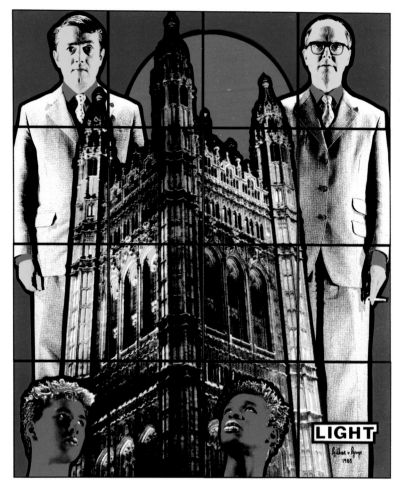

LIGHT. 1985. 241x201 cm.

The thing in the night with systematic splendour and dead unhappy making shapes. To pass, to blinking sea, to think a moment heavy hearted of things not lovely but speaking odd languages and making frowns on handsome brows. So leaden legged we see the abbey slide with weight of shyness with form and situation. Having past in turns and catching up confronts us with appealing hope, the tears streaming down its sleepless night tired windows. It wants to be friends.

90

OUR THING in the NIGHT

Text and plate from Gilbert & George's book DARK SHADOW. 1974.

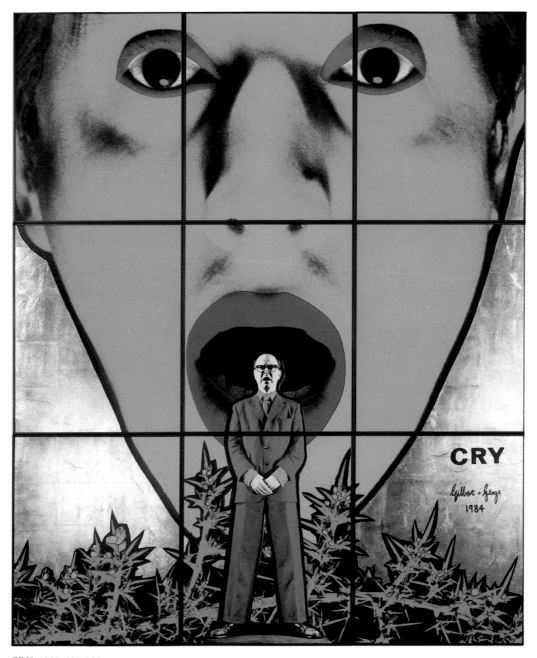

CRY. 1984. 181x151 cm.
When life begins, and the umbilical cord is cut, a cry unlocks the breath. That cry for life is the first motion of the vital forces.

DEATH HOPE LIFE FEAR

Chapter 14

The world that Gilbert & George have invented, formulated and increasingly elaborated since RED MORNING is overwhelmingly diverse. The realms of sight, of sound, of smell and of taste have all received their visual expression, as has humanity in its manifold sexual, religious, ethical and social needs and desires. Only a fragment of this world of imagery can be presented here. A number of themes have been merely touched upon, others not even mentioned. The World of Gilbert & George reveals itself to be too complex and many-layered for any one book to do it justice. Nevertheless, perhaps the themes singled out here may be helpful for a first approach to the work and afford some initial insight into the artists' World.

The complexity of that World is reflected in a number of works which deal with a specific theme in a many-sided and intricately conceived way. Especially in recent times, the artists have produced works remarkable for their sheer size as well as for their extraordinary wealth of colour and diversity of content. In this they resemble in a way the monumental charcoal drawings of the early stages of Gilbert & George's Descent. These too showed numerous motifs on an outsize

pictorial support. The basic difference between the two groups of works lies in their expressive potential. In the charcoal drawings, concepts and words were swamped by a colourless tide of uniformity (THE GENERAL JUNGLE) and lost touch with their meanings; in the new pictures images alone appear, sharply set apart from each other by colour and size. A conceptual void gives way to a plenitude of eloquent images.

In this context two works will be discussed. One, DRUNK WITH GOD (page 436), consists of a well-nigh unmanageable profusion of motifs; the other, DEATH HOPE LIFE FEAR, consists of four separate pictures designed to be seen as one (pages 434–35). The titles in themselves reveal that both works take life itself as their true theme: the former by presenting God as the many-sided essence of life, the latter by formulating separately four different but central views of life (and of its counterpart, death).

The word "drunk", in the title of DRUNK WITH GOD, is to be taken literally as an expression of flow and of animation. More than once in this work, fluidity and flux are shown in direct relation to the emergence of life. The flow of life is equivalent to a divine process: none other than the formation of man. This fact receives highly abstract expression in the centre of the picture. From the upper edge a hand (and it may be that of God; see page 444) pours fluid from a bottle into the open mouth of a boy who is kneeling at the bottom edge. To the left two plants and two tongues allude in different ways to this process of "drinking life". One plant grows down into the middle of the picture against a silver ground, the other rises to meet it against a gold ground. Between the two, the tongues touch, one blue and the other red. Like them, the gold and the silver, and the two plants, are in intimate osmotic contact. All this revolves about the sexual process of flowing, growing, taking shape, building up. As one

liquefies and disperses, the other takes on solid form, in constant interaction.

On both sides of the central "drinking scene", the process represented here is further differentiated. To take the left-hand side first: at bottom left stand Gilbert & George. With their arms and with two sprouting branches they point into the picture: upwards, into the centre and downwards. They open up the space in which the action is taking place by defining both its nature, as an organic, plant-like process, and its direction. As in FIRED (page 361), they stand behind buildings and a bridge; here, however, what goes on is not burning but building. At their feet a group of boys rise successively to an imposing height. Their alternate colouring, blue and orange, clarifies this gradual process of growth as a sequence of alternating movements. It is interrupted by what happens immediately to the right. Flanked by two monuments, four boys stand with long cylindrical staves in their hands. Their uniform red colouring, their frontal stance, the staves and the monuments, all indicate the quality of finished, full-grown form. The "little" boys have become fully developed human beings. They have matured into sculpture.

Above this group and a wet yellow pavement, Gilbert & George show themselves again, this time full-face, surrounded by black rings with finger-like excrescences in which, as also on the faces themselves, there are coloured ice-blocks. Gilbert & George are showing themselves in the guise of frost patterns, and these will melt on the pavement below. Here again, liquefaction and dispersal coincide with finished form. The artists face the prospect of their own dissolution, while the boys beneath them have just taken on form and firmness. To the left of the artists' heads (or the frost crystals), and above the representation of them as men pointing, the background is blue. Three fingers reach down from above, accompanied by four flowers which float like egg yolks on

roughly oval background shapes. In this part of the picture life is beginning to articulate itself. The articulations of the fingers refer directly to this; likewise the flowers, which are encircled like egg cells by the precious plasma that provides nourishment and protection as they grow and ripen.

Now for the right half of DRUNK WITH GOD: in direct relation to the central "drinking scene", Gilbert & George put in a third appearance. Half crouching, they traverse a sleeping city. A red full moon hangs above a dark row of buildings in front of which are two animals, a dog and a cat, both of them watchful and alert. In the midst of the darkness, lit only by the moon and a single street-light, they represent the life of animals in its most fascinating aspect: that of silent, total concentration on the world around them. In this, animal life foreshadows the life of man, who transcends his animal prototype by moving on to the active shaping of his world. And so, above the scuttling figures of the artists, there appear a few tokens from the human world: a glowing cigarette, money, keys, flag, food, digested food (excrement), clothing and – as a physical trace of man – the sole of a foot. Each image points to a single aspect of human culture. The keys and the flag, for instance, stand for man's home (both private and national), and the coin stands for his economic life.

At the top left-hand corner of DRUNK WITH GOD, three fingers point downwards into the picture. Something formally analogous occurs on the right: here, however, the descending forms are trickles of blood, as in BLOODED (page 321). They do not articulate, as the fingers do, but they feed those forces that articulate.

What is going on at the extreme right of DRUNK WITH GOD has analogies with another part of the left-hand half: the group of four boys beneath the frost-crystal faces of Gilbert & George. Here too there is a flow from above, and a

huge human figure rises up from below. He is a giant. Between his legs stand the dwarfish figures of Gilbert & George to indicate the scale. The giant rears up to a height that seems to fill the visual field. He dominates visually. At his side, almost to the same scale, are five heads. They coalesce like drops of the falling blood and crystallize into human faces. Here again, man is taking form; and this time it is blood that shapes him into a human sculpture.

Sighted in the crosshair of the two tongues and two plants, and against the silver and gold grounds of the sexual polarity, DRUNK WITH GOD presents an entirely divine scenario. Through all the realms of Creation, the mineral (city, sculpture), the vegetable, the animal and finally the human (as represented by the human environment and the human image), the scene is one of intense, sexually charged activity. Neither sexual pole is given precedence over the other; nor do both combine in some indefinable mischmasch. Flux and moisture may be above, or they may be below; so may form and structure. The state of being drunk with God manifests itself in the osmotic interchanges between his earthly emanations.

There remains to be discussed a work that is unique in the artists' entire output. DEATH HOPE LIFE FEAR is their first work to appear in several parts that can be read in constantly varying relationships to each other: DEATH in relation to LIFE, to HOPE or to FEAR, or in any of the other possible permutations. Equally, each of the four components has its own validity as an individual picture. Together they form a four-walled space which is a place for asking fundamental questions. What is formulated here is the whole range of the crucial issues of life and reality: death, hope, life and fear. Two of the four threaten life; two bestow and promote life.

A further characteristic of this work is its formal rigidity, which has an undoubted bearing on the individual titles.

Death Hope Life Fear

DEATH and LIFE refer to the death and life of those intimately involved, Gilbert & George themselves, who form the central motif in both these vertical compositions. HOPE and FEAR on the other hand widen the perspective to cover other people and life in general; so they are laid out horizontally to show those vistas and world's-ends within which the human viewer encloses his view of life. The horizon encompasses time and space, but presents both as perspectives on a human scale.

The description of this work will follow its antithetical structure: DEATH and LIFE, then HOPE and FEAR.

DEATH (page 434) approaches the given theme by way of its abstract sensory and chromatic equivalent: gold. This indicates directly that this is a process of burning and obliteration, or in other words of dying. On this ground, this assertion of sexual polarity, the rest of the picture is built up. The vertical axis is occupied by Gilbert & George, depicted several times over, one above the other. Their stance is always the same: arms by their sides, legs and feet together, rigid and impassive, they look straight ahead. From top to bottom the figures become progressively smaller, and at each change of scale a flower separates them: first a rose, then a daisy, then a rose again, and so on. Each figure, from top to bottom, thus seems to stand in front of a flower. The colours of the daisies, in particular, reinforce the message of death. Their red and yellow tips are like hungry flames that seem to consume the artists. This idea of engulfment and disintegration is reinforced by the presence of two mouths at the top of the picture. Both bare their teeth as emblems of devouring, open in one, clenched in the other. The mouths take, bite, chew and swallow life; they consign it to a dark inner cave, the place of burning.

The sexual process of death is formulated in several ways in the work: as gold ground, as fire, as dwindling, and as devouring. The mouths, as bodily organs, are particularly clear

indications that death is necessary for a further life. They devour in order to keep themselves alive, and with them the devourer himself. This manifold image of death is observed by two figures at the sides. Marked by the same colours as the burning flowers, one stands facing into the scene, one turns his back. They perceive death, just as it perceives them. The shared colour scheme points to this reciprocal awareness. And thus death acquires a personification quite distinct from those who are dying, and who in this case are Gilbert & George.

It was in the series RED MORNING that Gilbert & George first used the word "death" in a title. What they were doing was to acknowledge a repressed and overlooked aspect of life as a component of its sexual polarity. They were able to do this, perhaps, precisely because they themselves had just performed an act of death and destruction. Their own fiery sacrifice necessarily recalled to mind the violent, blazing, consuming aspect of life. A comparison between some of the RED MORNING pictures and DEATH shows how the work reflects an evolving awareness of death and burning. In RED MORNING it was images of puddles that signified death (as in RED MORNING DEATH, page 218); in DEATH, on the other hand, it is man himself who perceives his own death in a variety of different ways. The theme is the same, but its treatment has been elaborated and diversified, in specific reference to human death. DEATH, as against the RED MORNING pictures, bears the marks of a beauty that belongs to death alone. Gilbert & George here formulate in pictorial terms what they once put into words: "Beauty is Our Art."

LIFE (page 434) has a pictorial structure almost identical to that of DEATH, and so it is necessary only to mention the essential differences. The ground, once more, indicates the general theme. Silver shows clearly that the theme here is the sexual pole of life and growth. As in DEATH, Gilbert & George occupy the centre, and their figures repeat in a vertical

arrangement, progressively increasing (or diminishing) in size. Their attitude and their colour scheme are, however, radically different from those in DEATH. This time they hold out one arm sloping downwards, the other raised with elbow bent, and turn out their toes. In a sign language like that used by traffic policemen they are indicating Stop and Go. On either side, one indicates Stop and the other Go. Their mouths are wide open. Speech begins to articulate itself and to afford communication. The artists are calling upon life to flow. (The images are the same ones that were used in SPEAKERS, page 272, but the content and colouring are utterly different: another indication that the artists can use one and the same sign to express two completely different contents.)

A further difference between this work and DEATH is its colour. The monochrome of the suits has given way to an colour scheme of alternating areas of yellow and red which not only divides the suits into four main colour zones but sets each artist off from the one behind him. Here too, in the constant interchange between yellow and red, life is seen as a state of continual change and flow, a vital pulse.

Where in DEATH round flowers inserted themselves between the artists, in LIFE leaves appear, arranged like wings behind the array of figures as a whole. Two different kinds of leaf, in pairs, alternate all the way down the vertical axis. The top pair are fronds of seaweed, followed by leaves of a variegated land plant, flecked with yellow and white. The same sequence then repeats, diminishing in size all the time. What Gilbert & George indicate with their arm gestures and their motley suits, the leaves repeat in their own way. As well as green, they are coloured yellow and red; and their tips point upward. One set recalls the moist and nurturing element of the sea, and the fruits thereof; the other suggests living refinement and decorative artifice.

These leaf-wings reinforce two further important

aspects of the image of LIFE: life-giving moisture and the attainment of form. Flowers, as in DEATH, always speak of their own death, because nothing follows them but the new seed; leaves stand for the new unfolding of life. They orient themselves according to their environment, draw nourishment from it and help the plant to live.

LIFE, like DEATH, is crowned by a pair of human sensory organs. This time they are eyes, looking straight ahead between red-rimmed eyelids. These may look like lips, but they are not there to devour anything; they are there to perceive life in all its sexual activity and organic growth. LIFE presents the eyes as the organs of sense most proper to life. Instead of taking possession of life and absorbing it, they perceive it as a surface which cannot be grasped or owned.

Again, as in DEATH, two witnesses are present. Here too they are coloured to match the plant motifs, which in this case are the leaves. Through this identity of colouring, as in DEATH, they register their awareness of the life which, in return, is aware of them.

As between DEATH and LIFE, so between HOPE and FEAR there are direct pictorial analogies. But there are cross-affinities between the two pairs, too. For instance, HOPE (page 435) incorporates two elements from LIFE: the seaweed and the red/yellow colour scheme. FEAR, on the other hand, incorporates a rose not unlike that in DEATH; it also makes intensive use of the same shade of green which, in DEATH, colours what is seen of the faces that surround the two mouths. All four pictures have just one element in common: the green base on which nearly all the figures stand.

In HOPE there is a conspicuous horizon with several layers or strata. It stretches right across the picture, against a dominant dark blue background. It becomes narrower towards the sides and swells into a mountain in the centre. Its uppermost layer is made up of seaweed; the three others are disting-

uished only by colour. Immediately beneath the seaweed is a brownish-orange layer. Black lines that cut into the brown, like cracks, make it recognizable as solid, untilled, amorphous clay. This is followed by layers of watery blue and dark green; their slightly wavy edges suggest a soft, fluid quality. They might be water, or perhaps marsh. All four strata together suggest a fertile and life-giving soil which holds within it, moist and as yet unformed, the qualities that give life its power of organic growth.

At the summit, as it were, of this horizon line stand Gilbert & George. Turned to face slightly inward towards each other, they look forward, out of the picture. To either side of them are three boys' faces, while beneath them the pictorial space is almost filled by a group of standing and kneeling boys. The artists distinguish themselves from these other figures and faces in two principal ways. They are shown much smaller, like Lilliputians; and their skin colour is different. Where the boys' skin is mainly white, theirs is more like flesh colour. The colour of their hands and faces is also that of the "clay" level of the horizon. These two characteristics make Gilbert & George into a part of the horizon, seen through the foreground screen or wall formed by the other figures and faces.

Up to horizon level, the wall is made up of full figures. Behind and between six kneeling boys stand seven others. Their uniform colour scheme – clothes yellow and red, hair orange, eyes blue – and their emphatically symmetrical arrangement gives them a marked visual unity. This symmetry is repeated by the six faces at the top. These too share a colour scheme: orange hair and red eyeballs. Both groups that make up the "wall", figures and faces, are united by the closely similar presentation and equal treatment of each individual. As in MAN (page 361), each person is characterized in the same way. And, again as in MAN, two contrasting forms

of human essence are presented: aggressive and combative in the heads, ripe and fully formed in the group of figures below.

HOPE is made up of three principal pictorial areas: an impenetrable, dark blue ground, a horizon of nurturing vegetable substance, and a space-filling wall of figures and faces. These last, in particular, embody the idea of hope as represented by a new image of mankind, which means primarily man as sculpture. Like Gilbert & George themselves at the outset of their joint career, those depicted here are totally interchangeable in their capacity as sculpture. Each is sculpture just as much as the next. As a unitary, self-enclosed form, each is identical and equal to the others. But it is just because of this formal equality that they are so different and unequal. The essence of each, the aspect that is his alone, belongs to him irrespective of any other. Man acquires a form of his own, and on the horizon of organic existence it blossoms into sculpture: that is the message of HOPE.

This work also marks a fundamental departure from the traditional way of looking at pictorial horizons, in which one peered into the picture to find a horizon that represented the all-encompassing rim of the world. This horizon progressively emptied itself to become the horizon of infinity. The horizon in HOPE is quite different. The artists themselves stand on it, in a central position, and the whole picture opens out from them; so it is no longer really the viewer who looks at the horizon but the horizon (and consequently the whole picture) which looks back at the viewer.

Just as HOPE absorbs the seaweed from LIFE into its horizon, FEAR places the rose from DEATH in a central position. Gilbert & George, who stand atop the seaweed in HOPE, station themselves in FEAR below the rose, with which they share a colour scheme. Other parallels of colour and theme might be traced; they are significant because they make it easier to read the individual images and the picture

itself. The contrasts too, such as the gold and silver in DEATH and LIFE, are useful in approaching the four-part work as a whole.

One of the most evident contrasts between HOPE and FEAR lies in their directionality. The two pictures have the same format, but differ radically in the orientation of their motifs. HOPE arrays them horizontally, as the horizon itself emphasizes; FEAR builds them into monumental vertical statements.

Figures and heads in FEAR are sited and arranged like columns. The most immediately conspicuous objects are two pairs of green heads, placed centrally in each half, against a red ground, and filling the full height of the picture. Between the two lower heads appears a fifth green head. This, together with the artists, who are shown under its chin in miniature, another boy who stands on its hair, and the big yellow rose that looms behind him, makes up the central pillar of the work. All the heads are flanked by more figures, clad in white, blue and yellow and with more or less flesh-coloured skin, who match each other and the boy on the central head. They differ, however, in attitude, age and consequently also size. Four stand vertically arranged in pairs at the sides of the picture, and another pair flank the central head. The boy who stands on this head and in front of the rose is shown rather smaller than the other six. Low down in the background, and between the pillar-like configurations, are four comparatively tiny figures of boys who look in different directions, one up, one left, one right and one straight ahead. The figures of the artists, too, indicate directions. Back to back, they point and look at the monumental figures and heads that surround them.

As in HOPE, so in FEAR the persons shown are divided into three groups: artists with plant motif, boys' heads and boys' figures. The arrangement is very different, however. Forms with the same colour scheme are not placed within a

single horizon, a shared plane, as in HOPE, but one above the other, one behind the other, distinguished by differences of scale or even of age. They are thus isolated and categorized, and the whole surface is articulated as a space marked by variations of size. The rose encapsulates this overall impression. As the only plant motif, it does not form a horizon, as the seaweed does in HOPE, but stands alone behind the whole configuration of figures. As a "blossom", and thus as a symbol of impending death, it marks an important aspect of the theme: fear of the other, and above all fear of the other as a negative and destructive influence on oneself.

The prospect held out by HOPE is shown in FEAR from a very different angle. HOPE is the hope that each individual may fully develop his own unique form as a living sculpture. In FEAR, this same individuality of form reveals its fearsome aspect. This is not a cause for alarm, despair or even apprehension, as such: it refers simply to the perception of the other's identity and actions as a threat to oneself. This takes place primarily because the size or age of one individual can always be seen in terms of the other. The one orients himself by what the other is. By measuring himself against the other he comes to depend on the other's identity at the expense of his own. Life is caught up in a tangled web of dependency.

FEAR is an intensely visual and figurative formulation of the way in which each individual perceives and/or relates to others. One forms a structure by standing on another's head; heads rest on heads, while other heads look away towards others still. Gilbert & George themselves point up at the two "head pillars" from below. In contrast to HOPE, which shows faces only, the heads here are shown complete with necks. The pillars of heads consequently look like massive tree-trunks. They convey disquiet rather than reassurance. In addition the skin colour of the figures is not the same "sculptural" white as in HOPE, and this causes their identity as

sculptures to recede somewhat. They are flesh, and thus as ephemeral as the rose. This too is part of the imagery of fear: the awesome perception of transience within colossal forms.

FEAR obviously does not embody its theme in the familiar imagery of terror or of the dread of annihilation. None of the faces bears the marks of fear; none of the postures betrays the slightest apprehension. Fear is represented here by the thing that arouses fear. And even this is not conceived as an overwhelming threat but in human form. Like death, life and hope, fear is simply a part of life's pattern.

DEATH HOPE LIFE FEAR is a presentation of opposites which stand outside any simple schema of good and evil. None of the four is given precedence over another, or repressed, or placed in any ranking order. Each has a validity of its own; each displays a number of contrasts and affinities in relation to a second or indeed a third. Thus FEAR is not to be condemned, any more than HOPE is imbued with an exaggerated aura of eternal peace among men. HOPE and FEAR are different views, or different attributes, of one and the same motif, just as DEATH and LIFE share the same pictorial structure and the same (upward or downward) line of movement.

To work towards "the normality of tomorrow": that was the artists' initial intention, which has received pictorial formulation in innumerable works. In DEATH HOPE LIFE FEAR they map out for the first time the four cardinal points of the pictorial space that belongs to the new normality. This is not a normality that concerns itself with everyday routine, let alone one that equates the normal with the banal: it seeks to transpose life itself, together with all its general perspectives, into a realm filled with organic imagery. The pictorial space created by DEATH HOPE LIFE FEAR neither abdicates responsibility to some other-worldly power nor seeks to repress the "negative" or the "bad". The work as a

whole achieves a very human reconciliation of its four components, without confounding one with another.

The "normality of tomorrow" represents a reversal in the accustomed relationship between people and pictures. It is not for us, any longer, to try to grasp and comprehend them; they stand, wall-like, and contemplate us.

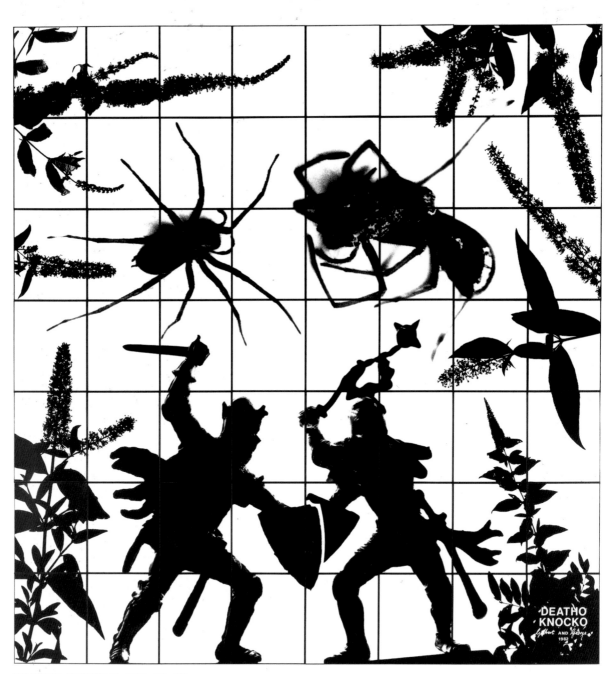

DEATHO KNOCKO. 1982. 422 x 401 cm.
One of the first large-scale works of Gilbert & George's Ascent.
The theme is set out in black and white.

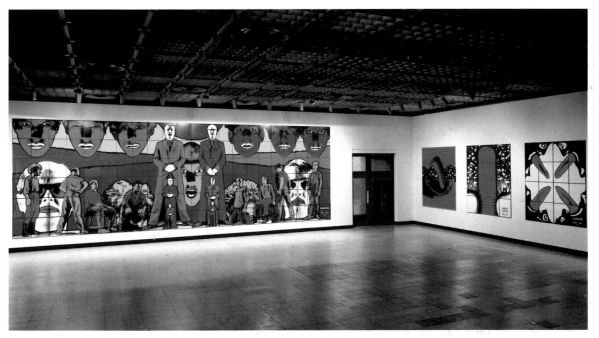

PICTURES 1982 TO 1986. Exhibition at the Hayward Gallery, London. 1987.

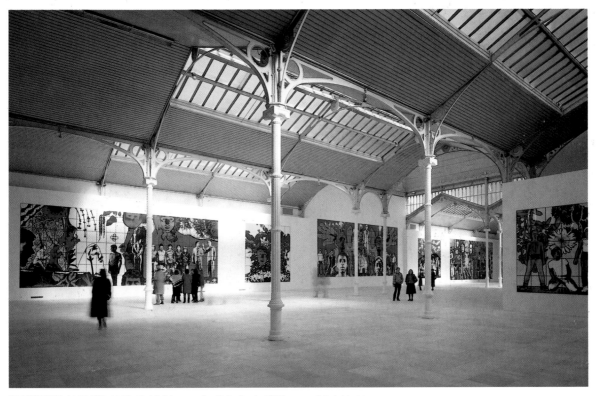

PICTURES 1982 TO 1985. Exhibition at the Palacio de Velázquez, Madrid. 1987.

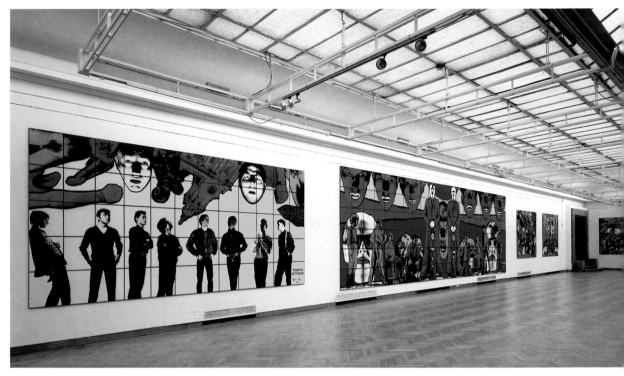

PICTURES 1982 TO 1985. Exhibition at the Palais des Beaux-Arts, Brussels. 1986.

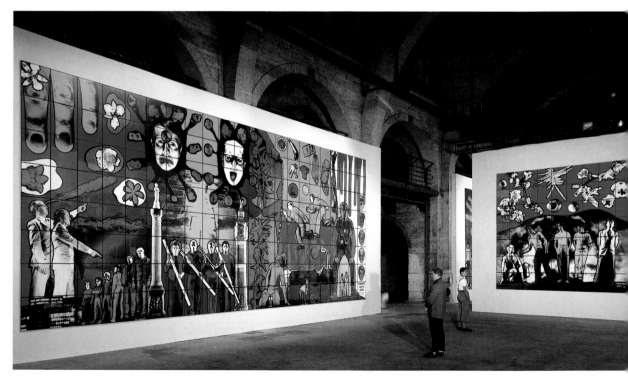

PICTURES 1982 TO 1985. Exhibition at the C.A.P.C. Musée d'Art contemporain, Bordeaux. 1986.

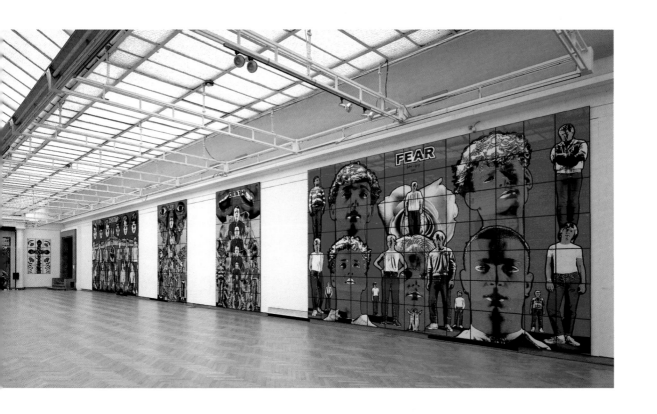

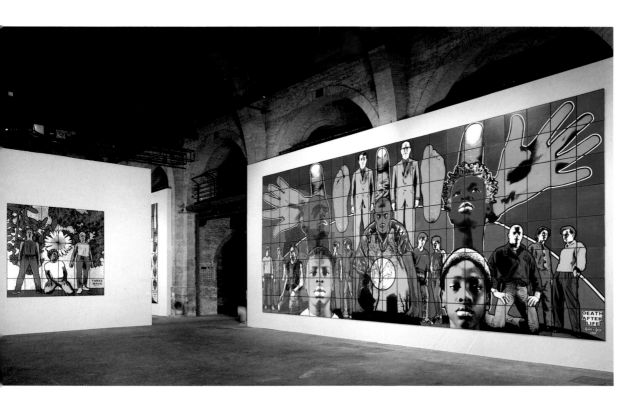

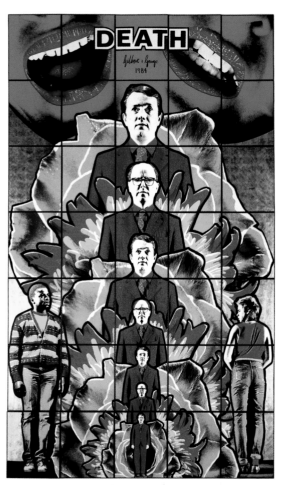

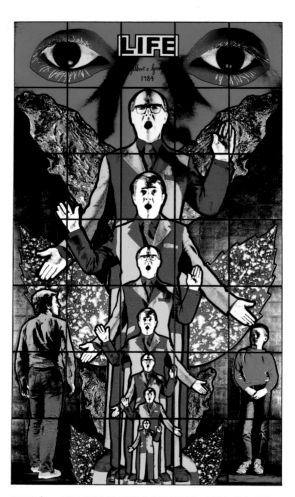

DEATH from DEATH HOPE LIFE FEAR. 1984. 422 x 250 cm. LIFE from DEATH HOPE LIFE FEAR. 1984. 422 x 250 cm.

DEATH HOPE LIFE FEAR. 1984. A Quadripartite Work.
DEATH and LIFE are two aspects of the same process. Both pictures are therefore animated by the
same movement. What distinguishes them is the specific direction of that movement and its sexual
identity: burning or thriving; muteness or speech; devouring or seeing; blossom or leaf. The same
applies to FEAR and HOPE, as ways of looking at others: both these pictures are laid out
horizontally, but in their spatial organization they are diametrically opposed.

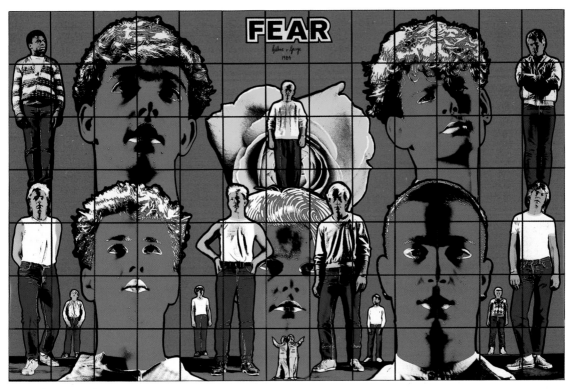

FEAR from DEATH HOPE LIFE FEAR. 1984. 422 x 652 cm.

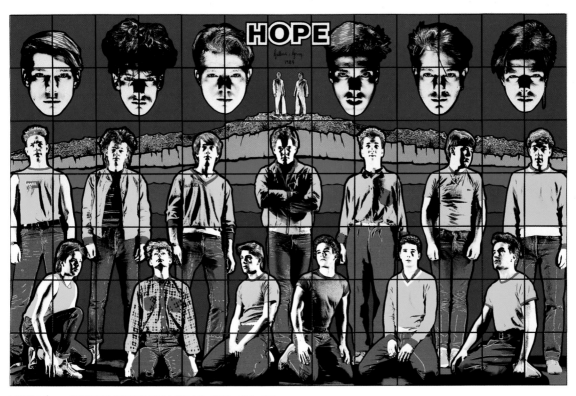

HOPE from DEATH HOPE LIFE FEAR. 1984. 422 x 652 cm.

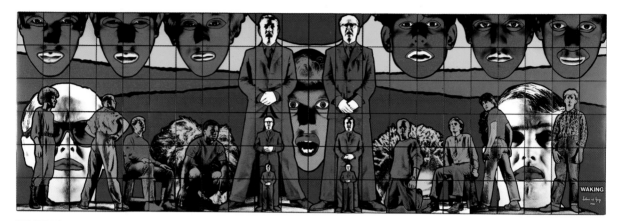

WAKING. 1984. 361x1103 cm.

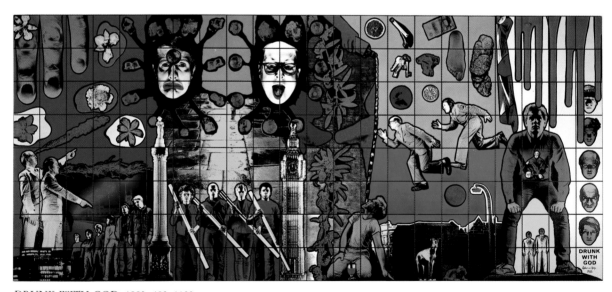

DRUNK WITH GOD. 1983. 482x1103 cm.
The hand of God dispenses sexual and cosmic forces. Humanity lives and dies by them; life
articulates itself and flows.

THE
REFINEMENT
OF LIFE

Chapter 15

In 1978, when Gilbert & George completed a sequence of works that began with the MENTAL series and ended with the images of "articulation" (see Chapter 5), they announced that their work would henceforth concern itself with beauty: "Beauty is Our Art." Essentially, this meant taking the raw, bare forces, places and beings of the preceding period and refining and embellishing their form.

This period may be likened to the establishment of a cosmic framework – or, as the mythologies call it, a "World Tree" – upon and through which the known world in all its abundance can organize and articulate itself. Gilbert & George's images of "articulation", in particular, with their theme of structure – whether that of a tree (branch, twig, trunk) or that of man-made architecture – point to this action of erecting a World Tree. Life unfolds from this central focus as each of its individual components grows ever more colourful and more complex.

A vivid example of this process of refinement and formal differentiation as applied to a specific theme – in this case that of society at large and the individual – emerges from a

comparison between THE QUEUE (1978, page 460) and the 1986 triptych CLASS WAR, MILITANT, GATEWAY (pages 454–57). THE QUEUE shows society at large through the image of a line of waiting people; beneath this, in the centre of the picture, two faces represent the individual. In the triptych, Gilbert & George redesign both groups, firstly by setting the queue in motion, secondly by showing the representatives of individual life at full length, and thirdly by furnishing these various forces and potentialities of autonomous existence with titles that refer to human values.

The human beings shown in CLASS WAR are thus not divided into mutually antagonistic classes but promoted into a single, transcendent class that expresses courage and the will to victory. GATEWAY, on the other hand, shows individuals in terms of their quest, their urge to create form and their constant openness to new paths and new modes of existence. MILITANT testifies to the human willingness to defend the existence thus achieved – in a collective and also an individual struggle – and to locate it in the realm of urban life.

To establish this context, Gilbert & George use a restricted repertoire of formal devices that express specific meanings by taking on a new form and a new character with each successive appearance. One of these is the image of the city, which is at least a background presence in all three works. A second is the plant motif, in the respective forms of leaf/fruit, blossom and branch/thorn. A third is the human presence: both that of the artists themselves, who appear in two of the pictures – filling the entire height of the picture in each case – and, more particularly, that of the other figures involved. Finally, there are the staves that most of the figures carry. Their function is clearly derived from traditional uses of staves such as the shepherd's crook, the bishop's crozier, the marshal's baton, the king's sceptre and the wayfarer's staff, all of them connected with the ideas of uprightness, seeking,

establishing, fighting, defending, acting and supporting. It follows that these same concerns, in their relation to individual and social existence, are shared by the figures in the triptych, each in his own way.

CLASS WAR takes up the theme of the queue, but here it moves forward along a path made up of fruit-bearing branches. On this symbolically fruitful path, a number of adolescent boys march from left to right. With staves in their hands they head towards a point on the far right where the front of the column has already come to a halt. This imaginary terminal point is prefigured, from the centre of the picture onwards, by the way in which the boys, initially naked to the waist, start to wear upper garments – even if, as in one case, the garment has slipped down from the wearer's shoulders to hang below the waist like a skirt.

Thus defined, the boys' horizontal movement is a progression towards the light: a progression that the background repeats in a vertical direction. Four pathways lead up towards a radiance that forms a symbolic counterpart to the light-coloured clothing of the boys. On these pathways, too, a procession of people moves upwards into the light.

The underlying movement in CLASS WAR, the gradual forward thrust into the light – and implicitly towards the place of action – is reinterpreted by the central motif of the picture, where a round nasturtium leaf, heavily bedewed with droplets of water, presents the movement in terms of omnidirectional flow, dispersal and spread. The impulse revealed by the structure of the leaf does not move in one line but through a process of proliferation and radial growth. This is also indicated by the number four, which appears in two guises, vertical (the four standing boys) and horizontal (the four paths); it can also be seen in MILITANT. The number in each of these cases is four because, like the structure of the leaf, four refers to the co-ordinates of space: front, back, right and left, or

north, south, east and west. To show any motif four times, therefore, means to evoke its presence everywhere.

This spreading movement is given the title of CLASS WAR because it applies to every human individual and seeks to carry human activity into every possible location. "War" here does not mean the struggle of one class against another, but that of a single class – humanity itself – to find and conquer its rightful place in the world.

The human beings shown here are kept in near-continual motion by the impulse to master, and then constantly to reaffirm, their own existence. What counts is not the goal, the ultimate objective and conclusion of the struggle, but the ceaseless flow of human beings towards an unattained goal in an unending endeavour to free themselves from the darkness. The need to concentrate unblinkingly on this objective, and not to be distracted by imaginary foes, is signified by Gilbert & George's wide open eyes flanking the leaf. They stare intently forward; nothing could possibly stand in their way.

CLASS WAR shows humanity struggling to pass from darkness into light (or, as the surface on which the human beings walk suggests, into "fruition"). This transition, symbolic of the spiritual regeneration of humanity, has of course been a classic theme – if not the universal theme – of art through the ages. As Goethe put it: "We are of the race that aspires to rise from darkness into light."[111] But traditional imagery always shows this radiance as the ultimate objective, the point of transformation or ecstasy; and no such immaterial, transcendent light is to be seen in Gilbert & George's triptych.

What do the boys do after they have seen the light, donned a radiant upper garment and advanced to a gateway? The answer is shown in the picture GATEWAY itself, where the boys, now almost entirely clad in light colours, are seen at the gates of the city, backed by a row of bushes in blossom.

Most have now discarded their staves and adopted half-erect postures that reflect the unfolding and the upward thrust of the blossoms behind them. They twist and bend, mostly looking up, prop themselves on an arm or both arms, and seem to be in the process of standing up.

The significance of this state of rising into mature form is underlined by the colossal images of Gilbert & George, who stand aside from the action, flanking it to left and right, like sentinels. They are shown as fully erect persons, established on a solid footing, and they hold their staves not like wayfarers' staffs but firmly planted, like stakes or tree trunks. Just as the background architecture presents itself as mature, established, erect and firm, so too do Gilbert & George. The path into the light, as seen in CLASS WAR, is not a goal in itself but simply a necessary part of the process of evolving one's own individual existence: this is clearly shown in GATEWAY. Light or radiance in itself is nothing. It represents liberation from darkness; but it is not true liberty, in the sense of a human existence conducted with full autonomy and self-determination.

In CLASS WAR Gilbert & George are present through their hypnotic stare; in GATEWAY they are symbols of fully established form; in MILITANT they are absent. The only large figures that are to be seen here are representatives of those who, in the other two pictures, are numerous but small: boys. CLASS WAR shows four boys standing still and four paths leading to the light; MILITANT shows the same number of boys in the selfsame pose that is adopted by Gilbert & George themselves in GATEWAY. Erect, having divested themselves of lightness (their upper garments), they take up a firm stance in front of a horizontally placed branch armed with red thorns. Echoing the vertical thorns, with all their overtones of protection and defence, the boys hold their red staves as upright as themselves; and, similarly echoing the

horizontal and vertical emphasis of the branch, the city in the background takes up the same posture of growth and defence. At either end it lies flat; in the centre it rears up vertically, like the thorns.

Just as in CLASS WAR there is no visible enemy, in MILITANT there is no form commonly associated with militancy, understood as the aggressive intent to destroy some specific target. What is literally militant here is something else: the readiness to carry through, maintain and defend the liberation achieved through CLASS WAR and the human development achieved by passing to and fro through the GATEWAY. Militancy here places itself wholly in the service of humanity. In a sense, MILITANT represents the goal towards which CLASS WAR points: the object of a process of constant striving, growth and formal elaboration.

This is not a process that ends with a "solution", an end-product with nothing to follow it; it is a process of human self-definition. In MILITANT the young human individual, whom THE QUEUE had already emphasized, has fully defined himself, so that from here he can pass on to pursue further objectives of his own. The absence of his light-coloured upper garments is a sign of this. The impulse to follow the light has drawn him on thus far, but light has not made a mature human being of him. It is only in the light that he can become conscious of himself, and then he can lay aside the magic of mere lightness and can himself become light, not as an attribute but as a form. He is light, just as in LIGHT (page 413) the tall, firm tower is light.

If the reading proposed here is adopted, passing from CLASS WAR to MILITANT by way of GATEWAY, focusing on the white garment that is put on and finally discarded, then the process of regeneration that emerges is a continual, or in other words a cyclic, one. It must constantly be begun anew. The human self-definition achieved in MILITANT may

be put to the test and enlisted in the service of CLASS WAR. Seen in this way, the four boys in MILITANT then place their individual strength in the service of the universal flow of the life force. They press forward from MILITANT to join the rear of the CLASS WAR march and put their shirts on again, leaving others to take their turn in the struggle to regenerate humanity.

This triptych is a perfect example of the way in which already formulated pictures may be elaborated through greater differentiation, new values and new content; and in another way, too, it points the way forward. This is shown above all by the leaf covered with droplets, in the centre of CLASS WAR. Seen in isolation, this represents the refinement and differentiation of interacting constituent forces. For both the leaf, as a symbol for the unfolding of physical life, and the droplets of water, as a promise of growth and proliferation through flow, present a visual image of those same sexual forces that are manifest in all their starkness to Gilbert & George in RED MORNING.

An image from Norse mythology may help to clarify the point. The leaves of the eternally green World Tree, Yggdrasil, are constantly bathed in a meadlike celestial honeydew that keeps the tree perennially alive and fresh.[112] This image survives to this day in the familiar guise of the Christmas tree, with its candles twinkling like sunlit dewdrops. In Gilbert & George's picture, too, the water droplets serve to instil new life into the human struggle implicit in the picture itself. Dewdrops, or any drops of water, are an allusion to constant regeneration; the specific content of the picture consists in the form and structure of the leaf itself.

The forces embodied in the leaf at the centre of CLASS WAR have appeared in a succession of different guises in Gilbert & George's work: as for example in WINTER TONGUE FUCK (page 339) and HOLY COCK (page 336),

with their backgrounds of flowing droplets, or in DRUNK WITH GOD (page 436), in which the hand of God dispenses the sexual forces that give life to the world. This is the context to which the pictorial invention of the leaf and the droplets belongs. It is no more than a model – an abstract figure, in a sense – which can elaborate a given theme only in terms of the specific pictorial form that serves as its vehicle. This is therefore an appropriate context in which to discuss a work that employs the leaf motif in a way utterly different from CLASS WAR.

Unlike CLASS WAR, the picture TEARS (page 470) is comparatively simple in construction. Against a light blue background, four bedewed leaves with serrated edges fill the picture area. Each leaf points either to the side or downwards, not upwards. This formal arrangement clearly shows that the "tears" of the title are not in fact the drops of water but the falling leaves. The position of the leaves shows the fall of the tears; the swordlike serrations define their nature.

The meaning of tears in this case is straightforward and immediately comprehensible: with tears human beings part, separate, register loss, and suffer the pain that speaks of falling away and being forsaken. The body is losing what it loves, or is moved by another's pain; and the consequent flow of tears consummates the separation.

TEARS does not show the specific cause of tears but their nature in general. Even they do not constitute a definitive image of pain and parting: all they can do is to let the pain come for a while. This is the significance of the dew that accompanies them. Its function is to subordinate the flow of tears to a greater flow, so that the pain of separation and parting may not last for ever.

Differentiation and refinement, in the work of Gilbert & George, have always had a twofold application: both to the picture itself, and to the wording that is an integral part of it.

Each complements the other, giving simultaneous visual and verbal shape to the artists' World. This World, as brought to our awareness in pictorial terms, is a form of language: it enables the beholder to know what he is talking about when he elects to use one word in preference to another. The best example of this is, once more, CLASS WAR, which takes as its title a term whose actual meaning is constantly being eroded by use, and which therefore needs renewing.

Class war in the traditional, historic sense presupposes a human society in which at least two classes exist in a relationship of mutual dependence. One of the two classes rebels against the other, which oppresses it. But now that classes have ceased to exist, and class enemies and class adversaries are no more than phantoms, class war in this sense has become redundant. Democracy has abolished it. In order to restore some validity to this deeply ingrained aspect of a cherished human value-system, it must be invested with a new content. And this is the purpose of the picture CLASS WAR.

The picture, not the words, supplies the new content. The mass of humanity, which formerly – as in THE QUEUE – stood passively and democratically in line, now realizes that the old class enemy has vanished, and harnesses class warfare to the purposes of its own self-definition. A form of super-democracy begins to take shape: now that human freedom is no longer contingent on the defeat of an adversary, all human strength is concentrated in one class, and that class is humanity itself. CLASS WAR enables every individual to say of himself with pride — and in total independence of any ideology — that he is a class warrior. He can once more use the phrase "class war" without mental reservations and without elitist pretensions.

Gilbert & George pursue ever more refined distinctions, in words and in pictures, even where it becomes difficult to find a conventional pictorial counterpart for an

aspect of common linguistic usage. For some years past, they have been working on a grammar of the person. They make pictures that give visible form to abstract concepts such as "I" or "you". (Normal speech can do this too, but only where the reference is to a specific, named person, never as a general image applicable to all.)

WE (page 268) provides a first pointer to this possibility of endowing a word with generalized meaning: in it the faces of Gilbert & George are interchangeable. It shows them as individual persons, but it also gives a picture of a "we"; and for all those who have no prior knowledge that the individuals shown are the artists Gilbert & George, this is what counts. Seeing the work, they are enabled to form an idea of a collectivity that is expressed in normal linguistic usage by the word "we"; and they are shown how a "we" can take visible form.

Other pictures that belong to this grammar of the person are HIM (page 268) and ME (page 408). Here, too, it is not the individual face but the picture and its presentation that defines the meaning of the titles. The grammar has been further amplified, to date, by three more works, I, YOU and THEY. Each time the aim is to supply a picture to give visual form to the common usage of the word, and to make clear, in a way that anyone can understand, what definition is evoked by the naming of oneself or of another person.

THEY (page 464), for example, shows Gilbert & George sitting side by side on chairs, dressed in identical colours and in a relaxed posture. They look the beholder straight in the eye, while at the same time stressing their own location by laying their hands on their thighs. "They" thus denotes the persons (in the plural; there might well have been more than two) who constitute a "bench" of equals, identifiable as such at a distance, and whom, by using the word "they", the beholder can hold collectively accountable. It is normal usage that endows the word "they" with its anonymous, impersonal

quality (as when we say "they've done..." or "now they're planning to..."). The picture THEY puts this linguistic convention into pictorial terms by exhibiting the persons that the word "they" stands for. For the first time it becomes possible to use the word "they" in the conventional way and at the same time point to a picture of "them". The fact that Gilbert & George play the part of "them" in this particular case does not mean that they ARE "they"; only that "they" always requires its appropriate visual image.

The pictures that make up the "grammar of the person" also point to another characteristic that is applicable to all Gilbert & George's pictures. The universal is coupled with the specific, and this is what defines the public dimension of the work. Their art involves everyone; everyone can take something from it. They emphasize what is universal, while simultaneously giving visual expression to the individual's part in it: thus, CLASS WAR represents the universal, and the individual's part in it gives rise to MILITANT. They always present the universal, in which the individual can find himself, and never the specific or subjective, which excludes the universal. The universal self is the servant of the individual self.

Just as in WE and THEY Gilbert & George give pictorial form to linguistic abstractions, in other works they operate similarly with numbers: the combination of word and picture leads on to that of number and picture. Early titles such as THREE WORKS – THREE WORKS (page 87), THREE WAYS (page 360) and FOUR KNIGHTS (page 244) already incorporate numbers, but only as an enumeration of pictorial elements and as a means of varying the theme; and the artists use later titles such as TWO HEADS, TWO COCKS, SIX PLANTS and SEVEN HEROES in a similar way. It is not until the work THREE, of 1984, that they use a number on its own as the title of a work. A second instance follows in 1986, this time a pictorial expression of TWO (page 462).

The Refinement of Life

In TWO, nine pairs of figures, symmetrically arranged in a pyramidal composition, represent the number Two. In addition to this dominant configuration, TWO features a dark blue urban background, as well as the colossal red faces of the artists themselves, who look in from either side towards the central and largest pair. The decisive factor, as far as the title is concerned, is that each of the pairs is one person depicted twice over, in mirror symmetry, as two identical figures in intersecting poses. In addition, each pair – with the exception of the large pair in the centre – is matched by an identical pair in the other half of the picture.

The pyramidal composition, and the direction of the artists' gaze, together govern the relative scale of the paired figures and their orientation towards the dominant central pair. These lines of orientation are also marked by a second compositional structure within the first. The apex of the pyramid consists of a group of three pairs, which differ from the others in two respects. Firstly, the figures have bare legs; and secondly, the two lateral pairs are the only ones who wear the crusader emblem on their chests. Unlike most of the others, they carry no staves.

The staves and the cross motif give visual expression to a common endeavour. The cross represents a pilgrimage, if not in the traditional sense of a journey through foreign lands (see the background); it also represents the idea of a crusade in the sense of the definition and pursuit of human values. The fact that these emblems accompany the transition from the lateral pairs in TWO to the central single pair serves to clarify the significance of pairing in this work. As the central pair exemplifies, each pair is engaged in the quest for values: they are on a crusade.

The identity between the two figures in each pair is not, however, a sign of that individual self-identity that Gilbert & George proclaimed at the outset of their career. Iden-

tity exists here, not because each pair consists of two identical persons, but because a shared concern transcends the pair. And it is because TWO is purely a manifestation of that common denominator that each of the pairs is a paired image of one person. TWO conveys the unity of the pair by showing each pair as one person twice over. This marks the significance of pairing in general. What counts, in public terms, is not the private views of the individual partners but the image that the pair present. And because this is the only thing that matters to the outside world, it is therefore the only thing that can change that world.

If ONE is contingency and unity, then TWO is strength. TWO takes on the unity of ONE to produce a common denominator, which is THREE. This relationship between ONE, TWO and THREE is presented twice over in the overall composition of TWO. The central triad consists of one pair flanked by two identical pairs; this group then represents unity, flanked by two further, identical groups of three pairs. Here a whole new aspect of Gilbert & George's art begins to emerge: alongside the picture and the word, number too is enlisted in the service of man.

The refinement of life, which Gilbert & George pursue in every field and which gives verbal and pictorial form to all the glorious ramifications of their World Tree, also applies to its death-dealing aspects. It has always been a mark of these artists that they juxtapose every theme with its contrary, on the principle that it can be adequately shown only by presenting both extremes together (as with FAITH CURSE or CURSE OF THE CROSS); and their latest work is no exception.

In A.D. (page 471) Gilbert & George enrich the progressive differentiation and proliferation of their World by presenting a vision of the world's end. The idea of a World Tree as a form of articulation, a scaffolding on which a world is

built, is here applied quasi-literally, through limb-joints (ARTI-CULI) and bodily structure. Each of the limbs, or by extension each of the pictures, stands for a specific portion of the world; and all of them, taken together, may be seen symbolically as the World Tree.

A.D. shows the end, and also the birth, of this World Tree. It embodies that moment in the world's history when the World Tree no longer stretches out its limbs in a process of proliferation and differentiation but arches its limbless joints into a wheel and spins, drawing all that exists into a vortex. This is the Year of the Lord, when world history comes to an end so that a new World Tree may come into being.

These limbless joints, sucked into a vortex, take visual form in A.D. as an elbow, a mouth and a navel. The navel, with its additional meaning of an axis (a nave or hub), marks the centre of the picture. Around it is the circle of an open mouth. The navel is the scar of a physical separation from the world; and the mouth reinforces this connotation by its roundness, its self-contained quality, its capacity to shut and separate. As in DEATH (page 434), it also conveys the idea of eating and assimilation: through it, life passes back to the world's hub, the AXIS MUNDI, the navel. And because this is not a process of articulation and outgrowth but of return, this central configuration is encircled by another wheel, consisting of a handless (symbolically unarticulated) arm. Above, the joint is extended; below, it is bent, with a watery crook. The two versions are linked at either side by images of a rounded elbow-point and a knee, so that all four together form an almost complete ring to echo those of the navel and the mouth.

The wheel of history, in the picture A.D., reveals no apocalyptic vision, no holocaust. It does not mark the end of all things but the hour of death; and this is always also the

hour of birth. The forces that embody the BIOS – the trunk and the limb joint – and the force that powers and regenerates it, which is that of water, converge at the AXIS MUNDI. Gilbert & George therefore employ the same pictorial metaphor here as in the works discussed above: a living tissue on which droplets of water symbolize the osmotic process of growth. This time, however, the body is not that of a plant but of a human being; and there is a reason for this. In the picture A.D., the Lord whose time has come is one who is neither superior nor inferior to man. The Lord of this World, its architect, creator and governor, who must die when it dies, is none other than man himself.

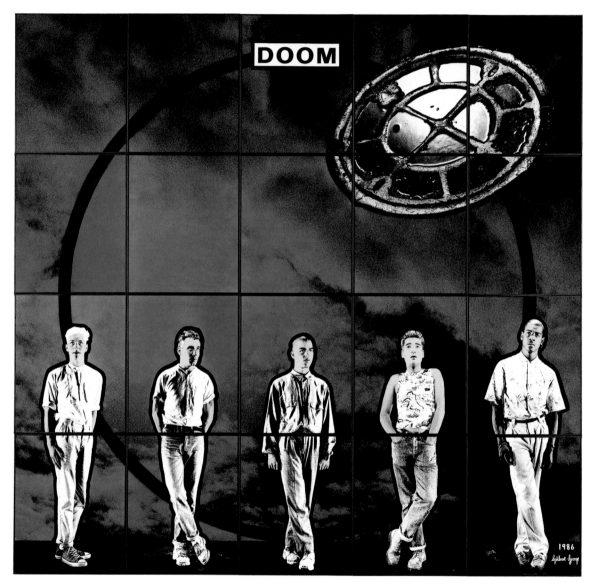

DOOM. 1986. 241x250 cm.
Everything, including the unfolding of the world itself, falls within the circle of the Wheel of Life,
rolling on to meet its fate.

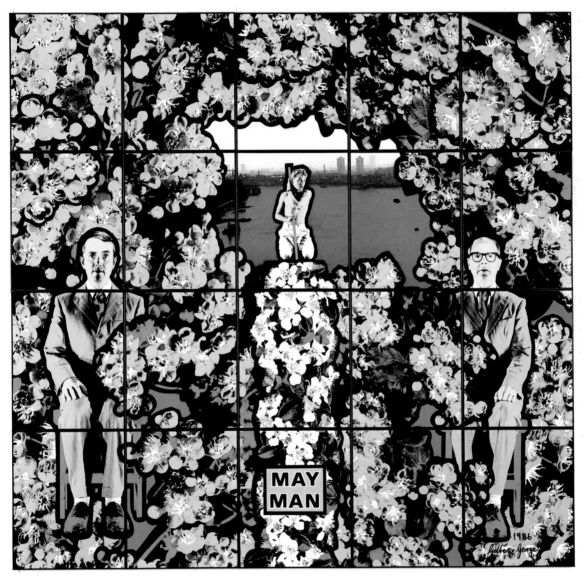

MAY MAN. 1986. 241x250 cm.
The refinements of life are subtler colours; finer distinctions; amplification of content (the theme of
"man" is more closely defined); abundance; and much more beside.

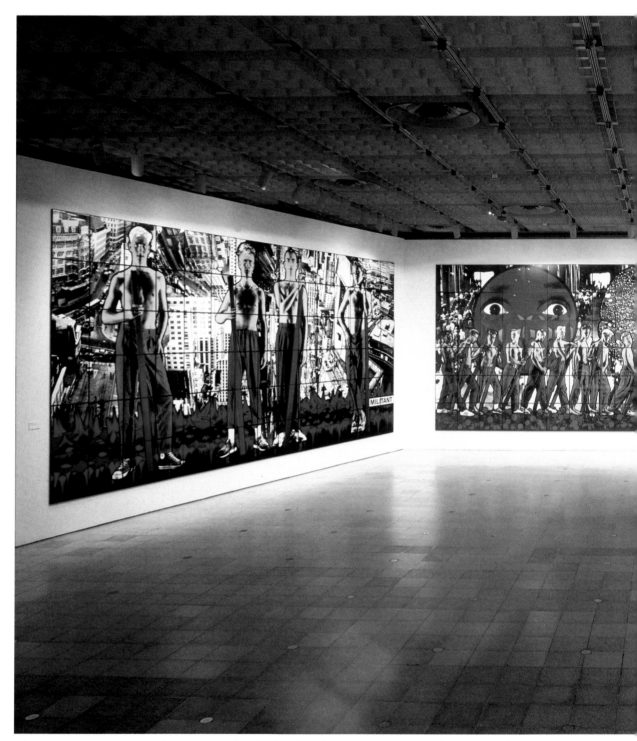

CLASS WAR, MILITANT, GATEWAY at the exhibition PICTURES 1982 TO 1986, Hayward Gallery, London. 1987.

Traditionally, triptychs in art have always embodied a narrative of the salvation of humankind. The triptych CLASS WAR, MILITANT, GATEWAY is no exception. Here humanity wins the battle for its own existence. The central panel shows the triumphal procession, and the theme is reinforced and amplified by the two wings.

454

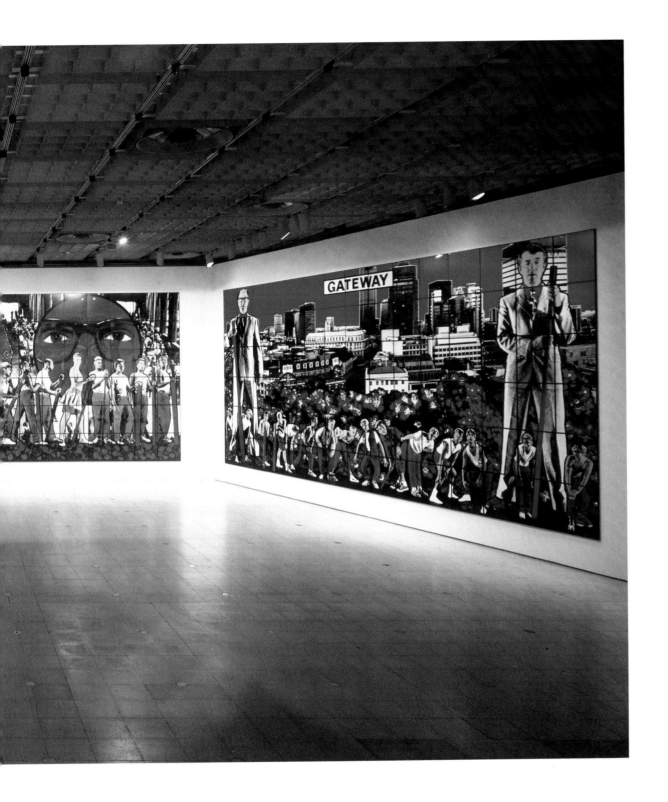

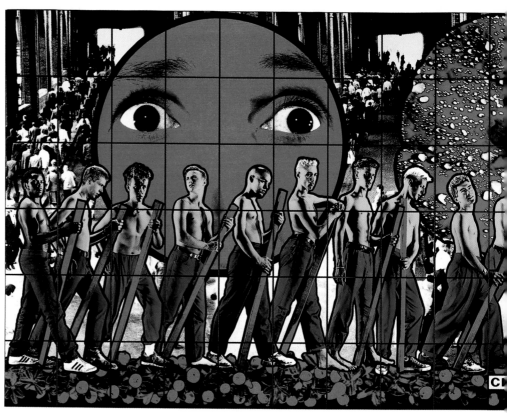

CLASS WAR from CLASS WAR, MILITANT, GATEWAY. 1986. 363×1010 cm.

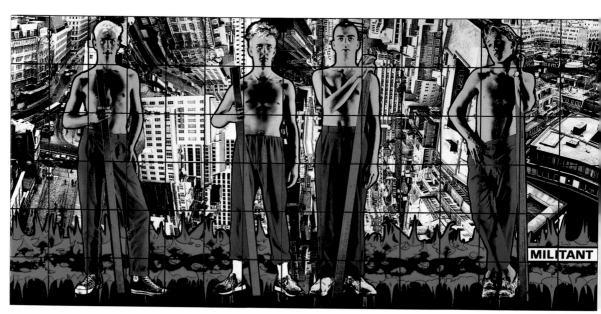

MILITANT from CLASS WAR, MILITANT, GATEWAY. 1986. 363×758 cm.

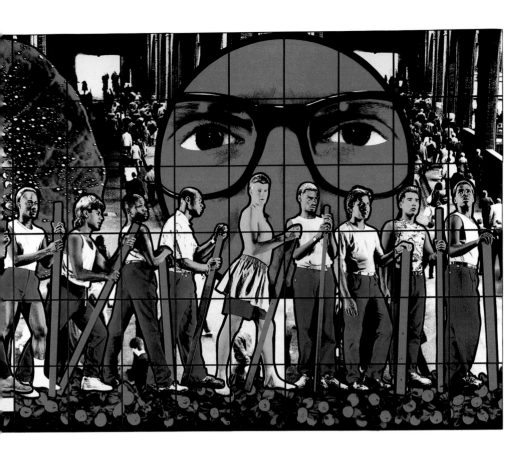

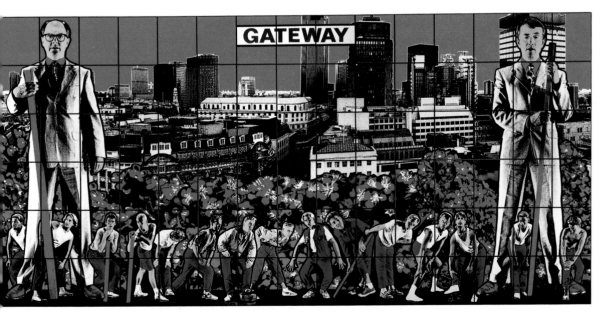

GATEWAY from CLASS WAR, MILITANT, GATEWAY. 1986. 363 x 758 cm.

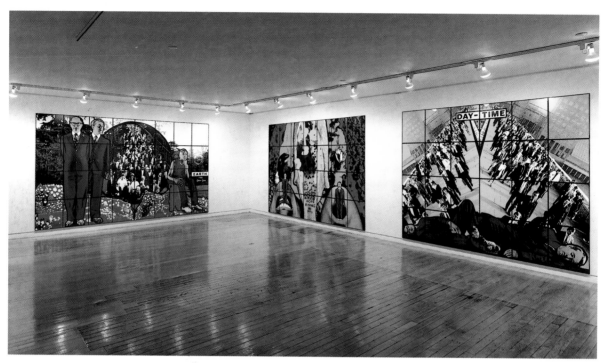

THE 1986 PICTURES. Exhibition at the Sonnabend Gallery, New York. 1987.

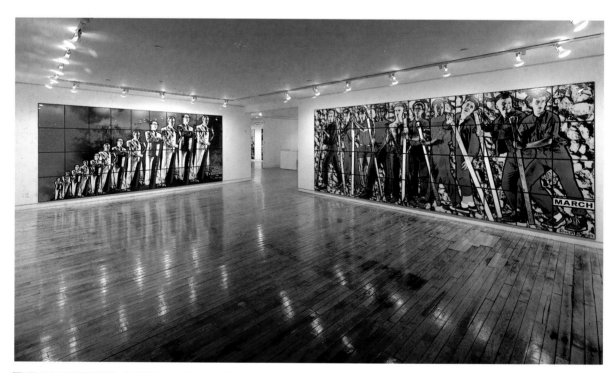

THE 1986 PICTURES. Exhibition at the Sonnabend Gallery, New York, 1987.

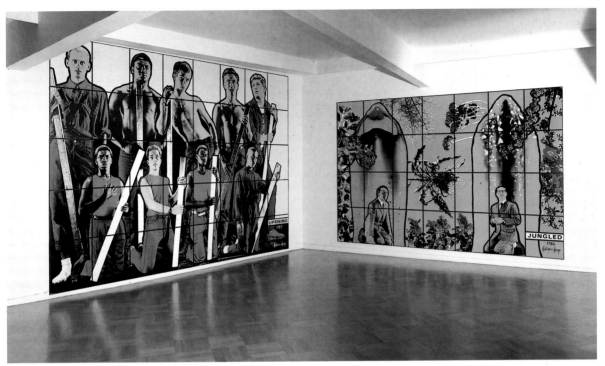

NEW PICTURES (1986 AND 1987). Exhibition at the Anthony d'Offay Gallery, London. 1987.

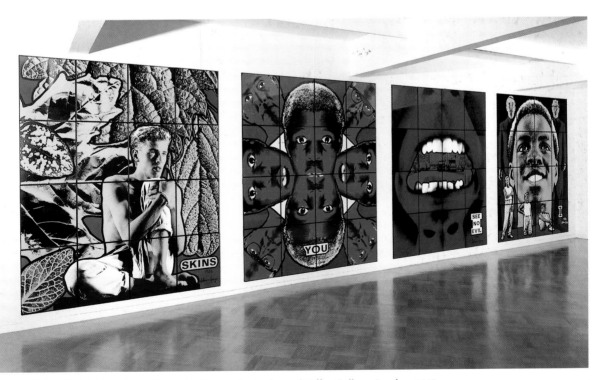

NEW PICTURES (1986 AND 1987). Exhibition at the Anthony d'Offay Gallery, London. 1987.

CHRISTMAS

CHRISTMAS. 1981. A Post-Card Sculpture.

"World Trees" on the Palace of Nebuchadnezzar II.

THE TREE

THE TREE. 1978. 241x201 cm.

THE QUEUE

THE QUEUE. 1978. 241x201 cm.

The tree is a symbol of life and of the world. In the traditional sense, the work of Gilbert and George is a World Tree. Each of their pictures is a living part of a living organism.

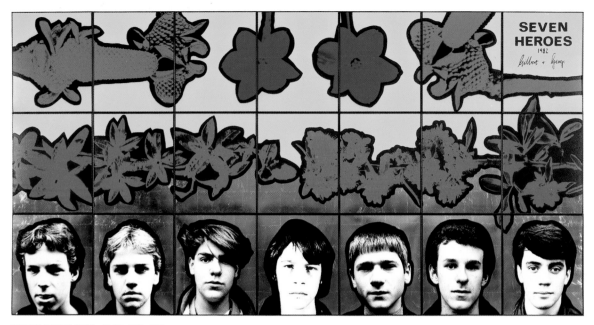

SEVEN HEROES. 1982. 181x350 cm.

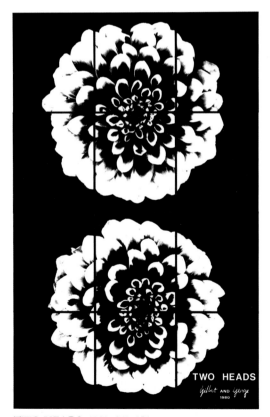

TWO HEADS. 1980. 241x151 cm.

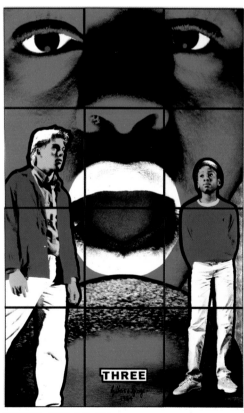

THREE. 1984. 241x151 cm.

Number, too, is in the service of humanity. It serves the purposes of variation, composition, organization and multiplication.

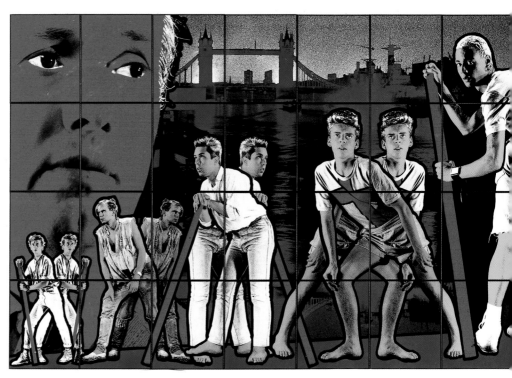

TWO. 1986. 242 x 758 cm.

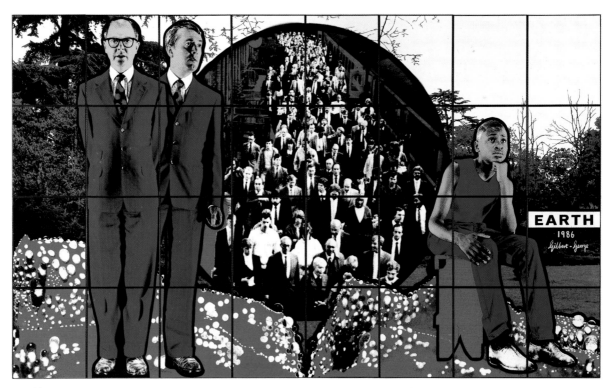

EARTH. 1986. 242 x 404 cm.
The osmotic working of life – the BIOS, represented in this case by the water that turns dead leaves
into compost – is analogous to human activity. Like drops of dew, human beings animate their world.

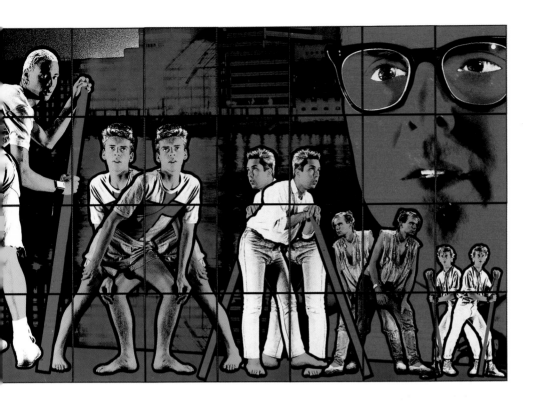

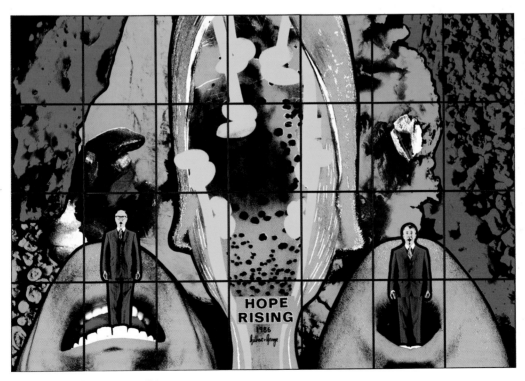

HOPE RISING. 1986. 242 x 353 cm.

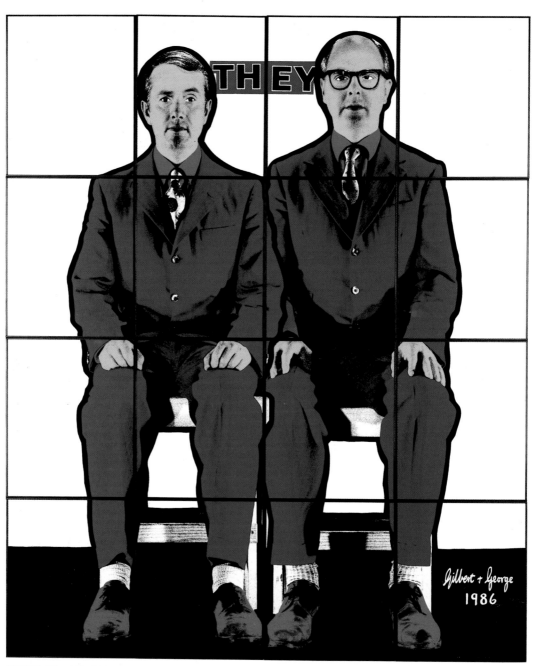

THEY. 1986. 241x201 cm.

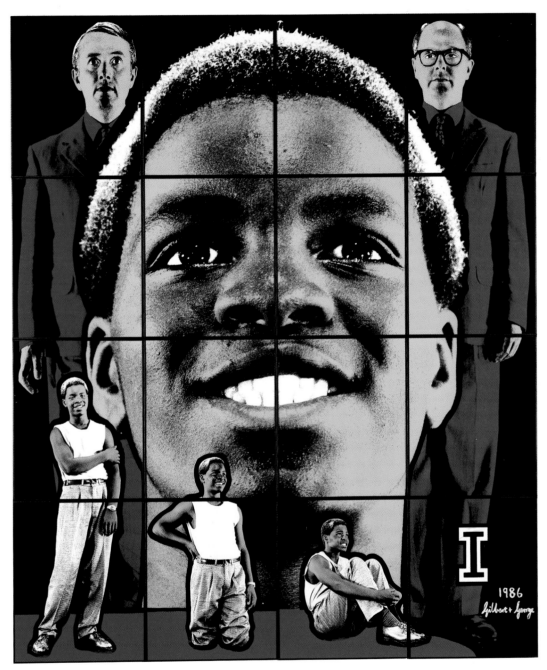

I. 1986. 241x201 cm.
Personal pronouns, and the pictures that go with them, represent the universal self. The individual can extract himself from them und make his own application. (See also WE, ME and HIM.)

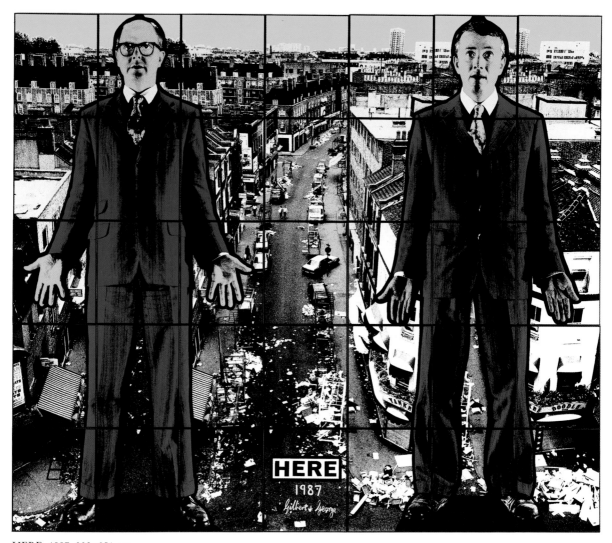

HERE. 1987. 302 × 351 cm.
Indications of place: even the positioning of the titles, one low, the other high, is indicative of the meaning. HERE shows the place in which human life is lived; THERE shows the remote, imaginary, peaceable realm of a Nature without humanity.

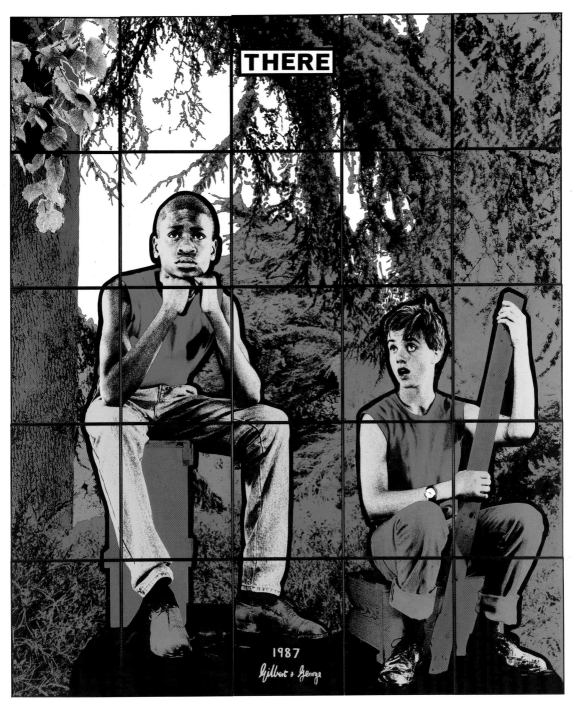

THERE. 1987. 302 x 250 cm.

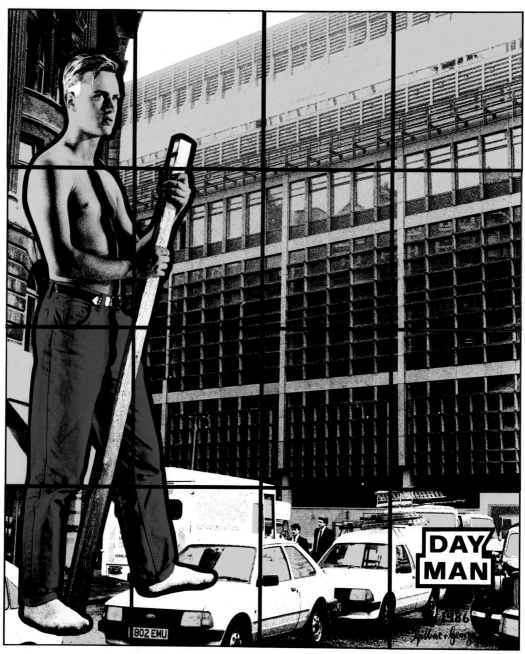

DAY MAN. 1986. 241x201 cm.

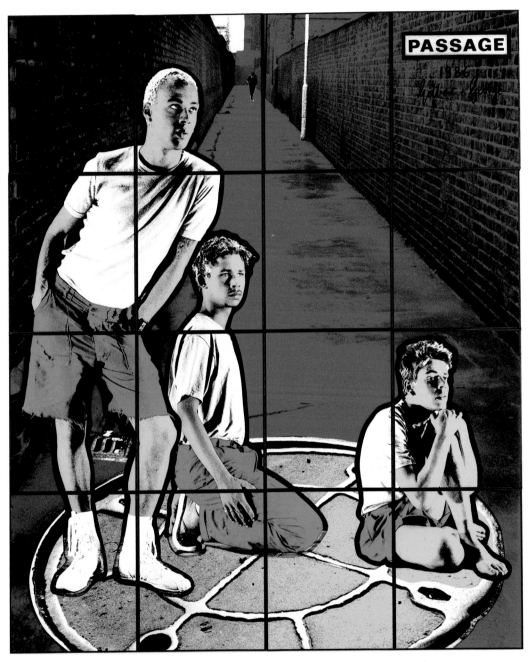

PASSAGE. 1986. 241×201 cm.
Far down the passage: three boys on the Wheel of Life.

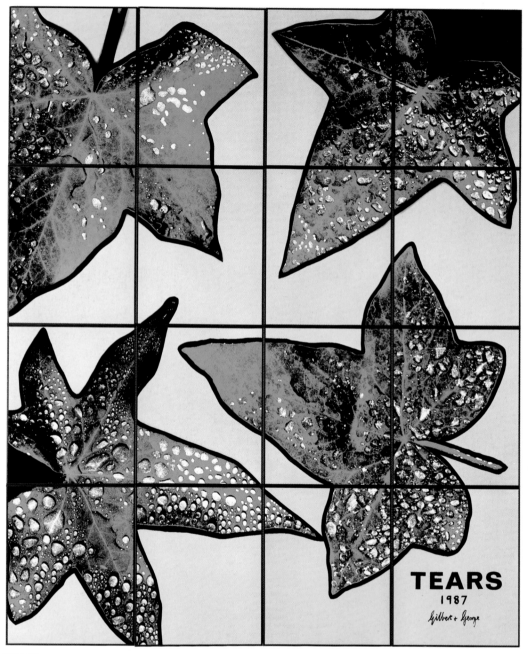

TEARS. 1987. 241x201 cm.
Physical structure – together with its regenerative element, which is water – stands symbolically for
the substance of life and its indwelling forces. As the configuration of the physical vehicle varies, the
contents represented by the image may become disparate and mutually unconnected.

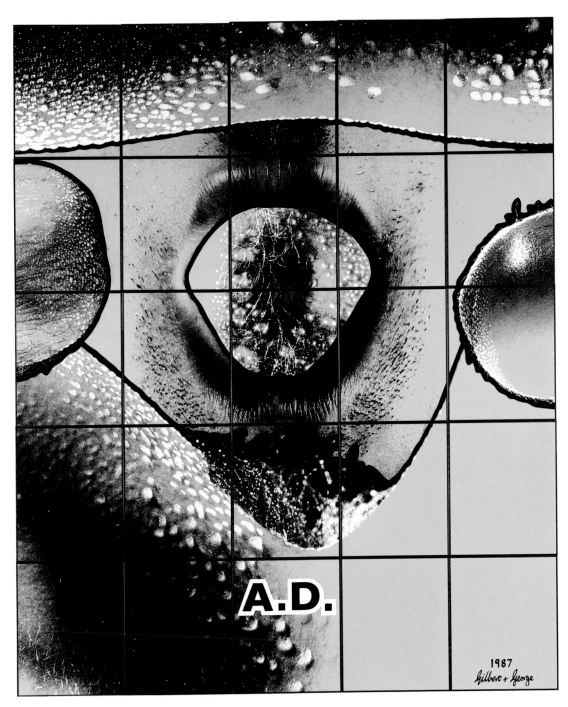

A. D. 1987. 302 x 250 cm.

Wheel of Life, from C. R. Ashbee, WHERE THE GREAT CITY STANDS, 1917.

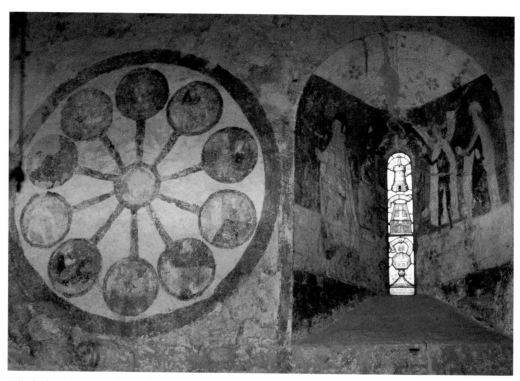

Wheel of Life, wall painting at St Mary's Church, Kempley, 12th century.

472

EPILOGUE

Gilbert & George now present us with a vast array of images. The contrast with the beginning of their career is total: there nothing, here plenitude. But the reversal is only apparent. In reality the idea of being a "human sculpture" has simply undergone a constant extension and elaboration in response to the unremitting need for more art, more life and a new normality. Their aim remains what it has always been: a crusade to reconquer human values. This crusade is a necessary one, because the point of departure of their art was also modern art's catastrophe: the total loss of creative power. It is worth briefly recapitulating the stages of the artists' progress, from a total dearth of content and values to a vast wealth of values and images, to show how all this harbours the seeds of a new art and a new life.

The outset of Gilbert & George's career, when they declared themselves to be two identical and interchangeable sculptures and thereby transformed the creative act into its antithesis, coincided with a total and universal collapse of mental and creative power. A block stood in the way, and this turned out to be none other than the hegemony of reason itself.

Epilogue

Reason, as the power which dominates man's awareness of life and of the world itself, has exhausted its potential while simultaneously imposing its own absolute control. It has become a stumbling-block, and yet its power is at its height. It deals with all forms of opposition to its profane, thoroughly explored world by simply seeing through them, exposing them as the products of a nostalgic hankering for outworn values. Over the centuries its constant endeavour has been to liberate man from his subjection to powers outside himself. It has flattened all opposition and undermined even the Utopia that it itself formerly proclaimed. No statement of value can sustain itself in the presence of reason, and no meaning can withstand its onslaught. The result has been the total disappearance of meaning and value. Everything, starting with man himself, is comprehended, dismembered and shown to be totally hollow.

The best single word to describe this state of affairs would be "absolute". Absolute, because it imposes the defining characteristic of the Absolute itself: all things and beings become self-identical. At this point the epoch, as represented by its form of awareness, has fulfilled itself by taking on absoluteness, the only divine quality that man can never live with. It remains possible to erect a simulacrum of a bygone (and irrecoverable) conception of nature and reality, but there seems to be no possible way out towards a new form of awareness.[113]

The worst thing about this predicament is that it leaves one in a state of total dependence on a form of awareness that has always aspired to make man independent and free. It has done what it set out to do, but in a sense it has also totally missed its objective, which is that of a society in which all are equal and all at peace. It has succeeded in imposing the LOGOS, the Word; but at the cost of destroying the BIOS, Life.

Even when reason becomes aware of its own baneful

consequences, it cannot cease to operate in the only way it knows how: by adopting a critical stance in relation to the external world, by demolishing imaginary entities and forces, by working for a society which will unite all mankind. It is the last-named that is reason's most basic task, in whose name it acts, and in whose name it is extremely effective. This in turn represents the major taboo area, reason's great stumbling-block. For reason has been at liberty to abolish everything except its own taskmaster, the idea of social union in whose service all its work has been done.

At the beginning of their career, Gilbert & George accepted this state of affairs in all respects; indeed, they embodied it. They were thus deliberately confining themselves in a prison from which there could be no escape except through the death of the taskmaster himself: the murder of the father. It remained for them to remove the central stumbling-block of the old awareness, which was the hankering for a "ground", a precept and a model for social life which would unite everyone.

The fact that Gilbert & George took a catastrophic endgame position as their point of departure explains why they have so little in common with the art of their time. The enemy, to them, was never an enemy to be overcome at all costs – as most contemporary art seeks to do – but the enemy that one must oneself become. To fight the foe and win, one must be prepared to infect oneself with his virus. This is the strategy that has marked their work to date, and this is what places Gilbert & George outside the scope of normal art history.

Gilbert & George saw themselves as the incarnation of an outworn form of awareness; and this was the guarantee that it would be overcome. They killed it by sacrificing it as the blood of life. What then appeared could be called "new" and "creative", because it had been freed from all trace of the

old. And it really was new. There was nothing new about it in the old sense of unfamiliar or previously unknown form; its forms were known and familiar. But in two respects it presented a new way of looking at life. Firstly, Gilbert & George perceived nothing beyond the surface; and secondly, what they perceived was the manifestation of a universal sexual polarity within the urban environment. There was now no "ground" to underpin life: only a sexually polarized space in which death and life could coexist. Death and its attributes, in particular, were now recognized as sexual to a high degree; for it was death that the old awareness had so consistently repressed. The death of the old awareness brought about the awareness of death. This took place within the ambit of the new, sexual awareness, which thus revealed itself from the outset in terms of the duality embodied in the creation myths of religious tradition.

From the raw, bare duality of urban space, Gilbert & George have ultimately brought forth a trinity. They have created a world by giving it form and endowing it with beauty. This process has been greatly helped by the fact that there are two of them, which means that they are able to give formal expression not only to the visible and audible world but also, and above all, to the social world. Together they have invented and established their own model of social life; it always takes at least two to do this. The old image of social life constantly sought to unite everyone, and the individual responded by importing or introjecting its values wholesale into his soul. The soul inflated itself into a microcosm, harbouring desires for liberation and self-realization that could never be fulfilled. Gilbert & George counter this with a new image of social life which makes no claim to be all-encompassing; social life has now come to reside above all in friendship.

Through their act of sacrifice, and as a result of their creation of a new World, Gilbert & George have plucked a

new fruit from the Tree of Knowledge. This has not served to elevate the artists themselves, to demarcate them and set them apart from others; on the contrary, it stands in the service of others. Their fruit, which is their World, is there to be given away, passed on to others. This is so even, or shall we say especially, when the artists themselves dominate the picture. This simply goes to show that it is open to anyone to put himself into the picture and create a World of his own: like Gilbert & George, the individual can formulate his own culture and his own imagery. The fact that Gilbert & George never make historical references, or draw on the inherited intellectual baggage of Western culture, but use themselves and familiar everyday motifs, makes their World, the fruit of their Tree, all the more precious. Anyone can read and understand it, irrespective of prior knowledge or education.

Along with their model of social existence and the urban imagery of their World, what Gilbert & George impart above all is a power which has increasingly receded into the background in Western history: the power of imagination and contemplation. This is the power to perceive life through its outer manifestations, instead of looking INTO it – as a reason-dominated awareness has always done – in search of a hypothetical inner content. This search always reveals only a void, because there is nothing there that man can ultimately hold and control; but imagination dispenses with the tangible and the certain in order to contemplate life in all its fullness and to formulate it in terms of imagery. Through the imagination, life can be seen in all the beauty of its organic growth and sexual polarity. Of course, all this can happen only at the price of one major concession: the knowledge that behind the imagery nothing exists to underpin the beauty that is felt and perceived.

Even in this there appears a fundamental religious notion, which is that human life is a fall from grace. Not so

much because some primeval transgression lies at the beginning of it — this need not be more than a metaphor — but because there is no solid ground on which to base the desire for life, the enjoyment of life or the glorification of life. So frail is human life, so much identified with torment and suffering, so beset by profound dilemmas, that it cannot possibly be described as a source of joy. It is and remains a form of suffering; but this is something quite distinct from the subjective suffering that afflicts the ego and obscures the true nature of human existence.

The sacrifice that Gilbert & George have performed is a general one, because it is for everyone. It liberates Western man from a delusion which led him constantly to dissect and eliminate what lay outside himself. He was helplessly in thrall to this delusion, which forced him to criticize, demolish and destroy because this was the only hope of salvation that he could see. He identified imaginary powers in the outer world as real ones which had therefore to be fought. His tactic of subversion was always directed at undermining this external foe. Gilbert & George's subversive intention is quite different: they accept a state of affairs without thereby confirming it, and they change it by making a gift of their own new awareness. Freed from the delusion that only the critical observation of others can bring salvation, they are in a position to set up something new.

It would be possible for their world model to proliferate explosively in the old world and subvert all that world's aspirations towards social union; but what is really subversive about it is its autonomous identity. Independent of the opinions, ideas and actions of others, it has its own ethical, moral and religious values and can point, what is more, to its own social structure. Gilbert & George thereby indicate what can be done with the modern State and its guarantee of personal freedom. One does not rise up against the State; one accepts it

in order to be independent of it. This comes close to a fundamental emancipation of man. Man can create and constitute himself, because he has recognized the dangers represented by others as hypothetical and imaginary, and because he knows himself to have the strength to become an autonomous self.

This kind of subversion shatters the old body of society to its core. Even at its most degenerate, society presents itself as an organic unity: all are meant to live within it in a state of equal, just and binding shared allegiance. Such a form of unity and equality is based on the ancient religious awareness of a Nature that unites and governs all men. This unity depends on the existence, at its leading edge, of an avant-garde whose role it is to challenge it, criticize it, ape it, or try to disrupt it. Whatever position the avant-garde might take up, that dependence was and is maintained.

The World of Gilbert and George, too, is an avant-garde, but no longer one that operates within the space of the old awareness. Their space, which they have been the first to open up, is a highly pagan one. Within it many spaces, times and worlds prevail, but none of them takes precedence over any other. Here there will be moralities in the plural instead of a decreed morality. In this space man can grow into a work of art, ungoverned by formal precedent, and develop his own being into a personal and individual aesthetic.

This is how Gilbert & George contrive to realize an aspiration that has been many times invoked in the course of this century: to abolish the distinction between life and art. Their art is indeed life, because in contradistinction to other artistic undertakings of our time it does not reflect the relationship between a lost image of humanity and the circumstances of today: on the contrary, it takes the material from which human beings and their World always have been built, and uses it as the basis of creation. Art is life, in deed.

The work of the artists Gilbert & George deserves

respect. Where nothing is to be found but utter silence and resignation, it offers a hint of a future that will serve mankind. It therefore has much to do with truth: not a truth that entails forcing everyone on to the same ground, or one that calls for objective verification, but a truth that makes possible a new awareness of life.

The artist's visions have nothing to do with any one binding, compelling truth, as Rudolf Kassner makes clear in a remarkable essay on Blake whose last words make a fitting conclusion to this book. The word "mysticism" here is to be taken in its etymological sense, as a reference to closed eyes: the very state in which Gilbert and George have approached the outworn awareness of life.

> In formal terms all art is superficial. In ideal terms only that of the mystic is so. Hitherto it has been customary to say the exact opposite, because nothing so readily takes people in as the word "mysticism". One pays a price for being a mystic. Visions are a great source of certainty to the person, and they are bad servants to the artist. They make the person into a saint, and the artist finds his salvation in being the least saintly of mankind.[114]

NOTES

1 The German word ERKENNTNIS has no single English equivalent, except perhaps the philosophical term "cognition", which is defined by the LONGMAN DICTIONARY OF THE ENGLISH LANGUAGE as "the act or process of knowing that involves the processing of sensory information and includes perception, awareness and judgment". In German, the Tree of Knowledge (Genesis 2.17) is DER BAUM DER ERKENNTNIS or DES ERKENNTNISSES. In this book the word has most often been translated as "awareness". – TRANSLATOR'S NOTE.

2 Two literary examples come to mind. The title of Robert Musil's novel THE MAN WITHOUT QUALITIES in itself points to a value-free state. In it, more than once, thought and feeling are described in terms of an state of irresolution, indifference and absence of value: "The intellect can nowadays find the most ingenious reasons why any action, or its contrary, is to be defended or to be condemned." (Robert Musil, DER MANN OHNE EIGENSCHAFTEN, Hamburg 1974, 218.) Nicolas Born's novel DIE ERDABGEWANDTE SEITE DER GESCHICHTE takes up a similar theme. Reality and the individual's own life are experienced as absolutely hollow and meaningless: "We find each other hollow, and when we are only memories we shall find each other hollower still. The grass will have vanished, cleared away with its roots and all. And it will become harder and harder to find new semblances to which a reality may be attached." (Nicolas Born, DIE ERDABGEWANDTE SEITE DER GESCHICHTE, Hamburg 1982, 56.)

3 "To be with art is all we ask" is the title of a short text which Gilbert & George wrote in 1970. With apparent naivety they pose the question of the origin and meaning of art, which is clearly seen as something wholly lifeless. But one has only to read between the lines to see that this seeming surrender to the inanimate conceals the desire for a lasting, living art.

4 Gilbert & George, SIDE BY SIDE, Cologne 1972, 97.

5 See Pierre Grimal, MYTHEN DER VÖLKER, Frankfurt/Main and Hamburg 1977, II.54, and Leopold Ziegler, ÜBERLIEFERUNG, Leipzig 1936, 448.

6 God as Absolute encompasses everything without manifesting it; values are consequently absent, because they are inherently relative and can never appear without a second object to serve as a point of reference.

7 Grimal (see note 5), II.55.

8 Genesis 1.2.

9 Grimal (see note 5), I.162,167.

Notes

10 Ibid., II.58.

11 Ibid., III.50.

12 Ibid., I.104–05.

13 It was Leopold Ziegler who drew attention to this. Enlisting the aid of the seventeenth-century mystic Jacob Boehme, he gives a cogent and convincing explanation why it was precisely the corpse of the rebel angel that became man, the image of God. Matter, despised as the incarnation of all that is "evil" or "non-divine", is redeemed and conducted towards the light. Man is therefore made from something that is "evil", but this very fact constitutes a triumph over evil. A fundamental dichotomy is thus overcome by divine intervention, and the initial transgression is redeemed. See Leopold Ziegler, MENSCHWERDUNG, Olten 1948, II.311 sqq.

14 The triad or trinity is already embodied in the primal state, as the prototype of what will later become manifest reality; but even here the Son is superior to his parents. In the Cosmic Tree of the Kabbalah, the triad appears as the letter SHIN, under the names of Binah, Hokhma and Kether. Kether is the son of the two others. The name Kether means "crown" or "wreath", which is sufficient indication in itself of his superiority to his parents. See Ziegler (see note 5), 310; for the primacy of the Son, see also 242.

15 Ibid., 294 sqq.

16 On the history and evolution of this intermediary role, see also Leopold Ziegler, GESTALTWAN-DEL DER GÖTTER, Darmstadt 1922, I.164 sqq. The idea that the world and its history are subject to a process of deterioration and decay is emphasized in Persian mythology. See Grimal (note 5), II.23 sqq. On the theme of cosmic renewal see also the chapter "Weltzeit und Geschichtszeit" in Ziegler (note 5), 333 sqq.

17 The name "Eternal Man" can be made to stand for the permanent state of evolution whereby man gradually takes form and constantly aspires to something higher. Seen in this light, the sacrifices that are recounted in narratives of theogony – the origin of the gods – are also manifestations of the Eternal Man, as for instance in the succession from Cronus to Zeus. Every sacrifice and every rebirth refines and sublimates the individual beings whose common source resides in an Absolute. In earthly life this process is embodied in the recurrent self-sacrifice of a God-Man. In broad terms this rests on a fundamental religious notion which links the creation of the world and of man with death. The death which is implicit in all duality (the "female" principle) is transcended by virtue of the fact that the matter of a dead body always gives rise to new, and in particular "higher", life (it is no coincidence that many traditions share the idea that "giants" or "Titans" lived in primeval times, and that from their immolated bodies a civilized race emerged). The image of Eternal Man thus presides over the unending process by which man learns his true shape: the anthropology that is coeval with the world itself. See also Ziegler (note 5), 244 sqq., 313 sqq.

18 Ibid., 295 sqq., 313.

19 Alongside the works by Ziegler cited here, reference should be made to a book by Uwe Steffen, who treats the theme through the Old Testament motif of Jonah as it appears in various cultures. Steffen's source references make his work probably the most comprehensive documentation of the life-history of the God-Man. It deals primarily with Jonah – devoured by a fish, that symbol of Hell and of ancient maternal wisdom – and so the theme of crucifixion, torture and martyrdom, emblematic of the eradication of a whole system of awareness, is relegated to a comparatively marginal position (as when the author examines the application of his theme to the life of Jesus Christ). It is probably Steffen's major achievement to have given the clearest and most detailed account of the God-Man's ordeal, his heroic journey through "separation from the world (dying) – trials and victories (initiation) – life-bringing return (rebirth)". See Uwe Steffen,

Notes

DAS MYSTERIUM VON TOD UND AUFERSTEHUNG, Göttingen 1963, 30 sqq., 171 sqq (on the mystery of Christ).

20 Ziegler (note 5), 335.

21 According to Ziegler (note 5), 335–36.

22 The essential function of the Philosophers' Stone was that of transmuting base or "polluted" metal into noble metal, whether silver or gold. But the Stone had its medicinal uses as well. See also Emil Ernst Ploss (ed.), ALCHIMIA, Munich 1970, 35 sqq., 121.

23 The equation of gold with the sun is part of the astrological world-view, according to which the planets in due order of precedence correspond to the hierarchy of metals. The sun (gold) has the highest place, followed by the moon (silver) and the other planets, each with its allotted metal. See Ploss (note 22), 32, 33.

24 The presumed derivation of alchemical doctrines from the CORPUS HERMETICUM – a loose compilation of Neoplatonic texts which medieval writers supposed to be the work of a single author in remote antiquity – played a considerable part in promoting such ideas. The supposed author, Hermes Trismegistus (Thrice-Great Mercury) was believed to be identical with the Egyptian god Thoth. His threefold authority as priest, philosopher and lawgiver, and his knowledge of God and the world, led a number of Adepts to suppose that through the alchemical OPUS they might attain participation in the divine. Such notions of divine inspiration can be traced even in the later days of the European alchemical tradition. See also Ploss (note 22), 113 sqq., and Stanislas Klossowski de Rola, ALCHEMY: THE SECRET ART, London and New York 1974, 14 sqq.

25 This is most evident in the parallel drawn by the alchemists between Christ and the Philosophers' Stone: "Alchemy in the High and Late Middle Ages looked elsewhere for a visual image of its processes. Where the ancient texts had named Orpheus as the Redeemer who set free and elevated the First Matter, the Christian alchemist, who was most often a cleric, named Christ. Christ redeems Man; the Stone of the Wise, the LAPIS PHILOSOPHORUM, redeems Matter, elevating it to its loftiest existential form, the metal gold." Ploss (note 22), 38; see also 140-42, 165. However, alongside Christ and other Biblical figures, the gods of Greek mythology still served as symbols for the alchemical process of purification. See Klossowski de Rola (note 24), plates 56-58 etc.

26 In the artists' text, A DAY IN THE LIFE OF GILBERT & GEORGE, of autumn 1971, an account of a clearly fictitious visit to the cinema is followed by the following statement: "And so we happily go back to Our art where only tiredness and searching play big roles, where all is thin on the ground, where greatness is made at the stroke of a brush, where something and nothing are both qualities."

27 Gilbert & George, SIDE BY SIDE, Cologne 1971, 105. An abstract picture on the following page, captioned "On and On", is accompanied by the following text: "On and On, expect no sleep, only melancholy rest. Only live with doing things like every bus, train, house and worker. It is most important that something has been done for only nothing has no existence of reason. Every moment of muscle is satisfying in the physique and intellect. That all is lost is not a fact so accept the gift of movement on this our planet. Because if not for you then it will be for a fellow creature. On and on."

28 In Dietmar Kamper, ZUR GESCHICHTE DER EINBILDUNGSKRAFT, Munich 1981, 205 sqq.: "Der Körper des Königs. Über einen dauernden Effekt der symbolischen Ordnung im Abendland".

29 Ibid., 211.

30 Ibid., 212.

31 Ibid., 218. Norman O. Brown, LOVE'S BODY, New York 1966, 139.

Notes

32 Kamper (note 28), 218-19. Brown (note 31), 137-38.

33 Kamper (note 28), 219.

34 Kamper (ibid., 220) makes reference to an "often quoted" lecture by Jacques Lacan with a title which he cites as follows: "The Mirror Stage as Creator of the Ego-Function, as Encountered in Psychoanalytical Experience". Kamper's main concern is to demonstrate that the young human individual almost inevitably takes on sovereign autonomy even before becoming able to establish a personality of his or her own in relation to other members of society. This has the consequence of implanting an unwarranted belief that the unitary identity of the subject is a given fact – although this is not the case at all. Kamper writes: "The mirror stage, with its fateful importance in the constitution of a subject who can say "I", opens the way to the Western conception of symbolic order as the Body of the King. This takes root, through the dynamics of the child-mother-father relationship, BEFORE traces of an individual identity appear." Ibid., 221–22.

35 Ibid., 221.

36 The working of the "Body of the King" as an ontological determinant in human existence is described by Kamper on page 224 of his book: "I should like to summarize once more, in slightly different terms, what this symbolic order in Western culture has done structurally to the body. This brings me back to my theme, which is as follows: 'Human Nature' as the stratified deposit of lengthy historical processes, with its own overriding effect on human experience; that is to say, the 'Body of the King' as an effective structure of human action, thought, feeling and perception."

37 Ibid., 207.

38 Jean Baudrillard has formulated a theory of cultural "simulacra"; see below, note 113.

39 In the interviews published as VON DER FREUNDSCHAFT ALS LEBENSWEISE, Berlin 1984, Michel Foucault several times refers to the idea of an existential aesthetic, an "aesthetic of existence" (71, 133 sqq.) In formulating this concept of an autonomous morality, determined by the subject himself, he makes particular reference to Greek ethics: "It seems to me that in Greek ethics people are more concerned with morality in relation to their own lives, their personal ethic and their attitudes to themselves and other people than with religious issues. What becomes of us after death? What are the gods? Do they intervene in human life or not? These questions were of little consequence because they did not affect ethics, and this in turn was not tied to a system of law… What interested the Greeks, their true theme, was the constitution of an ethic as an aesthetic of existence." (Ibid., 70–71.) The author is not concerned to revive Greek ethical thought, to recapitulate or to copy it. He sees in it simply a model which in its broad outline – the idea that the individual autonomously determines the way he lives his own life – points the way forward. The formulation of an aesthetic of existence, which will raise life, the BIOS, to the status of a work of art, must be sought and imagined above all in the realm of a new art, as Foucault points out a few pages later: "I perceive that art in our society has become something that applies only to objects, not to individuals or to life itself. Art is something special that is done only by specialists, namely artists. But why should not every individual be able to make his life into a work of art? Why should this lamp or that house be a work of art, and my life not?" (Ibid., 80.)

40 In their early days, Gilbert & George tirelessly emphasized the fact that they had elevated their whole life to the status of sculpture. In a short text dating from 1970, for instance, they wrote: "We are only human sculptors in that we get up every day, walking sometimes, reading rarely, eating often,… loving nightly,… travelling along, drawing occasionally, talking lightly,… greeting politely and waiting until the day breaks."

41 From A GUIDE TO SINGING SCULPTURE, 1970.

Notes

42 From THE PENCIL ON PAPER DESCRIPTIVE WORKS OF GILBERT & GEORGE, 1970.

43 This event took place on 26 January 1969 at the Geffrye Museum in London. See also GILBERT & GEORGE 1968 TO 1980, Eindhoven 1980, 46.

44 THE MEAL took place on 14 May 1969 at Ripley, Bromley, to the south of London. See also GILBERT & GEORGE 1968 TO 1980 (note 5), 54 sqq.

45 Quoted after Michael Moynihan, "Gilbert & George", in STUDIO INTERNATIONAL, vol. 179, No. 922, May 1970, 54 sqq.

46 Gilbert & George, SIDE BY SIDE, Cologne 1971, 111. Here is the complete text of the page: "Simplicity for meaning means only to be simple. The best things in life are free, indescribable, painful, delicious, rare and expensive. To deal with all these points which we here call 'Simplicity' we require a certain sweet fresh naivety. It is really all a question of balance between man and matter-understanding. Simplicity is a work of sophistication. A study in Simplicity becomes more and more to the point of reasoning. To deal with all."

47 Ibid., 101.

48 The three other laws, Nos 1, 2 and 4, are as follows:
"1. Always be smartly dressed, well groomed relaxed friendly polite and in complete control
"2. Make the world to believe in you and to pay heavily for the privilege
"4. The lord chissels still, so dont leave your bench for long".

49 Gilbert & George, SIDE BY SIDE, London 1971, 5.

50 Ibid., 41.

51 Ibid., 31.

52 Ibid., 59.

53 Ibid., 67.

54 In A MESSAGE FROM THE SCULPTORS, a postal sculpture of August 1969, they wrote: "Gilbert and George, the sculptors, are walking along a new road. They left their little studio with all the tools and brushes, taking with them only some music, gentle smiles on their faces and the most serious intention in the world."

55 See above, Note 3.

56 By way of dedication to the reader of their book DARK SHADOW, London 1976, which is a textual and pictorial account of their Descent, Gilbert & George wrote: "We hope that you have a nice time going through it."

57 The reference is to the text A DAY IN THE LIFE OF GILBERT & GEORGE, autumn 1971.

58 Ibid.

59 Gilbert & George, DARK SHADOW, London 1976.

60 Ibid., 73.

61 Ibid., 70.

62 Ibid., 98.

63 Ibid., 103.

64 Ibid., 100.

65 Ibid., 112.

66 Ibid., 1.

67 Ibid., 10.

68 Ibid., 6.

69 Ibid., 12.

70 Ibid., 123.

71 Ibid., 118.

72 Ibid., 116.

73 Ibid., 114.

74 Ibid., 128.

75 Ibid., 59.

76 Ibid., 54.

77 Ibid., 62.

78 Ibid., 17.

79 Ibid., 19.

80 Ibid., 18.

81 Ibid., 32.

82 Ibid., 60.

83 Ibid., 63.

84 Ibid., 41.

85 Ibid., 38.

86 Quoted after Brenda Richardson, in exhibition catalogue "Gilbert & George", Baltimore 1984, 25.

87 Gilbert & George, SIDE BY SIDE, London 1971, 123.

88 Ibid., 125.

89 Gilbert & George, DARK SHADOW, London 1976, 91.

90 Ibid., 94.

91 Adorno speaks of such a mimesis in positive terms: "The modernity of art lies in its mimetic relation to a petrified and alienated reality. This, and not the denial of that mute reality, is what makes art speak. One consequence of this is that modern art does not tolerate anything that smacks of innocuous compromise." Theodor W. Adorno, AESTHETISCHE THEORIE, Frankfurt/ Main 1970, 39; AESTHETIC THEORY, London and Boston 1984, 31.

92 Quoted after an interview with Jean-Hubert Martin on the occasion of the retrospective exhibition at the Centre Georges Pompidou, Paris, in 1981. The French text of the interview was inserted in the exhibition catalogue. In it (page 13) the artists said of the grid effect: "You look at the work of art on the wall. Without the grid you look at the photograph and try to understand what it represents; the eye looks into it like a frame or a television set. With the lines, on the other hand, it becomes flat. You see it as a whole, as a work of art on the wall, instead of looking for its content."

93 In THE WORDS OF THE SCULPTORS, 1969, Gilbert & George wrote, INTER ALIA: "It is important for new sculptors to come to terms with the modern limitations of sculpture, apparent only through the feeling of the eye."

94 From the film THE WORLD OF GILBERT & GEORGE, 1980.

95 Ibid.

96 Interview with Jean-Hubert Martin (note 54), 8.

97 The painting is by Reginald F. Hallward (1858–1948).

98 The root meanings of the Greek word KOSMOS are "order, decency, ornament". However, the Greeks themselves used it in a wider sense to mean "world order" or "the whole of humanity". The sense of KOSMOS as "ornament" has survived in such words as "cosmetic" (KOSMEIN, to order, adorn). See Paul Grebe, ETYMOLOGIE – HERKUNFTSWÖRTERBUCH DER DEUTSCHEN SPRACHE, Mannheim 1963, 362-63, art. KOSMOS.

99 Sutton Hoo is the site of a ship burial in Suffolk, England, which yielded the extraordinarily rich grave ornaments of an Anglo-Saxon king. Although the hoard stems from the period of the Anglo-Saxons' conversion to Christianity, c. AD 600, it is markedly pagan in its inspiration. See Helmut Roth, "KUNST DER VÖLKERWANDERUNGSZEIT", in PROPYLÄEN-KUNSTGESCHICHTE, Supplementband IV, Berlin and Vienna 1979, 214.

Notes

100 Ichthys, which is synonymous with Jesus Christ.

101 The Christian cross is most often interpreted as the instrument of Christ's martyrdom. But it is also a cross that cuts up and patterns the world – a cosmic cross – as Wolfram von den Steinen shows in his book Homo Caelestis. Das Wort der Kunst im Mittelalter, Berne and Munich 1965, 161 sqq., 261–62.

102 See Paul Grebe (note 60), 46, art. Ball; 74, art. Blut, Blüte.

103 Gilbert & George, the Complete Pictures 1971-1985, London 1986, vii. Under the title "THE LIFE FORCES" the artists write:
"True Art comes from three main life-forces. They are:
THE HEAD
THE SOUL
and THE SEX
"In our life these forces are shaking and moving themselves into everchanging different arrangements. Each one of our pictures is a frozen representation of one of these 'arrangements'."

104 This Tree of Life is in the Überseemuseum, Bremen.

105 Gilbert & George, Dark Shadow, London 1976, 95.

106 Michel Foucault, Von der Freundschaft..., Berlin 1984, 135–36.

107 One of the most virulent attacks on Gilbert & George for alleged paedophilia was in The Guardian. See "A Case of Good Pottery Training", in The Guardian, London and Manchester 28 March 1984.

108 Paul Grebe (note 60), 225, art. glauben.

109 See Herkunftswörterbuch Etymologie (Der grosse Duden, vol.7), Mannheim, Dudenverlag, 1963, 700, art. Tang, also 202, art. gedeihen.

110 Gilbert & George, Dark Shadow, London 1976.

111 Goethe's words are slightly adapted from something he wrote in a book review of a history of the ancient world: "Der Verfasser gehört zu denjenigen, die aus dem Dunklen in's Helle streben, ein Geschlecht, zu dem wir uns auch bekennen" ("Übersicht der Geschichte der alten Welt und ihrer Cultur von Schlosser, Frankfurt 1826", in J.W. von Goethe, Werke, Weimarer Ausgabe, Abt. 1, 41^2.210).

112 See Pierre Grimal, Mythen der Völker, Frankfurt/Main and Hamburg 1977, III.54.

113 Jean Baudrillard, in his theories of "simulacra" and the "hyper-real", has shown how present-day politics and art represent a mere simulation of the values and functions of a reality once assumed to be "true". Values formerly believed in are now merely acted out, thus heralding their imminent demise. See Jean Baudrillard, Kool Killer, Berlin 1978, 39 sqq., and Agonie des Realen, Berlin 1978, 7 sqq.

114 Rudolf Kassner, Sämtliche Werke, Pfullingen 1969, I.68.

BIOGRAPHY

GILBERT
Born Dolomites, Italy, 1943

GEORGE
Born Devon, England, 1942

Studied

Wolkenstein School of Art
Hallein School of Art
Munich Academy of Art

Dartington Adult Education Centre
Dartington Hall College of Art
Oxford School of Art

Met and Studied

St Martin's School of Art, London, 1967

PUBLICATIONS

1970
THE PENCIL ON PAPER DESCRIPTIVE
WORKS
ART NOTES AND THOUGHTS
TO BE WITH ART IS ALL WE ASK

A GUIDE TO THE SINGING SCULPTURE

Published by Gilbert & George, London
(edition 500)
Published by Gilbert & George, London
Published by Gilbert & George, London
(edition 300)
Published by Gilbert & George, London

1971
THE PAINTINGS
SIDE BY SIDE

A DAY IN THE LIFE OF GEORGE AND
GILBERT

Published by Kunstverein, Düsseldorf
Published by König Bros., Düsseldorf
(edition 600)
Published by Gilbert & George, London
(edition 1000)

1972
THE GRAND OLD DUKE OF YORK

Published by Kunstmuseum, Lucerne

1973
CATALOGUE FOR THEIR AUSTRALIAN
VISIT

Published by John Kaldor, Sydney

Biography

1976
DARK SHADOW

Published by Nigel Greenwood, London
(edition 2000)

1977
GILBERT & GEORGE

Published by Taxispalais Gallery, Innsbruck

1980
GILBERT & GEORGE 1968 TO 1980

Introduction by Carter Ratcliff
Published by Van Abbemuseum, Eindhoven

1984
GILBERT & GEORGE

Introduction by Brenda Richardson
Published by The Baltimore Museum of Art

1985
DEATH HOPE LIFE FEAR

Introduction by Rudi Fuchs
Published by Castello di Rivoli, Turin

1986
THE CHARCOAL ON PAPER
SCULPTURES 1970–1974
THE PAINTINGS 1971

Introduction by Demosthenes Davvetas
Published by CAPC, Bordeaux
Introduction by Wolf Jahn
Published by Fruitmarket Gallery, Endinburgh

THE COMPLETE PICTURES 1971–85

Introduction by Carter Ratcliff

POSTAL SCULPTURES

1969
THE EASTER CARDS
SOUVENIR HYDE PARK WALK
A MESSAGE FROM THE SCULPTORS (dated 1970)
ALL MY LIFE
NEW DECADENT ART (1969/1970)

1970
THE SADNESS IN OUR ART

1971
THE LIMERICKS

1972
1ST POST-CARD
2ND POST-CARD

Biography

1973
THE PINK ELEPHANTS

1975
THE RED BOXERS

MAGAZINE SCULPTURES

1969
THE WORDS OF THE SCULPTORS Jam Magazine, pp. 43–47 (Autumn)

1970
THE SHIT AND THE CUNT Studio International, pp. 218–21 (May)
WITH US IN NATURE Kunstmarkt catalogue, Cologne

1971
TWO TEXT PAGES DESCRIBING OUR The Sunday Times Magazine (10 January)
POSITION
THERE WERE TWO YOUNG MEN Studio International, pp. 220–221 (May)

1973
BALLS Avalanche, pp. 26–33 (Summer-Fall)

WORKS IN EDITION

1970
THE WORDS OF THE SCULPTORS (edition 35)
WALKING VIEWING RELAXING (edition 13)
TO BE WITH ART IS ALL WE ASK (edition 9)
TWO TEXT PAGES DESCRIBING OUR (edition 19)
POSITION

1971
THE TEN SPEECHES (edition 10)
THE EIGHT LIMERICKS (edition 25)

1972
MORNING LIGHT ON ART FOR ALL (edition 12)
GREAT EXPECTATIONS (edition 12)
AS USED BY THE SCULPTORS (edition 20)

1973
RECLINING DRUNK (edition 200)

Biography

1976
THE RED SCULPTURE ALBUM (edition 100)

1979
FIRST BLOSSOM (edition 50)

1987
NINETEEN EIGHTY SEVEN (edition 200)

1988
NINETEEN EIGHTY EIGHT (edition 6)

FILM AND VIDEO

1970
THE NATURE OF OUR LOOKING (edition 4)

1972
GORDON'S MAKES US DRUNK (edition 25)
IN THE BUSH (edition 25)
THE PORTRAIT OF THE ARTISTS AS (edition 25)
YOUNG MEN

1981
THE WORLD OF GILBERT & GEORGE Produced by Philip Haas for the Arts Council
of Great Britain (70 minutes)

1984
GILBERT & GEORGE South of Watford, ITV

1986
RENCONTRE A LONDRES Vidéo Londres. Michel Burcel, France
GILBERT & GEORGE La Estación de Perpiñán. TVE, Spain

LIVING SCULPTURE PRESENTATIONS

1969
OUR NEW SCULPTURE St Martin's School of Art, London
READING FROM A STICK Geffrye Museum, London
OUR NEW SCULPTURE Royal College of Art, London
OUR NEW SCULPTURE Camberwell School of Art, London
UNDERNEATH THE ARCHES Slade School of Fine Art, London
SCULPTURE IN THE 60'S Royal College of Art, London
(with Bruce McLean)

Biography

IN THE UNDERWORLD	St Martin's School of Art, London (with Bruce McLean)
IMPRESARIOS OF THE ART WORLD	Hanover Grand Preview Theatre, London (with Bruce McLean)
MEETING SCULPTURES	Various locations, London
THE MEAL	Ripley, Bromley, Kent (with David Hockney)
METALLISED HEADS	Studio International Office, London
TELLING A STORY	Marquee Club, London
THE SINGING SCULPTURE	The Lyceum, London
TELLING A STORY	The Lyceum, London
THE SINGING SCULPTURE	National Jazz & Blues Festival, Plumpton
A LIVING SCULPTURE	Institute of Contemporary Arts, London (at the opening of "When Attitudes Become Form")
UNDERNEATH THE ARCHES	Cable Street, London
POSING ON STAIRS	Stedelijk Museum, Amsterdam

1970
3 LIVING PIECES	BBC Studios, Bristol
LECTURE SCULPTURE	Museum of Modern Art, Oxford
LECTURE SCULPTURE	Leeds Polytechnic
UNDERNEATH THE ARCHES	Kunsthalle, Düsseldorf
UNDERNEATH THE ARCHES	Kunstverein, Hanover
UNDERNEATH THE ARCHES	Block Gallery Forum Theatre, Berlin
POSING PIECE	Art & Project, Amsterdam
POSING PIECE	Konrad Fischer Gallery, Düsseldorf
UNDERNEATH THE ARCHES	Kunstverein, Recklinghausen
UNDERNEATH THE ARCHES	Heiner Friedrich Gallery, Munich
UNDERNEATH THE ARCHES	Kunstverein, Nuremberg
UNDERNEATH THE ARCHES	Württembergischer Kunstverein, Stuttgart
UNDERNEATH THE ARCHES	Museo d'Arte Moderna, Turin
UNDERNEATH THE ARCHES	Sonja Henie Niels Onstad Foundation, Oslo
UNDERNEATH THE ARCHES	Stadsbiblioteket Lyngby, Copenhagen
STANDING SCULPTURE	Folker Skulima Gallery, Berlin
UNDERNEATH THE ARCHES	Gegenverkehr, Aachen
UNDERNEATH THE ARCHES	Heiner Friedrich Gallery, Cologne
UNDERNEATH THE ARCHES	Kunstverein, Krefeld
UNDERNEATH THE ARCHES	Nigel Greenwood Gallery, London

1971
UNDERNEATH THE ARCHES	Show Room du Garden Stores Louise, Brussels
UNDERNEATH THE ARCHES	For BBC play "The Cowshed", London
UNDERNEATH THE ARCHES	Sonnabend Gallery, New York

1972
UNDERNEATH THE ARCHES	Kunstmuseum, Lucerne
UNDERNEATH THE ARCHES	L'Attico Gallery, Rome

Biography

1973
UNDERNEATH THE ARCHES National Gallery of New South Wales,
 John Kaldor Project, Sydney

UNDERNEATH THE ARCHES National Gallery of Victoria,
 John Kaldor Project, Melbourne

1975
SHAO LIN MARTIAL ARTS Film Presentation, Collegiate Theatre, London
THE RED SCULPTURE Art Agency, Tokyo

1976
THE RED SCULPTURE Sonnabend Gallery, New York
THE RED SCULPTURE Konrad Fischer Gallery, Düsseldorf
THE RED SCULPTURE Lucio Amelio Gallery, Naples

1977
THE RED SCULPTURE Sperone Gallery, Rome
THE RED SCULPTURE Robert Self Gallery, London
THE RED SCULPTURE Art Fair, Sperone Fischer, Basle
THE RED SCULPTURE MTL Gallery, Brussels
THE RED SCULPTURE Museum van Hedendaagse Kunst, Ghent
THE RED SCULPTURE Stedelijk Museum, Amsterdam

GALLERY EXHIBITIONS

1968
THREE WORKS – THREE WORKS Frank's Sandwich Bar, London
SNOW SHOW St Martin's School of Art, London
BACON 32 Allied Services, London
CHRISTMAS SHOW Robert Fraser Gallery, London

1969
ANNIVERSARY Frank's Sandwich Bar, London
SHIT AND CUNT Robert Fraser Gallery, London

1970
GEORGE BY GILBERT & GILBERT BY GEORGE Fournier Street, London
THE PENCIL ON PAPER DESCRIPTIVE WORKS Konrad Fischer Gallery, Düsseldorf
ART NOTES AND THOUGHTS Art & Project, Amsterdam
FROZEN INTO THE NATURE FOR YOU ART Françoise Lambert Gallery, Milan
1970 THE PENCIL ON PAPER DESCRIPTIVE WORKS Folker Skulima Gallery, Berlin

Biography

1970
FROZEN INTO THE NATURE FOR
YOU ART Heiner Friedrich Gallery, Cologne
TO BE WITH ART IS ALL WE ASK Nigel Greenwood Gallery, London

1971
THERE WERE TWO YOUNG MEN Sperone Gallery, Turin
THE GENERAL JUNGLE Sonnabend Gallery, New York
THE TEN SPEECHES Nigel Greenwood Gallery, London
NEW PHOTO-PIECES Art & Project, Amsterdam

1972
NEW PHOTO-PIECES Konrad Fischer Gallery, Düsseldorf
THREE SCULPTURES ON VIDEO TAPE Gerry Schum Video Gallery, Düsseldorf
1972 THE BAR Anthony d'Offay Gallery, London
THE EVENING BEFORE THE MORNING Nigel Greenwood Gallery, London
AFTER
IT TAKES A BOY TO UNDERSTAND A Situation Gallery, London
BOY'S POINT OF VIEW
A NEW SCULPTURE Sperone Gallery, Rome

1973
ANY PORT IN A STORM Sonnabend Gallery, Paris
NEW DECORATIVE WORKS Sperone Gallery, Turin
RECLINING DRUNK Nigel Greenwood Gallery, London
MODERN RUBBISH Sonnabend Gallery, New York

1974
DRINKING SCULPTURES Art & Project / MTL Gallery, Antwerp
HUMAN BONDAGE Konrad Fischer Gallery, Düsseldorf
DARK SHADOW Art & Project, Amsterdam
DARK SHADOW Nigel Greenwood Gallery, London
CHERRY BLOSSOM Sperone Gallery, Rome

1975
BLOODY LIFE Sonnabend Gallery, Paris
BLOODY LIFE Sonnabend Gallery, Geneva
BLOODY LIFE Lucio Amelio Gallery, Naples
POST-CARD SCULPTURES Sperone Westwater Fischer, New York
BAD THOUGHTS Spillemaekers Gallery, Brussels
DUSTY CORNERS Art Agency, Tokyo
DEAD BOARDS Sonnabend Gallery, New York

1976
MENTAL Robert Self Gallery, London
MENTAL Robert Self Gallery, Newcastle

Biography

1977
RED MORNING Sperone Fischer Gallery, Basle
NEW PHOTO-PIECES Art & Project, Amsterdam
NEW PHOTO-PIECES Konrad Fischer Gallery, Düsseldorf

1978
NEW PHOTO-PIECES Dartington Hall Gallery, Dartington Hall
NEW PHOTO-PIECES Sonnabend Gallery, New York
NEW PHOTO-PIECES Art Agency, Tokyo

1980
POST-CARD SCULPTURES Art & Project, Amsterdam
POST-CARD SCULPTURES Konrad Fischer Gallery, Düsseldorf
NEW PHOTO-PIECES Karen & Jean Bernier Gallery, Athens
NEW PHOTO-PIECES Sonnabend Gallery, New York
MODERN FEARS Anthony d'Offay Gallery, London

1981
PHOTO-PIECES 1980–1981 Chantal Crousel Gallery, Paris

1982
CRUSADE Anthony d'Offay Gallery, London

1983
MODERN FAITH Sonnabend Gallery, New York
PHOTO-PIECES 1980–1982 David Bellman Gallery, Toronto
NEW WORKS Crousel-Hussenot Gallery, Paris

1984
THE BELIEVING WORLD Anthony d'Offay Gallery, London
HANDS UP Gallery Schellman & Klüser, Munich
LIVES Pieroni Gallery, Rome

1985
NEW MORAL WORKS Sonnabend Gallery, New York

1987
THE 1986 PICTURES Sonnabend Gallery, New York
NEW PICTURES Anthony d'Offay Gallery, London
GILBERT & GEORGE PICTURES Aldrich Museum of Contemporary Art, Connecticut

1988
THE 1988 PICTURES Ascan Crone Gallery, Hamburg

1989
THE 1988 PICTURES Christian Stein Gallery, Milan
FOR AIDS EXHIBITION Anthony d'Offay Gallery, London

Biography

MUSEUM EXHIBITIONS

1971
THE PAINTINGS Whitechapel Art Gallery, London
THE PAINTINGS Stedelijk Museum, Amsterdam
THE PAINTINGS Kunstverein, Düsseldorf

1972
THE PAINTINGS Koninklijk Museum voor Schone Kunsten, Antwerp

1973
THE SHRUBBERIES & SINGING SCULPTURE National Gallery of New South Wales, John Kaldor Project, Sydney
THE SHRUBBERIES & SINGING SCULPTURE National Gallery of Victoria, John Kaldor Project, Melbourne

1976
THE GENERAL JUNGLE Albright-Knox Art Gallery, Buffalo

1980
PHOTO-PIECES 1971–1980 Stedelijk van Abbemuseum, Eindhoven

1981
PHOTO-PIECES 1971–1980 Kunsthalle, Düsseldorf
PHOTO-PIECES 1971–1980 Kunsthalle, Berne
PHOTO-PIECES 1971–1980 Centre national d'Art et de Culture Georges Pompidou, Paris
PHOTO-PIECES 1971–1980 Whitechapel Art Gallery, London

1982
NEW PHOTO-PIECES Gewad, Ghent

1984
GILBERT & GEORGE The Baltimore Museum of Art
GILBERT & GEORGE Contemporary Arts Museum, Houston
GILBERT & GEORGE The Norton Gallery of Art, West Palm Beach, Florida

1985
GILBERT & GEORGE Milwaukee Art Museum
GILBERT & GEORGE The Solomon R. Guggenheim Museum, New York

1986
PICTURES 1982 TO 1985 CAPC Musée d'Art contemporain, Bordeaux
CHARCOAL ON PAPER SCULPTURES 1970 TO 1974 CAPC Musée d'Art contemporain, Bordeaux

Biography

THE PAINTINGS 1971 Fruitmarket Gallery, Edinburgh
PICTURES 1982 TO 1985 Kunsthalle, Basle

1987
PICTURES 1982 TO 1985 Palais des Beaux-Arts, Brussels
PICTURES 1982 TO 1985 Palacio Velázquez, Madrid
PICTURES 1982 TO 1986 Lenbachhaus, Munich
PICTURES 1982 TO 1986 Hayward Gallery, London

GROUP EXHIBITIONS

1969
CONCEPTION Städtisches Museum Leverkusen

1970
INFORMATION The Museum of Modern Art, New York
18 PARIS IV 66, rue Mouffetard, Paris
CONCEPTUAL ART, ARTE POVERA, Galleria Civica d'Arte Moderna, Turin
LAND ART
(UNTITLED) CAYC, Buenos Aires
PLANS AND PROJECTS Kunsthalle, Berne

1971
PROSPECT 71 PROJECTION Kunsthalle, Düsseldorf
THE BRITISH AVANT-GARDE Cultural Center, New York
SITUATION/CONCEPT Innsbruck

1972
DOCUMENTA 5 Kassel
THE NEW ART Hayward Gallery, London
CONCEPT KUNST Kunstmuseum, Basle

1973
CRITICS' CHOICE Tooth Gallery, London
ART AS PHOTOGRAPHY Kunstverein, Hanover
ART AS PHOTOGRAPHY The Museum Gallery, Paris
FROM HENRY MOORE TO GILBERT & Palais des Beaux Arts, Brussels
GEORGE
11 ENGLISH DRAWERS Kunsthalle, Baden-Baden
11 ENGLISH DRAWERS Kunsthalle, Bremen
CONTEMPORANEA Villa Borghese, Rome

1974
WORD WORKS Mount San Antonio College, Walnut, California
MEDIUM PHOTOGRAPHY Kunstverein, Hamburg

Biography

MEDIUM PHOTOGRAPHY	Kunstverein, Münster
KUNST BLEIBT KUNST	Kunsthalle, Cologne
PROSPECT	Kunsthalle, Düsseldorf
A GROUP SHOW	Palais des Beaux-Arts, Brussels
SCULPTURE NOW	Royal College of Art, London

1976

ARTE INGLESE OGGI	Palazzo Reale, Milan
GROUP SHOW	Fruitmarket Gallery, Edinburgh
THE ARTIST AND THE PHOTOGRAPH	Israel Museum, Jerusalem

1977

EUROPE IN THE 70'S	The Art Institute of Chicago

1978

EUROPE IN THE 70'S	Hirshhorn Museum and Sculpture Garden, Washington
EUROPE IN THE 70'S	San Francisco Museum of Modern Art
EUROPE IN THE 70'S	Fort Worth Art Museum
MADE BY SCULPTORS	Stedelijk Museum, Amsterdam
DOCUMENTA 6	Kassel
38TH BIENNALE	Venice
WORKS FROM THE CREX COLLECTION	Louisiana Museum, Humlebaek
WORKS FROM THE CREX COLLECTION	Lenbachhaus, Munich
WORKS FROM THE CREX COLLECTION	Stedelijk van Abbemuseum, Eindhoven

1979

EUROPE IN THE 70'S	Contemporary Art Center, Cincinnati
ON WALKS AND TRAVELS	Bonnefantenmuseum, Maastricht
UN CERTAIN ART ANGLAIS	ARC/Musée d'Art moderne de la Ville de Paris
WAHRNEHMUNGEN, AUFZEICHNUNGEN, MITTEILUNGEN	Museum Haus Lange, Krefeld
HAYWARD ANNUAL	Hayward Gallery, London
GERRY SCHUM	Stedelijk Museum, Amsterdam

1980

GERRY SCHUM	Museum Boymans-Van Beuningen, Rotterdam
GERRY SCHUM	Kunstverein, Cologne
GERRY SCHUM	The Art Gallery, Vancouver
GERRY SCHUM	A Space, Toronto
KUNST IN EUROPA NA '68	Museum voor Hedendaagse Kunst, Ghent
EXPLORATIONS IN THE 70'S	Plan for Art, Pittsburgh

1981

NO TITLE	Wesleyan University, Connecticut
ARTIST AND CAMERA	Arts Council of Great Britain Tour
WESTKUNST	Cologne

Biography

16 BIENAL DE SÃO PAULO	São Paulo
BRITISH SCULPTURE IN THE TWENTIETH CENTURY	Whitechapel Art Gallery, London
PROJECT 6: ART INTO THE 80'S	Walker Art Gallery, Liverpool
POINT DE VUE, IMAGES	Maison de la Culture, Chalon-sur-Saône

1982

ATTITUDES, CONCEPTS, IMAGES 60/80	Stedelijk Museum, Amsterdam
ASPECTS OF BRITISH ART TODAY	Metropolitan Art Museum, Tokyo
DOCUMENTA 7	Kassel
ZEITGEIST	Berlin

1983

PHOTOGRAPHY IN CONTEMPORARY ART	National Museum of Modern Art, Tokyo
ACQUISITION PRIORITIES	Solomon R. Guggenheim Museum, New York
TRENDS IN POSTWAR AMERICAN AND EUROPEAN ART	Solomon R. Guggenheim Museum, New York
NEW ART	Tate Gallery, London
URBAN PULSERS: THE ARTIST AND THE CITY	Plan for Art, Pittsburgh

1984

SYDNEY BIENNALE	Sydney
THE CRITICAL EYE	Yale Center for British Art, New Haven
ARTISTIC COLLABORATION IN THE 20TH CENTURY	Hirshhorn Museum und Sculpture Garden, Washington
HISTOIRES DE SCULPTURE	Château des ducs d'Epernon, Cadillac (Gironde)
HISTOIRES DE SCULPTURE	Musée d'Art moderne, Villeneuve d'Ascq (Nord)
HISTOIRES DE SCULPTURE	Espace Graslin – Manufacture des Tabacs, Nantes (Loire-Atlantique)
COLLECTIE BECHT	Stedelijk Museum, Amsterdam
ROSC	The Guinness Hop Store, Dublin
CONTENT	Hirshhorn Museum and Sculpture Garden, Washington
VIA NEW YORK	Musée d'Art contemporain, Montreal
GILBERT & GEORGE / RICHARD LONG	Museum of Art, North Carolina
PHOTOGRAPHY IN CONTEMPORARY ART	The National Museums of Art, Tokyo and Kyoto
COLLECTION ANNICK AND ANTON HERBERT	Stedelijk van Abbemuseum, Eindhoven
PRIVATE SYMBOL: SOCIAL METAPHOR. 5TH BIENNALE	Art Gallery of New South Wales, Sydney
THE BRITISH SHOW	Art Gallery of Western Australia
THE BRITISH SHOW	Art Gallery of New South Wales
THE BRITISH SHOW	Queensland Art Gallery

Biography

THE BRITISH ART SHOW	Arts Council of Great Britain Tour
TURNER PRIZE EXHIBITION	The Tate Gallery, London
DIALOG	Moderna Museet, Stockholm

1985

OVERTURE	Castello di Rivoli, Turin
BIENNALE DE PARIS	Grande Halle de la Villette, Paris
CARNEGIE INTERNATIONAL	Museum of Art, Carnegie Institute, Pittsburgh
ONE CITY A PATRON	Scottish Arts Council Tour
A JOURNEY THROUGH CONTEMPORARY ART	Hayward Gallery, London

1986

MATER DULCISSIMA	Chiesa dei Cavalieri di Malta, Syracuse
FORTY YEARS OF MODERN ART	Tate Gallery, London
FALLS THE SHADOW	Hayward Gallery, London
NEW VISIONS IN CONTEMPORARY ART	Art Museum, Cincinnati
COLLECTION PETER BRAMS	Fred L. Emerson Gallery, New York
OVERTURE II	Castello di Rivoli, Turin
TERRAE MOTUS 2	Istituto per l'arte contemporaneo, Naples
EYE LEVEL	Stedelijk van Abbemuseum, Eindhoven
THE MIRROR AND THE LAMP	Institute of Contemporary Arts, London
THE MIRROR AND THE LAMP	Fruitmarket Gallery, Edinburgh
TURNER PRIZE EXHIBITION	The Tate Gallery, London

1987

FROM THE EUROPE OF OLD	Stedelijk Museum, Amsterdam
FIFTY YEARS OF COLLECTING	Solomon R. Guggenheim Museum, New York
BRITISH ART IN THE TWENTIETH CENTURY	Royal Academy of Arts, London
BRITISH ART IN THE TWENTIETH CENTURY	Staatsgalerie, Stuttgart
CURRENT AFFAIRS	Museum of Modern Art, Oxford
CURRENT AFFAIRS	Budapest
CURRENT AFFAIRS	Prague
CURRENT AFFAIRS	Warsaw
KUNST RAI	International Exhibition Center, Amsterdam
INTRODUCING WITH PLEASURE	South Bank Centre, London
L'ÉPOQUE LA MODE LA MORALE LA PASSION	Centre national d'Art et de Culture Georges Pompidou, Paris

1988

ROT GELB BLAU	Kunstmuseum, St Gallen
COLLECTION SONNABEND	Centro de Arte Reina Sofía, Madrid
COLLECTION SONNABEND	CAPC Musée d'Art contemporain, Bordeaux
1988: THE WORLD OF ART TODAY	Milwaukee Art Museum

BIBLIOGRAPHY

1969
Elk, Ger van WE WOULD HONESTLY LIKE Museumsjournaal, 14.248–249
TO SAY HOW HAPPY WE ARE
TO BE SCULPTURES

1970
Reineke, K. U. UNTITLED Museumsjournaal, 15.117–119
Anonymous SINGENDE SKULPTUR, Der Spiegel, Vol. 24, No. 45
GLÜCKLICHE HAUER
Moynihan, Michael GILBERT & GEORGE Studio International, May,
179.196–197
Blotkamp, Carel DE WERKEN VAN GILBERT & Vrij Nederland, 13 June
GEORGE, SOMS IN LEVENDE
LIJVE
Tisdall, Caroline GILBERT & GEORGE The Guardian, 20 Nov.
Anonymous GILBERT & GEORGE Studio International, Dec.,
180.249–51

1971
Harten, Jürgen CONCEPT ART exh. cat. NÜRNBERG, 2TE
BIENNALE, Kunsthalle,
Nuremberg, 322–344
Harrison, Charles ART ON TV Studio International, Jan.,
181.30–31
Kenedy, R. C. PARIS Art International, 20 Feb., 15.52
Anonymous THE BRITISH AVANTGARDE Studio International, May,
181.200–239
Cambert, Jean-Claude GILBERT & GEORGE Opus International, 24/25 May, 96
Forge, Andrew THE SCULPTURE OF The Listener, 22 July
GILBERT & GEORGE

Bibliography

Brook, Donald	U. K. COMMENTARY	Studio International, Sept., 182.87–91
Celant, Germano	BOOK AS ARTWORK	Data, Sept., 35–49
Reichardt, Jasia	GILBERT & GEORGE	Architectural Design, Sept.
Jappe, Georg	MÄHNE UND ALLÜRE SIND PASSÉ	Frankfurter Allgemeine Zeitung, 8 Sept.
Kipphoff, Petra	GILBERT & GEORGE	Die Zeit, No. 37, 10 Sept.
Engelhard, Ernst G.	GILBERT & GEORGE	Deutsche Zeitung, 17. Sept.
Kipphoff, Petra	GILBERT & GEORGE	Zeit Magazin, No. 38, 17 Sept., 37–39
Anonymous	LEBENDE PLASTIK – LÄHMENDER KITSCH	Kölner Stadtanzeiger, 21 Sept.
Perreault, John	NOTHING BREATHTAKING WILL OCCUR HERE BUT…	Village Voice, 7 Oct.
Davis, Douglas	GILBERT & GEORGE	New Yorker, 9 Oct., 40–41
Kenedy, R. C.	LONDON LETTER	Art International, Oct., 15.66–71
Ashton, Dore	U.S. COMMENTARY	Studio International, Nov., 182.199–201
Reise, Barbara	PRESENTING GILBERT & GEORGE	Art News, Nov., 70.62–65
Garrel, Betty van	KUNST ALS EEN VORM VAN LEVEN	Haagse Post, 10 Nov., 88–91
McDonagh, Don	GILBERT & GEORGE	The Financial Times, 30 Nov.
Henry, G.	THE WHOLE PICTURE	Art International, Dec., 15.89–90/92
Pincus-Witten, Robert	GILBERT & GEORGE	Artforum, No. 10, Dec., 10.78–79

1972

Celant, Germano	GILBERT & GEORGE	Domus, No. 508, Mar., 50–53
Seymour, Anne	AN INTERVIEW	exh. cat. THE NEW ART, Hayward Gallery, London, 92–95
Weiermair, Peter	GILBERT STAMMT AUS DEM GRODENTAL	Tiroler Tageszeitung, 15 Jan.
Buhlmann, Karl	SELBSTDARSTELLUNG ALS BILDSPRACHE	Luzerner Neueste Nachrichten, 25 May
Cork, Richard	IT'S GILBERT & GEORGE, ALWAYS THE LIFE & SOUL OF THE PARTY	Evening Standard, 22 July
Zec, Donald	THE ODD COUPLE	Daily Mirror, 5 Sept.
Tisdall, Caroline	THE GREATEST TWO-MAN VAUDEVILLE ACT IN THE ART GALLERIES	The Guardian, 30 Nov.
Cork, Richard	MAKE MINE A DOUBLE SCULPTURE	Evening Standard, 1 Dec.
Vaizey, Marina	GILBERT & GEORGE	The Financial Times, 30 Dec.

Bibliography

1973

Blotkamp, Carel	GILBERT & GEORGE: ON COOPERATION ON TRADITION	ALBUM AMICORUM J. G. VAN GELDER, The Hague (Nijhoff), 42–46
Rose, Barbara	GILBERT & GEORGE	Partisan Review, No. 2, 215
Ammann, Jean-Chr.	GILBERT & GEORGE	Das Kunstwerk, Jan., 26.35–44
LeGrice, Malcolm	GILBERT & GEORGE	Studio International, Jan., 185.6
Brooks, Rosetta	A SURVEY OF THE AVANT-GARDE	Flash Art, No. 39, Feb., 6–7
Pluchart, F.	GILBERT & GEORGE, HUMAN SCULPTURES	Artitudes International, No. 3, Feb./Mar., 16–17
Vaizey, Marina	GILBERT & GEORGE	The Financial Times, 25 May
Vergine, L.	IL "CASO" GILBERT & GEORGE	Qui Arte Contemporanea, No. 11, June, 414–444
Nicklin, Leonore	AND HERE COME THE LIVING SCULPTURES	Sydney Morning Herald, 14 Aug.
Thomas, Daniel	STILL LIFE ON A TABLE	Sydney Morning Herald, 16 Aug.
Adams, Bruce	GILBERT & GEORGE FOR HIGH TEA	Sunday Telegraph (Sydney), 26 Aug.
Brook, Donald	BLUR BETWEEN ART & LIFE	Nation Review, 31 Aug.
Hector, Chris	THEY KEEP STIFF FOR HOURS	Nation Review, 31 Aug.
Baudson, Michel	GILBERT & GEORGE	Clés pour les arts, No. 36, 1 Oct., 13
Schuldt	L'ANGELUS DE MILO	Art Vivant, No. 45, Dec., 9–11
Vergine, L.	BODY ART	Notiziario Arte Contemporanea, Dec., 23–26
Davis, Douglas	LIVING STATUES	Newsweek, 3 Dec., 119

1974

Graf, U.	ZUR GESCHICHTE DER LEBENDEN SKULPTUR	Werk/Oeuvre, 61.219–225
Ohff, H.	GILBERT & GEORGE	Das Kunstwerk, 27.2–3
Lascault, Gilbert	UNTITLED	Paris-Normandie, 9/10 Mar., 16
Lepape, Pierre	UN ENTRETIEN	Paris-Normandie, 9/10 Mar., 16
Lynn, E.	GILBERT & GEORGE	Art International, Mar., 18.30–31
Anonymous	GAY GORDONS	Times Literary Supplement, June
Heard, James	GILBERT & GEORGE	Arts Review, 12 June, 26.435
Weiermair, Peter	GILBERT & GEORGE	Tiroler Tageszeitung (Wochenendbeilage), July 1974
Morris, Lynda	GILBERT & GEORGE	Studio International, July/Aug., 188.49–50
Pluchart, F.	NOTES SUR L'ART CORPOREL	Artitudes International, No. 12–14, July/Sept. 1974, 46–66
Trini, Tomaso	GILBERT & GEORGE	Data, Vol. 4, No. 12, Summer, 20–27
Novak, Robert	THE ART OF LIVING	Farrago Literary Supplement, 7 Sept.

Bibliography

1975

Anonymous	DANS LE COURANT DE L'ART CONCEPTUEL	Skira Art Actuel Annuel, 38–39
Bologna, Ferdinando	GILBERT & GEORGE	Il Mattino, 13 May

1976

Celant, Germano	GILBERT & GEORGE	SENZA TITOLO, Rome (Bulzoni), 211–214
Lowe, Shirley	GILBERT & GEORGE & US	Over 21 Magazine
Wellershof, Dieter		DIE AUFLÖSUNG DES KUNSTBEGRIFFS, Frankfurt/Main, 40–42
Grove, N.	EXHIBITION REVIEWS	Arts Magazine, Jan., 50.14–16
Ratcliff, Carter	THE ART AND ARTLESSNESS OF GILBERT & GEORGE	Arts Magazine, Jan., 50.54–57
Henry, G.	GILBERT & GEORGE	Art in America, Jan./Feb., 64.104–105
Wooster, A.-S.	EXHIBITION REVIEW	Artforum, Feb., 14.60–64
Roberts, Michael	THE ART OF LIVING	Sunday Times, 22 Feb., 43
Morris, Lynda	GILBERT & GEORGE	Listener, 22 May
Tisdall, Caroline	GILBERT & GEORGE	The Guardian, 27 May
Feaver, William	MENTAL IMAGES	The Observer, 30 May
Ford, M.	GILBERT & GEORGE	Arts Review, 11 June, 28.300
Fagone, V.	INGHILTERRA GIOVANE NELLA MOSTRA: ARTE INGLESE OGGI 1960–76	D'Ars, July, 17.16–29
McIntyre, A.	L'ART CORPOREL	Art and Australia, July/Sept., 14.74–78
Pincus-Witten, Robert	ENTRIES	Art Magazine, Oct., 51.17–20
Haden-Guest, Anthony	THE RED SCULPTURE	Paris Review, Winter

1977

Weiermair, Peter	GILBERT & GEORGE	exh. cat. GILBERT & GEORGE, Taxispalais, Innsbruck, 1–2
McNay, Michael	TWINNING WAYS	The Guardian, 7 Jan.
Walker, Dorothy	MARSHMALLOW AESTHETES	Hibernia, 4 Feb.
Carrel, Betty van	LAAT ONS HOPEN DAT KUNST WAAR IS	Hollands Diep, Mar., 3.46–47
Lucie-Smith, Edward	EVER SO NICE	Art & Artists, Mar., 11.27–29
Zumbrink, Jan	BEELDHOUWEN MET HET EIGEN LICHAAM	De Nieuwe Linie, 30 Mar.
Fuchs, Rudi	GILBERT & GEORGE	Art Monthly, No. 6, April
Piller, Mickey	WIJ NOEMEN ALLES WAT WE DOEN SKULPTUUR	Haagse Post, 9 Apr.
Laedermann, P.	BRITISH ART NOW	Midwest Art, Summer, 4.7
Wyndham, Francis	GILBERT & GEORGE	Sunday Times Magazine, 10 Nov., 18–23

Bibliography

1978

Kousbroek, Rudy	DE BEDROGEN VERBEELDING	NRC Handelsblad, 3 Mar.
Lorber, Richard	GILBERT & GEORGE	Artforum, May, 16.59 f.
Ratcliff, Carter	DOWN AND OUT WITH GILBERT & GEORGE	Art in America, May/June, 66.92–93

1979

Francis, R.	GILBERT & GEORGE	exh. cat. HAYWARD ANNUAL, Hayward Gallery, London, 89
Acha, J.	BODY ART	D'Ars, July, 20.36–45
Anonymous	GILBERT & GEORGE	Aspects, No. 7, Summer, 1–3
Heyting, Lien	WIJ POETSEN ELKE OCHTEND ONZE SCHOENEN	NRC Handelsblad, 7 Dec.

1980

Castle, Ted	GILBERT & GEORGE ARRIVE BEYOND ALCOHOL AND SEX	Art Monthly, No. 14, 8–11
Elton, L.	APPLE CRUMBLE	Artscribe, No. 24, 30–34
Morgan, P.	A RHETORIC OF SILENCE	BRITISH SCULPTURE IN THE TWENTIETH CENTURY, ed. Patrick Nairne and Nicholas Serota, 207
Ratcliff, Carter	GILBERT & GEORGE AND MODERN LIFE	exh. cat. GILBERT & GEORGE 1968–1980, Van Abbemuseum, Eindhoven
Anonymous	PERFORMANCES	Artes Visuales, No. 24, May, 32–50
Beks, Maartin	GILBERT EN GEORGE ENORM BEELDVERHAAL	Eindhovens Dagblad, 6 Dec.
Zumbrink, Jan	HET LEVEN ZELF ALS KUNSTVORM	Haarlems Dagblad, 11 Dec.

1981

Celant, Germano	GILBERT & GEORGE	BOOKS BY ARTISTS, Toronto, 100–101
Martin, Jean-Hubert	UN ENTRETIEN AVEC GILBERT & GEORGE	supplement to exh. cat. GILBERT & GEORGE 1968–1980, Centre Georges Pompidou, Paris
Nabakoski, G.	GILBERT & GEORGE	Kunstforum International, 1.122–127
Pouret, Martin	ART AND PURITY	ZG, No. 2
Puvogel, R.	GILBERT & GEORGE	Das Kunstwerk, 34.78–79
Walker, Stephen	LIVING WITH FEAR AND GILBERT & GEORGE	Blitz, Vol. 1, No. 4
Rokstedt, Wenzel	GILBERT & GEORGE	Playboy, Jan., 14

Bibliography

Blume, Mary	GILBERT & GEORGE, FROM LIVING SCULPTURE TO MODERN FEARS	International Herald Tribune, 31 Jan.
Roberts, John	GILBERT & GEORGE AT ANTHONY D'OFFAY	Artscribe, Feb.
Wilson, Simon	MODERN FEARS	Burlington Magazine, Feb.
Pohlen, Annelie	KALEIDOSKOP AUS WIRKLICHKEIT	Süddeutsche Zeitung, 3 Feb., 23
Trappschuh, Elke	TRAGISCHE ERFAHRUNG VON DISINTEGRATION	Handelsblatt, 3 Feb., 16
Hoghe, Raimund	DIE NORMALE KÜNSTLICHKEIT	Die Zeit, 13 Feb., 50
Flammersfeld, M.-L.	GILBERT & GEORGE	Du, Mar., 98
Anonymous	FLEISCHBESCHAU UND KÖRPERSPRACHE	Frankfurter Allgemeine Zeitung, 21 Mar.
Lucie-Smith, Edward	LONDON LETTER	Art International, Mar./April, 24.125
Lebeer, Irmeline	GILBERT & GEORGE, ART FOR ALL	Art Press, April
Hahn, Otto	VOYEZ, VOYEZ LES ARLEQUINS	L'Express, 19 May, 20
Francis, Mark	GILBERT & GEORGE, AN INTERVIEW	Whitechapel Art Gallery, London, 1 June
Mulders, Wim van	GILBERT & GEORGE: BEELDHOUWERS	Streven, July
Januszcak, Waldemar	MAKING SNAP JUDGEMENTS	The Guardian, 4 July
Vaizey, Marina	GILBERT & GEORGE, DANDIES IN DESPAIR	Sunday Times, 5 July
Lucie-Smith, Edward	GILBERT & GEORGE TALK WITH EDWARD LUCIE-SMITH	BBC Radio 3, broadcast on 7 Dec.
Hart, M.	GILBERT & GEORGE	Arts Review, 17 July, 33.309
Marcelis, Bernard	GILBERT & GEORGE: AN ITINERARY	Domus, July
Cork, Richard	FEAR AND SCULPTING	The Standard, 6 Aug.
McRitchie, Lynn	THE LIVING SCULPTURES LOOK AT LIFE	Performance Magazine, Sept./Oct.
Rona, Elisabeth	INTERVIEW: GILBERT & GEORGE	+ – 0 Revue d'art contemporain, Oct.
Burn, Gordon	THE PERFECT COUPLE	The Sunday Times Magazine, 18 Oct.
Morgan, P.	GILBERT & GEORGE	Artforum, Oct., 20.85
Collins, Nick	PEOPLE LIKE OBJECTS	Creative Camera, Nov.
Kinmonth, Patrick	GILBERT & GEORGE STILL IN MOVIES	Vogue (U.K.), Nov., 224–226
Brett, Guy	BEAUTY & THE BEAST	City Limits, 4–10 Dec.
Brown, Robert	THE WORLD OF GILBERT & GEORGE	British Film Institute Monthly Film Bulletin, 257, Dec.

Bibliography

Dadomo, Giovanni	ART FOR ALL: THE GILBERT & GEORGE SHOW	The Face, Dec.

1982

Anonymous		exh. cat. EXTENDED SENSIBILITIES – HOMOSEXUAL PRESENCE IN CONTEMPORARY ART, New Museum, New York, 39
Moravia, Alberto	MA CHE BELLE STATUINE	L'Espresso, 1 Jan.
Beaumont, M. R.	GILBERT & GEORGE	Arts Review, 29 Jan., 34.43
McEwen, John	FAÇADES	Spectator, 30 Jan.
Frey, Patrick	GILBERT & GEORGE IN DER FREMDHEIT IHRER WELT	Jahresbericht des Basler Kunstvereins, Kunsthalle, Basle, Feb.
Hyde, Phil	THE WORLD OF GILBERT & GEORGE	Performance Magazine, Mar.
Kent, Sarah	BLOOD HARD SLAVES OF BEAUTY	Time Out, 9–15 Apr.
McEwen, John	LIFE AND TIMES: GILBERT & GEORGE	Art in America, May, 128–135
Tsuzuki, Kyoichi	INTRODUCTION TO THE WORLD OF GILBERT & GEORGE	Brutus, Architectural Stylebook, 1 June
Beaumont, M. R.	KASSEL D7	Arts Review, 16 July, 34.385
Anonymous	EIN INTERVIEW MIT GILBERT & GEORGE	Tip, Berlin, No. 23, 8, 5 Nov.
Pelt, Hilde van	GILBERT & GEORGE	Gewad, Dec.
Anonymous	GILBERT & GEORGE	De Standaard, 12 Dec.

1983

Kaap, Gerald van der	HUNGER AND THIRST	Zien Magazine No. 5
Cooper, Emanuel	GILBERT & GEORGE, AUTHORITARIAN FASCISTS OR MISSIONARIES OF OUR TIME?	Gay News, 17 Feb.
Flood, Richard	EXHIBITION REVIEW	Artforum, Mar., 72/73
Smith, Roberta	GILBERT & GEORGE'S MODERN FAITH	Village Voice, 17 May
Becker, Robert	ART: LONDON'S LIVING SCULPTURE, GILBERT & GEORGE	Interview, Aug.
Cornand, Brigitte	PORTRAIT: GILBERT & GEORGE, ALLÉGORIES EN CHROMO	Beaux Arts, Sept.
Vespa	GILBERT & GEORGE	Gai-Pied, 1 Oct.

Bibliography

1984

Battcock, Gregory THE ART OF PERFORMANCE, New York (Dutton)

Finch, Liz MODERN FAITH AND INTELLECTUAL DEPRESSION Ritz, No. 88

Frey, Patrick IN THE STRANGENESS OF THEIR WORLD Parkett, No. 1

Holborn, Mark GILBERT & GEORGE STORM AMERICA'S CITADELS Aperture 97

Oliva, Achille Bonito DIALOGHI D'ARTISTA (Electa)

Richardson, Brenda NO PUZZLE, JUST DIFFICULT TRUTH exh. cat. GILBERT & GEORGE, Baltimore Museum of Art

Dorsey, John TWO ARTISTS OF A SINGLE MIND Baltimore Sun, 19 Feb.

Richard, Paul STRANGE, BOLD IMAGES FROM TWO ARTISTS WHO ARE ONE The Washington Post, 26 Feb.

Macritchie, Lynn LURE OF YOUTH City Limits, No. 129, Mar.

Sewell, Brian TWO OF A KIND Tatler, Mar.

Russell, John LONDON VIEWED AS A LANDSCAPE OF LOSS New York Times, 4 Mar.

Januszcak, Waldemar A CASE OF GOOD POTTERY TRAINING The Guardian, 28 Mar.

Allen, W. H. WINDOWS OF THE SOUL Baltimore Gay Paper, April

Cooper, Emanuel PERFECT PARTNERS Him Magazine, April

Gordon, Stephen ART GANGSTERS Art Line, April

Sozanski, Edward J. AS ONE Philadelphia Inquirer, 1 Apr.

Vaizey, Marina TO BELIEVE IS TO SEE Sunday Times: 1 Apr.

Russell Taylor, John REPRESSED ANGUISHES AND REBELLIONS The Times, 3 Apr.

Macritchie, Lynn THE BELIEVING WORLD OF GILBERT & GEORGE Performance Magazine, April/May

Bevan, Roger LONDON AND BALTIMORE Burlington Magazine, May

Cooke, Lynn GILBERT & GEORGE Art Monthly, May

Fawcett, Anthony, and Withers, Jane ALL FOR ART The Face, June

Kendall, Ena A ROOM OF MY OWN Observer Magazine, 10 June

Everingham, Carol J. TWIN SONS OF DIFFERENT MOTHERS UNLEASHING PRIMAL COLORS IN UNISON Houston Post, 23 June

Zevi, Adachiara LIFE, A GREAT SCULPTURE AEIOU Magazine, No. 10–11, July

Jeffrey, Ian ART RIGMAROLE: THEY ARE OUR BAUDELAIRE London Magazine, Aug.

Brooks, Rosetta SHAKE HANDS WITH THE DEVIL Artforum, Summer

Calhoun, Charles AN ART THAT HAUNTS THE MIND Palm Beach Life, Sept.

Bibliography

Schwan, Gary	BRITISH DUO ILLUSTRATE CONTROVERSIAL ISSUES	Palm Beach Post, 30 Sept.
Plagens, Peter	HOW ENGLISH IS IT?	Art in America, Oct.
Csonka, Ariane	THEY'LL GIVE YOU SOMETHING TO TALK ABOUT	The Miami Evening Times, 1 Oct.
Kohen, Helen L.	TWO PEOPLE, ONE ARTIST	Miami Herald, 7 Oct.
Sinderen, Wim van	IS THAT YOU GOD?	Vinyl, Nov.
Schmidt-Garre, Jan	NYLONHEMD & LAUTE KRAWATTE	Münchner Tageszeitung, 10 Dec.
Salerno, G. B.	L'OPERA D'ARTE HA 4 MANI E USA I KLEENEX	Il Manifesto, 28 Dec.

1985

Leccese, Pasquale	OUR FORTRESS	Domus, No. 661
Mennekes, Friedhelm		MYTHOS UND BIBEL (Katholisches Bibelwerk)
Salerno, G. B.	GILBERT, GEORGE, SAMUEL BECKETT	Flash Art, No. 125
West, Clive	MORNING COFFEE WITH GILBERT & GEORGE	Square Peg
Rein, Ingrid	KÜNSTLER SEIN DURCH UND DURCH	Süddeutsche Zeitung, 16 Jan.
Hegewisch, Katharina	HELDEN DER ZUKUNFT	Frankfurter Allgemeine Zeitung, 30 Jan.
Wilson, Simon	GILBERT & GEORGE	City Magazine, Mar.
Brenson, Michael	DUO WHO WORK AS SOLO	New York Times, 24 Apr.
Davvetas, Demosthenes	GILBERT & GEORGE ET RÉCIPROQUEMENT	Libération, 26 Apr.
White, Sally	GILBERT & GEORGE AT THE GUGGENHEIM	Arts Review, May
McGill, Douglas	TWO ARTISTS WHO PROBE THE MEANING OF LIFE	New York Times, 5 May
Withers, Jane	GILBERT & GEORGE GIVE A BROADWAY PERFORMANCE	The Times, 10 May
Lamoree, Jhim	HET SEKSUELE MYSTERIE ALS HEILIGE MIS	HP Magazine, 11 May
Brewer, Andy, and Daniels, Michael	LIVING SCULPTURE	Arrows Magazine, June
Russell, John	THE HIGH AESTHETIC STYLE OF GILBERT & GEORGE	House & Garden, July
Schwartz, Sanford	WE ARE ONE	The New Yorker, 19 Aug.

1986

Davvetas, Demosthenes	A CONVERSATION WITH GILBERT & GEORGE	exh. cat. CHARCOAL-ON-PAPER SCULPTURES, CAPC, Bordeaux

Bibliography

Jahn, Wolf	THREE WAYS	exh. cat. MATER DULCISSIMA, Syracuse, Sicily
Jahn, Wolf	WITH US IN THE NATURE	exh. cat. THE PAINTINGS, Fruitmarket Gallery, Edinburgh
Ratcliff, Carter	GILBERT & GEORGE: THE FABRIC OF THEIR WORLD	exh. cat. GILBERT & GEORGE, THE COMPLETE PICTURES 1971–1985, Bordeaux, Basle, Brussels, Madrid, Munich, London, 1986–87
Hakanson, Dan	DE LEVANDE SKULPTURERNA	Clic Magazine, Jan.
Wallace and Donohue	THE FEAR OF GILBERT & GEORGE	Art and Text, Feb.
Wozencroft, Jon	GILBERT & GEORGE	Touch Magazine, April
Codognato, Mario	GILBERT & GEORGE, L'OPERA, LE IDEE	Domus, May
Marcadé, Bernard	GILBERT & GEORGE	Art Press, May
Willaumez, Marie-F.	GILBERT & GEORGE PICTURES 1971–1985	Journal des Beaux-Arts, May
Froment, Jean-Louis	GILBERT & GEORGE	Connaissance des Arts, May
Gibson, Michael	GILBERT & GEORGE: TEDIUM IS THE MESSAGE	International Herald Tribune, 17 May
Albig, Jörg-Uwe	DIE MELANCHOLISCHEN DANDYS	Art, June
Fowles, John	THE ARISTOS	The Manipulator, June
Jahn, Wolf	NEUE BILDER EINES NEUEN LEBENS	Szene Hamburg, June
Fallowell, Duncan	TWENTY HAPPY YEARS OF PAIN AND MISERY	The Mail on Sunday, 22 June
Lamoree, Jhim	DE CULTUUR VAN GILBERT & GEORGE	H. P. Magazine, 19 July
Fallowell, Duncan	EINE SCHWATZ-SKULPTUR	Tagesanzeiger, 20 Sept.
Gassert, Siegmar	KOPF, SEELE, SEX: DIE SÄKULARISIERTE TRINITÄT	Baseler Zeitung, 29 Sept.
Cora, Bruno	GILBERT & GEORGE	Vogue Magazine, Oct.
Anonymous	STEREOMANEN IN REINKULTUR	Zofinger Tagblatt, Oct.
Meuli, Andrea	PANOPTIKUM DER HINTERGRÜNDIGKEITEN	Nordschweiz, Baseler Volksblatt, 4 Oct.
Waibel, Jürgen	IN DER KUNST ZU SEIN	Baseler Zeitung, 7 Oct.
Kageneck, Christian v.	MOSAIK DES LEBENS	Frankfurter Allgemeine Zeitung, 11 Oct.
Hollenstein, Roman	EINE KATHEDRALE ZEITGENÖSSISCHER BANALITÄTEN	Neue Zürcher Zeitung, 15 Oct.
Waibel, Jürgen	DAS DUO IST UNVERSCHÄMT MODERN	Stuttgarter Nachrichten, 24 Oct.

Bibliography

Stiwer, Pierre	INTERVIEW MIT GILBERT & GEORGE	Cafe-Creme Magazine, Autumn
Games, Stephen	ART PRIZE FOR "LIVING SCULPTORS"	The Independent, 26 Nov.
Januszcak, Waldemar	Y-FRONTS AND JUNK TAKE THE PRIZE	The Guardian, 26 Nov.
Murdin, Lynda	OH MISERY, GILBERT & GEORGE WIN ART AWARD	The London Standard, 26 Nov.
Russell Taylor, John	LOST OPPORTUNITY OF THE TURNER PRIZE	The Times, 27. Nov.
Sewell, Brian	THE EMPEROR'S NEW UNDERPANTS	The London Standard, 27 Nov.
Checkland, Sarah Jane	BY GEORGE... THEY'VE GOT IT	Today, Sunday, 30 Nov.
Brea, José Luis	EL MUNDO DE GILBERT & GEORGE	Sur Exprés, Dec.
Lucie-Smith, Edward	THE GOYAS OF SPITALFIELDS	The Times, 1 Dec.
Zutter, Jan de, and Borka, Max	DE WERELD VOLGENS GILBERT EN GEORGE: EVEN STOPPEN EN DENKEN	De Morgen, 1 Dec.
Braet, Jan	DE SPREKERS	knack magazine, 3 Dec.
Taylor, Brandon	THE JUNK BOND PRIZE	Art Monthly, 11 Dec.
Waibel, Jürgen	MIT IRONISCHER INBRUNST SUCHEN SIE NACH SINN	Mannheimer Morgen, 11 Dec.
Hoek, Els	NIEMAND + NIEMAND	Volkskrant, 12 Dec.
Barten, Walter	GILBERT & GEORGE: HET GAAT OM DE IDEEEN	Het Financieele Dagblad, 27 Dec.

1987

Jahn, Wolf	THE HUMAN CITY	exh. cat. FROM THE EUROPE OF OLD, Stedelijk Museum, Amsterdam
Brea, José Luis	GILBERT & GEORGE. ARTE CONTRA ARTE	Diario 16, Feb.
Withers, Jane	IL MONDO DI GILBERT & GEORGE	Vanity, Feb.
Tieghem, J.-P. van	GILBERT & GEORGE: THE ARTIST AS SPEAKER	Arte Factum, Feb.
Costa, José Manuel	GILBERT & GEORGE, ESCULTURAS VIVIENTES EN UN ARTE PARA TODOS	ABC, 2 Feb.
Costa, José Manuel	GILBERT Y GEORGE	ABC, 4 Feb.
Jarque, Fietta	GILBERT & GEORGE: CADA ARTISTA DEBE SIMULAR SER DOS PERSONAS CUANDO TRABAJA	El País, 4 Feb.

Bibliography

Markowski, Anna and Wojciech	GILBERT & GEORGE	Przekroj, Mar.
Dattenberger, Simone	VERTRAUTES ERSCHEINT WIE IM BEFREMDLICHEN TRAUM	Garmisch-Partenkirchen, 15 Apr.
Gliewe, Gert	GEHIRN, SEELE UND SEXUALITÄT	AZ, 16/17 Apr.
Jaeckel, Claudi	FOTOGRAFIEREN MIT MORAL	TZ, 16/17 Apr.
Rötzer, Florian	DER DOPPELTE NARZISS	Tageszeitung Berlin, 18 Apr.
Fenn, Walter	DIE MACHT DES TRIVIALEN	Weissenburger Tagblatt, 29 Apr.
Schütz, Heinz	GILBERT & GEORGE	Kunstforum International, May
Karcher, Eva	ZWEI SCHMUTZIGE MUSTERKNABEN	Süddeutsche Zeitung, 3 May
Gliewe, Gert	GEHIRN, SEELE UND SEXUALITÄT	Abendzeitung, 5 May
Metzger, Rainer	BILDER ALS AUSDRUCK DER ICH-MANIE	Bayerwald-Echo Cham, 5 May
Kronthaler, Helmut	DAS BILD VOM EIGENEN ICH	Hallertaver Zeitung, 22 May
Russell, John	THE HUGE IMAGES OF GILBERT & GEORGE	The New York Times, 5 June
Duncan, Andrew	THE ODD COUPLE	Observer Magazine, 28 June
Feaver, William	ART: GILBERT & GEORGE	Vogue (U. K.), July
Graham-Dixon, Andrew	THE TRAMP AS ARTIST	Harpers + Queen, July
Shelley, Jim	ART FOR ART'S SAKE	Immedia, July
Hughes-Hallet, Lucy	STUDIES IN STILL LIFE	The London Evening Standard, 2 July
Core, Philip	AN EXHIBITION AT THE HAYWARD GALLERY	BBC Radio 4, 6 July
Hughes-Hallet, Lucy	STUDIES IN STILL LIFE	The London Standard, 7 July
Todd, Bernadette	TWO NAUGHTY BOYS CAUGHT SWEARING	Ilea News, 7 July
Checkland, Sarah Jane	TABOO ICONS	London Daily News, 8 July
Jeffreys, Susan	A CHAT WITH GILBERT & GEORGE	Punch Magazine, 8 July
Russell-Taylor, John	GALLERIES	The Times, 8 July
Kent, Sarah	MISSIONARY POSITIONS	Time Out, 8–15 July
Dorment, Richard	GILBERT & GEORGE: TILL DEATH DO US PART	The Daily Telegraph, 9 July
Parry, John	TODAY PROGRAMME	BBC Radio 4, 9 July
Devlin, Polly	A PARTICULAR VIEW	International Herald Tribune, 10 July
Harris, Martyn	IT'S A JOKE BUT AT WHOSE EXPENSE?	Daily Telegraph, 10 July
Graham-Dixon, Andrew	DOUBLE EXPOSURE	The Independent, 11 July

Bibliography

Feaver, William	NICE LITTLE EARNERS	The Observer, 12 July
Shepherd, Michael	WALL TO WALL	The Sunday Telegraph, 12 July
Vaizey, Marina	THE DOUBLE TAKES THAT MAKE ART OUT OF LIFE	Sunday Times, 12 July
Packer, William	SLIM BRIDGE ON SHALLOW WATERS	Financial Times, 14 July
Januszcak, Waldemar	GOD'S EASTENDERS	The Guardian, 15 July
Kent, Sarah	PREVIEW	Time Out, 15 July
Auty, Giles	ROCK BOTTOM	The Spectator, 18 July
Murray, Callum	COMIC BOOK POP ART	Architectural Journal, 22 July
Cork, Richard	PROFANE PIETY	The Listener, 23 July
Sewell, Brian	BEWARE OF STRANGE MEN WHO DO FUNNY THINGS	The London Evening Standard, 23 July
Mejias, Jordan	HERREN DER KUNST: GILBERT & GEORGE	Frankfurter Allgemeine Zeitung, 24 July
Shelley, James	ART FOR ART'S SAKE	Melody Maker, 27 July
Sharrat, Phillip	THE "G" FORCE	Sky Magazine, 30 July
Hind, John	AN INTERVIEW WITH GILBERT & GEORGE	Blitz, No. 56, Aug.
Fealdman, Barry	PREOCCUPIED WITH SEX	Jewish Chronicle, 12 Aug.
Davvetas, Demosthenes	GILBERT ET GEORGE VONT EN TABLEAUX	Libération, 21 Aug.
Bignari, Irene	GENTE DI BRONZO	La Repubblica, 29 Aug.
Watson, Gary	AN INTERVIEW WITH GILBERT & GEORGE	Artscribe, Aug./Sept.
Archer, Michael	GILBERT & GEORGE	Art Monthly, Sept.
Griffiths, Lorraine	GILBERT & GEORGE FOR THE V+A	Weekend Voice, 3 Sept.
Hatts, Leigh	UNCOMFORTABLE FAMILY EROTICISM	Catholic Herald, 4 Sept.
Kimball, Roger	STRIKING SUCCESSFUL POSES	Times Literary Supplement, 4 Sept.
French, Philip	CRITICS' FORUM	BBC Radio 3, 5 Sept.
Shelley, James	DECLARATIONS	Westuff, Autumn
Allthorpe-Guyton, M.	GILBERT & GEORGE	Flash Art, Nov.
Bevan, Roger	THE LITERATURE OF GILBERT & GEORGE	Apollo, Nov.
Roberts, John	GILBERT & GEORGE: BEYOND THE ARCHES	Artscribe, Nov.
Thomas, Denis	DOUBLE TOP FOR GILBERT & GEORGE	EEC Europe, Nov.
Several contributors	COLLABORATION WITH GILBERT & GEORGE	Parkett, No. 14, Dec.
1988		
Scruton, Roger	BEASTLY BAD TASTE	Modern Painters, Spring
Davvetas, Demosthenes	GILBERT & GEORGE	Vogue Decoration, May

Bibliography

Whitaker, Andrea	GILBERT & GEORGE. DIE ZWILLINGE IM GEISTE	Pan Magazine, May
Anonymous	GILBERT & GEORGE	"SIX" by comme des garçons, Aug.

INDEX

Index

Index